RIG IT RIGHT!

Rig It Right! breaks down rigging so that you can achieve a fundamental understanding of the concept. The author will get you up and rigging with step-by-step tutorials covering multiple animation control types, connection methods, interactive skinning, BlendShapes, edgeloops, and joint placement, to name a few. The concept of a biped is explored as a human compared to a bird character allowing you to see that a biped is a biped and how to problem solve for the limbs at hand. *Rig It Right!* will take you to a more advanced level where you will learn how to create stretchy rigs with invisible control systems and use that to create your own types of rigs.

This highly anticipated **Third Edition** features updated chapters and images, including new chapters on modeling with proper edgeloop (Rule #1!), how to Rig It Right then Rig it Fast with parallel processing, and new helpful scripts for evaluating your rig with the profiler tools.

Key Features

- Hone your skills every step of the way with short tutorials and editable rigs that accompany each chapter (17+ rigs!!).
- Read "Tina's 10 Rules of Rigging" and build the foundational knowledge needed to successfully rig your characters.
- New content: Edgeloops for Good Deformation and Rigging for a Parallel World.
- New scripts for evaluating your rigs' performance.
- Access the Support Materials and expand your newfound knowledge with editable rigs, exercises, and videos that elaborate on techniques covered in the book.

Tina O'Hailey is an animation professor and author of animation textbooks and sci-fi/fantasy novels. She spent the first part of her career working as an artist development trainer for Walt Disney Feature Animation, DreamWorks Animation, and Electronic Arts.

RIG IT RIGHT! MAYA ANIMATION RIGGING CONCEPTS

THIRD EDITION

TINA O'HAILEY

CRC Press
Taylor & Francis Group
Boca Raton London New York

CRC Press is an imprint of the
Taylor & Francis Group, an **informa** business

Credit: Bird model by Alston Jones

Third edition published 2024
by CRC Press
2385 NW Executive Center Drive, Suite 320, Boca Raton FL 33431

and by CRC Press
4 Park Square, Milton Park, Abingdon, Oxon, OX14 4RN

CRC Press is an imprint of Taylor & Francis Group, LLC

© 2024 Tina O'Hailey

First edition published by Focal Press 2013

Second edition published by CRC Press 2018

Library of Congress Cataloging-in-Publication Data

Names: O'Hailey, Tina, author.
Title: Rig it right! : Maya animation rigging concepts / Tina O'Hailey.
Description: Third edition. | Boca Raton : CRC Press, 2024. |
Includes bibliographical references and index.
Identifiers: LCCN 2023038100 (print) | LCCN 2023038101 (ebook) |
ISBN 9781032555232 (pbk) | ISBN 9781032555249 (hbk) |
ISBN 9781003431121 (ebk)
Subjects: LCSH: Maya (Computer file) | Rigging (Computer animation)
Classification: LCC TR897.77 .O53 2024 (print) | LCC TR897.77 (ebook) |
DDC 006.6/96--dc23/eng/20231107
LC record available at https://lccn.loc.gov/2023038100
LC ebook record available at https://lccn.loc.gov/2023038101

ISBN: 978-1-032-55524-9 (hbk)
ISBN: 978-1-032-55523-2 (pbk)
ISBN: 978-1-003-43112-1 (ebk)

DOI: 10.1201/9781003431121

Typeset in Utopia Std
by KnowledgeWorks Global Ltd.

Access the Support Materials: https://www.routledge.com/9781032555249

CONTENTS

ACKNOWLEDGMENTS

Where to Find the Companion Data

There is a plethora of data that comes with my books. Support Materials for this book are available at https://routledge.com/9781032555249. I keep a backup of data at https://rigitright.gumroad.com/.

Please find me out there where I post updates about the textbooks, novels, and my caving-kayaking-hiking adventures:

https://coffeediem.wordpress.com
https://www.facebook.com/rigitright/

Dear Reader

Character setup, otherwise known as rigging, is an extremely odd topic. Most of my students don't know they like it until they've dabbled in the dark arts. My goal is to at least make students aware enough of the rigging process to be able to create small rigs for their senior project; to be able to work with character setup artists in their careers; to understand that it is extremely difficult and must be done correctly to enable the animator to animate well. In short, I hope students learn to respect their character setup artist.

What I have found in the past dozen years of rigging classes I have sat in, learned in, taught in, and learned in some more, is that out of every class there is maybe only one person who really has the desire and love of the craft to go on to become a career character setup artist. Of those people, only those who can script or code can move onto become a fully-fledged animation technical director. Of the other people in the class, there are a few more who understand it enough so that they are going to be able to do it when their job necessitates it. (I will get emails from students who assure me they wouldn't have a job if they hadn't been able to do basic rigging. Recently, I saw a post from a student who beat a rig problem and thanked me for enabling him to do so! How sweet.) Then there are the others—who shake their heads and grin sheepishly when I ask them if they think they will continue to rig. Very rarely do I meet a student who can't do it at all, and usually they can to some degree, just not to a production level. However, they always get enough from the lessons to help them better understand and communicate with the character setup artist.

The question is, which are you? No matter the answer—you will be able to get a lot from this book. I've broken things down into basic and advanced concepts. In the basic concepts, we will cover basic rigs and the concepts of how to rig them and then we will work our way up to a biped character. Each step of the way we cover methodologies (a fancy word for rules) to help guide you in any character setup problem which you come across. Ultimately, I hope you go on to read the advanced section of this book and can put together your own types of rigs and come up with your own methods.

How did I learn? I listened to a lot of character setup artists in my career. I sat in their workshops, I looked at their rigs, I broke them apart, I broke them, I fixed them, I broke them some more, I began testing and breaking things more. (This is before YouTube.) After a while, I noticed I had come to have a definite opinion of what worked and what didn't. Not every character setup artist will share that same opinion since this topic has a hundred ways to do something and they all work. I base my approach on rules (methodologies) I have developed to guide myself. To all of those that I have learned from, who taught me, who put up with my questions, thank you: Jason Osipa ("Beyond Blendshaping" class at EA), Jason Schliefer (letting me use his scripts and being supportive), Craig Slagel ("Rigging the Bond Ladies" workshop at EA), Jayme Wilkinson (whether to lock controls or not lock controls, and IK vs. FK debates, and most recently—my muse for all things parallel processing), Chris Christman ("Intro to Rigging" class at Disney), and the hundreds of students of mine who have tested methods, given feedback, explored what worked and didn't work when I was trying out a new idea and honing how to deliver things; again, thank you.

Did you really read this whole thing? Well, let's get down to business.

Warmly,
Tina

Special Thanks

The thank you page: because these things don't write themselves. Special thanks to the CRC Press team for your support, and finally, the O'Hailey squad—your unconditional love and support has always been my secret to anything and everything.

Special thanks to the wonderful alumni whose work you see in this text:

Mike Bedsole, SCAD BFA Animation 2012
Brian Hathaway, SCAD BFA Animation 2013
Alston Jones, SCAD MFA Animation 2012, http://www. alstonjones.com, bird model
Jarel Kingsberry, SCAD BFA Animation 2012, http://www. jarelkingsberry.blogspot.com
Stefan Lepera, SCAD BFA Animation 2011
Danny O'Hailey, SCAD BFA Visual Effects 2018, cover design (second edition)
Joseph O'Hailey, SCAD BFA Visual Effects 2021, MFA Animation 2024, tech editing (third edition)
David Peeples, SCAD BFA Animation 2013
Vivi Qin, SCAD MFA Animation 2012
Brenda Weede, SCAD BFA Animation 2012
Adam White, SCAD BFA Animation 2009

And special thanks to those that helped with the new chapters for the third edition:
Jayme Wilkinson, profiler and evaluation toolkit muse
Joseph O'Hailey, hard-core tech editing while working on a thesis
Lluis Llobera and Javier Solsona, rig101wireControllers script
Jason Bickerstaff, modelling techniques
Marty Altman, manageSuffix and extractFaces scripts, and always proofing my math
Eric Allen, edgeloop rules
Ashwin Inamdar, modelling techniques, https://www. iashwin.net/rigs
Mia Pray, Rijah Kazuo, Sagar Arun, Aang model with excellent edgeloops

The additional chapters for the third edition of this book were funded (in part) through a Savannah College of Art and Design Faculty Sabbatical Award

INTRODUCTION

Basic Rules of Rigging

Let's start with some rules to help guide us.

Where did these rules come from? From years of looking at rigs; watching rigs in production; dissecting rigs; putting rigs into group projects; watching them break; fixing them; watching them work; reading and looking at every rig I could see; then, I realized that I had developed an opinion of what I liked and what I did not like about certain rigs. (If you read the previous section, you already know this.) I finally put these opinions down as my rules for rigging. There are a hundred ways to do everything, which makes it so challenging to learn rigging. For this book, we'll use these rules and refer to them often. I found that if I start with these as a baseline for the basic concepts, it helps manage the learning process and maybe even curb some chaos. We'll cover these rules more in the coming chapters. For now, here they are.

1. Edgeloops—a good or bad rig starts with the loops.
2. Never keyframe on the geometry. (Rig for change.)
3. Lock what isn't going to be animated.
4. Keep geometry (GEO), controls (CNTRL), and skeletons (SKEL) in separate groups in the outliner.
5. Make controls that make sense to the animator.
6. Happy math—controls and joints should be zeroed out.
7. Happy history—always delete unneeded history to keep a rig fast.
8. Joint placement, preferred angles, and orientations—good models can go bad with poor joint placement. Take extra care here before any other rigging—or you'll be redoing your rig.
9. BlendShapes—never ever freeze them.
10. Skinning—make peace with it—a good rig with bad skinning is still bad.

It's like a mysterious trailer, isn't it? Sounds brutal, doesn't it? Skinning and math; what on earth? Don't worry. I can confidently say that in this book, you don't need to know a whole lot of math. Logic and problem-solving skills, however, you'll need a good deal of. Also, this book assumes that you have been working in Maya and have a basic understanding of modeling (at least some polygon modeling) and maybe have even tried your hand at setting keyframes on something. Therefore, this is not a "how to move the camera" or "how to get around in Maya" primer. If

DOI: 10.1201/9781003431121-1

you need to brush up, there are plenty of places out there. I'll suggest "Introducing Autodesk Maya" by Dariush Derakhshani. I tech edited the latest version and seriously enjoyed it. Also, built into Maya are helpful getting started tutorials. Look under **Help>Interactive Tutorials**.

Taking Control of Your Outliner/Node Editor/History

Before we get straight into setting up your first rig and gleefully animating it, let's take a look at a couple of important topics inside of Maya that maybe you have not seen before. We won't spend too long on this, honest. Most concepts we'll learn during the course of this book in an applied method; it helps it stick better in the ol' noggin.

Introduction to Nodes

If you open any book on Maya, you will find this topic discussed at great length. It is important to understand the basic principles of how Maya works under the hood, so we will also discuss this topic. Up until this point, perhaps you have modeled and animated with Maya. That takes one level of understanding: like driving a car. You know where the gas and brake pedals are; you know how to put gas in the car; maybe you have a high-level concept of how an engine works. But if pressed, you couldn't exactly talk about the finer points of how the engine's inner bits and pieces worked.

Let's take a simple object as our starting point. In a simple scene of nothing more than a polygon sphere, there seems to be only the sphere and the cameras looking at it, right? You know I'm leading you on; of course, there is more to it than that. Perhaps you even have a clue, because you've adjusted the "inputs" attributes to a sphere in your past modeling experience. Those who haven't, take a look in the channel box and under inputs, you will see the attributes that you can adjust for that primitive. You can adjust the radius, subdivisions axis, subdivisions height, etc. If you do not see these items in the "inputs" section of the channel box, be sure to have history on and then recreate the polygon sphere. In the image set out hereafter, the attributes for the pSphereShape1 are not shown for simplicity's sake. In newer versions, Maya also shows material settings for Arnold.

You can select the name of the attribute (e.g., subdivisions height), then click your middle mouse button in the main window and drag left and right to use a virtual slider (see Figure I.1). What does "input" mean exactly? Well, that brings us back to

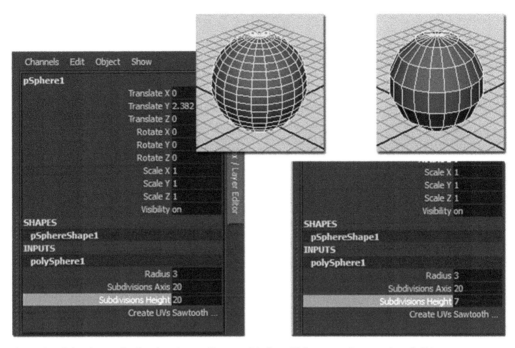

Figure I.1 Selecting and adjusting the attributes with the middle mouse button virtual slider.

the concept of nodes. Every object starts off with two nodes. You can think of a node as a box that contains information and does something with that information. There are two nodes to an object: **transform node and shape node**.

If you look in the channel box, when the sphere is selected, you see both nodes represented. The transform node contains all of the positioning information for your object. You know this as the translate, rotate, and scale information. What you may not have known is that all the animation you have been doing has been keyframed on what we call the transform node. OK, so now you have something witty to talk about at a cocktail party while reaching for another pig in a blanket: *... but of course, I keyframe the transform node, Thurston, and ... are these spicy?* I tell jokes. Why? Dopamine. Helps connect things better in the brain. Little laughter goes a long way when trying to teach new things. If you lack a funny bone, well, skip the jokes.

If the transform node tells the object where it is, what do you think the shape node does? If you said, it tells the object what it looks like—you are right. The shape node takes in all the inputs that tell the object what it ultimately looks like. By default, the primitive shapes have some built-in attributes that you can adjust, like height and width. But you can do more to the primitive shapes, as you may have learned in your basic modeling experience. We'll talk more about that in a moment.

How to Find the Transform and Shape Nodes

There are two main ways to see the shape nodes. You, by default, have been working only with the transform nodes in your initial career with Maya. Shape nodes are usually hidden from the average user since they get in the way. It would be like driving your car around with the hood up all the time: not advisable.

The first way for you to see the shape nodes is to open your outliner by selecting **Window>Outliner** or the **Perspective/Outliner** preset. In the outliner window, you can see the list with your object; that is, the transform node. Please, don't believe me; always double-check to make sure I'm not lying outright to you or having a senile moment: click on the **sphere1** node and look in the channel box. Do you see transform, rotate, and scale attributes? Yes? It is just as I suspected, a transform node.

In the outliner window, if you select **Display>Shapes**, you will see that a plus sign has shown up next to **sphere1**. Click on that plus sign and you will see the shape node (see Figure I.2). The icon will change once you open up the sphere1 to see the shape node. When you select that shape node, what do you see in the channel box? Well, look at that. You no longer see the transform information. You see the shape information under the inputs area. In this example, items visible are the radius, subdivision axis, and subdivision height. Render attributes, which we aren't concerned with for rigging, might also be visible. They all feed into the shape node since they describe what the object will look like. This probably doesn't seem too out of the norm for you since you have experience with the outliner. But, have you seen the node editor?

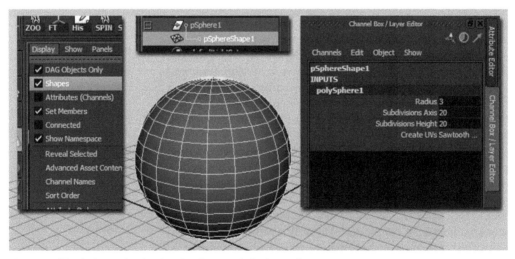

Figure I.2 Displaying and selecting the shape node in the outliner.

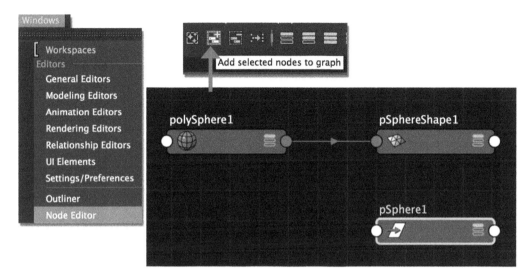

Figure I.3 Displaying and selecting the shape node in the node editor window.

With your sphere selected, open up the node editor window by selecting **Windows>Node Editor**. This takes a deeper look into the inner workings of your scene. The window might be blank. Make sure the sphere (transform node) is selected and then click on the **Add selected nodes to graph** button as seen in Figure I.3. This will show the shape node and the transform node. It looks like the transform node and the shape node have nothing to do with each other, doesn't it? The shape node and transform node are only hierarchically related, as seen in the outliner window. In other words, the transform node is a parent to the shape node. There is no other connection between them. Thus, they do not seem to be connected in the node editor. However, there are plenty of connections going on, which is what we will learn in depth. If you select the shape node named **pSphereShape1** and the transform node titled **pSphere1**, then click on the **Input and open connections** button found at the top of the **Node Editor** window. The shape node is where other connections come in and it connects to the shading group node.

Looking Under the Hood

Now don't forget how to find the shape node. As you see, it is the connection to so much. We'll need to be able to get to the shape nodes quite often. Put a sticky note on this page if you have to. You have officially opened the hood to have a look at Maya's guts. The node editor shows you the node networks: how things are interconnected (see Figure I.4). This is where we will need to get comfortable. I'll warn you, it gets a little muddy in

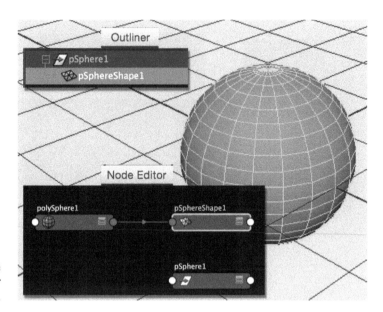

Figure I.4 Selecting the shape node in the outliner and the node editor windows.

here, so tighten your bootlaces. I'll help you see where to step and not get your boots sucked off your feet. Let's look again at the **polySphere1** node that feeds into the pSphereShape1 node (see Figure I.5). That is the node that you can adjust the sphere attributes on. Click on the three separate nodes to see what different attributes show up in the channel box. (We're ignoring the initialShadingGroup node and anything to do with materials and shaders for this book.)

Note: Maya has a node that represents almost everything it does (including its inner workings). So, it only shows you what you have asked to see (by clicking the input and output

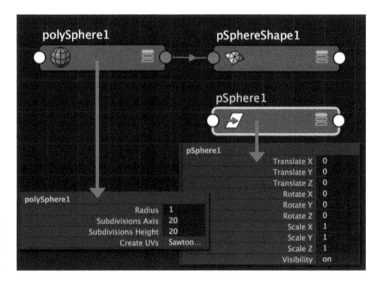

Figure I.5 Transform node and input node (polySphere1) feeding into the shape node and their keyable attributes.

connections button) in the node editor window. Otherwise, it won't show you anything. Maya has to simplify to only show you what you have asked to see. If it didn't and showed you all of the nodes, you would see hundreds of nodes that mean nothing in relation to what you are trying to do. Thick mud, indeed, and you wouldn't want to step there. I have two analogy streams, if you didn't notice: cars and thick mud. Just roll with me here. We'll chalk it up to random stimuli. [Professor smiles.]

You are doing great with these basic concepts. While we're here, let's talk a little bit about history. (*Keeping Stephen Hawking jokes to myself ... brief history ... oh, never mind.*) Go ahead and create some basic face extrudes on your sphere; model something with it. If you don't know how to do a basic extrude, you'll need to go freshen up on the mere beginnings of polygon modeling. That's beyond the scope of this book. See **Help>Interactive Tutorials>Intro to Modeling** for more modeling help. In Figure I.6, I've taken a sphere and using extrude, wedge, and a few other poly modeling tools created something that resembles a preschooler's drawing, if it were in 3D.

If you select your object and look again in the inputs area of the channel box, what do you see? Ah, you see all the extrudes etc. that you have created. You might know that if you select any of those names listed, you can adjust that particular extrude. (Using the **T** hot key, you can even recall that manipulator.) Well, you can adjust anything in the object's history because everything you did was based on a node and those modeling nodes are building up. Take a look in the Node Editor window

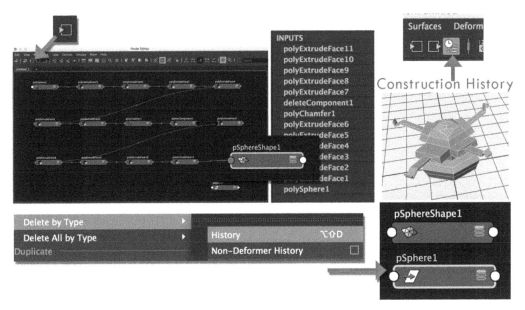

Figure I.6 Modeled object before and after "Delete History" is done.

(remember to have the object selected and click on **input connections**) and you will see a node for everything you just did. In fact, you'll see all of the extrude nodes hooking into the shape node. You aren't surprised, are you? Imagine how many nodes would be there if you had been modeling a human character or anything more impressive than a preschool 3D scribble? In fact, this is exactly why we delete history: those nodes s l o w Maya down. It has to think through each one of those nodes every time you attempt to do anything. Certainly not something you want to happen in a rig that you are animating.

Watch what happens to the node editor window when you delete history. Delete history by selecting: **Edit>Delete by Type>History**. All of those nodes are gone (see Figure I.6). In fact, the only things you are left with are the actual shape and transform nodes. No input nodes to be found. You could have even deleted them manually by selecting them in the node editor window and pressing delete on the keyboard. Maya would rewire things up automatically in the node editor window for you.

Note: If you do not have history turned on, the nodes will not build up. However, it is usually good practice to model with history on and delete history periodically. In Figure I.6, a red arrow points to the preserve history toggle.

That sets us up for a good start. Let's move on to the next topic then. Remember where this page is parked—you'll want to refer back to how to pick the shape node often, at least until you get used to it.

BASIC CONCEPTS

1

PROPS, PIVOT POINTS, AND HIERARCHIES

RULES COVERED
Rule #2: Never keyframe the geometry
Rule #7: Happy history—always delete unneeded history to keep a rig fast

If you don't get any further than this chapter, you will have learned something that will certainly save your rear end in your own personal projects. It is simple … remember your conversation with Thurston at the cocktail party about keyframing the transform node? Let's push that concept a bit further.

First let's think about that transformation node and what it really tells you. "Where the object sits," the apt student in the front row might say. Correct. Every transform node tracks how far the pivot point of the object is moved, rotated, or scaled from the origin, which is the center of the grid/universe. The pivot point of an object is where those numbers are tracking to. There are two ways to move the pivot point of an object. Make sure your move tool is selected and the object is selected.

1. Hit the **Insert Key** and you can toggle back and forth between the pivot point and moving the object. (Note the cursor icon change.)
2. My favorite is to hold down the **d** key. While holding that key down, you are in pivot point manipulation mode. Mac users will find this method useful, as Macs do not have an insert key.

After adjusting the pivot point, you will see that when you rotate or move the object, the manipulator shows up at the point where you placed the pivot. A trophy, for example, might tilt from the bottom if it was knocked over. Thus, its pivot point needs to be moved to the bottom. This is an important concept to gather. Putting pivot points in the right place will be one of those things that will bite you in your rigging process (see Figure 1.1). So, you'll be hearing about pivot points quite a bit in the coming chapters.

DOI: 10.1201/9781003431121-3

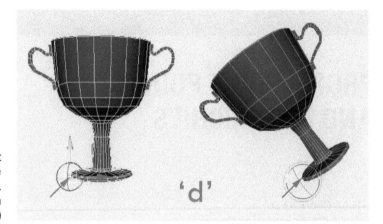

Figure 1.1 Moving the pivot point adjusts where the transform manipulator exists. (Model by David Peeples, with permission.)

Zeroing Out

For almost all objects that we deal with in this book, there are a couple of things you need to do for them. One is to delete history—we've already seen that. The other is to freeze transformations. What this does for the animator is set the current position as the zero point. Meaning that the animator can zero out (type zeros in all of the transform node's attributes) and the object will return to this neutral, rest position.

We'll find a rule about that somewhere around here later. But for now, let's see what happens when you zero something out. In an artist's view, when you have an object selected and click on **Modify>Freeze Transformations**, you will see that the attributes in the transform node all turn to zeros and ones (see Figure 1.2). Go ahead and try it. I'll wait.

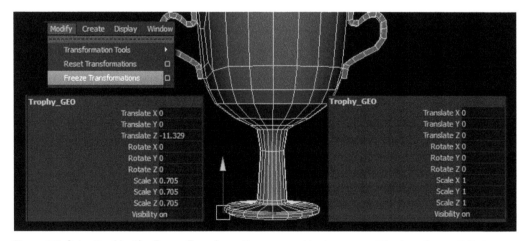

Figure 1.2 Selecting Modify>Freeze Transformations on an object zeroes out the transform attributes.

Geek cocktail party note: To the artist, it looks like the transform node has been zeroed out. If you want to impress Thurston at that cocktail party, you can bring up the fact that nothing is really ever zeroed out. If he were to look in the attribute editor under the transform tab, he would see that the local pivot point has taken the numbers from the main attributes as seen in Figure 1.3. If you know a little about multiplying matrixes, you might recognize that all objects have their own "universe" they live in, and when you freeze transformations, you are really just multiplying matrixes so that the artists think it is zeroed out. In fact, there are scripts on Creative Crash that help you resurrect those numbers if you froze when you ought not to have. In version 2022+ of Maya, you'll see an additional area titled **Offset Parent Matrix**. Something fancy that we'll discover later. So, you can tell Thurston, *Freezing transformations pretends to set zeros for the translate and rotate attributes. They are still there, just hidden from the animator.*

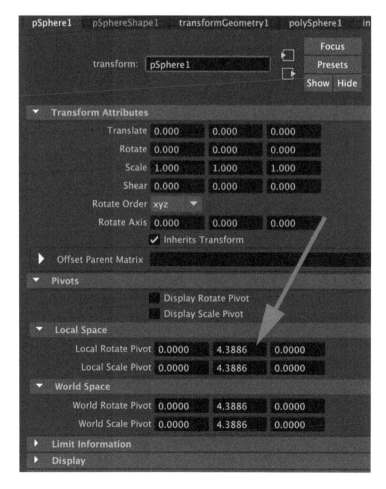

Figure 1.3 Hidden pivot information that most artists don't see.

Using Group Nodes to Hold Animation

Let's look at our first hands-on example. In the file **chpt1_ trophy_v1.ma**, we have a simple object: a trophy. Note that the trophy is well named, has deleted history, and has been zeroed out.

We'll focus on the bottom frames of Figure 1.4 where the trophy needs to simply fall over, tipping on its base. To enable that for our animators, we only need one pivot point for them to animate.

1. Select the **Trophy_GEO**.
2. Create a group: **Edit>Group** (CNTRL g).
3. Rename the node to be **Trophy_GRP**. Don't put off renaming; name as you go.
4. Move the pivot point to the bottom of the trophy by using one of the methods described previously. I like to use the hot keys "**d**" and I'll also hold down "**v**" to temporarily snap to point. This will make placing the pivot point on the edge of the trophy just a little bit easier.

In the outliner, we can see the group node is a parent to the trophy node. If you select the group node and look in the channel box, what do you see that is striking? Think back to what we learned in the introduction of this book and what your first cocktail party conversation with Thurston was about. There's something missing when you select a group node. There is not a shape node. Group nodes are nothing but transform nodes that hold translate, rotate, and scale information. They do not have anything visible, so they do not have any inputs in the channel box. Since they are just empty transform nodes, they are great to use as animatable nodes for the animator.

If we think about Rule #2, it says we should not animate on the geometry. So, just to remind us of that, the transform attributes need to be locked so that they cannot be animated.

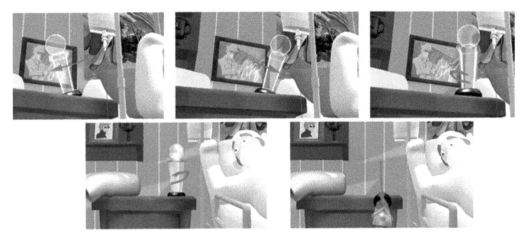

Figure 1.4 Example of a trophy animation that shows how we will rig our trophy to fall off a dresser.

To lock attributes, select the **Geometry**, select the names of the attributes in the channel box, right mouse click, and select **Lock Selected**. Do not select *Lock and Hide Selected*. That would hide the attributes altogether, something we'll want to learn later on when we are 100% sure we don't want those attributes around. Otherwise, you could set yourself up for a couple more button clicks to get those hidden attributes back. (Later on, I'll tell you a story about what overlocking and hiding of attributes can do for a production's sanity.)

Warning: Locking geometry attributes is not a normal practice. We'll just do it for now so that we remember to follow Rule #2. Later on, after you are used to this concept, you won't need to lock the geometry. I'll point out where it could get you into trouble since locking geometry can actually make something break: somewhere around Chapter 5.

Pro Tip: Locking channels that won't be animated is necessary in Maya 2018+. If the channels get static animation keyframes placed on them, the parallel memory management of Maya will watch that static channel like a hawk. And. Slow. Down. Oh no! We'll talk about that more in Chapter 21.

Now, you can animate the rotating trophy. Remember, we are animating on the group node (see Figure 1.5). Select the **Trophy_GRP** node, press "**s**" to set a keyframe, advance time, and rotate the trophy and set another keyframe. Continue as needed. Once you have set your keyframes on the group node, you can play back your animation to see the trophy fall. I'm assuming you know how to animate at least a little bit. In order

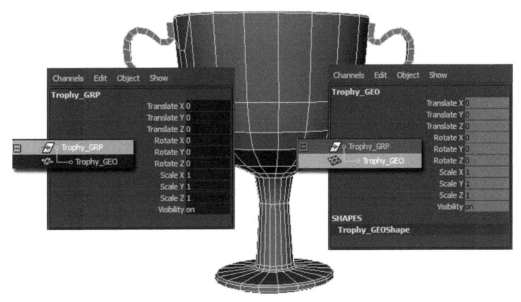

Figure 1.5 Group nodes have no shape node. We will use the group node to animate and lock the geometry's attributes so we don't accidentally animate the geo.

to do character setup, you need to have experience animating. The best character setup artists are animators at heart. Either they are flat-out great animators or, if not great, at least have passion or empathy for it. If you don't know what it takes to make a great pose or animation, how would you be able to create a rig for it?

Excellent, if we were in a classroom together we would see a dozen or so falling trophies on display. Your scene is animated; everything is just fine. But, wait—the art director has just walked into the room and declared with great dismay you have animated the wrong object! It wasn't a trophy after all, there was a story change and it is supposed to be a donut that falls off the dresser. Guess you will have to start over? Never fear, Rule #2 has saved you. With prop animations, if you keep your animation to the group nodes and not on the geometry—you can replace the geometry easily without losing any animation (see Figure 1.6).

To update your rig, first make sure that your **Trophy_GRP** is back at its "zero point" with translate and rotate set at zeros. Then, create a donut (**Polygon>Torus**) and place it at the same place as the Trophy. Remember to **Freeze Transformations** and **Delete History** on it. Good job, you remembered to label it, didn't you? We simply need to make the **Donut_GEO** a child of the **Trophy_GRP**. For that, let's learn a couple of new ways to create children. (*Professor looks at you blankly—what is so funny about that statement? And if the professor were George Burns, he would puff on a cigar while still looking at you blankly. Of course, even I am too young to get that reference—go look it up.*)

Figure 1.6 Animation keyframes on the Trophy_GRP.

Making Children

Up to this point, you might be aware that you can select the desired child object and then the desired parent object and then use the "**p**" hot key, or **Edit>Parent**, to create a parent–child relationship. This works just fine, but in rigging, you want to have a little more visible control of who is a child or a parent. You'll also want to be able to do this quickly. So, we'll learn a gestural way to create a parent–child relationship.

In the outliner, you can **middle mouse** drag the **Donut_GEO** on top of the **Trophy_GRP**, and once you let go, the Donut_GEO will become the child. You can easily middle mouse drag and drop objects in the outliner window and parent or unparent objects (see Figure 1.7).

You **cannot** do the same in the **Node Editor** window. That editor only shows connections between nodes, which we will explore in depth soon. It does not show hierarchical relationships. There is another window you could use: the hypergraph, found under **Windows>Hypergraph:Hierarchy**. In this window, you use the same gestural mechanism: middle mouse drag the donuts translate node on top of the trophy group node and it will become a child. See Figure 1.8.

Select the trophy geometry and hide it by changing the **visibility** attribute to **0** or using the hot key **CNTRL h**. (Generally, studios have a policy that visibility attributes are the only thing that remains "unlocked" in the channel box.) Now, play back your animation and you can see that nothing was lost. The animation was on the group node, so anything placed as a child under that node gets animated. You could put a whole box of donuts there, and they would rotate off the dresser.

Hopefully, you see this is a great lesson to learn. Let's say that you have your own student senior project to do. You have a generic idea of what the models will look like and what the animation should be. However, you are waiting for someone to complete the modeling of the objects for you. You are waiting and waiting and waiting. They are doing a great job on the modeling, but you are losing time, which could be spent animating, refining the timing and the story. What to do? Oh—with this one concept, you can create blocky stand-in prop models, proceed with their pivot point animation, and then replace them with the high-res model when your friend is done. Brilliant—you have broken free of a waterfall process of animation where you wait for each and every step to finish

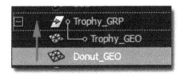

Figure 1.7 Middle mouse dragging the Donut_GEO to be a child of the Trophy_GRP in the outliner.

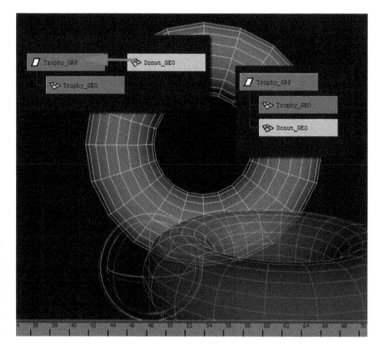

Figure 1.8 Middle mouse dragging the Donut_GEO to be a child of the Trophy_GRP in the Hypergraph Connections window. The donuts now animate.

before proceeding to the next. Now, you have created a parallel process where you can continue forward even while the modeling stage is still finishing. If that is all you take away from this book, it will help you out greatly.

Oh, you want more? OK. What else can we do with this concept? What if your object doesn't just tip over? What if it has to tip from one side and then the other, as you saw in the example images in Figure 1.4? In that case, you would use multiple pivot points or multiple group nodes to animate with. This method is the cornerstone of 3D animation and hasn't changed since its invention. Often with props (noncharacter objects), pivot point animation is all you need.

To create the trophy with multiple pivot points, simply add in a group for each pivot point. When animating with the group nodes, hierarchy matters. If you have two group nodes, Trophy_Tip_Left and Trophy_Tip_Right, whichever is the parent will affect the child. So, if you rotate the left group node and it is the parent, the right one will go along. However, if you rotate the right group node, the left one will stay in place since it is the parent. This is to your advantage. Make sure the parent is the first pivot point that needs to be animated. So in our new storyboard, the trophy rotates left, then rotates right, settles, and then spins a little on its base. We'll add three group nodes for that. With the trophy selected, add the following groups:

1. **Trophy_Spin__GRP**—move the pivot point to the bottom center of the trophy.

2. **Trophy_Tip_R_GRP**—move the pivot point to the bottom right of the trophy.
3. **Trophy_Tip_L_GRP**—move the pivot point to the bottom left of the trophy.

Make sure their hierarchy has the following hierarchy: spin group>parent of tip right>parent of tip left>parent of Trophy GEO (see Figure 1.9).

The top node, **Trophy_Spin_GRP**, also controls where the rig is placed, so we left the translate attributes open. Now let's test the functionality of our rig. We can move the rig around and set keyframes on the **Trophy_Spin_GRP** node. We can spin it flat on its bottom axis. We can also tip it left first and then right (see Figure 1.10).

There are some things to remember about pivot point animation. The translate node should always be on top since it will move all of the other nodes along. Children nodes can translate as well; just remember that if you translate a child node, it moves away from the rest of the rig. Maybe your rig needs that to happen.

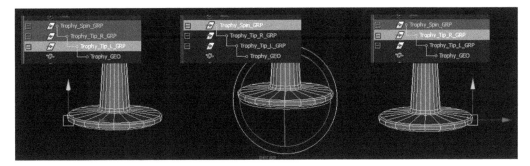

Figure 1.9 Trophy with three group nodes for pivot point animation.

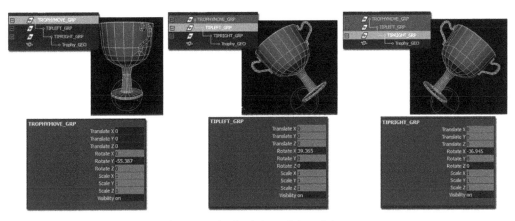

Figure 1.10 Trophy rig spins on its bottom axis, tips left, and then right.

Let's finish up this trophy rig with a look at Rule #3. Later on in this book, we will learn how to add animator controls to the rigs. Before we get there, we have to make sure we truly understand what it is that we are leaving for the animator to animate.

Lock What Isn't Going to Be Animated

I promised you there was a rule for this. This is super important. When you make a rig and hand it off to someone who has no idea what you have done, you have one main way of communicating to them: only give them what they need. Your job is to lock all attributes that you do not want to be animated. Usually, you don't want them to be animated because it will break the rig. For example, you have created specific nodes to translate and specific nodes meant to animate with a certain pivot point. To make sure we don't move things that we don't want to move in our trophy rig, we'll lock the following attributes:
1. **Trophy_Spin__GRP**—lock **Rotate X, Z**.
2. **Trophy_Tip_R_GRP**—lock all **Translate**, **Rotate Y**, and all **Scale** attributes.
3. **Trophy_Tip_L_GRP**—lock all **Translate**, **Rotate Y**, and all **Scale** attributes.

This is a very simplified rig now. Before handing this off to an animator, double-check that it does what you needed and nothing extra is left unlocked. If you are absolutely, positively sure, have done a test animation, and have the rig approved by the supervising animator, then you can hide the attributes as well.

Select the locked attributes and **right mouse click** and select **Lock and Hide Selected**. Now, the attributes are no longer keyable and are no longer able to be manipulated. Your rig is ready to go into production. The completed rig can be seen in the example file: **chpt1_trophy_v2.ma**.

Now, for my story. I once made a bucket rig for a training class at Disney. It was super simple, and I thought I was being clever by locking everything down and hiding attributes. However, the animators I was handing it to wanted to add more group nodes for pivot point animation and needed to access more attributes than what I had left. They had to unlock and unhide every group node that I had on there. There was certainly a good-natured phone call that came my way—they didn't want things locked down. I hadn't given the rig to them to test first. In my defense, I had just finished working with a group that needed everything locked down since they were newer to the production rigs. It certainly brings home the importance of having your intended audience give feedback before you lock and hide everything.

What to Do If You Have Hidden Attributes and Want Them Back

Select the object and then select the menu option: **Window>General>Channel Control**. In this window, there are two tabs: **keyable** and **locked**. If something is keyable, it is seen in the channel box. If something is locked, it cannot be manipulated, indicated by a grayed-out manipulator and a gray attribute box in the channels box. (Depending on the version of Maya, it may be fully grayed out or only has a small, dinky gray box after the attribute name.)

Select the desired attribute in the long list of nonkeyable items and then select the ≪**Move** button. It isn't that difficult to do. It just takes a little bit of time to locate the attributes you need (see Figure 1.11). If you value time, you'll realize that every single saving of a couple of seconds in your methods will add up to a lot of time you can utilize on better tasks.

Pushing the Concept

One more thing to point out before we end this chapter—what if you were doing a bouncing object that needs to squish down while rotating? The order of your group nodes will greatly impact how the rig behaves. This shows a little better with a ball—a rubber ball—that needs to rotate and then squish on the ground. Let's see what the order of the group nodes does for this rig.

The nodes on the left of Figure 1.12 depict a ball with the following group nodes:

> **Ball_Move_GRP** (pivot point at top of object)
> **Ball_Rotate_GRP** (pivot point at center of object)
> **Ball_Scale_GRP** (pivot point at bottom of object)

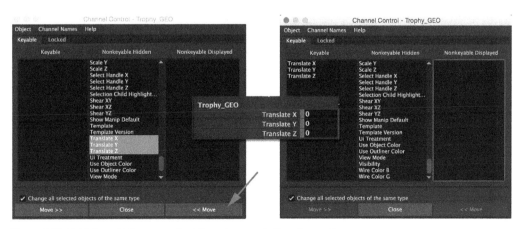

Figure 1.11 Unhiding attributes so that they show up in the channel box.

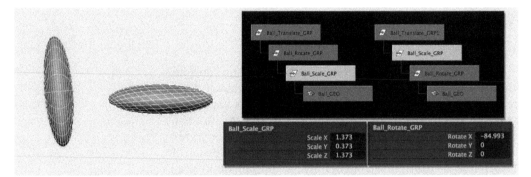

Figure 1.12 Ball with rotation first, which causes a "flipping pancake" effect, vs. a ball with squash first. Both rigs have similar rotation and scale settings. The order of the nodes makes the difference.

You can see that when you rotate the object, the scale node gets rotated as well, so the pivot point ends up rotating away from the floor. This isn't the desired effect. Instead, try this node hierarchy, as seen on the right side of Figure 1.12:

Ball_Move_GRP (pivot point at top of object)
Ball_Scale_GRP (pivot point at bottom of object)
Ball_Rotate_GRP (pivot point at center of object)

Now, if you were to look at my sketchbook from the year 2019, I'm-not-telling-you, you'd see notes for this very same thing in my first computer animation class, way back in my undergrad days. Well, none of the software I learned to use then exists today. In fact, I never used the high-end software I learned in college. It was bought out and disappeared. (And back in my day, that software and the computer together cost as much as a house. I digress.) But, this concept is still true today: hierarchy animation. Software changes, but the problems that need to be solved do not. Therefore, these topics will be around. Sure, there are other ways to make squishing objects. We'll learn about them in the next chapters. For now, a good thing to know is that sometimes hierarchy animation is all you need to get the job done.

Let's move on to some more ways to make a squishing rig.

2

DEFORMERS

RULES COVERED
Rule #1: Edgeloops—a good or bad rig starts with the loops
Rule #3: Lock what isn't going to be animated

In this chapter, we will start with a humble polygon cube and learn how to use deformers on it. Deformers, preschool work, you say? You want to skip ahead to joints and skinning? Do not underestimate the power of the deformer. Sometimes, they are all you need on a simple rig; and sometimes they will be that extra nuance you need on a larger rig. New deformers get added quite often. Therefore, we will devote a chapter to getting you started with deformers. Many have been around for a long time. In fact, most of these we will learn are the remaining bits of code from the software I learned during college—back in the stone age. That software company was bought, as were many other competing software companies. All the best parts of the code were combined together to form what you know as Maya; now, a huge 3D beast which has been around for eons.

Now, let us look at our simple cube. Go ahead and create a polygon cube with default values. Scale it tall. Place it at the center of the world; freeze it and delete history. Let's rename it to **Bob_GEO** (Bob, for short). Make sure that Bob is selected and let's add a deformer to it. From the **Rigging** menus, select **Deform>Nonlinear>Bend**. Switch to **wireframe** mode. You'll see that an icon has shown up in the viewport at the center of your cube, Bob. In the outliner, you will see a node titled **bend1Handle**. This is the transform node for the deformer. If you cannot see the bend1Handle in the outliner window, you may need to select **Show>Show All** in the outliner in order to see the deformer transform node. In older versions of Maya, this node showed up automatically. Or, you can use the Node Editor window by selecting the **bend1Handle** in the viewport, then clicking on the **Add selected nodes to graph** button in the Node Editor window. **Animators** will be able to use the outliner window and not automatically see the clutter of other nodes like deformers. Riggers need to learn to wade through the clutter and decipher it.

The deformer itself is hooked into the shape node of your Bob_GEO. Select **Bob** and in the channel box, open the attributes

DOI: 10.1201/9781003431121-4

for the deformer by selecting **bend1** found under the inputs area. There are a couple of attributes, but the main one you are looking for is called **Curvature**. Somewhat misleading, you may see a curvature attribute under the bend1Handle shape node. It will have a yellow box next to the text field and will not be adjustable. It is being fed by the curvature attribute found under **input>bend1**. Adjust the curvature and you would expect to see the cube bend. But it doesn't, does it? It acts a little weird, just moves from side to side. Why is that? Ah yes, you need to have edgeloops—enough tessellation for the bend to happen. We'll talk about that more at the end of this chapter. You can see in Figure 2.1 that the Bob-cube was recreated with an additional amount of subdivision height edges added in. Those edges gave the geometry enough information to be bent by the bend deformer. Go ahead and redo this. Make a polygon cube, as we did above, and add subdivisions before you delete history. Many newcomers make that mistake, not adding in edgeloops, and get flummoxed a little about why the deformer doesn't work. Not you; you won't make that mistake at all.

The bend deformer and many of the other nonlinear deformers are location-specific to the deformer icon. This means you can move the deformer icon around to obtain different effects. For example, if the deformer is moved higher up the cube, the apex of the bend occurs higher. In Figure 2.2, you can see examples of moving the deformer slightly higher, and adjusting the low bound attribute to 0 so that only the top bends.

The bend deformer has numbers in its transform attributes and is unable to be frozen. Therefore, it is not a good idea to let the animator animate the transform node of the deformer directly. You can put a group node over it for now; in the next chapter, we'll learn how to create animator controls.

Let's think about our Bob_GEO as a simple rig. What the animator wants to do with this Bob character is to move him around, rotate him from the bottom, and bend him from the top

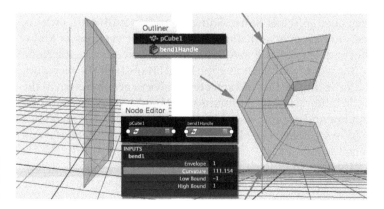

Figure 2.1 Bend deformer will bend an object, but it needs to have enough edgeloops.

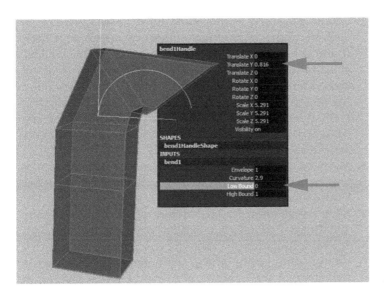

Figure 2.2 Deformers can be moved to affect where the bend happens. Low bound set to 0 limits the lower half.

(like a candy cane). We already have the bending needs taken care of, but, how to move the character around and then bend him? Using what you already know, all we have to do is add in a group node for the animator to animate (refer to Figure 2.3).

1. Select the **Bob_GEO** and the **bend1Handle** nodes in the outliner or **Node Editor** window.

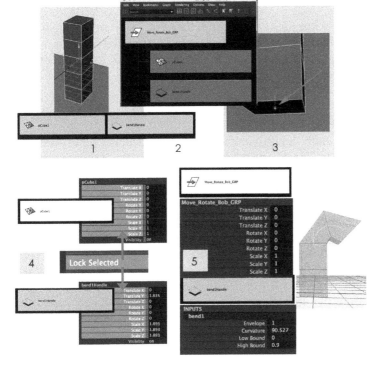

Figure 2.3 Creating a simple cube rig which moves, rotates from the bottom, and bends. Example rig: **Bob_Bend.ma**.

2. **CNTRL g** to create a group node (it will be the parent of the deformer and geometry); rename it **Move_Rotate_Bob_GRP**. If you click on name of the node, in the Node Editor window, you an easily rename it. The Node Editor window does not show hierarchical relationships like the outliner does. Another window you can use to see hierarchical information is the **Window>General Editors>Hypergraph:Hierarchy** window. It shows deformers automatically. (There are many ways to accomplish things in Maya.)

3. Move the pivot point of the **group** node to the grid at the bottom of the cube using "**d**" and "**x**" hot keys ("**x**" is the hot key for snap to grid).

4. **Lock** the **geometry's** AND **deformer's Translate**, **Scale**, and **Rotate** attributes to remind us not to break Rule #2.

5. The remaining functionality for the animator is moving, rotating, and scaling the group node, and adjusting the curvature of the bend handle. This requires digging in the outliner or Node Editor. We'll make it easier for the animator soon.

For now, we're naming the group nodes with what type of function they have. This helps us in the long run to see exactly what we are rigging and what we want the animator to animate. In the coming chapters, we'll start creating user interfaces, which hook up to these group nodes and attributes.

Nonlinear Deformers

There are many types of deformers. We won't go through them all, since that is what the help documentation is for. We'll highlight just a few so that you can begin to experiment on your own.

Squash

The help documentation shows the squash deformer the same way I use it and teach it. Here is the gist of that deformer visualized in Figure 2.4. The attributes which can be used to make an object squash on the ground are shown. Note, that the icon was moved so the middle of the icon was placed at the bottom of the trashcan. You'll notice the manipulator shows up at the middle of the squash handle, and after the deformer is moved, the manipulator can be seen at the bottom of the trashcan. Then, the attributes were set at: **Low bound = 0**, **High bound = 1.5**. Adjusting the low bound moved the bottom half of the deformer icon to near the bottom of the trashcan. This makes the object squash to the "floor." Adjusting the high bound allows the top portion of the squash to contain more of the trashcan object.

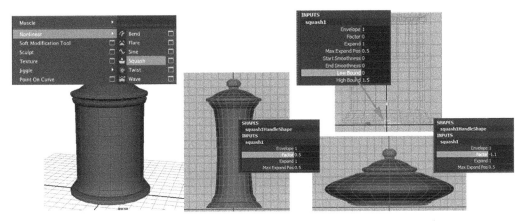

Figure 2.4 Squash attribute used to squash a trashcan at the bottom, as if on the ground. (Model by Brenda Weede, with permission.)

Wave

Like all of the nonlinear deformers, the wave deformer depends on where it is placed as to how it works. Usually, when you have an object selected and create a wave deformer, it doesn't line up the way you want it to. You'll need to rotate the deformer icon, generally on its Z-axis, so that it lies flat with your object. For example, the trophy in Figure 2.5 (with enough edgeloops/tessellation to withstand deformation) has a wave deformer rotated 90 degrees on its Z-axis with an **amplitude** of –0.9, and a **wavelength** of 1.5. It is also scaled. To animate the wave, the animator could keyframe the offset attribute. Depending on your rig, you might want the wave deformer to move with the object or have the object move independently from the wave deformer. We'll see this later on, when we make our Super Hero Toothbrush rig. (They screen professors for how kooky our class exercises are. Haven't you ever noticed that?)

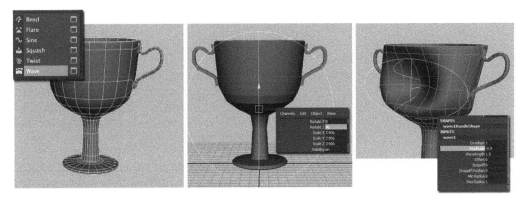

Figure 2.5 Wave deformer applied to a trophy. (Model by David Peeples, with permission.)

Changing Deformation Order

As you added these deformers, did you keep an eye on the Node Editor window? Take a moment and add a few deformers to an object and watch the nodes that show up in the Node Editor window. What happens if you have more than one deformer? Obviously, they have been hooked up in the order you created them.

Does that matter? You have a sneaking suspicion it must, or I wouldn't have brought it up. Yes, it does matter. Let's see an example. If you have a tall cube character, who needs to bend over and twist (quick, go read the help on how to create a twist deformer), it could look awful if the deformations happened in the wrong order.

Create a tall **cube** object with plenty of edgeloops/tessellation. (Name; delete history; freeze transformation.) With that cube selected, create a twist deformer by clicking **Deform>Nonlinear>Bend**. Reselect the cube, then create a bend deformer by clicking **Deform>Nonlinear>Twist**.

Let's see what happens when you both twist and bend your cube. With the cube selected, you can see both deformers show up in the channel box. Open the **bend1** deformer's attributes and adjust the **Curvature**, so that the cube bends over. Next, open the **twist1** deformer's attributes and change the **End Angle**. You would expect the twisted cube to bend over nicely. Imagine if you had a short dryer vent hose that you twisted and then bent over. But instead, it bends then twists as a whole and ends up looking distorted. You may need to know the technique to fix this when you get to other exercises in this book, so remember where this tip is. You'll be back. With the object selected, **right mouse click** and hold on top of the object. This brings up a context menu (when you were new to Maya, you may have accidentally bumped into that context menu and selected things you didn't want to select. Maybe not; maybe that was just me). In that context menu, select **Inputs>All Inputs....** This brings up an odd little window which shows you all of the node inputs that are going into your shape node. You can see the same things in your Node Editor window and in the channel box. What this window does is let you change the order without having to disconnect and reconnect a thing in the Node Editor window (thank heavens!). Simply **middle click** on the **twist** deformer (which is on the top of the list) and **drag** it **under** the bend deformer, then release. In the viewport, you should see the shape of your object change, as it now thinks about the deformers in a different order (refer to Figure 2.6). In this window, it thinks about the deformers starting from the **bottom** of the list.

BUG warning: Now, in class, I've seen a bug show up where we cannot get the inputs window open. Instead, we get an error message about a *//Error: Object 'row1' not found.* I think it has to do with a script we use that somehow causes something to puke.

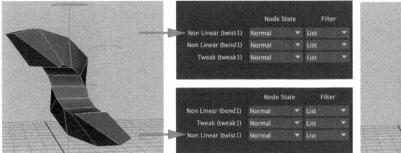

Figure 2.6 Adjusting deformation order to get proper deformation.

I've never run down the issue, since it is only one or two people a class and we are all using the same rigs, models, scripts, setups, computer, software, etc. To get around it, we had to select our geometry—go to **File>Export Selection**, and then import that object into a new scene. I hope you do not run into that issue.

Lattice

We'll look at just a couple more things before we do this chapter's rigs. Next up: the good old lattice. This deformer has been around for an awfully long time and was mighty helpful in the old days of rigging NURBS characters. NURBS characters were made up of all patches, which had to be held together and move like a unit. Lattices are still great for deforming multiple objects that need to squash and deform as if one. Lattices are also great for when objects make contact with areas: squashing wheels, smashing flour sacks against walls; punched faces; the list could go on. We won't go over everything about a lattice; read the help documentation for more. Let's highlight the basics. Create a **sphere** or any simple object (name; delete history; freeze transformation). With the object selected, click: **Deform>Lattice**. We'll use the default settings. You can see in the **Hypergraph:Hierarchy** window or **Node Editor** that you have two nodes this time: a **lattice** and a **lattice base**. Think of it like this: the lattice base is the start point and the lattice is the end point for the deformation. For now, we'll leave the lattice base alone, but you can read further in the help documentation about fun things you can do with the base. **Select** the **lattice** and look in the channel box. The lattice has attributes that allow you to change the amount of resolution it has: **S**, **T**, and **U** divisions. You'll want to adjust those before you tweak the lattice. Next, **right mouse** click and hold over the lattice in the viewport and select **Lattice Point**. You are in lattice point, **component mode** now. Select a lattice point—it should turn **yellow**—and move it around. You can see that the sphere deforms with the lattice. Now select the sphere and move it up and down. As the sphere

Figure 2.7 Lattice used to deform an object locally and lattice with an object moving through it.

moves through the lattice, you see it regain its normal shape and then deform.

As you can see, for a rig, the lattice might need to move with the object and be animatable, or be stationary and have the object move through it, depending on what the rig needs. To move the lattice with the object, both the lattice and the lattice base must move along with the object (see Figure 2.7). To have the object move through the lattice, both the lattice and the lattice base stay stationary.

Cluster

Some people love them, some avoid them entirely. I think it comes down to a misunderstanding and one simple default value. Let's see if we can clear up this bad reputation the cluster gets. A cluster handle is a visual shortcut created to select components. Take our simple polygon sphere that is named; has deleted history; and frozen transformations. Select vertices by right mouse clicking on the object and going to vertex mode (or hitting the hot key F8) and select a few vertices. Create a cluster by going to **Deform>Cluster**. Use the default settings for now. The cluster handle is created and is visible in the viewport and in the outliner. When this cluster is selected, it has its own pivot point and can be moved, rotated, or scaled and will affect those original selected vertices. What is this good for? Everything! This can be used for small nuance animation, such as deformation of a cheek when something is pressed against it, or a pillow, and so forth, all the way to blinking eyes, smiles, eyebrow raises, hair overlapping animation, curves, and so on.

Why the bad reputation? Two things:

1. Cluster handles are difficult to select in the viewport. They'll need an animator control added to them, like everything else we have been doing.

2. Most of the time, you do not want to use the default settings. You want relative to be **ON**.

The problem shows up when you go to move the object and the cluster. So, take your cluster handle and the sphere and group them together by selecting **Edit>Group** (or CNTRL g). Name that group **Move_Bob_GRP**. Select the **group** and **move** it. It moves its children.

The cluster is not set to relative, so it is deforming the sphere even though its transformation node isn't receiving any direct numbers.

Select the **clusterHandle** and see for yourself, it still has zeros in its translate values. It only inherited its position from its parent **Move_Bob_GRP**. That is because the relative setting is turned **OFF** (see Figure 2.8). Relative means that it will only adjust the vertices relative to the object's position, not the world's. I think of it as global versus local. To change this, select the **cluster1Handle** and go to the **Attribute Editor** by using the hotkey **CNTRL a**; locate the **cluster1** Shape tab, and click the relative checkbox **ON**. Your sphere should go back to its normal shape.

Note: If you have multiple cluster handles selected and try to change their relative option in older versions of MAYA, it will only change the last selected handle. In 2018, it will change all of them. In 2023, you get a tab for each cluster in the Attribute Editor. Click through each tab and change the Relative option.

Unlike what we have done in the previous chapter, you **cannot** put a group node over the clusterHandle, use the group node to move the cluster, and have the cluster still affect the geometry. It will only offset the cluster without affecting the geometry because the relative setting is turned ON.

It is important to look at what we just did. We broke down many things into their smallest pieces, most of which we will

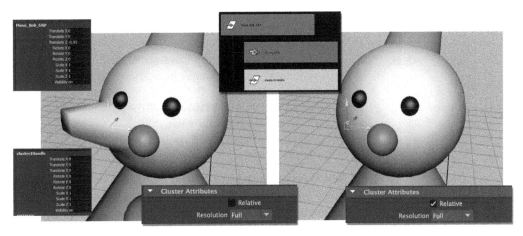

Figure 2.8 Relative ON versus relative OFF when being moved by a parent node.

now put together to create a rig. This is an important concept. Rigs are complex beings, with many moving parts. If you try to do too much of something that you are new to, all at once, then you won't have a good grasp on what went wrong and why. It is best to break the functionality of your rig down into small bits; get it working on a test object first so you fully understand it; then slowly start to put the pieces together. Oh yes, that sounds like you are doing it twice, how could you possibly have time for that? You are testing and only doing the "doing it" once. Much less than if you tried to do it all at the same time, trust me. I'm not even going to say you will change this method as you become more advanced. Perhaps the rote stuff you can rig straight ahead without testing, but then all of the other fancy things that you will want to put in your rig will take some research and development time in a simplified, focused fashion. That is problem-solving at its finest: breaking it down into manageable chunks and conquering them one at a time.

Super Hero Toothbrush

We'll make a simple rig together now. We need to create "Super Hero Toothbrush." He will need to (1) bend forward from the neck; (2) twist to look around; (3) squish down on the ground to jump; (4) move; (5) rotate from the bottom; (6) scale; (7) also have a flapping cape, which the animator can manually animate (see Figure 2.9). There is nothing automated on this rig. Sketch on your own to think of what other things your rig might use for a good story. Start with the storyboard first and rig to it.

Start with **chpt2_Toothbrush_Start.ma**, which contains a well-named, frozen, no history toothbrush. Now, let's take the functionality one step at a time (refer to Figure 2.10).

Twist to look around = twist deformer.

1. Select **Toothbrush_GEO** and create a twist deformer by selecting **Deform>Nonlinear>Twist**.
2. Move the **twist1Handle** so that it appears in the center of the toothbrush's body.
3. Adjust the **Twist** deformer's **low bound** attribute to be **0**.
4. Adjust the **End Angle** to see deformation to the toothbrush; return to **0**.
5. Move and scale the **twist1Handle** so that it twists mostly the upper portion of the toothbrush.
6. **Lock** all but the **End** attribute in both the transform and shape node.

Bending from the neck = bend deformer.

1. Make sure your **twist1Handle End Angle** is set back to **0**. Have nice math before moving on.
2. Select **Toothbrush_GEO** and create a bend deformer by selecting **Deform>Bend**.

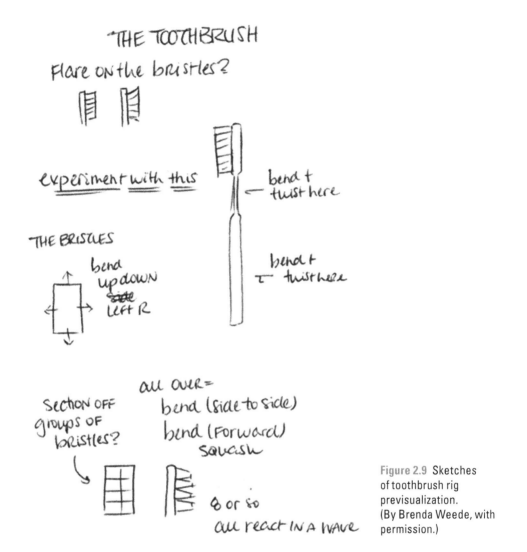

Figure 2.9 Sketches of toothbrush rig previsualization. (By Brenda Weede, with permission.)

3. Move the **bend1Handle** so that it appears in the center of the toothbrush's body.
4. Adjust the **bend** deformer's **low bound** attribute to be **0**.
5. Rotate the **bend1Handle** –90 in **Y** so that when the curvature is adjusted the head of the toothbrush bends back and forth.
6. **Lock** all but the **Curvature** attribute in both the transform and shape node (refer to Figure 2.11).

Test

Always test things as you go. Are these in the right order? Are they both working? Can the animator find only the attributes you want them to animate? Are all others locked? Good. Don't

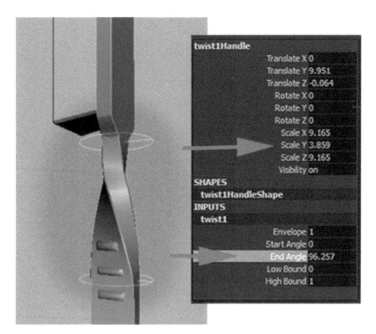

Figure 2.10 Twist deformer to look around.

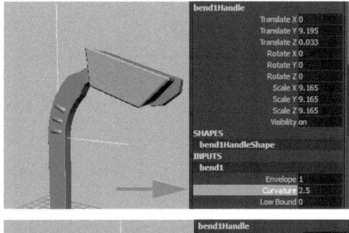

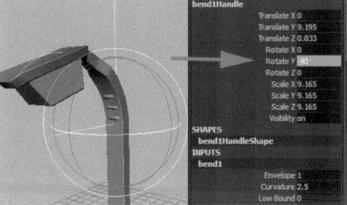

Figure 2.11 Bend deformer to bend from neck. (Toothbrush model by Brian Hathaway, with permission.)

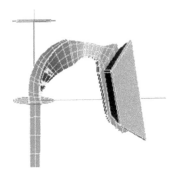
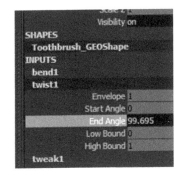

Figure 2.12 If the bend was added last, it should show up on the top of the input list. The toothbrush should bend over and twist while bent over.

move on unless those two are working (see Figure 2.12). If something is broken, stop and fix it. It won't get any better; it will just get more buried.

Squish down on the ground = squash deformer.

1. Select **Brush_GEO** and create a squash deformer by selecting **Deform>Nonlinear>Squash**.
2. **Translate** the deformer so that when the factor is adjusted, it squishes at the bottom of the object.
3. Adjust the **squash deformer's low bound** attribute to be **0**.
4. Adjust the **high bound** to include as much of the upper toothbrush as you want (refer to Figure 2.13).
5. **Lock** all but the **Factor** attribute in both the transform and shape node.

Stop and test again. Still working? Is the high bound on the squash deformer interfering with the bend deformer? Adjust the high bound until they work well together aesthetically.

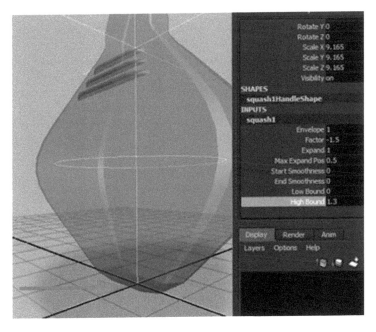

Figure 2.13 Squash deformer added to the toothbrush.

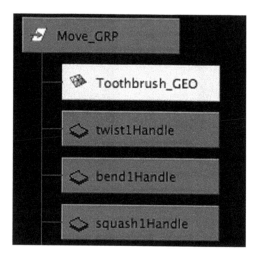

Figure 2.14 Toothbrush hierarchy.

Move = group node to move object and all deformers.

6. Select **Brush_GEO** and all three deformers.
7. Create a group node—**CNTRL g** or **Edit>Group**.
8. Rename the group node **Move_GRP**.

Stop and test again. If you move using the Move_GRP, do the bend, twist, and squash still work? Remember to reset everything back to **0** (refer to Figure 2.14).

Warning: Do not reset the character back to the 0 point by using the undo button. Reset your rig by zeroing it out. This way you can see that it is zeroing out correctly as you make it. Also, if you undo, you might be undoing something you really wanted to keep. That something might not show up as being missing for a long time, usually resulting in an exclamation of "I don't know what happened...." My personal rule, I can undo one or two times, maybe three if it is highly visible movements that I have done, but no more. I do not trust myself nor undo.

Rotate from the bottom = move the pivot point of Move_GRP.

1. If it isn't already there, select the **Move_GRP** node and move the pivot point to the origin point, which happens to be well planned and at the bottom of the toothbrush, by holding down "**d**" and "**x**" on the keyboard.

Stop and test.

Scale = already in the Move_GRP node.

Your toothbrush is already parented under move_GRP, and nothing else is needed.

Stop and test by selecting the **Move_GRP** node and scaling your rig. Look at it. All of the basic functionality is there.

That looked too easy. What things could go wrong? The deformation order could be incorrect, which would show up as a weird twist or skewed squash. You know how to fix that. The pivot point of the group node could have moved incorrectly causing the scale to be offset. The deformers weren't put

under the move group node, so the object moves away from its deformers. This would cause it to bend correctly at its zero point, but become skewed as it was moved away from its zero point. Whew, good thing you tested every step of the way. That saves time catching the errors as you go instead of letting them compound.

Important note: The origin (or center of the universe for the big thinkers) is very important to the rigging process. Since all group nodes automatically put their pivot point there, it is easiest to use it as your default position and have your model positioned with the pivot point at the bottom of it, or dead center.

Now that the basic functionality is there, let's take a look at putting a cape on this fellow, shall we?

1. Create a **polygon plane** with at least **four** lines of tessellation in the width and the height.
2. Freeze, delete history, name: **Cape_GEO**.
3. Select all the **vertices** on the **Cape_GEO** except for the ones right against the toothbrush; create a wave deformer by selecting **Deform>Nonlinear>Wave**.
4. Make sure that the icon for the **wave1Handle** is flat with the cape.
5. Adjust the **Wave Amplitude** to **0.3** and the **Wavelength** to **1.3**.
6. **Lock all but** the **Translate** and **Offset** attributes.
7. **Test** the **Offset** attribute and also translate the **wave1Handle** to see what type of control the animator has.
8. Select the **Cape_GEO** and the **wave1Handle** then group together (CNTRL g).
9. Rename the group node: **Cape_GRP**.

 You have a functioning cape, but how do we get it to follow along with the toothbrush? Yes, make it a **child** of the **Move_GRP**. But, what about when the toothbrush bends? Twists? Oh, I see. This cape won't follow along with any of that will it? Let's see....

10. In the outliner, middle mouse drag the **Cape_GRP** to be a child of the **Move_GRP**.

 Test the rig by moving it around, the cape follows. Now bend the rig. The cape does not follow. You can adjust the cape, so that it is not so noticeable, by the following steps:

11. Select the **Cape_GRP**.
12. **Move** the cape group to a place below the bend and above the squash.
13. Remember to **Freeze Transformation** on that group node, so that it becomes the new zero point. (Because the **wave1Handle** has locked attributes, you will get an error message if you try to freeze transformation. Open the options for **Modify>Freeze Transformation** and only freeze the **translation** attributes. Make sure to reset the options before you close or the next time you freeze transformations

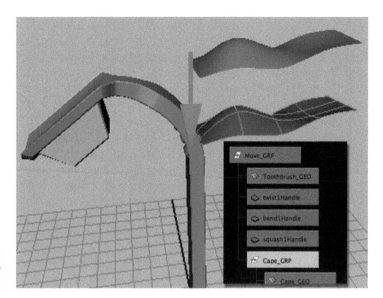

Figure 2.15 Moving the Cape_GRP to attach below the bend deformer.

from the pull down menu it will only do the translation. If you use a shelf button freeze transformation, it will use the default options that you created the button with.) See Figure 2.15.

14. Adjust the **Cape_GRP's pivot point** so that it stays at the origin. (Use snap to grid d + x.)

15. Lock the attributes of the **Cape_GRP** unless you want the animator to be able to animate its offset.

The completed toothbrush can be viewed in the file: **chpt2_Toothbrush_End.ma**. We didn't really fix the problem of the cape not following along with the bend; we made a compromise. In order to fix it, we have to redo the rig. What? You are shocked? This happens all the time. The order of things sometimes makes a big difference and you often have to redo whole sections of rigging; a lesson best learned early on. Advanced riggers learn to script their actions so that they can simply adjust what they did then rerun the script. (There is a way to use MEL or Python commands to fix it—see the extra online chapter, Automate Yourself, and look up the MEL command connectAttr.)

You can view the redone rig in the sample file: **chpt2_Toothbrush_EE.ma**. EE stands for "Extra Effort," a grading term used in my classroom. EE separates those who would compromise and maybe compromise the animation, and those who will become streamlined enough in their rigging skills to be able to redo the rig and plus it, thus enriching the animation ability of the character. What had to be done? A good detective doesn't ask "Who did it?" just like a good rigger won't broadly ask "How do you do it?" Instead, the good rigger, like the good detective, will delve down to the succinct question that needs to

be answered: the key question. The key question, which needs to be asked for this cape problem is: can multiple objects be deformed by the same deformer? Yes, they can.

1. Delete the three deformer handles.
2. Select the **Move_GRP**, which should be a parent of the Brush_GEO and the Cape_GRP.
3. Recreate the deformers: bend, twist, squash.

Deformers added to a parent or group node will affect all of the children. The cape is bent along with the toothbrush, as is its wave. Now, I made this look simple, like my geometry teacher who used to make so much sense when he told me the proofs. But, once class was over and I was left with my notes, I could hardly recreate anything we had done in class until I had practiced over and over again with my own problems. Same thing here: go off and redo this rig on your own without this chapter and logic out each step until it makes sense. Don't try to do rigging by following step by step. That turns it into a recipe which can only make one rig. Instead, you want to play with the recipe and add your own spices. Some cakes will flop or turn out dry. Others won't. (My heavens, I've moved from cars, to mud, to baking—where will the analogies go next?)

Other Deformers

While trying to bake your own recipe for a toothbrush rig, here are some deformers that you might want to look at: Flare, Wire, Wrap, Sine, Jiggle, Wrinkle, Point on Curve. Looking back over the concepts we had in this chapter, we learned about a type of deformer that I said was good for multiple objects. Did you catch that one? We could use a lattice to take care of the bend, twist, and squash. In fact, you could put a lattice deformer over the cape group and geometry, and then apply the deformers to the lattice!

What? Holy twisting boxes, you can do that? Sure. Give it a try. The takeaway message is there are so many ways to rig it. What you want is the one that will animate the best for your story's needs.

Appendix 2.A: Edgeloops for Good Deformation

Before we move on to Chapter 3, we need to make sure you are up to speed on your modeling skills. It is time to look back at *Rule #1: Edgeloops—a good or bad rig starts with the loops.*

A model with bad topology cannot be rigged well.

A model with good topology that is rigged poorly cannot be animated well.

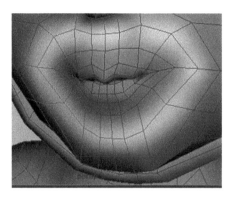

A model with bad topology that is also rigged poorly is a complete nightmare.

It isn't enough to have a model with quads evenly spread out across the surface like butter—they have to be in the right place and have to be designed to facilitate movement.

But what is an edgeloop you might ask? An edgeloop is "a row of connected edges lined end to end, which define a specific feature. This row of edges typically forms a loop, but does not have to."[1] You can see an example of an edgeloop around the mouth of the character in Figure 2A.1.

Most importantly, the edgeloops describe how the model is going to bend so that the character can be posed. In Figure 2A.2, you see three fingers with differently created edgeloops. Finger A has edgeloops that are straight up and down; they do not contour along where the bend should happen. This is a very common type of edgeloop creation for the new modeler. Note what happens when that finger is bent. The wide surface area, which was created by those straight edgeloops, gets pulled in and collapses into a concave rubbery fold. Finger B has edgeloops that taper toward the area of the bend and widen on the knuckle. They enclose the area of maximum deformation.

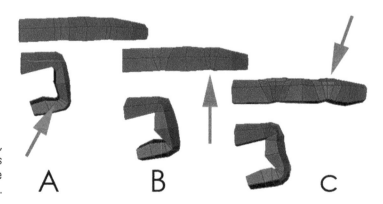

Figure 2A.2 Fingers A, B, and C with different types of edgeloops, and the deformation they create.

A B C

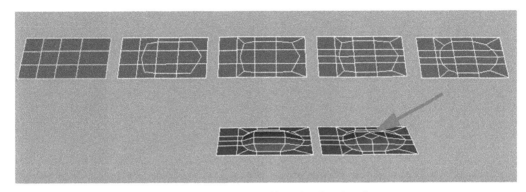

Figure 2A.3 Adding circular edgeloops for joint pads. Note the chamfered vertex.

You can see that the smaller surface area creates a tighter wrinkle/bend on the finger. There is nothing else special done to these fingers. They are both deformed the same way and have the same contours, only the edgeloops are different. The difference is the surface area in the bend.

Finger C goes just a little further and adds a circle pad of edgeloops at the top for the knuckles (a favorite of mine). This gives a flat area, which mimics that of the fleshy areas on knuckles. The center vertex was selected and chamfered. Look up chamfer to see how to get a quad from a single vertex. I like that little quad for elbows and patellas (knee caps) (see Figure 2A.3).

I like to paint this analogy: have you ever worn kneepads? Maybe when putting in carpet or playing volleyball? Kneepads that are just plain cylinders and have big wide bands behind the knee do not bend well, and ultimately cause great pain to the wearer since they bunch up and have too much surface area to deal with, whereas knee pads that have a smaller surface area behind the knee than on the front will not bunch up and bend better at the back of the knee. Don't believe me? Go put on some plain cylindrical kneepads and crawl around on the ground for about 20 minutes. You'll know what bad edgeloops are and possibly have bruises to prove it (See this link on my blog: https://coffeediem.wordpress.com/random/ for an image of this analogy.) (see Figure 2A.4). This image shows different types of loops with the same joint system and default skinning. No skinning touch up has been done, obviously. Note how the edgeloops bend.

Take a look at the same leg geometry with well-placed joints, good loops, and proper skinning in Figure 2A.5.

We could write a whole book about this, but you get a brief chapter. Here are a few places to learn more about proper modeling techniques and edgeloops. I recommend the following resources:

- *Edgeloop Character Modeling for 3D Professionals Only* by Kelly L. Murdock and Eric M. Allen, 2006, Wiley, NJ. (A little older, but the rules have not changed. Topology needs are the same.)

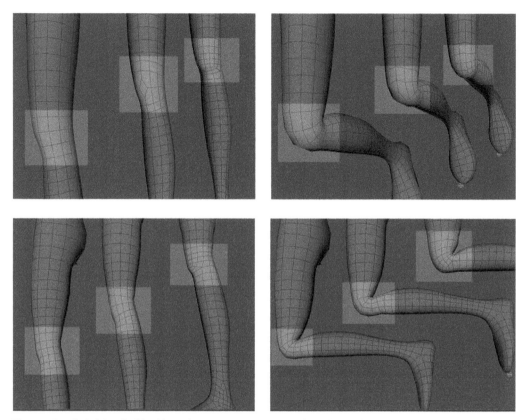

Figure 2A.4 Painful cylindrical knee loops versus happy wedge-shaped knee loops versus lovely double loop knees.

- Tarek's modeling DVD, *Organic Modeling*, is out of print. However, you can find those videos on Tarek's youtube channel. Watch his block modeling tutorials and you'll see how to think in edgeloops at the beginning steps of modeling. Plus, his voice is very zen. https://www.youtube.com/@esotareq/videos.

Figure 2A.5 Solid loops make for proper deformation. Aang modeled by Mia Prey and rigged by Rijah Kazuo and Sagar Arun (https://agora.community/content/aang).

- *Guides for 3d Artists* by Johnson Martin. This website gives solid advice for creating topology that can be animated. The images I like best are step-by-step how to move three-edge and five-edge poles. While his images are created in Blender—the tips are software independent. https://topologyguides.com/.

The book *Edgeloop Character Modeling* is one of my favorites because it has rules (that doesn't surprise you, does it?). It is definitely an analytical approach to modeling, which gives the reader a foundation to build upon.

Edgelooping is "modeling so that all surface contours naturally flow into each other, the way they do in the human body. This ensures the skin deforms in the direction the muscles naturally flow" (Figure 2A.6).

So, a good model, which will deform well, must have the edgeloops behaving along the same surface contours of the muscles. This is the only way for the geometry to move as it should. It takes reading the whole book, plus watching Tarek's videos to really get an understanding of how to model well, and is beyond the scope of this book. If you are not familiar with modeling, please take a moment (or month) and look at those resources. For those of you that have modeled some, let's take a closer look at ways edgeloops can make or break your rig.

The rules of edgelooping put forth by Murdock and Allen are as follows:

1. Avoid large quads (they will have rendering issues).
2. Edgeloops run along crease lines (wrinkles, bends).

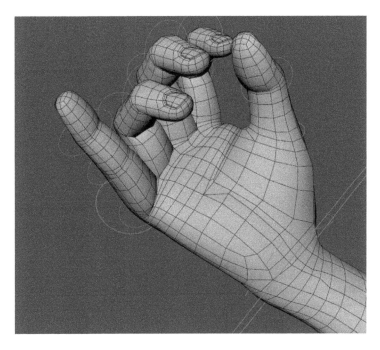

Figure 2A.6 Hand edgeloops. Aang rig modeled by Mia Prey (https://agora. community/content/aang).

3. Avoid edgeloop termination (better a quad than a pole).
4. Wisely position weak deformation areas: hide nonquad, noncomplete edgeloops, and terminating edgeloops.
5. Enclose areas of maximum deformation: shoulders, hips, elbows, and joints.
6. Define the form outline.
7. Three edges define a curve.
8. Avoid long, thin quads.
9. Final rule: ignore these rules. Good models are made by talented artists that know the rules, and when to break them.

The most important points for our purposes in this book are #2 and #5. Edgeloops should run along crease lines (wrinkles and bends) and should enclose areas of maximum deformation such as the shoulders, hips, elbows, and joints. You saw the finger example above.

Another example to show you edgelooping would be the torso shoulder area. This is sometimes referred to as a "cape" since the edgeloop resembles a cape wrapping around the shoulders. See Figures 2A.7 and 2A.8, which show a low poly creature with a nice edgeloop following along the bottom of the pectoral muscle and up to the deltoid muscle. The pectoral actually attaches underneath the deltoid. Often beginners create their shoulders and arms by extruding them straight out of the sides of the torsos causing square deltoids that do not flow over the pectoral muscles. You'll further note in Figure 2A.8 the edgeloops surrounding the mouth which will facilitate emotions and lip synch rigging.

A method learned from Tarek's modeling is to extrude the shoulders out from the torso, then extrude the arms down from that deltoid. Last, rotate the extruded arm vertices up, as if they

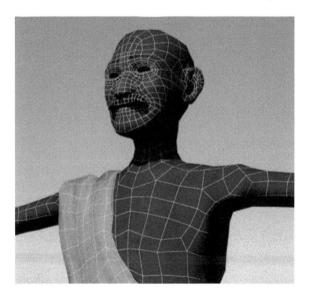

Figure 2A.7 Model of a cape edgeloop by Eric Allen.

Figure 2A.8 Aang model with a cape edgeloop by Ashwin Inamdar, Aang rig (https://www.iashwin.net/rigs).

had been extruded out of the side of the shoulder. This results in a nice cape line which will deform well.

Another modeling and rigging note: advanced models should have the arms modeled pointing down about 45 degrees and the shoulders rounded forward slightly to equal the natural planes of the body. (Watch *The Making of Ryan* by Chris Landreth for more explanation on this. The dvd is still available at Amazon: http://www.a.co/cp6D2hX.) If you do this, make sure the arms don't touch the torso—that makes for a skinning nightmare. However, in the beginning stages, we will model with flat arms in the traditional T pose.

That winds up this chapter. Make sure you take your time to get these basic concepts and really understand them. I even have a pinterest link for edgeloops, because this is my zen— looking at good topology. Isn't it yours? https://www.pinterest. com/tinaohailey/mmmm_edgeloops/.

Wonder what we're going to do next?

Note

1. "A row of connected edges lined end to end, which define a specific feature. This row of edges typically forms a loop, but does not have to." is a quote from Edgeloop Character Modeling for 3D Professionals Only by Kelly L. Murdock and Eric M. Allen, 2006, Wiley, NJ.

3

USER CONTROLLERS

RULES COVERED

Rule #4: Keep geometry (GEO), controls (CNTRL), and skeletons (SKEL) in separate groups in the outliner

Rule #5: Make controls that make sense to the animator

Rule #6: Happy math—controls and joints should be zeroed out

In the previous chapter, we created a toothbrush rig. This chapter will start with a similar toothbrush, which has an additional bend deformer for the low portion of the toothbrush instead of a squash deformer. Begin this tutorial by opening **chtp3_Toothbrush_Start.ma**. Like Chapter 2's superhero toothbrush, this rig has a main move group at the top of the hierarchy, then the geometry and three deformer handles. The bend and twist deformers only have the attributes open that we want to animate: **BendHigh** and **BendLow** each have a curvature attribute; the twist deformer only has the end angle attribute open for the animator to animate with.

Let's write down a list of rig specifications, or what the rig can do:

1. Bend high
2. Bend low
3. Twist
4. Move, rotate
5. Scale

When creating a list of specifications for your rig, they should match what you have in the storyboards or sketches of the animation. Hopefully, you don't have something on the specification list that is not in your animation. Don't rig something you don't need. (That should have been a rule.) If your rig is clean enough, you can add functionality later on.

What we'll do now is learn how to add controllers for the animator to work with, which drive these lower-level attributes. Up to this point, we have been working in the outliner and have been playing with these attributes in the shape node. They are a pain to get to. No animator in his or her right mind wants to spend time clicking through all the nodes to animate. This is how we used to do it. This is 1990s style rigging. All animators had to know what the outliner was. So, imagine this was a dinosaur that talked and walked around back in 1996 in an early 3D Disney

DOI: 10.1201/9781003431121-5

Feature Animated film. (Hey, they didn't sing.) The outliner on a large character was hundreds and hundreds of nodes deep. The animator had to be able to traverse through those nodes and find what he needed to animate. It was crazy-slow. Then someone came up with the idea of putting an icon above the dinosaur for the animators to grab and animate. They created on-screen controls. They put cones overtop of the dinosaur, and when you grabbed them and rotated them the neck rotated, or a tail rotated. That was astounding progress back then. It became necessary when animators were not the ones rigging their own characters, and often times did not know how to rig. Whether the animators knew how to rig or not, animation controls saved serious time.

We have spent a few chapters in precontrol rigging, so you can get a clear understanding of the animatable rig and what is actually animating. It is very important to understand what it is that is actually being animated first. The next level is creating a user interface for the animator to interact with your rig. You have a clear idea of what we need to animate and now get to decide how to make controls which drive the character.

Feels like a rule should be around here. Let's see: **Rule #4: keep geometry, controllers, and skeletons separate from one another.** (If you don't hear the Genie from Aladdin spout off these rules each time, I'm sorry. You need to go watch Aladdin a few times to match my brain—you will then.) This rule is the main difference between this book and other books on rigging. It is a fundamental rule that changes how we approach many things. I learned it by first watching a Character TD at Disney and then saw it again in the *Art of Rigging*. It is a little more advanced way of thinking. The basic difference is that you might want to automatically create a controller and simply make it a parent of the object, thus not keeping them separate in the outliner/ hierarchy. But it leads into an animation issue which bothers me and I'm leading you away from that: green highlighted rigs. You might have noticed it in the previous chapter's rig. Other benefits coming about from this type of rigging, often found in production, are that the rig becomes much easier to maintain, fix, expand, etc. It is much more logically put together. In computer programming terms, I think of it like a low-coupling method (which isn't a perfect analogy). (*Did you tell Thurston that? "Low-coupling, darling. You never heard such a term?"*) Sorry, letting the inner geek show. Anyone with some OOP in their background is nodding. (Not going to spell that out—you can look it up if you are curious; not pertinent.)

The next rule is super important as well. **Rule #5: make controls that make sense to the animator.** We'll start with that a little in this chapter and then deal more with it in the next chapter. While we're taking notes, let's make sure to highlight **Rule #6: happy math—controls and joints should be zeroed out.** (We'll get to joints later on in another chapter.)

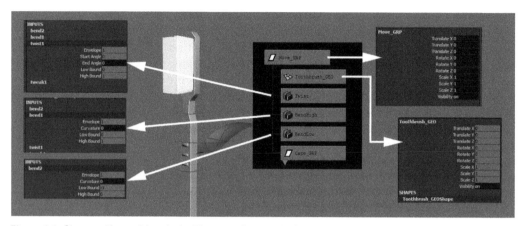

Figure 3.1 Chapter 3's toothbrush rig. The transform node for each deformation handle is named but the shape nodes still have their original Maya-made name.

Open the example file: **chpt3_Toothbrush_Start.ma**. Let's look at the **BendHigh** function of the toothbrush (refer to Figure 3.1). Without a user interface, the animator has to open the outliner, find the controller, find the BendHigh handle, open the shape inputs in the channel box, and then locate the bend1 attribute. That is a lot of clicking. We want to cut down the clicking. We want to give the animator something to grab. Right now, we're going to use circles. In the next chapter, we can get into fancier controls.

For the animator's controls, we will use NURBS. Can you guess why? Is there anything special about NURBS curves, which spring to mind from your early modeling days? They do not render (unless you do some fun Renderman tricks to them)! The animator can render at whim and the NURBS curves do not get in the way by rendering. Also, NURBS curves can easily be hidden in the window by deselecting **Show>NURBS curves** when the animator wants to create a playblast. (*Did Thurston at the cocktail party just ask what NURBS stands for? It is a distraction technique to keep you from getting the last mini crab cake. You can answer, while swiping that crab cake, "That's so old, we just call them NURBS. Who cares?" My apologies to those that like to say it.*)

You can draw your own **NURBS** curve, or use a **circle**. Do NOT use a NURBS square. Instead, use a circle (refer to Figure 3.2). We can use a NURBS circle, adjust the **degree to linear**, and bring the **number of sections** down to create a square, triangle, etc. The reason you do not use a NURBS square is because it is actually four grouped lines. If you select the square, you only get one side of the square selected and that isn't good for animators.

1. Create a NURBS circle which looks like a square (degree = linear, sections = four).
2. Name it **BendHigh_CNTRL**.

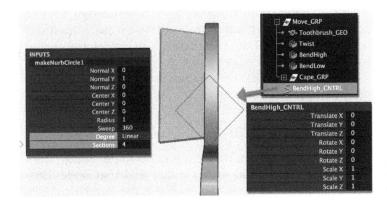

Figure 3.2 Making a square from a circle, and creating the BendHigh_CNTRL.

3. Place it toward the top of the toothbrush, close to the object and where the bend happens.

4. Once you get it in place, remember to freeze transformations and delete history.

Just to point out the **CNTRL** at the end of the control name. We're building in a naming convention to make our lives easier on down the road. That will enable us to select all of our CNTRLs when we want to find the animatable controls in one step.

One-to-One Controllers

Now, we are going to learn how to hook the controls up to animatable attributes. There are many ways to hook things up, but there is a basic pattern to the connections. We are going to do a 1:1 (pronounced "one-to-one") connection (refer to Figure 3.3). That means the number the controller has will be pumped directly into the attribute which we are going to hook it up to, so, if the translate X of the controller has a value of "3.5" in it, and it is connected to a curvature attribute, the curvature attribute will also get a "3.5." You can take any number and plug it into anything else; however, we will use something which makes visual sense to the animator.

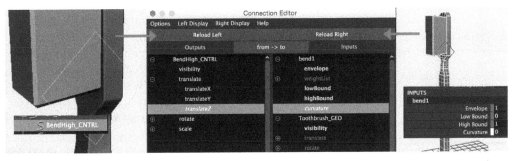

Figure 3.3 Loading the BendHigh_CNTRL and the bend1 input node into the Connection Editor for a one-to-one connection.

We will connect the **Translate X** of the **BendHigh_CNTRL** and hook it up to the **Bend High>bend1>Curvature attribute**. Did you find the curvature attribute we're looking for? Just in case, let's make sure. We're going to look at multiple ways to connect things in. First the cleanest connection for a one-to-one—the Connection Editor.

Connection Editor

We'll connect the controller you made to the **bend1** input node. We need to make sure we can find that node. (Just a nomenclature thing, if you look closely; BendHigh—the transform node, has a BendHighShape node which holds now all of the inputs. The bend1 node is an input node.)

1. Open the **Windows>General Editors>Connection Editor**. This window is a no fuss way of allowing you to connect one thing to another.
2. In the outliner, select the **BendHigh_CNTRL**, in the Connection Editor click on **Reload Left**.
3. Select the **toothbrush** geometry, in the channels box scroll down and locate the bend1 listed under inputs. Click on the name **bend1**. You'll know you have the correct one when you can select the node and see the curvature attribute in the channel box. Adjust the curvature to make sure it is the high bend at the top of the toothbrush. Remember to set that attribute back to **0** before you continue. In the Connection Editor, click on **Reload Right**.

The Connection Editor should have BendHigh_CNTRL listed on the left-hand side, and the bend1 node will be on the right-hand side. If for some reason the items load incorrectly, or don't load at all, you can select the BendHigh_CNTRL and click on Reload Left, and then select the bend1 node and click on Reload Right (refer to Figure 3.3).

A lot of extra attributes show up in the Connection Editor window at first. They get in my way, so I like to hide them. To minimize those attributes, for both the left and right side, select the pull down **Display>Show Nonkeyables** to toggle that **off**.

Stop. Make sure before you continue you have things loaded in the right order. You are connecting from the controller, **BendHigh_CNTRL** (which should be on the **left** of the Connection Editor), to the **bend1** input node (which should be on the **right** of the Connection Editor). In this window, you hook things up from the left to the right like a switchboard operator does. Wait a sec, you don't know what that is, cause that's even before my time. OK—it's like hooking up the mouse to your computer, or game controller to the console.

On the left side, where the control's attributes are, open up the translate attributes by clicking on the plus sign. This will show you all of the individual attributes. We only want one of

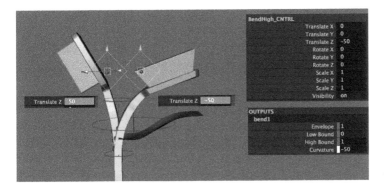

Figure 3.4 BendHigh_ CNTRL driving the curvature of the bend1 node with its translateZ value.

them. If we chose just "translate," we would have all three of them selected (x, y, and z). Select **Translate Z**. It will highlight and turn italic. Then on the right side, which is the **bend1** side, click on **curvature**. This will then highlight and turn italic. The connection has been made (refer to Figure 3.4). If you select the **bend1 node**, look at the attribute in the channel box to see the connection has been made, indicated by the curvature attribute having turned yellow or having a yellow box next to the text field (depending on which version of Maya you are using).

Test. Grab the control and translate it in **Z** and you should see that the curvature adjusts. If your bend goes the opposite way to your control movement, that's OK, we'll learn to fix that type of thing later on.

What could go wrong? What happens if, when you click the button to connect the attribute in the connections window, things move? More than likely, you forgot to freeze your controller. Remember, this is a one-to-one connection, so any number in your controller's translate attributes will be pumped into the curvature attribute when you connect it.

What if you made that mistake: how do you break your connection? If you still have the Connections Editor open, you simply reclick on the curvature and that will deselect it and break the connection. Usually, I never have that window up. In order to break connections, you have to have everything reloaded properly: too much clicking for me. Instead, you can select the toothbrush geometry, open up the **bend1** and get to the **curvature** attribute. Select the curvature attribute and **right mouse** click on it, then select **Break Connections**. The attribute will no longer be yellow and you have broken the connection between the control and the attribute. The problem with this method is that you aren't really sure what the connection was which you broke. If you are trying to diagnose a problem, you can't see what is connected to what, only that something is connected by looking at the channel box. Also, if you still have the Connection Editor open, it won't update; so it could confuse you. We'll get deeper into Maya to know exactly what is connected to what.

Time to get back into the Node Editor window.

1. Select the **BendHigh_CNTRL**.
2. Open the **Node Editor** window by clicking on **Window> Node Editor** and click on **Add selected nodes to graph** if needed.
3. Click on the **Input and output connections** button to see the connections to and from the BendHigh_CNTRL.

Here, you can see the connections between the nodes. A line connects the BendHigh_CNTRL to the bend1 deformer. In older versions of Maya, you might see a unitConversion1 node in-between. If you hover your cursor over the arrows, you'll see a popup which shows that the BendHigh_CNTRL.translateZ connects to the bend1.curvature after it passes through the unit conversion node. (*That is called dot notation, another thing to tell Thurston. He's going to be mighty impressed with you. It simply means that it is the name of the object or node, in this case bend1, "dot," and then the name of the attribute "curvature." Fancy, huh? Thurston didn't know that.*) Now, you'll see dot notation for the rest of your life.

As seen in Figure 3.5, you can delete connections (arrows) and nodes in the Node Editor and also you can do the connections there. Now, we're getting into the mud.

How do you connect things in the Node Editor? (This is my favorite way to do it.) We'll create a controller and connect it to the **LowBend**, but this time we'll connect using the Node Editor.

1. Create another square from a NURBS circle. Place it toward the low bend area of the toothbrush.
2. **FDH** (freeze and delete history). Name it **BendLow_CNTRL**.
3. Select the **BendLow** bend deformer in the **Outliner**.
4. Refresh the **Node Editor** window by clicking on **Clear the graph** button followed by the **Add selected nodes to graph** button, and finally the **Input and output connections** button. You can also middle mouse drag items from the outliner to the Node Editor.
5. Find the **bend2** node. Remember, if you can see the attributes in the channel box when you select a node, you can connect it.

 Be careful in this window. We'll get through the features step by step. It is easy to get lost. Follow the directions closely and you'll get the hang of this window.
6. Select the **BendLow_CNTRL** in the Outliner. In the Node Editor, click the **Add selected nodes to graph** button.

Figure 3.5 Breaking connections in the channel box.

NODE EDITOR

Before we go any further, right here is where the whole class grinds to a halt. Save where you are and let's look at the many ways you can view information in the Node Editor. I didn't show you this at first in the introduction because I wanted to trick you into rigging. Too late now, you are here. Let's see how to not get lost in this window.

If you select everything in the Node Editor window, and click on the Input and output connections button then select everything in the Node Editor window, and click on the Input and output connections window again the graph will grow. When it stops growing, it will keep reorganizing itself. What fun.

The text field at the far right side of the window, which by default has a −1 in it, and the buttons to the left of that: **Reduce traverse depth by one**, and **Set traverse depth to zero**; go ahead and click the buttons. Get it out of your system. Then set the text field back to −1, hit enter, and leave it alone. Someone in the class, including the professor, will click the "zero it out" button and wonder what happened to the nodes.

Last, on the keyboard hit 1, 2, 3, 4. Hit 1 again. This displays different levels of information in the nodes. If you have nothing selected, all nodes will display the level selected. If you have a node selected, only that node will adjust its display. Click around. Get accustomed to the window. Ready? Let's continue.

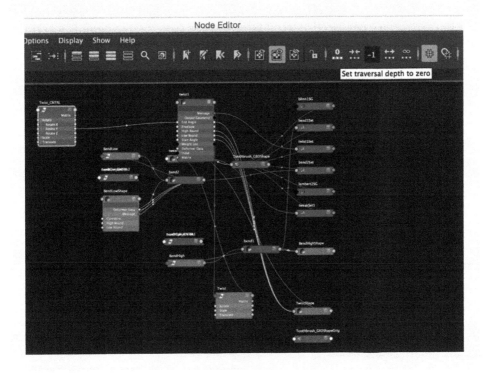

Find the right nodes. Locate the **BendLow_CNTRL** and the **bend2** input node. You can move things around so they are next to each other in the Node Editor window as well, if that helps you see things better. Make sure you have the BendLow_CNTRL (transform) node and not the shape node.

7. Select the BendLow_CNTRL node and hit "**3**" on the keyboard to show the "**full mode**" of the nodes. Click on the plus sign to the left of Translate attribute listed in that node. It will open and display the x, y, and z attributes.

8. Select the bend2 node and hit "**3**" on the keyboard to show the "**full mode**." The curvature attribute will display.

These are the attributes we will connect. If you had nothing selected and clicked "3," every single node would open up into full mode (refer to Figure 3.6).

9. Click on the **green** circle to the right of the **BendLow_CNTRL's TranslateZ**, and click drag to the **blue** circle to the left of the **bend2's Curvature** attribute, then **release**. A yellow arrow will follow your cursor.

10. Once you release the mouse button, a connection will be made. In older versions of Maya, a unit conversion node will be added in between the two attributes. In newer versions, you'll see a double arrow. If you were to look in the channel box, the bend2's curvature attribute has a yellow box indicating a successful connection.

Test and make sure: move the **BendLow_CNTRL** in the perspective window and make sure the **lowbend** is working. The controller moves faster than the bend does. There's a reason. Look at those colored circles again. If you hover your cursor over the colored circles themselves, you will see a popup which tells you that these are different data types. Translates are linear numbers. Curvature is an angle. Green indicates

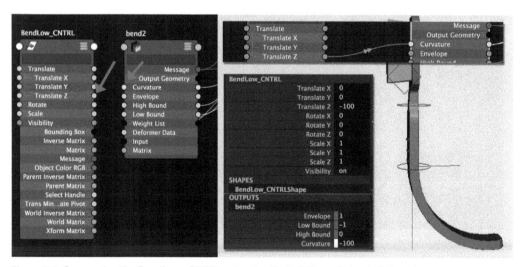

Figure 3.6 Connecting the BendLow_CNTRL using the Node Editor window's full mode.

Figure 3.7 Setting limitations on the controllers. The controllers are very far off-screen.

floats, blue indicates radians; this is why the unit conversion node was added.

So far, we have a rig with two controllers on it: a bend low and a bend high. Let's stop and think about our rule: "**Lock what isn't going to be animated**" (aka don't tick off the animator, they'll let you know). You only have to deal with that rig once; they have to animate it day after day, shot after shot. The smallest thing can get in the way of the animation. The two controllers we have made have too much freedom of movement, which doesn't do anything at all. So, we want to lock everything that shouldn't be animated. For both of these controllers lock the **Translate X, Translate Y**, all of the **rotates** and **scales**. That leaves only Translate Z open. While we are thinking about rules, there is **Rule #5: make controllers that make sense to the animator**. A way to do this is to limit the controller somewhat. In newer versions of Maya, the curvature is no longer linear so the rig bends only slightly when moving the controllers. In older versions, where the curvature attribute was a float (number) it collapsed the rig into a ball. For now, we'll continue on and limit the controllers (refer to Figure 3.7). Later, we'll learn how to add in a multiplying node to give us more bend. It's the same technique we'll use to correct if your controller and bend are moving opposite of one another.

To Limit the Controllers

1. Select **BendHigh_CNTRL**.
2. In the **Attribute Editor** (CNTRL A), you can find the tab for the transform node. Note that there are tabs for all of the nodes and connections.
3. Find the **BendHigh_CNTRL** transform node tab>**Limit Information**>**Translate**. Here is where you limit the movement range.

4. In the main viewport, move the control in **Translate Z**, so that the bend is as far as you think it should go, plus some. Example: **30**.
5. In the Attribute Editor, click on the arrow next to **Trans Limit Z's current value**. This will put the value into the Max column. Then click the **box** next to **Max** to turn it on.
6. Move the control so that the bend is the other way. Example: **−30**.
7. Click on the arrow next to the **Trans Limit Z's Min value**. This will put the value into the Min column. Click the **box** next to **Min** to turn it on.
 Repeat these steps for the BendLow_CNTRL.
 Now your controllers will only go in Z from 30 to −30. You have limited the animator's movements. That's good. But it can also be bad: you've limited the animator's movements. Hopefully, you gave him or her a little more on the min and max than they will need so that they don't have to ask for more. This can be an evil thing. Nothing will bring the wrath of an animator down upon you faster than limiting the animator's ability to get that pose. What might look like "too far" might not look too out of range in a certain camera angle or perspective. The character might need to be "broken" or pushed too far, which will look just right for the pose, but looks weird when in a neutral rigging position. (As a side note—there is a method of rigging called "broken rig," which means a rig can be supremely broken apart and its individual pieces moved away from the rest of the body, or stretched into crazy positions. That's an advanced topic, but definitely gives the animator more freedom to pose to the camera. We talk about that in Part 3 of this book.)

The other side of the coin is to not limit anything, to keep everything entirely open. That can slow down the animator as well, since they can yank the controller and collapse the rig, or put it into a position they don't truly want. This makes them have to move the control back and then move it again gently, and ultimately is giving them more mouse dragging time: a time waster. There has to be a middle ground between the two. It is possible, but you will only find it by being involved with your animators and making sure they are testing the rig and you are asking their opinions of what key poses they need to get. Let's work on connections a bit more.

Adding More Animator's Controllers

Twist the Top of the Toothbrush

1. Place a NURBS circle that looks like a triangle at the top of the toothbrush (three sections).

2. **Freeze** it; **delete history**; name it **Twist_CNTRL**. The rotate Y of the controller is going to hook up to the twist's end twist attribute.

3. **Lock** all the attributes for the **Twist_CNTRL** except for **rotateY**.

4. To connect them, select the **Twist_CNTRL** and the **toothbrush geometry** and open the **Node Editor** window. (Remember to clear graph, add selected to graph then click on input output connections.)

5. Locate the **Twist_CNTRL** and the **twist1** node. Double check in the channel box that you can see the attributes we need to connect, which means you have found the correct nodes. You know how to use the Connection Editor and you also know how to use the Node Editor window. There is another. (Please, tell me you are getting these Star Wars references.)

6. If you CNTRL middle mouse, drag the Twist_CNTRL node on top of the twist node, Maya will open the Connections Editor with the correct items loaded. This way you can find things in the Node Editor window, like the shape nodes, but can still use the connections window instead of using the right mouse button.

7. **Twist_CNTRL.RotateY** connects to **twist1.End Angle** (You choose what method you connect them with.) (refer to Figure 3.8). These are both radians so a unit conversion node is not added.

When you rotate the **Twist_CNTRL**, the twist twists. (Say that three times fast.) You will notice that when you rotate the controller to the left, the twist goes to the right. This is because the numbers are going one-to-one. The twist deformer really needs a negative number to turn to the left but we are giving it a positive number. We'll learn how to fix that later. For now, I hope that it annoys you. It should. This means you have the makings of a good character setup artist.

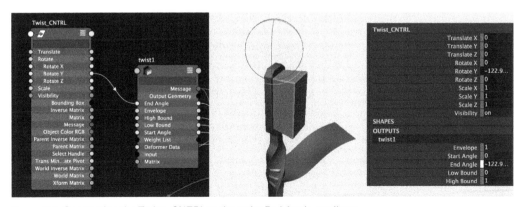

Figure 3.8 Connecting the Twist_CNTRL to the twist End Angle attribute.

A New Type of Connection: Constraint Connections for Translate, Scale, and Rotate

Main Controller to Move the Toothbrush

Next, we will work on the main control which will move the object and all controls we have added. This is going to work with the translation and rotation of a controller hooking up to translates and rotates of the driven objects. We will learn about constraints for this connection.

1. Create a circle and place it at the bottom center of the object. Use the origin to line up the control. You will note that the geometry and all of the deformers line directly up with the origin. This helps you use the fact that groups, etc. have their pivot point placed at the origin as default.

2. **Freeze** transformations, **delete history**, rename the object **Main_CNTRL**.

 Gotcha: If you have the options for freeze transformation adjusted, watch out: if freeze transformation is not set to the default, then you will have attributes which don't freeze. You'll notice a red error in the bottom right hand of Maya's window in the status line. (I do it all the time myself.)

 This connection is not going to be a one-to-one connection, as we mentioned. For translates, rotates, and scales, you want to use a different type of connection; I will explain later on why you wouldn't use a direct one-to-one connection. Right now, it might just bake your noodle. Instead, let's concentrate on what will work, then we'll concentrate on what wouldn't work. The next type of connection is a constraint. Constraints **are good** for translate, rotates, and scales.

 We want this **Main_CNTRL** to translate and rotate the **Move_GRP**. Your first instinct might be to simply make the group node a child of the Main_CNTRL. But, I went and put Rule #4 out there, didn't I? **Rule #4: keep geometry, controllers, and skeletons separate from one another**. Why does that rule exist?

 • It keeps the rig more manageable.
 • It keeps the geometry from turning green when you select the controls to animate it.

 That is my pet peeve. It bothers me to see the green-highlighted character when I have selected a control, plus it makes a nice tidy rig when all of the animatable controls are in one hierarchy together. Click on the Move_GRP node just to see what I mean. The parent and all of its children turn green. If you follow that methodology of making the control a parent of your

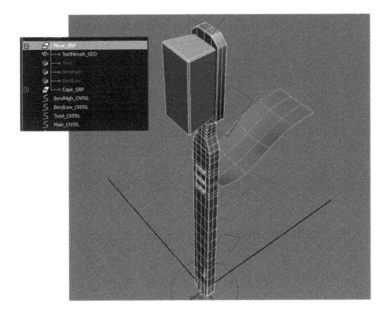

Figure 3.9 Selecting a parent. In this case, a group node turns the geometry green. This can get in the way, visually, of the animator.

geometry (which makes your geometry turn green when you animate), you open a Pandora's Box. It lets you go down the path to a messy rig. That's my opinion—and I share it with you here. Now, let's see how to work with that rule and have a nongreen rig (refer to Figure 3.9). (*I'm pretty sure Thurston would say, "Lovey, she doesn't like the color green. How could anyone not like green? I mean, after all, it is the color of moolah. Frightful."*)

3. Select the controller (**Main_CNTRL**) and the group (**Move_GRP**). It is important how you select. You have to select the controller (the **driver**) and then the animatable group node (the **driven**). If you select it the other way around, the connection will be made backwards. **Oh no!**

4. Select **Constrain>Parent**. (Note this is not Edit>Parent.)

5. Click on the **option** box to make sure that the tool is set to the default settings. Click on **Apply**.

Test: Now, when you select the controller and move it, the object moves and rotates but does not turn green. Plus, the hierarchies are completely separate, very clean (refer to Figure 3.10).

If you look in the channel box, you will see the group node's attributes for translate, rotate, and scale have turned blue. That's a good color. Yellow was a direct connection. You might know pink as animation. Blue means a constraint. Green in the channel attributes, however, is a color we don't want to see in this class. It means that you have more than one incoming connection. The only time it should show up is when you WANT it to show up, and that would be advanced. It would show up if

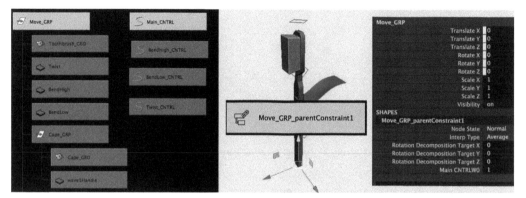

Figure 3.10 Create a parent constraint to connect the Main_CNTRL to the Move_GRP.

you were animating multiple constraints, for example, juggling (refer to Figure 3.11).

In the settings for parent constraint, there is an important option called "maintain offset." When it is **off**, it expects everything to be zeroed out. If your controller or group node were not zeroed out, the group node (and the character) would jump or shift when you applied the constraint. If you were dealing with a driven object that could not be zeroed out, like a deformation handle or a skeleton (which we will learn about later on), then you would need to have maintain offset checked on.

If you can, always have everything zeroed out, which is our next rule. **Rule #6: happy math—controls and joints should be zeroed out**. It makes life a whole lot easier, cleaner, and not so full of surprises with unintended jumping characters.

Constraints are more than a one-to-one connection. If you look in the outliner, there is a new node with the constraint name. This can be renamed or deleted, just like any node. You can also select the control or the group node and open up the

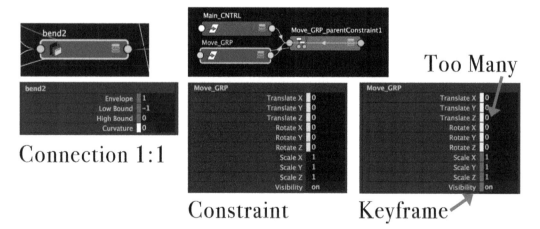

Figure 3.11 Different visual cues for connections. Unless you plan for it—green in the channel box is bad.

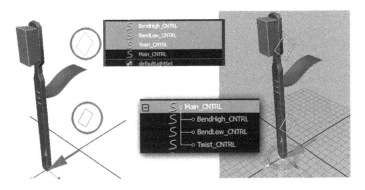

Figure 3.12 Controllers are made children of Main_CNTRL so the controls all move together when the toothbrush is moved.

Node Editor window to see how the connection has been made. You will see a bunch of arrows flowing from the control to the constraint node and then to the group node. This connection node can also be deleted in the Node Editor window as well.

We still have one more thing to deal with in our rig. If you move the Main_CNTRL, the toothbrush walks away from his bend controllers. Move the Main_CNTRL in Z to see the symptom; the bend controllers do not move with the Main_CNTRL, as seen in Figure 3.12. We want those to go along with the whole rig. That is an easy fix. Our controllers have their own hierarchy:

1. Make sure all of your controllers are zeroed out to their neutral position (else the numbers will be thrown to the children and your rig explodes).

2. Simply **middle mouse drag** those deformation controllers (**BendHigh_CNTRL, BendLow_CNTRL, Twist_CNTRL**) in the outliner and drag them on top of the **Main_CNTRL**.

This will make them a child of the Main_CNTRL. They now move with the rig. You might have already caught that intended issue and put them in the correct spot, since we learned how to move them with the character in Chapter 2. If you did fix it before you got to this paragraph, you are showing distinct symptoms of being a rigger when you grow up.

Clean-Up Time

Let's clean up all of our controls and geometry to make a nice orderly rig in the outliner. Why do we care? Not only does it make the rig easier to maintain, bug fix, etc., but it makes it easier to export and import multiple copies. Imagine you wanted to animate a chorus line of toothbrushes. You want to easily be able to select the character, export it, and import copies of it. (Copy and Paste isn't going to quite work like you want it to. You need to import in duplicates.)

To clean up, let's put all of the GEO into a group, and the CNTRLs in their own group.

1. Make sure that all controllers are zeroed out before you begin.
2. Select the **Main_CNTRL**.
3. Create a group. Name it **TB_CNTRLS**.
4. Select the **Move_GRP**.
5. Create a new group. Name it **TB_GEO**.
6. Select both the **TB_CNTRLS** and the **TB_GEO**.
7. Create one more group, name it **TB**. Those group nodes are just for organization. They do not animate.
8. Select the group nodes: **TB_GEO**, **TB_CNTRL** and **lock** their **attributes**.

Test the rig. Does anything break? Move, rotate, bend low, bend high, twist? Does it zero out? A way to test is to:

1. Select all of the controllers.
2. Select the **Main_CNTRL last**. It will be the last one showing in the channel box.
3. Select the Translate X field then drag down to the Rotate Z field.
4. Type in a 0. Hit Enter.

This will put a 0 in for all of the translate and rotate attributes for all of the controls selected since they all have the same attribute names (refer to Figure 3.13). This makes it very easy for our animator to open the CNTRL group and select all of the animated controls to create a character set with

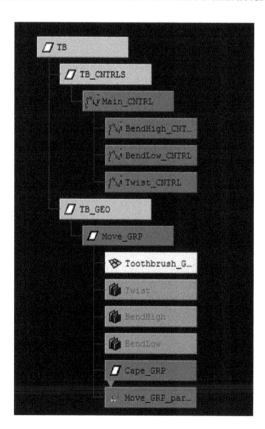

Figure 3.13 Cleaning up the nodes shown in the Hypergraph:Hierarchy window.

(Animation>Key>Create Character Set [option box]>All keyable attributes). If you have ever dug into a rig that had controls all buried in the hierarchy, you will find it is very time consuming. Save the clicks for useful things—Hah! Now when you get a green rig or channel, you will think of this book forever.

Gotcha: If your Main_CNTRL had numbers in it (breaking Rule #6) and was not zeroed out. When you make any controller a child of that Main_CNTRL, they will inherit its offset and move, thus collapsing your character. Oh my! Rule #6 was extremely important. If you want to experience all of the gotchas, teach rigging to a class of 20. They will show you everything that can break. "*Thank you, students.*"

Adding Scale to Our Rig

You'll note that our rig does not yet scale. This is the last bit of functionality we need to add. If you scale the Main_CNTRL, you'll see that the controllers themselves scale but the toothbrush does not. This is because the controls are in a separate hierarchy than the geometry; we followed Rule #5. This is an easy functionality to add. We want to make the TB_GRP node scale. So, let's set up a **scale constraint** between the **Main_CNTRL** and the **TB_GRP** (refer to Figure 3.14).

1. Make sure all controls are zeroed out and the Main_CNTRL has 1s in the scale. Select the **Main_CNTRL** and then shift select the **Move_GRP**. (Driver, driven.)
2. Create a scale constraint by selecting **Constraint>Scale**.

 Oops! Did you get an error? "Could not add constraints or connections." Why did you get that error? Select the **Move_GRP** and look at the channel box. What do you see? Are your scale attributes locked? Locked attributes mean not only can we not animate those attributes, it also means that Maya can't attach anything to them either.
3. **Unlock** the Move_GRP's attributes by selecting the **scale X, Y,** and **Z**; right mouse click, select **Unlock**. Repeat step 2.

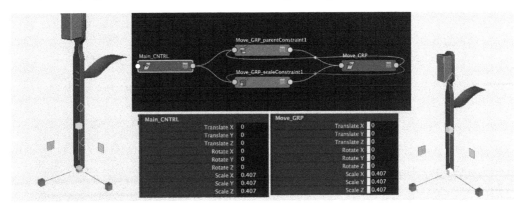

Figure 3.14 Adding a scale constraint to complete the rig.

Gotcha: When I was testing this rig out, there was a keyframe on the group node. That keyframe also kept us from adding a scale constraint since keyframes are actually time nodes connected to attributes. What? Go look for yourself. Create a test object and keyframe it. Now, go look at it in the Node Editor window. I'll wait for you. Neat, huh?

Test. Choose the Main_CNTRL and scale it. If everything went well, your channel box for the Move_GRP should have all blue channels and your rig should now scale. Rig done. Well, almost.

Gotcha: If you were connecting to multiple group nodes or multiple objects, you want to make sure that all of the pivot points are at the right place. Scale works on the driven's pivot points. So, if you did a scale constraint to three individual objects and one of those objects had the pivot point off to the side, it would scale to the side. You can use group nodes over objects to fix this. Make sure the group node's pivot points are placed correctly at the origin and attach the scale constraint to the new group node. Now that you've seen constraints in action, let's talk about them for a brief moment. There are a few common types: point, aim, orient, scale, parent to name a few (refer to Figure 3.15). (Back in my day, we did not have parent constraints.)

Point = translate
Orient = rotate
Aim = look at (like eyes)
Scale = scale (self-evident)
Parent = translate and rotate

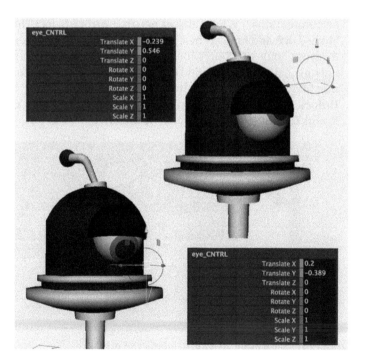

Figure 3.15 Aim constraint is used for eyes to follow an eye controller's translation. (Model and rig by Brenda Weede, with permission.)

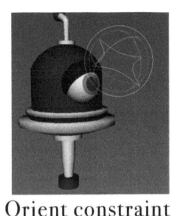

Orient constraint Parent constraint

Figure 3.16 Orient constraint uses the driven's pivot point—the eyelid in this case. Orient and point constraints are useful when the controller's pivot point is not the same as the object. Parent constraint will use the controller pivot point— not useful for this eyelid. **Oops!**

Parent constraint is a little different than applying a point and an orient constraint to an object. A parent constraint uses the driver's pivot point whereas point and orient constraint uses the driven's pivot point. What difference does that make to you? If your controller does not have its pivot point exactly where you want the rotate to happen, say on a joint or at the hinge of a box which should open etc., the rotate will happen incorrectly.

Take a look at the sample file **chpt3_Constraint_Example. ma** to see an aim constraint example (refer to Figure 3.16). Gosh, I remember how hard it was for me to understand the first time I looked at that. But of course, I don't think I had access to the manuals at that time, and I was trying to figure it out for myself.

Gotcha: If you select the channel box attributes and break connections for a constraint, the constraint node still exists! It does not get deleted. You can still see it in the outliner. This can lead to trouble because you might forget and see the constraint there and think that since it is there, it must be working. This will cause some lost time until you realize it is not hooked up. I've seen it happen in class many times.

Note: Look in the options boxes for the constraints—you can limit which attributes get constrained. In this beginner section of this book, we don't need that. But one day you will be fancy with your rigs and you just might need it.

I'm about sick of seeing a toothbrush—how about you? So, let's move on to a different rig. Remember, each of these concepts builds on the other. If you didn't get something, it doesn't get any easier. Go back through this chapter until you can break down each step and understand it. Oh, you have it? When you learn new concepts, come back to this rig and make it better. OK then, let's turn the page.

4

UTILITY NODES AND CUSTOM ATTRIBUTES

RULES COVERED

Rule #4: Keep geometry (GEO), controls (CNTRL), and skeletons (SKEL) in separate groups in the outliner

Rule #5: Make controls that make sense to the animator

Let's recap the rules we have covered so far:

#1. Edgeloops—a good or bad rig starts with the loops.

#2. Never keyframe on the geometry. (Animate for change.)

#3. Lock what isn't going to be animated.

#4. Keep geometry (GEO), controls (CNTRL), and skeletons (SKEL) in separate groups in the outliner.

#5. Make controls that make sense to the animator.

#6. Happy math—controls and joints should be zeroed out.

#7. Happy history—always delete unneeded history to keep a rig fast.

In this chapter, we will talk more about **Rule #5: make controls that make sense to the animator**. To accomplish Rule #5, we will learn about utility nodes—my favorite!

In the last chapter, we put controllers on a toothbrush. In that rig, what might not make sense to the animator? If you aren't sure, do a test animation with the character. What frustrated you the most? If it frustrated you (and you know the rig), it will really frustrate someone who doesn't know the rig as well as you.

On our toothbrush rig in Chapter 3, the twist controller turned one way but the toothbrush twisted the other way. That and many other simple user interface issues can get in the way of animating. It takes a little bit of extra care to fix those issues. That extra care can streamline the animator's workflow and help production.

I don't know about you—but I'm a little tired of the toothbrush. If you don't mind, we'll use a different looking rig with the same type of attributes. What we learn in this chapter can be applied to the rig in Chapter 3. Oh—that sounds like a quiz. In Figure 4.1, we have a fish which has a similar twist issue as the toothbrush. The fish model has a twist deformer for the whole body and a bend deformer for just the whiskers.

DOI: 10.1201/9781003431121-6

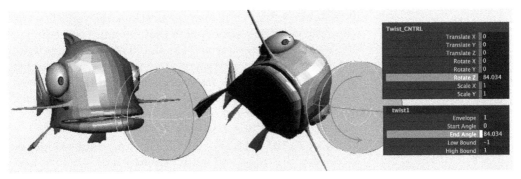

Figure 4.1 Rotating the Twist_CNTRL to the left causes the fish to twist in the opposite direction. The twist end angle needs a positive number. (Model by Stefan Lepera for SCAD 2010 group project "Drag N' Fly", with permission.)

We have a one-to-one connection from the controller to the twist's end angle attribute. The issue is that the number required is the opposite of what we are getting from the twist controller. The controller is giving a negative number when we twist to the right, but the twist end angle needs a positive number to be twisted to the right.

The type of connection we need is not a one-to-one connection or a constraint connection. We need to have a modified connection. In other words, the number we need in the twist attribute is not the same as what is coming from the controller. How do we adjust that number? There are those who will jump straight to expressions. Not us. We'll save expressions for when we can't do it any other way. Expressions are a mathematical formula you can enter into the channel box, which will do the math for you and adjust the number. They are neat and those who love them love to use them. However, I do not and will not show you expressions until we have exhausted every other way to do the same thing. Here's the reason—expressions are not very fast. They calculate every frame, every time you do anything, because they don't know any better. We are going to learn how to use nodes. Why? We use nodes because nodes do calculate very fast. Use nodes first, expressions last.

Do you want something else to talk about with Thurston at that cocktail party? Hope this is at another black-tie affair. You really get around in the social scene, don't you? When an attribute is marked as having been changed and Maya needs to think about it, it is considered "dirty." When it is marked as not having changed, and therefore can be skipped during an updating of time (when you scrub the time line), then it is considered "clean." Nodes know when they are dirty or clean. This is how Maya manages what it should update when you scrub through the timeline. It doesn't think and update everything, only the things that are marked "dirty." Expressions are always dirty and can never ever be clean. It is how they are designed. So, they

calculate every frame. Too many expressions and your rig starts to become very, very slow. Add to that the multi-threading of 2016+'s parallel processing and you find that expressions if not used thoughtfully can make a rig extremely slow. More on that toward the end of the book. (*Dirty expressions; take that Thurston! He really is a good friend and admires all of these tidbits you tell him. He can't get enough.*)

Open the chpt4_Sue_Shi_start.ma file:

1. Select the **Twist_CNTRL** and open the **Node Editor Window**, click on the **Input and output connections** button to load the nodes.

 There is a line connecting the output of the **Twist_CNTRL** going into the **twist1** node. We want to place something between those two nodes to adjust that number. For example, in Figure 4.1, if the Twist_CNTRL is at 38 and we want the twist1 end angle to be at a −38. Do you remember junior high math? Maybe it was grade school, I don't remember. What do we need to do to make a 38 turn into −38? Multiply it by −1. We want to hijack the number, which is going between the controller and the twist, and do some funky magic with it and multiply it by −1. We will add in a node to do this. To do this, we are going to use a utility node (refer to Figure 4.1).

2. In the Node Editor window, click on the **Toggle the create node pane on and off** button. This opens a pane full of nodes we can use.

3. Select the **Utilities** section.

 You might think these nodes have something to do with rendering. You wouldn't be wrong. Inside of Maya, you can basically do compositing type of effects with your textures using these nodes. It's pretty neat if you haven't gotten into it. However, we're going to use these for rigging and make them do our bidding. (*Insert evil laugh.*)

4. Click on Multiply Divide.

 The new Multiply Divide node shows up in your Node Editor window, hopefully near your Twist_CNTRL and twist1. If not, move the view around until you locate the Multiply Divide node (refer to Figure 4.2).

 If you select this new **Multiply Divide** node and look in the **attribute editor**, you can see that it has an "input one" and an "input two" as well as a pull down for you to choose multiply, divide, or power. You probably learned power in a math class that I never took. The Multiply Divide node is set-up for three numbers. They are not labeled. You can assume they stand for either RGB or XYZ. You can use any of them. We're going to use just the first column and ignore the rest. The first input is going to be the number from the controller and the second input will be what we want to multiply it by.

5. In **Input2X** (second row, first column), type **−1**.

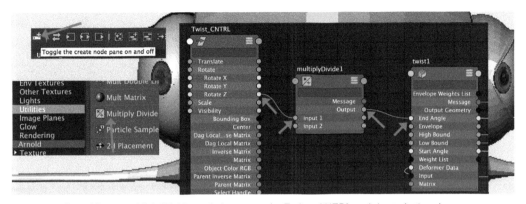

Figure 4.2 Attaching a multiply/divide node between the Twist_CNTRL and the twist1 nodes.

6. Change the operation to **Multiply** (if it wasn't already there).
 We need to get the rotate z number from our twist control and pipe it into the input one.

7. Locate and open up the **Twist_CNTRL**, **multiplyDivide1**, and **twist1** node in the Node Editor window by selecting them and clicking **2** or **3** on the keyboard and opening up the needed attributes.

8. Select the arrow between the **Twist_CNTRL>Rotate Z** and the **Twist1>End Angle**. Then press **delete** on the keyboard to remove that connection.

9. Drag a connection from the **Twist_CNTRL>Rotate Z** to the **multiplyDivide1** node's **Input1>input1X**.
 This adds a unit conversion between the Twist_CNTRL and the multiplyDivide1 node.

10. Complete the connection by dragging an arrow from the **multiplyDivide1>Output X** to the **twist1>End Angle**. This adds another unit conversion between the nodes.

Now your twist controller should work correctly, and the twist control and the twist of the fish should all go in the same direction (refer to Figure 4.3). This is such a nice thing, which the animator appreciates. For example, in bipeds, to be able to rotate both arms down at the same time is a nice thing and saves time as seen in Figure 4.4. However, depending on the arm setup you use, it is not an automatic thing. Usually the arm controls, when selected and rotated together, make the arms go in an opposite direction: one up, one down.

It can take a utility node to give that functionality to the animator. (Go try it on any Tom, Dick, or Sally rig you can download out there. Most of them don't have this feature, do they? That's what I thought.)

It takes a little bit of clicking and navigation to use the utility node. Once you get it though, utility nodes are excellent tools for you to have. There are many ways to use them.

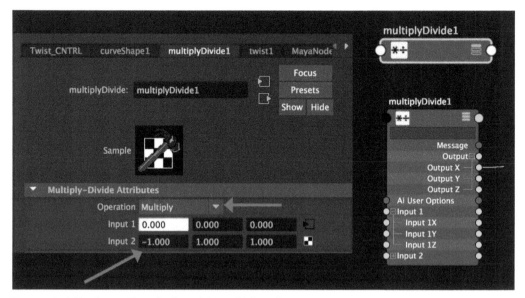

Figure 4.3 Adjusting attributed editor of the multiply node.

Figure 4.4 Carlos model by Adam White rigged to have both arm controls rotate down when both controls are selected and rotated in negative Z (with permission).

Where Else Could You Use This?

What if you had an icon controller, which was a translate but was going to a rotate type of attribute (ignoring the concept that we usually use constraints for rotates). Much like we had with the toothbrush. The translate icon moved in X from 0 to 100, but the rotation value in the bend barely moved. So, you might want to have the rotation behave quicker. You could add in a Multiply Divide node and multiply that translate by 5, 10, or 360. (*Oh, tell Thurston rotational numbers are radians. I can see him now hollering over his shoulder, Lovey, did you hear that? Radians, they say. I simply adore this geeky fellow.*) If you become afflicted with the love of utility nodes, take a look at what other nodes there are.

The Problem with One-to-One Connections

Now that you know the different types of connections, let's pause to look at the difference between one-to-one connections and constraints, which I mentioned in the last chapter. In doing so, I would like to illustrate why we use constraints for translate, rotates, and scales. Let's look at two seemingly similar rigs. Please open **chpt4_BoyWithHat.ma**. In this file, there are two versions of a boy with a hat rig. There are two controllers: a helmet controller and a head controller.

The boy with the red helmet on the right is made with constraints (refer to Figure 4.5).

1. The helmet controller is parent constrained to the helmet.
2. The head controller is parent constrained to the head (and the body since we haven't learned how to use skeletons yet).
3. The head controller is a parent of the hat controller. It moves fine. When you move the main head controller, the red helmet moves too.

Beginner's mistake: Being a parent means that in the outliner the head controller is the parent of the hat controller via a hierarchy. Remember, this is completely different from a parent constraint, which is a connection you make between controllers and what they are driving. Parent constraints are seen via the Node Editor window, or in the outliner as a node with a different icon.

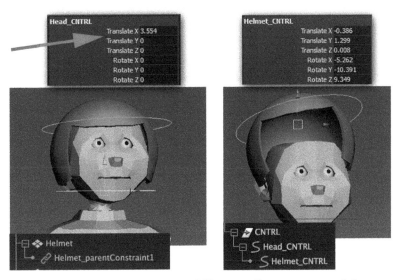

Figure 4.5 Boy with the red hat rig works as expected. The controllers are connected via parent constraints. When the body controller is moved, the helmet and its controller move too.

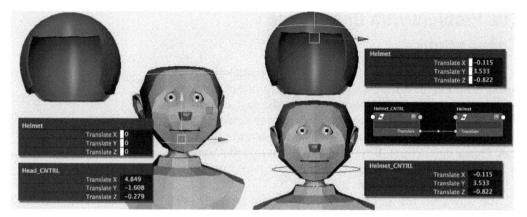

Figure 4.6 Boy with the blue helmet rig does not work as expected. The controllers are connected via direct one-to-one connections. When the head controller is moved, the helmet does not move! (Helmet by Brenda Weede, with permission.)

The blue boy on the left is made with direct one-to-one connections (refer to Figure 4.6).

1. The head controller is connected translate-to-translate with the head geometry.
2. The helmet controller is connected translate-to-translate with the helmet geometry.
3. The helmet controller is a child of the head controller.

When the helmet controller is moved, the hat moves. When the helmet controller moves, the helmet controller and the man's head move, but the helmet does not! What on earth? Try again. You move the helmet controller, the helmet moves. But when you move the head controller, the helmet controller moves but the helmet stubbornly does not budge a pixel. What is going on here?

Let's look closer. Move the head controller. Now, look at the numbers in the helmet controller. They are still at 0. The controller has been offset by its parent, the head controller, but it has inherited no numbers. Since it is directly connected with the geometry, it is still sending a 0 to the translate attributes of the helmet geometry. Oh, I remember the first time I did this, I couldn't figure out what I had done wrong. I redid it, redid it, and redid it again before I realized what the problem was. This can't creep in because we are keeping the controllers separate from the geometry. If you keep the controllers in their own hierarchy, then you need to use constraints for translates, rotates, and scales. There are times to break this, yes. But, now you know why we use constraints in this rigging methodology. That might have baked your noodle just a little bit. I'll get a coffee and wait while you play with the rig until you have that "aha" moment. Go ahead—take a closer look. I'll wait. There is a video in the companion data showing this concept.

Utility and Low-/High-Resolution Switch

Let's take a look at another use of a node to add functionality to a rig. In our sample rig, **chpt4_Boy_Polysmooth_start.ma**, Robby has been modeled in low resolution. We strive to keep our rigs with as low a resolution a model as possible to make it faster for the animator. You do not rig with the high-res—it makes the rig move too slowly and frustrates the animator. Some pipelines allow for a version of the high-res to be seen by the animator; they can turn it on and off as they animate to see how the poses are really looking. Other pipelines do not have the high-res version in the animatable file at all. They export the animation and apply it to a renderable high-res rig. In our beginning rig here, we are going to use the poly smooth function, and turn that on and off to create a semi-high-res version of our animatable rig.

We will put in a switch which will turn a high-resolution model on and off. In our sample file, as should be the case in your own models, the model is done, completely done; a nice low poly with good loops. The history has been deleted and it is frozen. (All happy math.)

1. Select the **geometry** and then select under the modeling menu **Mesh>Smooth**. This adds a polysmooth node that smooths the geometry. You will also be switched to a Show Manipulator tool mode, which shows a popup window that allows you to enter in different levels of smoothness. (Which you can accidentally make huge if you click on the bottom right of it.) When you switch to move, rotate, or another tool, the popup will go away.

2. Change the division to **0** and this will display the model's low-resolution version (refer to Figure 4.7).
 a. 0 = low resolution
 b. 1 = medium resolution
 c. 2 = high resolution
 d. 3 = insane resolution silliness (sometimes referred to as fine)

Figure 4.7 Changing the polysmooth's division attribute.

You want to keep this node around. So **do NOT delete history**. If you were to delete history now, it would get rid of this node. Even if you deleted nondeformer history, it would still get rid of this node. Don't do it! It is very easy to accidentally obliterate this node if you delete history out of habit.

If you select the geometry and look in the Node Editor window, find the **polysmoothface1** node. On this node, lock all but the divisions attribute. We'll want to give the animator a nice control to adjust the divisions attribute so they do not have to go digging for it.

How Do We Create a Custom Attribute on an Existing Controller?

So far, we have covered one-to-one connections, constraints, and modified connections with utility nodes. All of these connections have been to attributes which exist. What if you want to create a controller that has other types of attributes on it? Custom attributes? You've come to the right place. Let's learn how (refer to Figure 4.8). Continuing with our red helmet boy, you can open the file **chpt4_Boy_Polysmooth_v2.ma** to see the rig so far.

1. Select the **Head_CNTRL**.
2. In the Node Editor, right mouse click at the top of the **Head_CNTRL** node and select **Add Attributes....**

 Common beginner mistake: make sure you have the controller selected and not the geometry.

 The Add Attribute window opens up. We can create our own attributes and hook them up to anything.
3. Label this "**LowHigh**."
4. Make Attributes: **Keyable** should be **on**.

Figure 4.8 Creating a custom attribute on the Head_CNTRL.

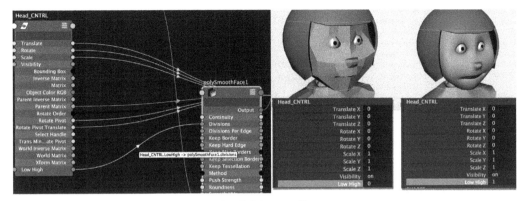

Figure 4.9 LowHigh attribute hooked up to the divisions attribute.

5. Under data type, choose **integer**. That means there are no decimal points.
6. Minimum = **0**
7. Maximum = **4** (We'll go a little higher than needed.)
8. Default = **0**
9. Click **OK** and close the window.

Now a **LowHigh** attribute shows up in the channel box, and you can see it in the Node Editor. You can change the numbers, but nothing happens yet. We haven't hooked it up to anything.

We need a one-to-one connection from this custom attribute to the divisions attribute. Hook it up to the divisions attribute using any method you want to (refer to Figure 4.9). For example:

1. Select the **Head_CNTRL** and the **geometry**.
2. Open the **Node Editor** window. Clear the graph, add the selected nodes and click on input output connections. Move the nodes around until you have the **Head_CNTRL** and the **polysmoothface1** nodes visible.
3. Drag a connection from the **Head_CNTRL>LowHigh** attribute to the **polysmoothface1>Divisions**.

Test: Select the Move_CNTRL and adjust the LowHigh attribute to make sure it drives the divisions. You should see the geometry change resolution as you change the LowHigh attribute.

What Could Go Wrong?

You could connect it backwards, in which case the LowHigh attribute would turn yellow instead of the divisions attribute. You could have put the custom attribute on the geometry instead of on the controller. Not a good thing since we don't want the animator to touch the geometry; which is why we create controllers.

Enum

Are you curious about those other data types in the create attribute window? If you answered yes, I hope you realize that you are definitely showing strong rigger symptoms. I was very curious when I first was learning. Let's start again and try a different data type, something other than an integer.

Re-open **chpt4_Boy_Polysmooth_v2.ma**. Let's suppose the animator doesn't like scrolling back and forth with a virtual slider (like me) and would rather have an on-screen controller for animatable attributes and a toggle for things like this LowHigh attribute.

1. Select the **Head_CNTRL**.
2. In the Node Editor, right mouse click at the top of the **Head_CNTRL** node and select **Delete Attributes…**.
3. Choose **Low_High** and click on delete. Now to remake that attribute:
4. In the Node Editor, right mouse click at the top of the **Head_CNTRL** node and select **Add Attributes…**.
5. Name: **Low_High**.
6. DataType: **Enum**.

 Enum means enumerator. At the bottom of the window, we can create words that are assigned a numeric value (refer to Figure 4.10). (*Enumerators in other scripting languages let you assign a name instead of a numeric value; tell Thurston.*) By default, Maya has the words green and blue created for you. Usually, you don't want to keep those words.

7. Click on the word **green** and change it to **Low**.
8. Click on the word **blue** and change it to **Medium**.

 How do you add a third name?

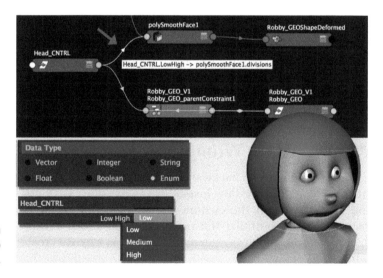

Figure 4.10 Creating an enumerator attribute to drive the divisions attribute.

9. Click on the **empty** space where a third name should be—ah! Add the word High. (That took me 10 minutes the first time I saw this window. I kept looking for a plus button.)
10. Click on **OK**.

If you can't see the attribute you just added in the Node Editor, select the **Head_CNTRL** node and hit **3** on the keyboard.

These names are given an automatic number based on their position. The first word is given a 0. The second word is given a 1, etc. It is a numbered list starting at 0, just like an array (if you know what those are). For example: low = 0, mid = 1, high = 2, crazy = 3. In the attribute editor, you will see a pull down menu as your **LowHigh** attribute. Hook it up as we did before:

1. Locate the **controller** and the **polysmooth** nodes in the Node Editor window.
2. Connect the **Low_High** attribute to the **divisions** attribute, as we've seen how to do previously. (You aren't skipping around are you?)

Test. Change the values of the LowHigh attribute to make sure the geometry indeed changes resolution.

One Odd Thing to Note about the Polysmooth Node

You may have noticed that the eyes do not move with the head when you move poor Robby around. There is a reason for this. The eyes could be a simple child of the geometry. If they had been children, however, when you select mesh>Smooth it will only apply itself to the last object in the hierarchy. That would have been an eyeball, and we would have clicked polysmooth over and over again and thought it wasn't working. Polysmooth will apply itself only to the lowest item in the hierarchy. What? That's a good gotcha. You'll have to perform the polysmooth operation on each object before you make any hierarchies with your objects.

Polysmooth can be used as a modeling tool. If you have divisions set at 2 then delete history, the resolution of that object will stay high. Not really what you want for this class; it will make your rig slow. It is just something to watch out for. To finish up the rig, you can make the eyeballs a child of the geometry, if that was bothering you.

"One-to-Many" Connections

Before we close this chapter, let's add a few parting ideas. If you happen to have three objects, which all have their own polysmooth nodes on them, you can still have them driven by one controller. That will work, and is a "one-to-many"

Figure 4.11 Renaming objects and connecting one attribute to many.

connection. Simply hook the output of your lowHigh attribute three times—once into each of the polynodes. (*Thurston says, "One too many? That sounds like what happens when I offer my kids a dollar, next thing you know I'm handing out dollars to all the kids and the dogs till my wallet is empty."*)

Random note: If you have multiple objects, which all have a prefix and then a number (tooth1, tooth2, tooth3, etc.), and don't want to label them all you can select all of the objects and in the upper right corner of Maya, choose Rename. Type in tooth and then enter (refer to Figure 4.11). This will name all selected items tooth and number them. Nice, huh? That existed when I went to college. In fact, all the options you see in that area existed back then: absolute move, relative move, etc. Of course, they were a command line item then, back when the dinosaurs roamed.

You guys are dangerous now—you know one-to-ones, one-to-many, utility nodes, constraints, deformers. Right now, we could stop our journey together, walk away and you still have enough to do a senior film with simplified characters. I envision stylized characters, like googly-eyed sushi in anamorphic form. (Look them up on http://ThinkGeek.com.)

Are you going to stick around for more? OK. Let's move on to the next subject.

5

JOINTS

RULES COVERED
RULES COVERED

Rule #6: Happy math—controls and joints should be zeroed out

Up to this point, we have been doing prop rigging. It is a subject not often found in books and which could occupy a book entirely on its own—wholly dedicated to all of the problems you might have to solve: buckets, teapots, bicycles, IV bags with dangly tubing, beds, phones, pianos—you name it. If you read my blog, I keep kicking around an idea of writing that book. *Cause wouldn't that be fun?* We also added in small characters which could be deformed simply. All in all, a good skill set to have. It is time to learn more about characters.

Now, we leave that world of using group nodes (somewhat) and get into skeleton systems and skin. That sounds messy, if not gross. We'll still use group nodes, but more as offsets and for organization. We are going to learn a whole new method of rigging and take it in small steps. I find it helps things sink in better that way; better than trying to learn every single concept all at once.

The problem with what you are about to learn is that sometimes it is the only thing people think about using, and they forget about the simple group nodes and deformers that we learned about in the first part of this book. The other issue we're going to notice now is that once you start getting into joints, you lose the ability to squash and stretch your rig—unless you get into some advanced rigging. Base rigs do not squash and stretch. We'll get into exactly how to do that later in the advanced section.

First, we have to learn about skeletons or, as Maya calls them, joints. Let's learn how Maya thinks about joints. No matter what software you deal with, bones or skeletons are the same math, the same problem being solved. But each software will handle the skeletons/joints slightly differently, whether it is Maya, Max, Blender, Cinema4D, Harmony, After Effects, etc.

The first rule when drawing skeletons in Maya is: **do NOT draw skeletons in the perspective window**. It will only draw the skeleton flat on the grid and not how you want it. Older versions of Maya wouldn't even let you draw joints in the perspective window. The best way to draw a skeleton is facing the bisecting axis of the bend. (What?) When you draw the joint, you want to

DOI: 10.1201/9781003431121-7

draw it in the window that faces the main rotation angle. For example, if creating legs on a character facing Z, you would build them in the side window so that you see the knee bend. The same holds true when drawing a spine. Arms held out in a T pose would be made in the top window since they hinge in the Y-axis. As we go through these types of joint creations together, take careful notice of what window the skeletons are drawn in. For now, though, let's simply get used to the joint tool, and then we'll delve deeper into how to use it. Switch to the Rigging mode if you are not already there.

1. In any window (except perspective—we talked about that), select **Skeleton>Create Joints** and click a couple of times to draw three to four joints. Hit enter on the keyboard to complete the joint chain and the **Select Tool** becomes the current tool.

For each click, you see a small ball appear. After the second click, a bone connects the two joints you have created. You can see in the outliner that each ball is called joint1, joint2, etc., and they are children of one another. (You may have to click on **Show>Object>Joints** in the Outliner to see the joints listed.) You can unparent these joints and reparent them in any manner you want. The topmost joint is the "root" or the parent. If you select it, you can move the whole joint chain around. The root is the only joint that is meant to be translated; all other joints are meant to be rotated.

If you break the joints' hierarchy apart by middle mouse dragging them out from underneath each other in the outliner, or the Hypergraph:Hierarchy window, the bone connections will go away and you would be left with the ball portion of the joint. You can manually parent them back together by middle mouse dragging them on top of each other in the outliner, or Hypergraph:Hierarchy window (refer to Figure 5.1). Remember that the top joint is the parent and rotates everyone underneath. This is important when making a skeleton for a rig.

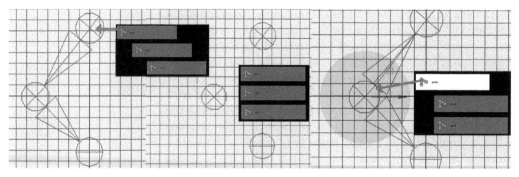

Figure 5.1 Creating joints, parenting, and unparenting them.

Note: You can adjust the visible size of the skeleton by going to **Display>Animation>Joint Size**. It is just a viewing attribute and does not make a difference to the behavior of the joint.

If you were to make the skeleton backwards, meaning that you create a spine from the neck down to the tailbone, the main rotate for the spine would be at the neck. This would work if you were rigging a rubber chicken, which has to be held by its neck, or some other doomed rig that must be hung from its neck. But, for normal living beings, the body's spine rotation starts at the base of the spine. To fix this type of issue, you would select the base of the spine, the tailbone, and select **Skeleton>Reroot Skeleton**. (That sounds like a gardening term to me.)

Warning: Joints should only be rotated, except for the root, which can be rotated and translated. We'll talk about the ill effects of moving a joint soon. (Yes, they can scale, but that's in the advanced portion.)

Now let's look at how joints rotate other joints. It is important to note that every joint (represented by a ball) rotates its children. If one joint has three children, it will rotate those children. If those children have no children, they are at the tips—they do not rotate anyone and generally do not do anything. (Very lonely, those "tippies" are.) A thing to keep in mind is to put in a joint where you need something to rotate. Don't scoff—it is a common mistake. I just looked at a nice-looking rig the other night from the Internetz; students turned it in as part of their rigging research homework. Great model, good rig, and it had a jaw skeleton which could not rotate. Surely a mistake, and one that they didn't have time to fix. It happens often, as a new rigger you put in the main joint for, say, the head and then add in the tip of where the jaw goes, and where the eyes go, etc. Then when you rotate the head joint, everything rotates along well. But, when you go to select what you think is the jaw, it really selects the head joint. You cannot rotate the jaw unless it has its own small round joint. If you are naming your joints as you go, it might help you realize what you are missing.

Joints Are Tricky Things

The first problem is making sure you have **enough joints** to rotate and haven't forgotten any joints, as we see in Figure 5.2 with the forgotten jaw joint. This problem can be fixed without too much redoing of rig creation during the rigging process.

The second problem is **where** do you place the joints in the geometry? You want to place them so that they bend well with the model's nice edgeloops.

If you have great edgeloops, but put the skeleton in the wrong spot, your rig can move poorly. To see this concept in action, have a class of 20 individuals rig the same character—it is most

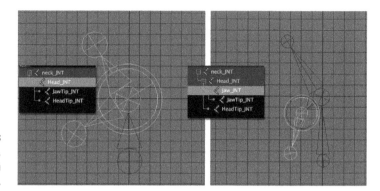

Figure 5.2 Parent joints rotate the children. Remember to put in enough joints for proper rotation.

illuminating. Sometimes, art directors or character designers will sit down and work out anatomical diagrams for the rigger to know exactly where the bone placement is. In advanced rigs, one would strive (or at least I would) to make things not symmetrical and not straight. Since we as humans have flaws, we are not machined 100% perfect. However, for our first characters, we'll stay with **symmetrical** and perfectly lined up feet and knees under hips. It is slightly easier to rig a straight character.

The third problem to be aware of with joints is the one that is most problematic for beginners. It also quickly becomes the most difficult to fix without having to redo control connections. The number one thing that could mess up how your skeleton rotates is **joint orientations**. Let's take a look at this problem/ challenge.

Let's look at making a skeleton again. When you make the first click of the skeleton, it draws a joint: **joint1**. When you click for the second time, if you drag the mouse around a little until you find the right spot for your second joint, watch what happens to joint1 when you let go of the mouse button to draw **joint2**. Joint1 rotates to line up with joint2. Try it again: click and drag around **joint3**, let go, and watch **joint2** rotate to line up. Why? What it's doing is rotating the X-axis to follow down that bone.

If you rotate the bone in **X**, it should rotate as if it were a screw, that is, around itself. OK. If you move the joint, it will mess up that X-axis. I know, I told you not to move joints. But for now, go ahead, in the name of learning.

Note: You can hold down **d** and move the joint itself and none of its children will follow.

If you try to rotate the bone, you will see that the rotation in X is not lined up at all. When you are first creating the skeleton, unless you draw joints perfectly in the right spot, you'll need to move them to adjust them. Most of the time, you will mess up the rotational axis of the skeletons as you create them. You won't translate joints when you are animating them, only in the creation process. So, we'll need to learn how to fix those joint rotational axes, also referred to as joint

Figure 5.3 Watch your joint orientations when you draw the joints. The bone gets out of alignment when you move the joints. (There's a chiropractor joke in there somewhere.)

orients, or local rotation axis in various books and throughout the Maya menu.

Note: Make sure you are rotating in object axis mode. Double click on the rotation tool and make sure you are in object mode and not in world axis mode, since we are fixing the object's local rotational axis (refer to Figure 5.3).

Orient Joints

There is an order to fixing the rotational axis. The order depends on how the joint is going to animate. For our beginning rigs, we'll stick to the following: **X down the bone, Zs to the same side, and Ys out the bend**.

Let's create a spine type of skeleton together. In the side window, create a spine by clicking at the bottom and then creating four or five more bones up through the spine to where a neck would be. In other words, draw a line of bones from bottom to top. Let's look at how to make that "spine" rotate correctly. The first axis to fix is the axis that points down the bone. In our case, it is the X-axis. Xs are fairly easy. Maya will do it for you. The others, you'll have to do yourself.

1. Select the root joint (the topmost joint in the spine's hierarchy) and select **Skeleton>Orient Joint** (the default settings). The X-axis for each joint will snap down the bone.

What could go wrong? If you get an error stating "nonzero attributes," it is probably because you have rotation numbers on the joint itself; you rotated the bone at some point while you were drawing it. To get rid of those rotation numbers, freeze transformations on the joint: Modify>Freeze Transformations. You want to see all 0s in rotations and 1s in scale. The translate attributes will always have numbers in them; joints need to know where they exist in the universe to work. After you freeze transformations, you will be able to use the orient joint tool.

Notes: I've had comments come in from other riggers that in older versions of Maya you could not freeze transformations of joints or "bad things would happen." I believe it. Remember

Figure 5.4 Spine does not rotate in a FK (forward kinematics) method well. The Z-axis are not aligned. Orient axis fixes any X issues. We use snapped rotation to fix the Z and Y alignment.

what we learned about freezing, where it was not really getting rid of the numbers, but just hiding them? The best way to avoid this is to not rotate the joints when adjusting them, and keep those rotation values clean and at 0 without having to resort to freezing.

The next axis to adjust is the axis where most of the rotation will happen. In this joint system, it will be the Z-axis. Imagine a spine that is rotated in FK, forward kinematics. This means you select all of the joints in the spine and rotate them at the same time. It makes the spine curl over nicely. Other joint systems which work like that would be ears, tails, fingers, toes, etc. If your Z-axis are not all lined up in the same direction, then the nice bend will not happen (refer to Figure 5.4). Some joints will rotate oppositely because negative 5 rotates one joint forward while in the other joint, with a flipped Z, it rotates backwards.

Note: When selecting FK joints, start from the last joint (but not the tippy, tippy joint), then hold down shift and select the other joints. For this class, all of our Xs go down the bone, and all of our Zs in each FK area should go to the same side, which will give a nice bend: legs, spine, ears, tails, fingers, etc.

Here is the easiest way to rotate the Z- and Y-axis, which does not involve MEL commands. (MEL is the Maya Embedded Language scripting language in Maya.) When you are beginning, it is not the right time to whip out some MEL scripting just because we can: too much typing. Try it in a class of 20 (I did), you'll stall the class for something that can be done much quicker. You'll learn some MEL later. We'll need to manually rotate the rotational axis so that all of the Zs point the same direction. Where can you see and select the joint axis?

1. Select the **root** joint.
2. Go to **Component** mode (F8 or click on the Component mode button at the top of the Maya window).
3. Click on the **question mark** button. (Really. It stands for miscellaneous components.)

If you right click and hold on the question mark button, you'd see that it turns on local rotation axis and image planes. Now the joint orients are selectable. Hold on, wait a sec. I need to tell you something. Usually, you do not want to manually rotate those joint orients; at least, not in the beginning. Instead, you want to rotate them perfectly 90 degrees or so. Here is where we will not whip out MEL, sorry.

4. Double click on the **rotation** icon to see the tool settings.
5. Momentarily turn **Step Snap** to **Relative** and set the value to **45**.
6. Select the joint rotational axis and rotate it around the **X**-axis so that all of the **Z**s point in the same direction. The rotate will snap in 45-degree chunks.
7. Make sure to turn **Step Snap off** when you are done; it can be very annoying when you are animating.

The last thing to look at is Y. To keep things clean, I like to keep the Y-axis pointing out the bend. You can see this same concept in other rigging books, too. For example, a knee would have the Y pointing out the front, or a spine would have the Ys pointing out the back. This is to keep any side-to-side forward kinematic motion all going in the same direction.

You'll find that every animation house has a different way in which they like their axis. There is an advanced topic about how to rig to avoid gimbal lock, which you might have seen mentioned in *How to Cheat in Maya*, where you would adjust the joint orients based on what type of movement it will do. (This is the best way, and we'll get to it later.) There are also rigs for game engines, where the game engines don't care about anything but one set of axis so it can calculate the bone movement faster. The ones I have seen were Y up the bone, and that character had to be facing positive Z. But, back to our basics.

A thing to remember about joints is that they have translate information in them. Therefore, they cannot be zeroed out and moved back to a default position. If they get nudged accidentally (you might even do it yourself as a newbie rigger), there is no way to get it back to the default pose.

This can break a rig, as you are aware now, and can mess up your joint rotational axis. If an animator accidentally picks the joint and moves it, there is no way to zero it back out. This can cause a lot of heartache for an animator and lost time. So, as shown in Figure 5.5, don't let animators touch your joints. (What was funny in that? The students always snicker and I don't understand; sad animators who mess up rigs.) Before you let your rig out to prime time and let animators play with it, you want to hide those joints. You cannot lock joint attributes. That can cause issues later on when we add in IK (inverse kinematic) handles. Remember to hide the joints before release.

Note: If you select a joint and look in the attribute editor, you can adjust the joint draw style and adjust the radius to the

Figure 5.5 Don't let the animator touch the joints. (Illustration by Brenda Weede, with permission.)

individual size. You can CNTRL click and drag in the field for a virtual slider.

Character with a Skeleton: Googly-Eyed Puppet

Open **chpt5_BlueMonster_start.ma** to find the low-res geometry of a googly-eyed puppet with hands that are ultimately driven by sticks. You've seen characters like this before, hopefully. We'll start by creating a spine, which starts at the base of the puppet and goes through to the top of the head.

1. In the Side view, using the **Skeleton>Create Joints**, click once at the bottom of the puppet to start the root joint.
2. Click **three** more times to draw the spine going up the body.
3. Click at the base of the **neck** and at the **top** of the **head**.
4. Hit **Enter**.
5. Label these joints: Spine1, Spine2, Spine3, Neck, and HeadTip.

Next, we will add in a joint to open and close the bottom jaw (refer to Figure 5.6).

1. In the Side view, using the **Skeleton>Create Joints**, click on the existing **Neck** joint.
2. Click near the **neck** joint to form the jaw's hinge.
3. Click at the **tip** of the jaw.
4. Hit **Enter**.
5. Label this joint: Jaw and JawTip.

Next, we'll add in the left arm. Watch what windows we draw these in.

Figure 5.6 Drawing the spine, head, and jaw joints in the side window.

6. In the **Side** view using the **Skeleton>Create Joints**, click on the **Neck** joint. This will connect our arms to the neck.

7. In the **Top** window, click for the shoulder, elbow, wrist, and palm.

 Hit **Enter** on the keyboard.

8. Label the joints: L_Shoulder, L_Elbow, L_Wrist, L_Palm.

 Are the joints in the right place?

 Take a look around and see that your joint placement looks like it might animate well. Are the joints lining up with an edgeloop? Are they mostly in the character where a real skeleton might be? Move them as needed to place them in the correct place. Then, just to be sure, select Spine1 and **Freeze Transformation** on the joint system.

 In looking at the arm being a child of the neck joint, it doesn't feel correct. A sock puppet can probably rotate its head forward without moving its shoulders (refer to Figure 5.7). To fix this (it's easy):

1. In the outliner, middle mouse drag the **L_Shoulder** to be a child of the **Spine3** joint.

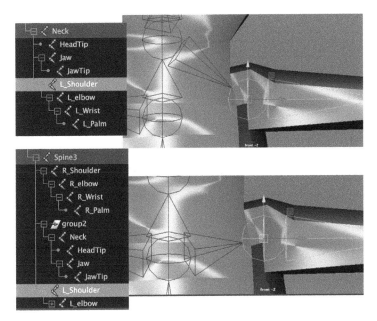

Figure 5.7 Changing the connection point of the left arm to be a child of Spine3.

Now the arm's connection bone is redrawn, and we can rotate the head forward without adjusting the arms. It is easy to reparent joints to have them behave differently.

Check Your Joint Rotational Axis

What was the first axis we fixed: the one pointing down the bone? Correct: the Xs. Are they all pointing down the bone? Let's fix them (refer to Figure 5.8).

1. Select the **Spine1** and in object mode (when the skeleton is green) select **Joint>Orient Joint**. Use the default settings.

 The spine moves all together in a forward kinematic motion, so all of the Zs should at least be in the same direction. Do you have any wayward Zs not facing the same direction as anyone else?

 Rebel Zs.

2. Select the **Spine1** joint and go to component mode (**F8**). Click on the **question** mark to see the joint rotational axis.

3. Change the **rotation** tool to snap rotate in **45**-degree chunks by double clicking on the rotation tool and turning on step snap. Set value to 45.

4. Select any rebel **Z**-axis and rotate them until they match other Zs in the spine.

5. Make sure the **Y**-axis all face out the back of the spine.

 Test: In object mode (green skeleton), select each spine joint and rotate all of them in Z. The spine should curve nicely forward and back.

Next, what about the arm's rotational axis?

1. Select the **L_Shoulder** and go to component mode to see the rotational axis.

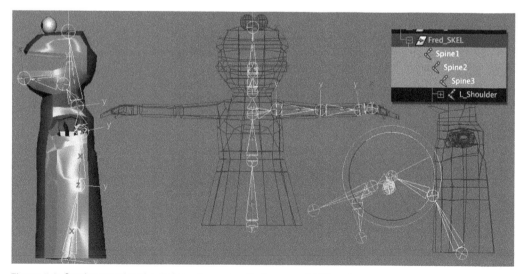

Figure 5.8 Setting rotational axis for spine correctly for a good FK bend.

2. Are all of the Xs down the bone? If not, go back to object mode and do **Skeleton>Orient Joint**. (Remember the tippy joints axis don't matter.)

3. Are all of the Zs pointing the same direction? If not, go to component mode and snap rotate them to be in the same direction.

4. Are all of the Ys pointing in the same direction? In this case, for the arm we'll allow them to point straight up. It won't much affect how we rotate the arm since it will be driven by an IK (Inverse Kinematic) handle.

Creating the Right Arm the Easy Way

Once you have completed one arm (note that we did not do fingers, if you were to do fingers, complete those before moving on), we can ask Maya to duplicate the joints for us by:

1. Select **L_Shoulder** (make sure you are in object mode, the skeleton should be green).

2. Select **Skeleton>Mirror Joints**.

3. In the window, select Mirror function: **YZ**. This is the bisecting plane up the center of the character.

4. In Search type **L** and in Replace type **R**. This will create a duplicate arm on the other side of the character and label it **R_Shoulder**.

5. Click **OK**.

6. The new right shoulder needs to be moved slightly in X to match up with the geometry since the geometry is not perfectly symmetrical.

Simple Inverse Kinematic Arm

This character's arms are puppet arms, which are moved as if driven by a stick attached at the wrist. Unlike your arms, which are driven from the shoulder, this character's arms are driven from the wrist. That is exactly when and why IK (Inverse Kinematic) arms should be used. Mostly, human arms are animated in FK (Forward Kinematics), since they are driven by the shoulder. IK is usually used when the wrist is driving, or when the hand is going to contact something. Feet, for example, and legs are almost always IK since they contact the ground. When you get into climbing or gymnastic characters, the legs need FK and IK. For now—a simple IK arm.

1. Right mouse click on the **L_Shoulder**.

2. In the popup menu select: **Set Preferred Angle**. Repeat for the **R_Shoulder**. This makes sure that the arm knows which way it is going to bend. In versions before Maya 2011, I didn't find this absolutely necessary. In 2011 and beyond,

it avoids arms popping around when we add an IK handle. (I'm leaving that old note in there, because it is precious.)

Note: Do not draw your joints perfectly straight. You will want to draw the joints so there is a bend in the direction you desire them to bend. Else, Maya may choose the wrong way to bend when an IK handle is added.

3. Choose the tool **Skeleton>Create IK Handle**; select the option box.

There are two visible choices for IK handles: **Single-Chain Solver**. Single chain is very fast, and is a hinge joint. Good for fingers, ears, tails, etc. **Rotate-Plane Solver**. Rotate-Plane is a ball and socket joint, good for shoulders and hips. For our simple character, we are going to use single chain. We'll cover rotate-plane when we get to the biped.

4. Select **Single-Chain** in the option box.

5. Click on the **L_Shoulder** joint and then the **L_Wrist** joint of the character. Some prefer to do this in the outliner. Or you can click directly in the viewport. Make sure you are clicking on the joints. A line is drawn and there is an ikHandle1 placed at the wrist.

6. Rename the ikHandle1 to **L_Hand_IK**.

You can select it and translate it. The elbow bends based on how the skeleton was slightly bent and the set preferred angle was done. When you rotate the IK handle, the elbow rotates along with the wrist. This is very simple, and works for the concept of a puppet arm attached to a stick. IK handles allow animators to use translate values to animate. The animator moves the IK handle (or a control which moves the IK handle) and that, in turn, rotates the joints and figures out where the elbow should go. (In my day, I remember when this was invented and we didn't have it yet ... we dreamed of IK handles. Now you have it for free, and some animators have developed a bad habit—IK handled arms can make for some bad arcs in animation. But our character has sticks leading his wrists, so it works.)

Make sure you undo just enough so that your IK handle goes back to the original position, or, since undoing can be dangerous: right mouse click on the joint and choose **Assume Preferred Angle**. This should put the arm back to the default position. You may have noticed the IK handle has numbers in it. Ah, something that you will want to hide from the animator, and instead, give him a zeroed out controller. Good idea (refer to Figure 5.9).

1. Create a **controller** and place it at the wrist. (**Freeze; delete history**.)

2. Center the controller's **pivot point** on the **wrist** joint. (Hold down "v" to snap to the joint.)

3. Label the controller **L_Hand_CNTRL**.

This controller is going to move and rotate the IK handle. However, if we directly connect it to the IK handle, in older

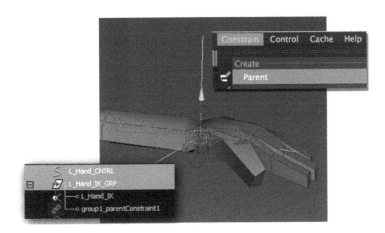

Figure 5.9 Creating an IK handle and controller to move and rotate the arm.

versions of Maya, we get a slight issue with the IK handle not refreshing when we zero out the controller. Let's create a group node as a buffer over the IK handle. (We'll look at what would happen if you didn't do it in just a few sentences.)

4. Select the **L_Hand_IK** and create a group by hitting **CNTRL g**. Name that group L_Hand_IK_GRP.
5. Snap move the center of the **L_Hand_IK_GRP** to the wrist by holding down **d** and **v**.
6. Select the **L_Hand_CNTRL** and the **L_Hand_IK_GRP**. (Make sure you select in the right order: Driver/Driven).
7. Create a **Constrain>Parent constraint**.

Test: Select only the **L_Hand_CNTRL**; move and rotate the controller. Does the arm move and rotate? Repeat for the right arm. Don't forget the group node over the IK handle. I'll wait. What would happen if you didn't have the group node? I saw the same issue in a Digital Tutor rig: when you moved the controller back to zero—the IK handle wouldn't snap back until you jiggled the controller: slightly annoying. On a lark, I threw in a group node to see what would happen. Aha! Fixed it. In newer versions of Maya, this seems to not be the case. I'll keep the fix here just in case. Use or don't use. Up to you.

Waist Control

To create a control that moves the skeleton of the character up and down is simple:

1. Create a control: FDH (freeze, delete history); label it **Hip_CNTRL**.
2. Place the controller at the bottom of the character.
3. Make sure the **pivot** is on the **Spine1** joint.
4. Select the **Hip_CNTRL** and the **Spine1** joint (in that order!).
5. Create a **Parent Constraint**.

Test: The **Hip_CNTRL** should move and rotate the character's spine. The arms will stay behind with their IK handles. This is expected. IK arms do not move with the body unless we use another controller, which we'll create next.

Main Move for the Character

We'll create a controller that moves the whole character, including the IK arms (refer to Figure 5.10).

1. Create a controller, FDH. Label it **Main_CNTRL**. This controller should be bigger than the **Hip_CNTRL**.
2. Place the controller at the bottom of the character.
3. Make sure the pivot is on the **Spine1** joint.
4. Make the **Hip_CNTRL**, **L_Hand_CNTRL**, and **R_Hand_ CNTRL** children of this **Main_CNTRL**. It drives them (and the character) mostly via hierarchy.

Test: When moving this controller around, the whole skeleton and existing handles should move and rotate as well.

That didn't seem so difficult at all did it? We have two arms driven by IK handles with controllers attached, a bottom spine joint driven by a controller and a main control for the whole character. Since this is a puppet with an invisible hand inside of it driving it, we will not put in spine controls. Hold your hand up—if you have a sock puppet on your hand, can you "bend its spine"? Oh, I suppose not since your arm won't bend like that. We have those joints in there just in case an animator needed that functionality. Instead, let's go ahead and skin the character to the bones—which sounds like it would be the opposite of what it does. When you skin a character, the geometry gets "bound" to the joints and each vertex is assigned an amount of how much it listens to (or is influenced by) the nearby joints.

Interactive Skinning

We'll get the basics of skinning into your heads now. In keeping with the teaching method of this book, we'll learn

Figure 5.10 Hip_CNTRL and Main_CNTRL.

enough to get started, get an "aha" moment, have a little fun, then come back again later to learn more.

1. Select the root joint of the skeleton, which is Spine1. (Remember the term root means that it is the parent joint.)

2. Shift select the monster_GEO. (Do NOT select the eyes, and make sure you have the geometry and not the group node selected.)

3. **Skin>Interactive Bind Skin**.

 This tells the geometry to rotate with the skeletons. The issue then is, how does it know what looks good? Ahh—it doesn't. We have to tell it by "adjusting the weights," or adjusting how much the vertices move with which joints. At the moment, you are in the tool that allows you to adjust the weights, but it is difficult to see what you are doing unless the character is in a pose (refer to Figure 5.11).

4. Select the rotate tool and bend your character forward by rotating the spine joints.

5. Select the **Spine1** joint.

6. Select the **Skin>Interactive Skin Bind Tool**.

 A colorful interactive tool is displayed. By pulling on the various axes, it visually shows what vertices will move with the Spine1 joint. It took me a second to figure out at first, but if you click and drag on the red circles which scales the whole "tube," the interactive tool can be rotated as well. Orange is the area of most influence and blue is the area of least

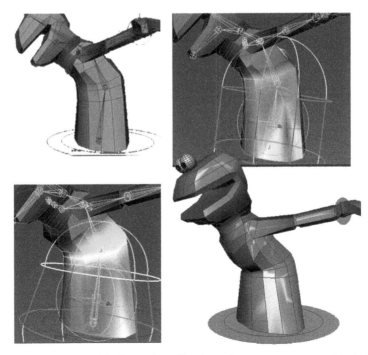

Figure 5.11 Using the interactive skinning tool to adjust how the geometry moves with the joints.

influence. To have no influence, there should be no color on the area.

7. Click on each of the joints to see what their assignment looks like, and adjust to get a good blend between the assignments of each joint. As you adjust the tool, you can see the skin adjust based on its influences. Watch out—the JointTip has influence over the top of the head. If you forget to adjust it, the top lip will move with the jaw.

Them Eyes

Why didn't we skin the eyes? The eyes don't deform with the joint system; they only move and rotate with it. Let's deal with them now. We want the eyeballs to do one main thing: move and rotate with the head and body of the sock puppet. Puppet's eyeballs are fixed so they do not look around at things. In later characters, we'll learn how to do that as well.

There are many ways to accomplish having the eyeballs move and rotate with the head. As you have guessed, I'm fond of group nodes—so that is what we will use. We want to constrain the eyeballs to the skeleton, but I want to leave the eyeball geometry alone and not have it directly constrained. So instead:

1. Make sure all controllers are **zeroed** out and the skeleton is back at the preferred angle.
2. Select both **eyeballs** and create a **group**.
3. Name the group **Eyes_GRP**.
4. Snap move the pivot point to the **Neck** joint. (Remember d + v snap moves a pivot to a point or joint.)
5. Select the **Neck** joint and shift select the **Eyes _GRP**.
6. Create a **Constrain>Parent** (default settings).

Test: Now the eyes move and rotate with the rig.

Cleaning Up

Let's clean up the outliner and make it tidy. Create the following groups: **Fred_CNTRLS**, **Fred_SKEL**. Change the name of **Monster_GEO** group node to **Fred_GEO**. Place the controllers under the **Fred_CNTRLS** group and the skeleton under **Fred_SKEL** group. You'll note the geometry is already in the correct place and all groups are under the character group titled **Fred_GEO**. Place the groups with the IK handles under the **Fred_SKEL** group node.

Take a moment to lock all attributes that the animator will not animate: scale attributes on the L_Hand_CNTRL, R_Hand_CNTRL, and Hip_CNTRL. Hide those skeletons and IK handles; we don't want the animators getting a hold of them. The easiest way is to turn the visibility off for the Fred_SKEL group node.

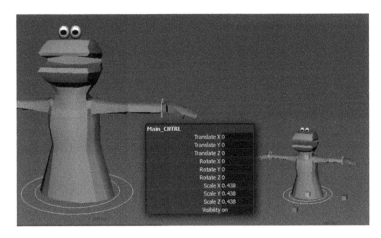

Figure 5.12 Scaleable Fred sock puppet.

Scale

For our method of rigging, making a scalable rig is fairly easy.

1. Select the **Main_CNTRL** and scale it to test what works. Oh, the controls scale, but the character doesn't quite scale correctly. We can fix that.
2. Select the **Main_CNTRL** and then shift select **the Fred_ SKEL** group.
3. **Constrain>Scale Constraint**.

Test. Scale the Main_CNTRL and see that everything scales, except for the eyes.

4. Select the **Main_CNTRL** and then shift select the **Eyes_GRP**.
5. **Constrain>Scale**.

Test. Excellent; everything should scale.

The eyes didn't scale because they were not a part of the skinned geometry. When you created a scale constraint to the group node over the skeleton, this constraint scaled the skinned geometry only (refer to Figure 5.12). Why did we put the scale constraint to the group node over the skeleton instead of directly to the root joint? Go ahead, try it. (Save first.) It doesn't work. Scale is not passed down or inherited from joint to joint, so we had to do a global scale on all of the joints by using a group node. You are ready to test out your sock puppet. Happy animating.

Jaw Controller

Add a controller which opens and closes the jaw joint.

1. Place a controller near the jaw. **FDH**. Label it **Jaw_CNTRL**.
2. The pivot point should be at the **Jaw** joint.
3. Select the **Jaw_CNTRL** and the **Jaw** joint.
4. Create a **Constrain>Orient** (with maintain offset **ON**).
5. That controller would be a child of the **Hip_CNTRL**.
6. Lock the translate and scale attributes on the **Jaw_CNTRL**.

Figure 5.13 Jaw_CNTRL added. Skinning is working OK.

You'll need to adjust the interactive skinning on the head joint to get the mouth to open and close correctly. Don't sweat the skinning too much right now. We'll learn another way to get better control of the skinning in Chapter 8.

Head Controller

There is one last control to add so the character can rotate its head around (refer to Figure 5.13).

1. Create a **Head_CNTRL**. Place it near the neck. **FDH**. Place the pivot point at the Neck joint.
2. Select the **Head_CNTRL** and the Neck joint, create an Orient Constraint (with maintain offset on).
3. Make the **Head_CNTRL** a parent of the **Jaw_CNTRL** (and a child of the Hip_CNTRL).
4. **Lock** the **translate** and **scale** attributes.

There you have a simple sock puppet rig. The completed rig can be found in the chapter material: **chpt5_BlueMonster_ complete.ma**.

Well, don't you feel more dangerous now? Are you scratching your head at anything? OK, stop and turn around. Redo this chapter until you can get a better feel as to why the group nodes are being created, what the constraints are doing, and how the hierarchy is working. When you are ready, we'll be waiting for you in the next chapter.

BLENDSHAPES AND
SET DRIVEN KEY

This is our last little rig together before we launch into the biped. Are you excited? My, how far you have come. Instead of repeating the rules, I'll list some handy notes I had lying around:

Note: When adding constraints to joints or IK handles: maintain offset must be on.

Note: Once you place your controller and add a constraint, you cannot adjust the pivot point of the controller unless you want your rig to suffer a horrible crippling disease only cured by swear words and the undo button.

Note: IK handles can be frozen (you have to temporarily turn Sticky OFF in the attribute editor), but I'm always afraid the universe will rip apart. I've never seen it break something, but I might be causing small black holes somewhere.

Note: If you use the duplicate tool to duplicate a controller, like a foot or hand controller, a trick is to move the pivot point to the origin. Click **Edit>Duplicate Special**. Scale in −1 in X. This will flip it. Freeze and modify>center pivot for both controllers. Watch out if you duplicate constraints, they will show up in the outliner but do not work. Do not copy and paste—that's nasty.

Note: Also, you can put multiple items in a group and scale the group in −1. You can move the group's pivot point without any issues for the items in the group and define your own mirror axis. Delete the group afterward. Tip by Kori Amacker.

OK, we're ready for our last topics. With these, you will have gained the keys to the kingdom because with these, you can do anything. Our two topics are blendshapes and set driven key.

We'll start with blendshapes. Blendshapes are very useful, especially for facial animation. Raising eyebrows, closing eyelids, smiles, phonemes, and lip sync types of things. You can use blendshapes as corrective blendshapes; for example, when an arm is bent and you want the bicep to bulge, a vein

DOI: 10.1201/9781003431121-8

to pop out, or you open the mouth and make double chins. In this chapter, we will look at the basics of blendshapes to get you started.

This is a full-time job for a modeler and a rigger team, and can take up lots of time to get it right. If you don't have the blendshapes your character needs, then your character cannot act except with body language. I would suggest reading Jason Osipa's *Stop Staring: Facial Modeling and Animation Done Right* (see the Epilogue) to get the fuller picture once you are comfortable with these basics. Though, I don't know how well the expressions he uses to mix the blendshapes will hold up in the parallel mode of Maya 2018+.

A lot of time is generally spent between the animator, character designer, modeler, and rigger to get the blendshapes just right. Blendshapes themselves can be sculpted in ZBrush, for example. Though I love ZBrush, for this book, we'll stay in Maya for the basics. Maya 2016 added a blendshape editor and the sculpting functionality is based upon Mudbox, so there are tools handy inside of Maya for our blendshape sculpting. You'll also note that the blendshape tools have changed drastically in recent versions of Maya. The older pipelines are still valid. Newer versions have streamlined the process.

Open **Chpt6-Octopus_Blendshape_Start.ma**. This file has one character in the center of the screen labeled Octopus_GEO. He is frozen and has the history deleted. This is the main character. We want to make three blendshapes: Happy, Sad, and Angry. We will create duplicates of the main character and sculpt the faces to be Happy, Sad, and Angry. Then we'll set up sliders so that we can turn these blendshapes on or off:

1. First hide the skeletons or make sure that they are unselectable by turning on the selection mask for joints. Else, they will get in your way.
2. Select Octopus_GEO and open the **Windows>Animation Editor>Shape Editor**. This is a newer editor.
3. Click on **Create Blend Shape**. This creates a blendshape deformer node that the target shapes will pipe into once we create them. If you have the node editor open, you can see them being added.

We will create the target shapes (sometimes referred to as blendshapes). Technically, they are target shapes via the vernacular of Maya's interface.

1. Click on **Add Target** in the **Shape Editor** window. You'll note the edit button is red, meaning what you are about to do next is to the blendshape target and not the base geometry. Super important! If the edit button is not on (red), then you'll mess up your geometry. OH NO!
2. Using the **sculpt tool**, make a happyish shape (see Figure 6.1).
3. In the **Shape Editor**, pull the influence slider back to **0** and turn off the edit by clicking on the red button.

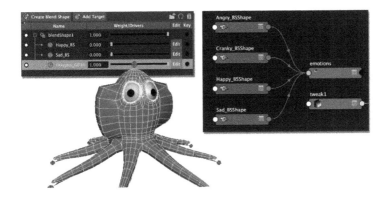

Figure 6.1 Creating a blendshape. Octopus modeled by Brenda Hathaway (with permission).

4. Rename the target shape to **Happy_BS** by right mouse clicking on the name and selecting rename.

5. Repeat steps 1–3 and create a **Sad** and **Angry** shape.

To adjust the blendshapes, you want to make sure you are in edit mode by clicking on the edit button so that it turns red. You'll also want to turn the influence slider to 1 to see the whole blendshape. Adjust the target shapes at a component level. Meaning, move the vertices, use the sculpt geometry tool, the soft deformer tool, or any type of deformer to create the sculpt that you need. Scaling the overall geometry will not make any effect—that is, adjusting the transform node. You want to adjust the components themselves. If you use the soft modification tool, it might have the history turned off. If the history is turned it on, it will leave behind an "S" handle, which you could adjust.

Another thing to remember is you should not create your blendshapes until you have finished modeling the main character. We'll talk about what to do if you need to fix some geometry in a second.

Gotcha: One last thing, during testing, skinned characters began to develop odd twisting geometry and bulges where no bulges had been sculpted (Maya 2018). I fixed it by unskinning the character and then adding the blendshapes. I reskinned the characters afterward and no errors occurred. Adding blendshapes before skinning helps eliminate issues like this. We'll look at the advanced option again later in this book and talk about deformation order and parallel processing to make rigs fast.

These virtual sliders adjust from 0 to 1 to turn the blendshapes on and off. You can click the edit button on any one blendshape and continue to edit it.

Just as a side note, you can also type in numbers bigger than 1 and the blendshape will continue to adjust the vertices based on the original way that they were being moved. This can be a good thing to give the animator, when you put a controller onto these attributes. Perhaps they might want to push the blendshape just a little bit further than what was created.

If you need to adjust the geometry, even after you have made the blendshapes and connected them, you can. For example, if you add in a nose by extruding a face, then select the main character and go to **Edit>Delete by Type>Non-Deformer History**, which will delete the extrude node and then flow the extrudes down into the blendshape targets automatically in newer versions of Maya (2011+). In older versions of Maya, you need to select the main character and click Animate>Edit Blendshape>Bake Topology to Targets.

In older versions of Maya, we made multiple copies of the model and then connected them back as blendshapes, as you may have seen in version one of this book. This newer method allows you to sculpt them directly in place, eliminating many potential issues and shortening this chapter!

There are many features in blendshape you can discover on your own. One to point out is that if you select the blendshape targets for Happy and Angry and then, in the Shape Editor window, click on **Create>Add Combination Target**, this creates a new slider that combines both Happy and Angry target. In addition, you can edit this new combination target, which allows you to create a corrective blendshape over top of the two shapes. It is basically multiplying the shapes together and has more options if you check out the options box upon creation. Very useful. For now, we'll stick with the basics.

To finish up, go ahead and skin your character by selecting the skeleton's **joint1** and the geometry and then clicking on **Skin>BindSkin**. We'll take the default settings.

Hooking a Controller up to a Blendshape

There are a few ways you may have seen this when doing rig reviews:

1. Having one controller with lots of custom attributes to control the blendshapes.
2. Having a single slider-looking control that goes up and down to control one.
3. Having a single slider-looking control that goes up and down to control two blendshapes.
4. Having a square-looking slider to control four blendshapes that blend together nicely like Open & Closed, Wide & Narrow (Osipa style).
5. Having a controller that moves along the surface of the face, which when moved turns on the blendshape; for example, a Left Smile.
6. Having a CNTRL shaped like a wire representation of the object (such as a mouth). This is a more advanced option; the shape of the wire is animatable and drives the blendshape(s) (also found in Jason Osipa's *Stop Staring* book).

The list could probably go on, you get the idea. We'll learn how to do style #1: a single controller that has lots of custom attributes. This is the easiest, it has the least onscreen controllers. You'll have to ask your animators if they like that or not.

1. Create a Circle controller (NURBS), **FDH**; rename **Face_CNTRL**.
2. In the channel box, click on **Edit>Add Attribute**.
3. Enter the following: Long Name: **Happy**, DataType: Integer, Min: 0, Max: 1, Default: 0, click **Add**. (Clicking Add will keep the window open.)
4. Repeat for Sad, Angry, and **Cranky**. Click **Close** when completely done to close the Add Attribute window. These attributes now show up in the channel box when the Face_CNTRL is selected.
5. Select the Octopus_GEO, open the **Node Editor**, click on **add selected node to graph** if the node does not show up automatically. Select the **Octopus_GEOShape** node and click on **input and output connections**. This will display the emotions blendshape node and the target shapes which connect into it.
6. Select the emotions **blendshape** node and hit three on the keyboard to open the node and display the attributes. Click on the small **plus** sign next to the **emotion** blend node's **Weight**. This will display the target shape's influences. If you look in the attribute editor, you can see the attributes we want to connect to.
7. Next, select the **Face_CNTRL** and in the Node Editor, click on the **Add Selected Node to Graph** button. Hit **three** on the keyboard to display the attributes of the **Face_CNTRL** node.

Reposition the nodes so you can see both the emotions node and the face_CNTRL node. Now you are ready to connect them. Simply drag to connect.

1. Click the **right green** circle on the **Face_CNTRL** and drag to connect to the **left** side of the corresponding **green** circle on the blendshape influence attribute in the **emotions** blendshape node. This is quite a mouthful (refer to Figure 6.2); it's much easier that way.
2. Repeat for the rest of the blendshapes.

The attributes found under the face's blendshape node will turn yellow once they have an incoming connection. Test by adjusting the attributes on the Face_CNTRL; they should turn the blendshapes on and off. Splendid, but I don't like those types of attributes. Didn't I tell you? I prefer on-screen attributes when animating. Less distance for me to move, and I can use my left mouse button instead of my middle mouse button. OK, let's start again.

1. Delete the **Face_CNTRL** that you had with all of those attributes.
2. Create a **NURBS** circle as before, **FDH**; rename **Happy_CNTRL**.

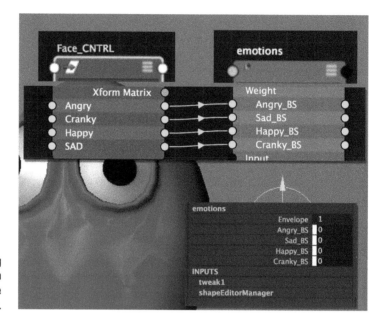

Figure 6.2 Connecting the Face_CNTRL custom attributes to the blendshape via the Node Editor.

3. **Lock** all attributes BUT **Translate Y**.

This time we will drive the blendshape with the up and down movement. It will be a one-to-one connection to drive one blendshape.

4. Using the Node Editor window, select and open up the nodes so that you can see the **emotions>Weight** attributes and the **Happy_CNTRL's Translate Y** attribute.

5. Connect the **Happy_CNTRL.TranslateY** to the **Emotions. Weight.Angry_BS** by dragging a connecting arrow.

How did you do? Did you get that? I'm not giving you step-by-step on how to move things around in the Node Editor window. You should have that by now. Keep practicing if you don't (refer to Figure 6.3).

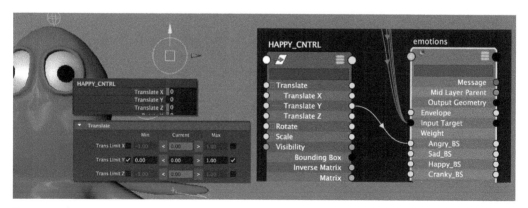

Figure 6.3 Creating limited controllers with a one-to-one connection to drive blendshapes.

6. Select the **Happy_CNTRL**, in the Attribute Editor located under the transform node, click the **Limit Information>Translate arrow**.

7. Turn on the limits in Trans limit **Y**.

8. Set the min to **0** and the max to **1**.

9. Repeat to have an on-screen control for each blendshape.

Test: Moving the Happy_CNTRL up and down should only move so far up and down and turn the blendshape on and off.

Note: If you had a left happy and a right happy that were both adjusting the center vertices, when you turn on both blendshapes, those center vertices will be told to move twice, once by each blendshape. The solution? Either make the blendshapes taper off at the crossover points (the center vertices) or you can create a combination target. (I told you those were useful.)

Blendshape Weights

This is a nice tool concept used in many places in the Maya interface. This usage allows you to paint how much vertices should obey the blendshape.

Select the main object and open the paint blendshape tool found under **Deform>Paint Weights>BlendShape**. Make sure to click on the small box to open the options window. There is a list of the blendshapes, and visible on screen is a visual representation of how much the vertices are listening to the blendshape. A completely white character means that all vertices have a value of 1:100% listening to the blendshape. A black character visually means 0, so the vertices are completely ignoring the blendshape. In-between are shades of gray: 0.5 = 50% listening.

Replace with 0 by painting in black. Paint out areas that the blendshape should not affect (refer to Figure 6.4). This is

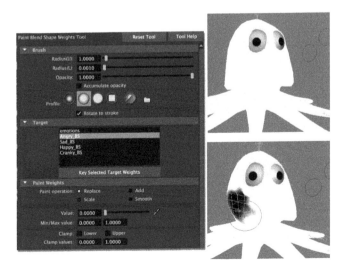

Figure 6.4 Painting blendshape weights.

great for when you have jiggly areas where a vertex has moved slightly during the sculpting process and you don't want it in your blendshape. As in the note mentioned earlier, you can also use this where you have many overlapping blendshape areas, which need to blend together nicely.

Things That Can Go Wrong

1. Do NOT delete history on the main character: it will delete the blendshape node and any deformer nodes. You CAN delete nondeformer history and it will not delete the blendshape node.

 In the newer method of creating blendshapes, there is no geometry for the blendshapes listed in the outliner. In some of the companion data Maya files, you may find blendshape geometry tucked away neatly in the outliner. The method of having separate blendshape geometry can still be used. We'll see it in other chapters. This newer method is cleaner and makes for a clean outliner. Take a look at Chpt6-Octopus_Blendshape_Completed_v3.ma. It has the controller with the virtual sliders, Chpt6-Octopus_Blendshape_Completed_v4.ma has an on-screen controller for each blendshape.

 Pipeline notes: As mentioned earlier, blendshapes should be done BEFORE you skin your character. The vertex movements need to be read in before the main skin movement occurs.

 Our final small character is a tentacle type of character. Please open chpt6_medusa_start.ma for the following lesson in blendshapes and the new topic: set driven key. The file has a medusa(ish) model that is frozen, has history deleted, and is modeled about the origin. There are joints already in place: a root joint with children head and eyes joints. There are also tentacle joint systems, which are not connected to the root joint.

Make Sure Your Orients Are Correct

1. Select all of the **joints** and **Freeze Transformations**, just to make sure there are no numbers in the rotations.
2. Select **each tentacle** and click on **Skeleton>Orient Joint** (with the default settings) to orient the X rotational axis. It is actually good practice to have the separate joint systems unparented when you orient the joints. **Orient Joint** will go throughout the whole hierarchy—which can sometimes orient something incorrectly based on its parent.[1]
3. Check to make sure Zs are all lined up in the tentacles. Discrete Rotate them if they are being wayward—which they probably are.
4. Check to make sure Ys are pointing up. (Tippys don't matter.) Do you remember how to check those? (refer to Figure 6.5).

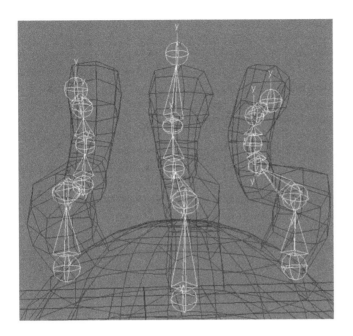

Figure 6.5 Proper joint rotational axis, Xs up the bone, Zs all the same way, and Ys pointing the same way out the back or major bend.

Parent the Joints Together

The Root is already a parent of the Head.

1. Make the Head_SKEL a parent of the snake01, snake02, and snake03.

Add the Blendshapes

In this case, I have already created the blendshapes for you and they exist in the outliner. You can use the newer method and the shape editor and create them yourself, or add the existing blendshapes using the following steps:

1. Select all the blendshapes in the outliner (found under the medusa_GEO>medusa_BS group node).
2. Shift select medusa_GEO.
3. Click on **Deform>Blendshape (option box)**. Name the blendshape node: faces.

If you open the Shape Editor, you have sliders for each one of the shapes. Since these shapes are actual separate geometry, in order to edit them you must unhide them in the outliner. This is a useful pipeline if someone else is modeling your blendshapes and you are importing them. Inversely, you could create them with the Shape Editor window and import and export separate files.

Bind the geometry:

1. Select Root_SKEL and body_GEO.
2. Skin>Bind>Interactive Bind Skin.
 a. Default Settings.
 b. Max Influences: **2** (this means how many joints can influence a vertex).

Once bound, you can adjust the amount of influence each joint has on the vertices with the colorful manipulator that appears. If you change tools for some reason, to get back to this tool, you can select the joint and select **Skin>Other>Interactive Smooth Bind Tool**. Drag on the green ends to lengthen the coverage; drag on the red circles for an overall scale; stretch coverage with the blue lines.

1. Start with the **Root**'s influence. Adjust the tube so that it only affects the **body** and part of the **neck**.
2. Adjust the **head** so that it affects the **head**, some neck, and no snake tentacles.
3. Now for the **tentacles**. The most difficult part will be the first two joints. The rest of the tentacle joints are probably OK, without needing much tweaking.
 a. Select the **snake01_SKEL**—rotate, scale, and adjust the tube's influence so that blue barely touches the head (see Figure 6.6). Rotate the joint in Z to see the effect of the skinning you have assigned.
 b. Continue through the other **joints** in the **tentacle** and adjust their influence.
 c. Remember that other tentacles (especially since they are close) might have influence, too. See Figure 6.6, where the middle tentacle's joint3 influence is HUGE and dominates over all of the other tentacles.
 d. Select the joints in each tentacle (individually) and rotate in Z to see how the skin moves. Adjust the influence tubes as needed to get better movement.

Yes, this part takes a little time and finesse. Remember that multiple joints can affect a vertex. Because we set the joint limitation to **2**, the overlap should be minimized (refer to Figure 6.6). I find that some students love the interactive bind tool and others do not. We'll learn other methods in Chapter 8.

Test: The character should rotate properly. When a joint is rotated, a blendshape can still be turned on and off with no adverse effects.

What could go wrong? If you rotate the joints and the character bends, but when you turn on the blendshape, the character stands back up straight and pulls off its skeleton, then your deformation

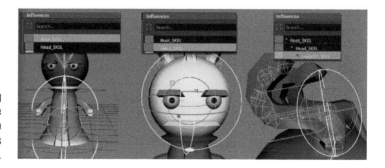

Figure 6.6 Adjusting interactive binding of the medusa character. Watch for multiple influences overlapping in close areas.

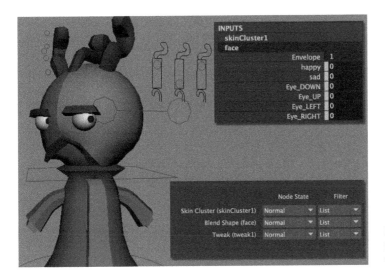

Figure 6.7 Adjusting the inputs so the blendshape works with the skinning.

orders are incorrect. Note that joint placement not near the edge loops causes for poor rotation of the skin areas such as tentacles. You might have put the blendshapes on after the skinning (or it's gremlins). To fix this, right mouse click on the geometry (not the skeleton ... good luck ... hide the skeleton or use the selection mask options if it keeps getting in the way) and select **Inputs>All Inputs**. In the window that pops up, middle mouse drag the blendshape node underneath the skinCluster node. Don't worry about the tweak node that Maya created; it needs that to put everything back together again (refer to Figure 6.7). You should see your character instantly bend back over with the skeleton rotation and show its blendshape, too. Problem solved.

Adding Controllers

Main_CNTRL

1. Create a **controller**; place it at the base of the character; **FDH**; name it **Main_CNTRL**.

 This controller will move the root joint. That will move everyone.
2. Select the **Main_CNTRL** and shift select the root joint **Root_SKEL**.
3. Create **Constrain>Parent**.

 Test: Your character should move when you move the Main_CNTRL. (Make sure you only have the Main_CNTRL selected, not the control AND the joint.)

Cleaning Up the Outliner

Make sure all geometry is grouped under a group node named medusa_GEO. The skeleton needs to be grouped under a group

node labeled medusa_SKEL. The controller is grouped under a group node named medusa_CNTRL. The GEO, SKEL, and CNTRL groups are grouped under a final Character group. You can see the sample file is already well grouped for you. Those group nodes do almost nothing except keep things organized. We will use the medusa _SKEL node for our next step: making the rig scale. (This should all sort of feel familiar now, at least I hope so.)

Scale-Ability

1. Select the **main_CNTRL**, then shift select the **medusa_ SKEL** group node.
2. Add a Constrain>Scale constraint. This will scale everything that was skinned. Note the eyes: they are not skinned.
3. Select the main_CNTRL and the Eye_GRP.
4. Create a **Constrain>Scale** constraint.

If your outliner is not well organized, then it will be difficult to add in a scale constraint and easily capture everything which needs to be scaled.

> **Note:** Skinning and nonlinear deformers are not usually used together. Bend, Twist, etc., will rip the skin off the joint (ouch!). Joints are their own type of deformers. You can still use the other deformers: clusters, wire, lattice, etc., just not the nonlinear deformers.

> **Bonus:** Just to put a thought in your head: lattices can be skinned. You could have an object with a lattice around it and have the lattice skinned to the joints instead. This is a method for objects that are made up of lots of objects or patches (like NURBS).

> **Another method:** Another way to go about tentacles would be to have them modeled in a straightened out position and put the joints in that way, as we did with the octopus. I've seen both methods used: model/rig curled up and model/rig straight. This character was modeled curled up and rigged in that position.

Set Driven Key

Set driven key is a feature that is kind of like visual scripting for the animator.

Usually, students have a light bulb turn on and exclaim, "I can do ANYTHING with this" and they take off running. Others have a hard time getting it. Some can only use it for the applications I show them. Those that get it understand that with set driven key, you can make one control do many things, you can automate things, and you can simplify things for the animator without hardcore scripting. We are going to use set driven key to set up a controller that does more than one thing. Up to this point, we've used a "one-to-one" controller or "one-to-many" where it took the

output of an attribute on the controller, either a translate value or a custom slider attribute, and plugged it into one or multiple items. We learned we could hijack that number and pump it through a utility node to multiply it. But, what if you didn't care what the actual number was from the controller? What if there was no mathematical correlation between what the controllers did and what the thing it drives did? You simply want to have a relationship that states when the controller was at position A the thing driven would do "this," and when the controller was at position B the thing driven would do "that." We can do that with set driven key. It is a cause and effect relationship.

We'll continue with the medusa tentacle-ish character, created by Brenda Weede in one of my rigging classes, to illustrate set driven key usage. Use what you have created so far, or open **Chpt6_medusa_ v2.ma**. This character has six blendshapes all feeding into one blendshape node, meaning that all of the blendshapes were selected followed by the main geometry and a Deform>Blend Shape was applied. (We did that earlier in this chapter.)

Unhide the **blendshapes** (hidden under the medusa_GEO), and switch to the right side window to see the blendshapes lined up visually/logically. On stage left of the character, you see a Happy and Sad blendshape; to stage right of the character, you see four eyebrow blendshapes. The blendshapes are named appropriately and have been applied to the main character. If you select the body_GEO geometry, you can see in the channel box that the blendshapes have logical names, which we will now hook up to the controllers. We'll start with a controller driving the Happy and Sad blendshapes. The HappySad_CNTRL is a slider that is locked in all but translate Y and is limited to move only within a rectangle.

1. Open the (**Animation Area**)>**Key**>**Set Driven Key**>**Set...** window.
2. Select the **HappySad_CNTRL** and click on LoadDriver, then select the **TranslateY** attribute.
3. Select the **face** blendshape node and click on **LoadDriven**, then click on the Happy and Sad attributes. (Find the face blendshape node either in the Node Editor window or select the body_GEO and in the channels box click on the face node attribute found under the inputs section.)

Note that the driver can only be ONE attribute, but it can drive many things. To set the relationships, you will set keyframes that indicate "when the controller is in this position these blendshapes will look like this." Refer to Figure 6.8.

Setting the Neutral Position

1. Make sure the **HappySad_CNTRL** has a **Translate Y** of **0**.
2. Make sure that both **Happy** and **Sad** blendshapes values are 0.

Figure 6.8 Setting up the HappySad_CNTRL to drive the Happy and Sad blendshapes with set driven key.

3. Click on the **Key** button in the set driven key window.

This sets that relationship. Note that the set driven key keyframes do not show up in the timeline. They will show up in the graph editor and turn pink in the channel box attribute to note the incoming connection.

Setting the Happy Position

1. Move the **HappySad_CNTRL** up as far as it will go.
2. Turn on the **Happy** blendshape by setting the attribute to **1**.
3. Click on the **Key** button in the set driven key window.

Setting the Sad Position

1. Move the **HappySad_CNTRL** down as far as it will go.
2. Turn on the **Sad** blendshape by setting the attribute to **1**. The Happy blendshape was automatically turned to **0** when you moved the controller past the 0 point.
3. Click on the **Key** button in the set driven key window.

Test: Move the controller up and down and see the Happy and Sad blendshapes turn on and off.

Gotcha: Occasionally, no matter what you do, when you click on an object, it automatically brings in the shape node. This can happen if you have the geometry in a display layer and locked but also gremlins. Look in the set driven key window and under the Options window, make sure that Load Shape Node is not checked on.

Cleaning Up

The character is skinned and mostly rigged. We want the controllers to ride along with the character when it moves. Select the Face_2BS_CNTRL (which is the rectangle parent of the HappySad_CNTRL) and make it a child of the main_CNTRL found under the medusa_CNTRL group node.

For some of you, maybe a light bulb switched on in your head. Set driven key is kind of neat. You might be thinking, I

didn't care for utility nodes and that math—this could be used to make items move faster or slower, or backward, or anyway I want when a controller is moved. Yes, you're thinking correctly. You can also use set driven key to do things automatically for the animator. Let's see what that entails.

Set Driven Key to Do Automatic Corrective Blendshapes

The medusa character has been setup with eyebrow blendshapes. We're going to make those adjust automatically, as the eyes look up and down and left and right. Look in the side window to see the four blendshapes that have been created and labeled: Eye_UP, Eye_DOWN, Eye_LEFT, and Eye_RIGHT. (Incidentally, this technique can be found in the *Art of Rigging* (see the Epilogue) and in an older *Making of Leon* DVD tutorial.)

An aim constraint has already been created so that the eyeballs follow the eye_CNTRL. Click and move the eye_CNTRL to make sure that I'm not testing you.

Side note: For those who want to know how the aim constraint was created, create a circle for the eyes to look at; FDH; name it eyes_CNTRL. Select the eyes_CNTRL and then one of the eyeballs. Create an aim constraint (**Constrain>Aim**). Set the options to have the Aim vector in Z set to 1. Repeat for the other eye. We'll learn later on why the 1 value is set in Z and not in X or Y.

Now, we can set up a relationship between the controller and the blendshapes with set driven key.

Set Up the Driver and the Driven

1. Open the **Animation (menu set)>Key>Set Driven Key** window.
2. Select the **eyes_CNTRL** and click on **LoadDriver**. Select **TranslateY**.
3. Select the **face** blendshape node in the **Node Editor** window and click **LoadDriven**. Select **Eye_DOWN** and **Eye_UP**.

Up and Down Blendshape for the Y

1. Set the **eye_CNTRL** at **0** in **Translate Y** position and the **Eye_UP** and **Eye_DOWN** blendshape attributes at **0**. This is the default pose.
2. Click on **Key** in the set driven key window to set the default **0** position.
3. Move the **eye_CNTRL** up in **Y** so that the eyes look up. Turn on the **Eye_UP** blendshape found in the face blendshape node.

4. Click on **Key** in the set driven key window to set the eye up position.
5. Move the **eye_CNTRL** down so that the eyes look down. Turn the **Eye_UP** blendshape to **0**, if it isn't already, and turn the **Eye_DOWN** to **1**.
6. Click on **Key** in the set driven key window to set the eye down position.

Left and Right Blendshapes for the Z

1. In the set driven key window, change the driver to be **TranslateZ** and the driven to be **Eye_LEFT** and **EYE_RIGHT**.
2. With the **eye_CNTRL** at the neutral position and **Eye_LEFT** and **Eye_RIGHT** set to **0**, click on **Key** in the set driven key window to set the default **0** position (refer to Figure 6.9).
3. Move the **eye_CNTRL** left so that the eyes look left. Turn the **Eye_LEFT** blendshape found in the face blendshape node to **1**.
4. Click on **Key** in the set driven key window to set the eye left position.
5. Move the **eye_CNTRL** right so that the eyes look right. Turn the **Eye_ LEFT** blendshape to **0**, if it isn't already, and turn the **Eye_RIGHT** to **1**.
6. Click on **Key** in the set driven key window to set the eye right position.

Test: Move the eye_CNTRL up, down, left, and right to see the eyebrows automatically adjust.

Note: Our eye control is made up of a left vision, right vision, and a parent control over them. We only set the automatic set driven keys for the parent control, not the individual eyes. Our blendshapes are for both eyes. If you had individual blendshapes for each eye, for example, Left_Eye_UP, Right_Eye_Up, etc., you would need to create set driven keys to each individual eye controls. The parent controller would also need its own set driven key to drive the blendshapes. Why? If you move the parent node,

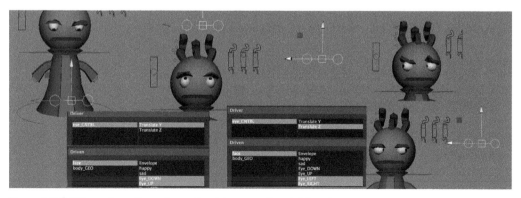

Figure 6.9 Setting automatic eyebrow blendshapes with set driven key.

the translate numbers do not show up in the children. Without the numbers going to the children's translate, the set driven key thinks the children are still at 0. Ooh, another baked noodle moment. This is the family of issues that we saw and the reason why we use constraints instead of one-to-one connections for translate, rotates, and scales: inheritance issues.

Automatic blendshapes can be used to add double chins to characters when they look down, or narrow their mouths when they open their jaw, create puffy wrinkles when a smile happens, or any type of automatic movement. Remember, the more automatic you make the rig, the more you have removed from the animator's hands.

What could go wrong? You didn't hit the key button enough and forgot to save a position or keyed the wrong pose so your blendshape doesn't do all of the shapes needed. If you select the main geometry and look in the graph editor, you will see that the graph represents the blendshape and the translation of the controller. You can adjust the set driven key relationship here (you can also adjust the spacing of the in-betweens).

If you have more than one blendshape node, you will not get the intended results. You can create a set of blendshapes feeding into one blendshape node and then create another set of blendshapes feeding into another blendshape node. Only one blendshape node will work at a time. This method keeps blendshapes from interacting together—but can be surprising if you think it is a "bug" when it is a feature you put into your own rig—intentional or not.

Set Driven Key to Drive a Forward Kinematic Tentacle

An easy solution for a tentacle (or snaky hair) is to have one controller that curls the tentacle in the Z-axis. You can start with the companion data version of Medusa: chpt6_medusa_v3.ma.

The sample file has controllers that are iconic, have limited translation, and the parent boxes and icons have the display overrides set to reference (see Figure 6.10).

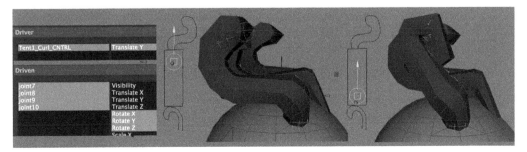

Figure 6.10 Curling the tentacle with FK joint rotations by a controller hooked up via set driven key.

1. If not using the sample file, create a controller and place it to the side of medusa, **FDH**; rename it to Tent1_Curl_CNTRL.
2. Select the **Tent1_Curl_CNTRL** and click Load Driver in the Set Driven Key window. Choose its **TranslateY** attribute as the driver.
3. Individually, select the joints of a snake tentacle; for example, snake_01_SKEL, joint7, joint8, joint9, and joint10. (Oh my—bad labeling. Ten points off.)
4. **Test rotate** those joints in the Z-axis. They all rotate the same; our joint rotations are correct: Huzzah! Put the joints back to their zero rotation.
5. With the joints still selected, click Load Driven in the Set Driven Key window. Choose all of the joint's **RotateZ** attributes as the driven.

Setting the Default Position for the Snake Tentacle

1. The **Tent1_Curl_CNTRL** is at its neutral position, as are the joints in the snake tentacle. Click on **Key** button in the set driven key window.
2. Translate the **Tent1_Curl_CNTRL** down.
3. Select the individual tentacle joints and rotate them in **Z** until the tentacle curls up nicely. Click on **Key** button in the set driven key window. To get a good curl, the joints might not all need to be rotated the same amount.

Test: Move the Tent1_CNTRL up and down to make sure that the tentacle curls and uncurls as intended.

More Advanced Controller Setup

What if you wanted to give the animator an easy method of using a slider to curl the tentacle but also wanted them to have the option to adjust each individual joint? You might think you can simply add in controllers for the animators to drive the individual joints, too—but it won't work. The joint should only be driven by one incoming connection to its rotation Z. What to do then? We can use hierarchy to help us. Welcome back the group node here to help us have dual controls over a joint's rotational axis. We'll use a group node that the animator does not see to control the set driven key. We'll then use a visual controller for the animator to do manual rotation with. Set this up on a different tentacle, which has not had controllers added to it yet.

1. Create a controller for each joint. A circle will do, **FDH**. Label them correctly: **Tent1_os_CNTRL**, **Tent1_os_CNTRL1**, **Tent1_os_CNTRL2**, etc.
2. Snap move each control to be at each joint in the tentacle or to the side. The pivot point can be at the center of the controller.

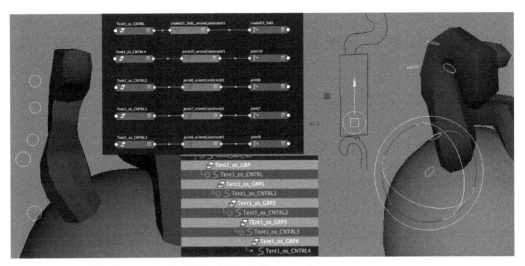

Figure 6.11 Set driven key tentacle AND individual joint controls.

3. **Select** each **individual CNTRL** and create a **group**. Name the groups **Tent1_os_GRP**, **Tent1_os_GRP1**, etc.
4. The pivot point for the group nodes can be at the center of the controller. Simply click **Modify>Center Pivot**. You should now have for each joint in tentacle two a group node as a parent of a controller, both with pivot points at the same joint.
5. Place the grouped controllers into a hierarchy: **Tent1_os_GRP1** is a parent of **Tent1_os_CNTRL**, **Tent1_os_CNTRL** is a parent of **Tent1_os_GRP2**, etc. (see Figure 6.11 for hierarchy).
6. Select the **Tent1_os_CNTRL** and the corresponding **joint** (make sure you selected the visual controller).
7. Create an **orient** constraint (maintain offset should be ON).
8. Repeat for the other controllers and their respective joints on tentacle one.

That is the animator's control. Now, to set up the automatic curl like we did earlier, except this time the group nodes are the driven instead.

1. Create a **controller** and place to the side of medusa, **FDH**; rename it to **Tent1_curl_CNTRL**.
2. Select the **Tent1_curl_CNTRL** and click **Load Driver** in the **Set Driven Key** window. Choose its **Translate Y** attribute as the driver.
3. Individually, select the **Tent1_os_GRP**, **Tent1_os_GRP1**, **Tent1_os_GRP 2**, etc.; click **Load Driven** in the Set Driven Key window. Choose all of the group node's **RotateZ** attributes as the driven (make sure you have chosen the group nodes) (see Figure 6.11).

Setting the Default Position for the Snake Tentacle

1. The **Tent2_CNTRL** is at its **neutral** position, as are the joints in the snake tentacle. Click on **Key** button in the Set Driven Key window.
2. Translate the **Tent2_CNTRL up**.
3. Individually, select **the Tent2a_GRP, Tent2b_GRP, Tent2c_GRP**, etc.; and rotate them in **Z** until the tentacle curls up. Click on **Key** button in the **Set Driven Key** window.

Test: You should be able to move the Tent1_curl_CNTRL for the automatic curl and individually adjust the tentacle with the individual controllers. Make sure that anything the animator is clicking on has no yellow or blue attributes. Yellow attributes should only show up in an animator control if they are caused by a character set. If they are caused by an incoming connection, like a set driven key or constraint, then once the animator sets an animation keyframe, the keyframe will turn off the constraint. Oops!

What else could you do? We only rotated in Z. You could also add a rotate in Y. What would that look/animate like?

Warning: If you ever make a constraint, or set a keyframe, and see the channel box turn green, STOP what you are doing and undo. Green means more than one connection and unless you are advanced and know what you are doing, you have probably just broken your rig. You don't want more than one connection, unless it is something you planned to do. At this point: no green channel. See the file chpt6_medusa_v4_Completed.ma to see the completed rig.

Extra Effort

What if Your Tentacle Is Not Lined Up with the X- or Z-Axis?

If you take the time to line up a controller with an angled joint and then freeze the controller, the rotation axis will match the world again and be offset from the tentacle. Darn. This leaves the animator with a rotational axis different from what the joint is. It still works, but it isn't very animator friendly. Why is it this way? When you freeze transformation, the object freezes to its parent. If there isn't a parent present, then the world is the parent. Therefore, the rotational axis matches the world axis. So, we need a parent with the offset axis of the joint. We will use a group node to do this, of course. Open Chpt6-OffsetControl_example_start.ma and locate the TentA1_CNTRL around the tentacle. Select that controller and select rotate tool. You'll

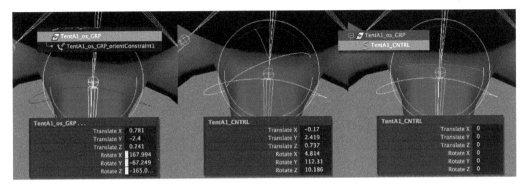

Figure 6.12 Freeze transformation magic with an offset group node to create controllers with lined up rotational axis. See example in Chpt6-OffsetControl_example.ma.

notice that the controller is frozen, but the x rotational axis is not lined up with the joint. Here's how to fix that.

1. With **NOTHING** selected, create a **group** node. **Snap** it to the **joint**. Name it appropriately like **TentA1_os_GRP** (see Figure 6.12). Another way to snap it to the joint is to use a point constraint with maintain offset **OFF**. (Select **joint** and then **group node**, if you wish.)

2. To get the correct rotational offset of the joint, select the **joint** and then the **group** node.

3. Create an **orient** constraint (with maintain offset turned **OFF**—otherwise you won't get the rotational numbers).

4. If you look at the group node, you can see that there are now rotational numbers in the channel box. This is what we need. **Do NOT freeze transformation** on this group node. You have to keep those numbers there.

5. **Delete** the orient constraint in the outliner. We no longer need it.

6. If you had made a point constraint in step one, **delete** it too. Its services are no longer in need. We only needed those constraints to get the position and rotation numbers.

7. Make the **controller** a **child** of the **group** node.

8. With the **controller** ONLY selected, **freeze** transformations.

9. Voilà! A frozen, zeroed out controller with a rotation axis matching the joint. Notice that the rotational manipulator matches the joint now and the controller is zeroed out.

10. **Lock** the attributes in the group node, so it doesn't accidentally get manipulated. Continue as usual. The group node is never touched by the animator. They pick the controller to animate with, unaware that you have offset the rotational axis for them with freeze transformation magic.

Ever the more powerful, you are in the ways of rigging. Congratulations. There are many other ways to do tentacle-type creatures. Before moving on, I encourage you to create your own

character and try to put many of these techniques to use. Make sure to animate it to really test it out. Have a friend animate it too and tell you what they thought of the functionality. When you are ready to proceed, join us in the next chapter where we see many of these concepts put together in our first biped.

Note

1. In testing, I get an error that there are nonzero rotations on joint4, but there are not. Odd. In Maya 2023, it is joint2. No rotations. Still odd.

THE BIPED

7

THE BIPED

There is a concept we have not covered up to this point since our rigs have been pretty simple. Now, we will create a biped rig that is a little more complicated and mimics what could be done in an animation pipeline with a larger team of artists. The concept is called referencing. There are two places where the word "reference" is used in Maya. One place is in the layer editor, where one clicks on the third box on the layer, which sets the display mode. There is a reference layer display mode where the model can be shaded but cannot be selected. That is a reference display mode. What we are talking about here is "creating a reference," which refers to having one file reference another file, or point to another file. This is great when working in a production pipeline where multiple people are working on the model, rig, and animation. The work can be done in parallel. Here's a snapshot of how it is done.

Create a model file, save it as MyModel_v1.ma. Let's say that this model is being created by Joe Polygon. Joe has only created a low-resolution model and handed it to Jackie Joints, who will rig the character.

Jackie Joints will create a rig file and reference in Joe Polygon's **Mymodel_v1.ma** file by clicking on **File>Create Reference**. She saves the rig file as **MyRig_v1.ma**. This couples together the two files. When she opens **MyRig_V1.ma**, it also opens **MyModel_v1** inside of itself. If any changes happened to Mymodel_v1.ma, then those changes are brought in. Clever, huh?

Joe Polygon can continue to work on refining the model; Jackie Joints can work on adding more controls onto the rig. Jackie will hand out an early version of the rig, which has the base movement controls and a low-resolution version of the model to the animators. The goal is to get the rig to the animators as early as possible so they can block in animation and the director can get a vision of what the film is looking like in a rough state very early on. This way changes can be made earlier rather than later. The animators, Pat Keyframe, and others receive the model and rig files. The animators create their own animation file, **MyAnimation_v1.ma**, and inside of it, create a reference for **MyRig_v1** (which is calling MyModel_v1). Now you have three files coupled together (refer to Figure 7.1).

DOI: 10.1201/9781003431121-10

Figure 7.1 My Animation_v1 is created, which references MyRig_v1, which references MyModel_v1.ma.

MyModel_v1.ma MyRig_v1.ma MyAnim_v1.ma

Figure 7.2 Change in MyModel_v2 is updated inside the MyAnimation file.

MyModel_v2.ma MyRig_v1.ma MyAnim_v1.ma

When Joe Polygon has the final model created or Jackie Joints has a new version of the rig, the animator can, at any given time, change the reference to point to the newer file (File>Reference Editor>Reference>Replace Reference) (refer to Figure 7.2). Now, that is great for a production pipeline.

We will use referencing in our next character: the biped character. The biped will take a few chapters to cover. Let's begin.

1. Create a project by selecting **File>Project Window**.
2. Create a **name** and **location**, use **defaults**, click on **accept**.
3. **File>Create Reference** (option box)
4. Select **chpt7_Marv_Bird_GEO_v1.ma**.
5. Under Namespace options, choose: "Merge into selected namespace and rename incoming objects to match." (This gets rid of long names with ":" in it and keeps the simple geometry name.)
6. Open the **File>Reference Editor** to see the reference file path and namespace used (refer to Figure 7.3).

Note: If you see a pop of error message stating that there might be data loss, you can ignore that. It is from an old render node from older versions of Maya.

Once the bird geometry is brought in, you can see the icon in the outliner is very different: it has a blue dot next to it indicating this is a reference object.

If you look in the reference editor, by opening File>Reference Editor, there is something very important to know. First off, you can see the link to where the geometry is being sourced.

Figure 7.3 Creating a reference to the geometry file.

This can be updated as you modify the geometry file. Why would you adjust the geometry file? Maybe to add edgeloops, blendshapes, etc., or maybe the art director has made a change to the look of the overall model.

Why do we do it like this? As stated previously, we like this because it generally isn't one person modeling, rigging, and animating. So, instead, this pipeline mimics production where multiple people will be doing individual parts. This allows for a low-res model to be rigged for base movement and moved into animation, while the high-resolution model and higher detail rig are being developed in parallel. Time savings? Yes. However, good communication, naming conventions, and pipelines need to be established for it to work.

To do it another way—to wait for the model to be done, then wait for the rig to be done, then animate—you sadly set yourself up to run out of time when animating. Also, by the time you get through that waterfall process, you might find something got changed along the way. Perhaps you spent time rigging something that wasn't needed, since most changes are discovered only after animation gets started and the story is first seen together in a work reel.

Here is a chart to help consider what are the most important rig features to implement, what to focus on most, and what to put off until last. The horizontal line of the grid is for how important the feature is to the story. The vertical line is how much time or risk is involved in implementing the feature. (This is a game development concept I've seen in use and repurposed here.) Refer to Figure 7.4. So, let's take a couple of sample features: hair, automatic blendshapes for neck waddles, and phoneme blendshapes.

Hair could rate very high on the time/risk line but may be super important to your story. For example, Rapunzel is all

Time/Risk

AVOID LIKE THE PLAGUE
Hair

phonemes
Show Stopper

WASTE OF TIME

LOW Hanging FRUIT
neck waddles

Supports Story

Figure 7.4 Rigging features applied to a risks vs. support of the story chart.

about the hair, so it would need to go into preliminary tests and rigging first. If the story wasn't all about the hair and the character wore a hat all the time anyway, it wouldn't rate as highly on the important-to-story scale. Automatic blendshapes for neck waddles are low on the time/risk line and moderately support the story. Phoneme blendshapes are moderate on the time/risk line; they do take a lot of time to sculpt but are safe features to implement—you know how to do it. If the story has any dialogue, then the phonemes are incredibly important on the scale. When you step back and look at the quadrants, you'll find there are four. Neck waddles fall into the "Low Hanging Fruit" quadrant. These are things that can be easily implemented and help give nuance to the story. Things in the upper right quadrant: phonemes, for example, are "story breakers." If you can't get those features, you can't support the story. Imagine a bald Rapunzel! You will want to put those into development quickly to make sure you can do it or hire the right consultant to get it done. If the story wasn't about hair and the character wore a hat, then hair would fall in the upper left quadrant. This area is "avoid like the plague." It tends to hold those whizzbang features that took a lot of time to implement, were a lot of fun to figure out, but really add no value to your story. Usually something story-critical was sacrificed for the time spent on the dynamic hair or the "shiny" feature that wasn't useful. The bottom left quadrant is reserved for things very easy to do—but are useless. It is coined, "why bother?" Those are complete wastes of time—though, they can be funny

and useful in other ways. For example, there was a rig that Brian Jeffcoat made for the 2D animators on Brother Bear. It was a 3D version of the moose with antlers. The animators used this to aid in perspective. The rigs had a shelf of tools and one was titled "make funny." Indeed, when pressed, the moose were adorned with Groucho Marx glasses and mustaches. Definitely a "why bother" that gave the animators a tickle. It was their first time animating in 3D and the levity was appreciated.

Another thing to consider when rigging a character for a quick moving pipeline is to make sure the animator has the main movement and rotation controls first, so that they can block in the movement of the character. A thing to consider when rigging multiple versions of a rig, and giving it to the animator, is if the animation controls' hierarchy changes, the animation will look different and could potentially be lost. The more you rig, the more you'll develop a style for which controls go first, and which controls go next without messing with the hierarchy. Having a strong methodology (like we do in this book) certainly helps maintain order when trying to rig in passes for production. A gentle reminder, always test your rigs (by animating them) before sending your rigs into production. If you can, have an animator test them for you and give you feedback. In a perfect world, you can do that ... then there is the production world. I wish you the best of luck.

Reminder: In these next chapters, our tutorial will have both a rig file AND a geometry file. When sending this file to your friends to show off, send both files.

Huge note on the geometry file: Make sure there is no keyframe information on the geometry, or in the rig file. A misplaced keyframe on a CNTRL or the geometry in a reference file cannot be changed except in the original file itself. This can make it difficult to diagnose as well. Make sure the history is deleted in the geometry file or else the rig file will start to slow down. Make sure that the blendshapes are created in the geometry file. Everyone has their notes? **Save** the file you have created (which points to the referenced geometry): chpt7_Marv_bird_RIG_v1.ma.

We will create a typical skeleton. There are a few types of joints I require my students to have. We'll talk about them in the next paragraphs. The rest you can add as you think is needed for animatability. As you place your joints, remember the things to consider: what movement is needed, joint placement within the edge loops, joint hierarchy, and joint orientation. Whew, that's a lot it seems at first. After a few characters, it starts to become more natural.

First off, there are a few types of movement that I like to have in a character, no matter what type of character it is. To take care of the upper body movement, the lower body movement, and the overall movement of the character, I like to have three

Figure 7.5 Three joints make up the upper body, lower body, and root joint.

separate joints. I learned this from the Bond Girls' rigs at EA. The joints end up being: Upper_Body_JNT, Lower_Body_JNT, and Root_JNT (refer to Figure 7.5).

Upper body will manage the spine, the shoulders, the arms, and the head. When you rotate the upper body, all of the upper body should go with it. The lower body, I call the cha-cha. It is often forgotten by students new to character setup. You can't do a walk without the cha-cha. The root joint will move both the upper body and the lower body. Eventually, when we get it rigged, you will be able to squat the character down by grabbing the root joint, since the IK hands and feet do not move with the root joint.

1. Using **Rigging>Skeleton>Create Joints**, create three separate joints.
 - **Left** mouse click once.
 - Hit **enter**.
 - **Repeat** two more times.
2. Label these joints **Upper_body_JNT, Lower_Body_JNT**, and **Root_JNT**.

Where to place them? I usually like them around the belly button area. They can be all on top of each other; however, I tend to place them in a straight line with one another in a human character. For this bird, however, I will place the root behind the upper and body joints. Now you have three joints just hanging out in space, without any relationship to one another. To fix that, make the **upper body** and the **lower body** a **child** of the **root** joint. All the other joints will "hang" off the upper body and lower body joints.

The Leg

First, take a look at the hip and ankle alignment. A hip directly above the ankle is easier to rig than an offset hip and ankle relationship. You can still rig it, but to rig it right, there are a couple of other steps to get the controller to line up. We

learned how to do a controller hooking straight up to things previously and we even covered doing offsets. If your feet are out of alignment with the hip, then, more than likely, the feet are not straight out in Z (or X, depending on which way you're building your rig) and you'll need to use offsets. We'll go ahead and add in offsets to this rig.

In the **Right side** view of the bird, we will draw the leg. The way the bird was modeled means we will draw in the front window. The first joint is the hip, somewhere in the side of the belly mass—where a hip joint would normally be, then a knee joint, and then an ankle. From there, we'll make a ball joint and the toes. We do not make a heel joint right now. We might add one in later. First, create the hip, knee, ankle, and middle toe joints. Then hit enter. In the perspective view, move the joint system into the mass of the leg. Create another joint chain for each toe by first clicking on the ankle in the perspective view, then in the side view click to place the toe joints. Hit enter when you've completed each toe.

Label them appropriately. Choose your own method but have a method, for example:

L_hip_JNT, L_knee_JNT, L_ankle_JNT.

L_inside_ball_JNT, L_inside_toe_JNT, L_inside_toetip_JNT.

L_middle_ball_JNT, L_middle_toe_JNT, L_middle_toetip_JNT.

L_outside_ball_JNT, L_outside_toe_JNT, L_outside_toetip_JNT.

You may have to move the knee and ankle joints to fit into the geometry, especially if you do not have a straight-legged character. Remember, you can hold down the **d** key to move the joint and not its children. Remember that we are moving joints, which means we will need to fix the joint orientations. Just as a note, a human character with a shoe would be very similar, there would only be a ball and toe joint, however. A barefoot human with wiggly toes would, obviously, have more joints for the toe joints and generally one ball joint (refer to Figure 7.6).

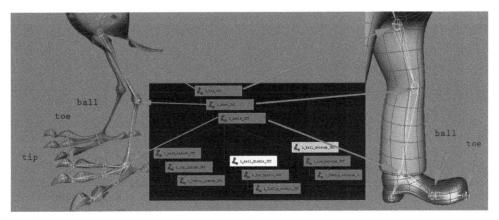

Figure 7.6 Leg joint system drawn in the side view of the bird vs. a human leg.

To fix the joint orientations:

1. **X first:** select the hip joint and select **Rigging>Skeleton> Orient** Joint. All the Xs should twist around to face down the bone.

2. Next, fix the **Zs:** select the hip joint, go to component mode, and click the question mark to view the axis.

3. Using the rotation tool with **step snap** rotate on, **rotate** the knee axis until the **Z** points the same way the ankle and hip do. Make sure all Zs are facing the same way; "tippies" don't matter. To get the perfect Z alignment, you may need to manually (without discrete rotate on) rotate the Z to align correctly. On some characters, you may need to rotate the hip and the knee rotational axis at the same time manually to make them line up. Our bird rig was fine with step snap rotation.

4. Lastly, make sure all the **Ys** point out the same direction. To keep all the Zs toward the inside of the leg, the Ys will point out the front. **Step snap** rotate if necessary.

 Test: In object mode, select the shinbone and the hip bone, and rotate in Z to make sure the leg rotates correctly forward and back. A character with straight up and down legs should have a leg movement that goes straight back and forward. A character with an ankle that is not directly underneath the hip will have an angled rotation (refer to Figure 7.7). A bird is different, isn't it? A human biped would kick his own rear when moving his leg back. However, the bird when lifting his leg naturally would have the hip rotate back and the lower leg rotate forward.

 So, this means that the hip's Z needs to be opposite of the knee to get a proper FK movement.

5. **Step snap rotate** the hip to be opposite of the knee so that the rotation of the leg moves like a bird leg.

 Check again to make sure all of the rotational axes are good. Now, let's easily create the other leg.

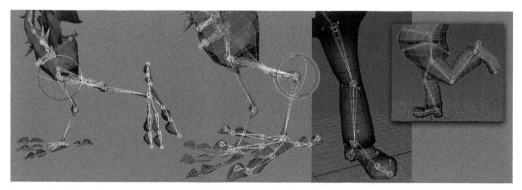

Figure 7.7 Bird with improper hip Z rotational axis and proper Z rotational axis; human leg with proper rotational axis.

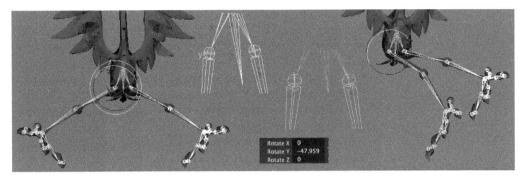

Figure 7.8 Mirroring joint with behavioral settings (on left) vs. orientation settings (on right).

Make the **L_hip_JNT** a child of **the lower_body_JNT**. Then select the **L_hip_JNT** and select **Skeleton>Mirror Joints**. Look for the bisecting plane that comes between the character; in this case, the **YX** plane needs to be selected. You can also change **L** to **R** by filling in the replace fields (refer to Figure 7.8).

Your choices are **Behavior** or **Orientation**. Behavior means that both legs will have the same axis and orientation means that both legs will have opposite axis. What does that mean? This is a nice feature for the animator. It means that he can select both legs and rotate them out (positive) or in (negative) at the same time if set to behavioral. If orientation is chosen, then the legs will simply go left and right together. **Behavioral** is the choice we would like to have selected. Keep in mind that in order for the orientation ability to be used by the animators, the controls have to be set up correctly too. If you look at the joint orientations, you will see the difference in the Xs and Ys. The left leg Ys are poking out the back, the right leg Ys are pointing out the front, and the Xs are opposite as well. That's OK. Zs are the same in the leg. So no freak-outs allowed when you look at your joint rotational axis and see they are different for each side. It's OK. We told it to do that with behavioral mirroring.

The Spine

The way I tend to do spine joints is by doing three or four joints to mimic the movement of the back. Now, if you were to watch Chris Landreth, the creator of *Ryan*, on the *Ryan Extras* DVD, you would get a great lesson in the anatomy of the spine and which areas move and which ones don't. For instance, the lower back moves and rotates; it is where the bulk of your range of motion comes from. As we know, us older people with bulged or slipping disks can't move around so much. Also, the mid back behind your rib cage doesn't actually individually rotate because ribs are attached to the vertebras. For a realistic rig, special attention needs to be paid to how the joints are placed

to mimic a human being or the specific being you are trying to recreate (if creating a digital double, for instance). In cartoony characters, you might want to break the laws of anatomy and add in some ability to rotate in the upper back, where the rib cage connects, just to get a better line of action when doing a pull or a lift animation. Either way, keep the number of joints to the absolute minimum you can. It is ludicrous to create a joint for every single vertebra; don't do it. It becomes a skinning nightmare and your back doesn't articulate that way anyway. When placing the joints, make sure that they line up with edge loops. It is best to mimic the curve of a spine and place the spine toward the back of the character, though you can get away with not placing the spine joints exactly on the back of the geometry. The joints can be placed more inside the geometry. I've seen characters with the spine placed right in the center like it was a character on a stick; I'm not convinced that moves well since we do tend to rotate, well, from the back of our body.

At the top of the spine, put in a neck joint. I like to create two neck joints (at minimum) to get a good bend and then a joint for the head that will rotate the whole head. The tip of the head joint I leave at the top of the skull. Even though it is not used, it can have things attached to it (bunny ears, hats, etc.).

Off of the head joint, place a jaw joint. Remember that you'll need to click on the head joint, click again to place the jaw hinge, and then click to create the tip of the jaw. As I mentioned before, beginners often forget to put the jaw hinge joint in and expect it to rotate. It bears repeating. Our character doesn't have much of a back, and is pretty much all neck and a beak—so much more fun. Since this character needs a broader movement in the head, we'll add an extra joint for the top beak to open as well. Anatomically, we don't move this way. Only our lower jaw hinges open. However, this extra joint will give the animator some extra range (see Figure 7.9).

Remember to label the joints that you made. Select all of the individual spine joints so they are each selected and in the renaming field (at the top right of Maya's window), type Spine_JNT and hit enter. Depending on the way you selected the joints, it will name them Spine_JNT, Spine_JNT1, and Spine_JNT2,

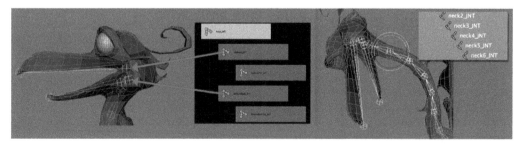

Figure 7.9 The neck, head, and jaw joints of our bird character.

Figure 7.10 The spine, neck, head, and jaw joints of our bird character vs. a human character.

starting with the joint you selected first. I love that renaming tool (refer to Figure 7.10).

Name the neck joints and the head joint as well, and any jaw joints that you might have added. Remember to put in a "JNT" or "jnt" suffix in there to ease selecting all joints later on in life.

Joint Orientations

Select the **Spine**; **Skeleton>Orient Joint** to get the X-axis all lined up. Since this is a complete FK unit, the spine on up through the neck (it bends together), we want it to have the same Z-axis throughout. In component/question mark mode, we can see that there are probably some Zs not going the same way. Snap step rotate the Zs so that they all point the same way. I tend to point all the Zs off to the character's right (screen left). All the Ys should point out the back of the spine, out the bend. (I'm taking liberties and not numbering these steps in the interest of page space, since you should be used to these by now.)

Now that the joint orientations are correct and labeling is good, make the spine a child of the **upper_body_JNT**. Now when you rotate the upper_body_jnt, the spine moves along with it. (Make sure snap step rotation is turned off.) Test the rotation of your spine: select all spines individually (and the neck and head, too) and rotate them in Z. A proper bend forward and back should happen, or else your joint orientations are incorrect. Be careful, if you make the spine a child of the lower back and out of habit click on orient joints—that carries through from the parent. Parenting or orienting joints after parenting will adjust what you just set up. So always give another careful look around your joint system after you have parented and/or oriented joints.

The Arms/Wings

The arms should be drawn in the **top window** to get a nicely made flat arm in a T pose, meaning that the arms are held out in a "T" position from the body. You can also rotate the arms down so that they are held down from the body at 45° or even rotated forward slightly. For our class, we will rig in a straightened position. If you watch or have read anything by Chris Landreth, he swears modeling and rigging the arms at 45° is the most natural position to create your arms in. It is how we naturally move. For cartoony characters, the needs will be different. Some systems, motion capture or otherwise, would rather you create the arms in the "T" position, so make sure to check with your production pipeline.

Our character is a cartoony bird, so we're going to create a main bone structure for the wing and then bone chains for the main feathers. It will have an IK/FK switch. We'll add in a lower wing twist, which would be equivalent to your lower arm twist. The joints we'll create (with an exception for the fingers) are going to be very similar to what you would do in a human arm.

Create the shoulder by clicking in the front view of the bird, which is in the side window, and click where an elbow would be. In-between the wrist and the elbow, we will add a wrist-twist bone. Click once for this middle wrist-twist and then again for the wrist; see Figure 7.11 as your guide.

Human difference: Were this a human arm with a straight lower arm (instead of a bent wing), we would have to be concerned with keeping the lower arm straight. To keep a lower arm and its extra wrist-twist joint straight, you would need to snap click the wrist-twist joint and the wrist joint to a grid line. This will make sure that the elbow to the wrist was completely straight. Once the elbow, wrist-twist, and wrist were created, you could move the elbow and rotate it to get the arm joints situated in line with the geometry while looking in the top and side windows. In this case, you do NOT move (translate) the wrist or wrist-twist joint—that would defeat the straight lower

Figure 7.11 Wing joint placement and arm joint placement. Arrow indicates wrist-twist joint.

arm setup. If you must move the lower arm or wrist, only adjust it when in the original snapped to grid position and only move it along the X-axis, which should be straight up and down the bone. This will keep everything straight.

If you wanted to create an exceptionally easy beginner arm, it should lay flat, as seen in Figure 7.11, with the wrist in line with the shoulder. This will help the controllers line up easily and eliminate many jiggle issues in the arm. However, most geometry does not line up that way so we will learn a more intermediate method for setting up the arm or, in our case, the wing. In a more advanced rig, the arm is usually down at a more natural angle. Our character has his wings extended up to spread out the feathers for ease of rigging and skinning. What does that mean for adding in controllers? It means that you have to remember how to do the offset nodes we learned back with the tentacle creature.

The wrist-twist joint; why did we add that in there? Hold your arm out and try to rotate just your wrist joint. You can't do it. In fact, your wrist twist is based off the movement of two bones in your arm. Instead of creating two bones (which you can see in some rigs), we're just adding in a joint that will handle the lower arm twist, which also rotates the wrist. I've seen rigs with upper arm twist joints as well. This is needed if your rig is really getting a full range of motion in the shoulder area, like a quarterback or gymnast; it depends on the rig.

Label your joints: **L_WingShoulder_JNT**, **L_WingElbow_JNT**, **L_WingWristTwist_JNT**, and **L_WingWrist_JNT**.

In the perspective window, **move** the arm and place it in the geometry. In a human character, remember not to move the lower arm twist or wrist joint, rotate them instead.

Orient Joints

Select the wing and **freeze transformations** to zero out the rotations you introduced into the arm. Remember, if you try to orient a joint, which has rotations on it, it will only puke a warning at you. Next, select the **wing** and click **Skeleton>Orient Joint**. For the wing, make sure the **Zs** are in the same direction; our bird has the Z axis facing out the front of the wing, and for this rig, we'll leave the **Ys** pointing to the outside of the wing. Note that the wrist joint's X-axis points down the main finger/feather of the bird (see Figure 7.11). (I'm glossing on the button clicking, since I'm assuming you've read how to orient joints. If not, refer to Chapter 5 where we went over this in detail. You didn't skip ahead, did you? The beginning portion of this book is very methodical, with each lesson building upon the previous one, so that you aren't overwhelmed with too much alien info.)

Hands/Feathers

While we're in the neighborhood, it is time to create the joints for the feathers. We'll only do joints for the four top, large feathers. Think of those as fingers on a thumbless hand. Draw the joints for these feathers in the side window, and make sure to line up the joints with edge loops for a proper bend. In the perspective window, move and adjust the joints as needed to fit within the geometry. Label the joints appropriately: L_Feather_A1_JNT, L_Feather_A2_JNT, etc. Repeat for each feather. These feathers are not a child of any joint, yet. Once the feathers are created and nicely labeled, go ahead and orient the joints (**Skeleton>Orient joints**), make sure that the Zs are all in the same axis and the Ys point out the top of the "knuckles." You may want to manually rotate the Y-axis to point out of the "knuckle" joints. Snap step rotate won't work since the feathers are not perfectly 15° or 45°.

Select the joints of each feather and rotate them in Z to make sure that it is rotating along the natural plane of a feather. What is the natural plane of the feather? You would turn to the model sheet or animator to answer that question. For our bird, rotate your joint's Y rotational axis to enable a rotation in Z that points the feathers toward the "thumb" feather.

Parent the feather joint systems under the **wrist** joint (refer to Figure 7.12). Double-check that the wrist rotational orientation lines up so that the X is pointing down what would be the middle finger if it were a real human, so that when the wrist is rotated, the hand does not rotate off kilter. (What is a kilter anyway?)

Clavicle

If you touch your collarbone right below your neck, that's the "joint" we need to put in next. This joint is going to be a parent

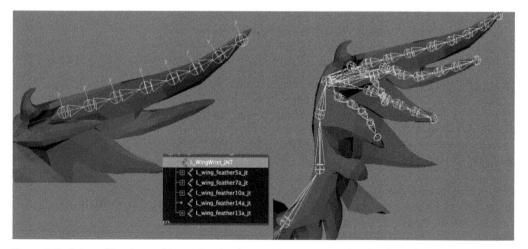

Figure 7.12 Joints of feathers with rotational axis properly set parented under the wrist joint.

of the shoulder and represents the clavicle or collarbone. Click once in any window (but NOT the perspective window) with the **Skeleton>Create Joints** tool and then hit enter. Label the joint **L_Clavicle_JNT** and move it (using the perspective window) to where in the mass you think the clavicle joint should be—somewhere under the neck of the bird. In a human, this joint allows you to raise your arm above the T pose.

Hold your right arm out. Place your left hand on your clavicle. With your right hand extended straight out from your body, your clavicle is not engaged. Your shoulder has raised your arm. But, if you raise your arm any higher—go ahead, raise your arm up above your head. Notice that your clavicle did that motion. If you have ever broken your collarbone, you might have difficulty in this movement. Our bird's natural pose is with the wings above the T pose, so the clavicle should be lower than the shoulder.

Make the **L_WingShoulder_JNT** a **child** of the **L_Clavicle_JNT**, and make sure that the Clavicle_JNT's **X** orientation is pointing **down the bone toward the shoulder**. Because you made the clavicle a parent of the shoulder, it does not know that it should point its X toward the shoulder. You'll need to manually orient that joint. Watch out if you use Skeleton>Orient Joint; it will more than likely undo anything you had done in the feathers. For this one joint, **rotate the rotational axis manually**. If you did use Skeleton>Orient Joint, quickly look at the wrist and other joints in the spine to make sure that they did not orient incorrectly, since they are down the hierarchy from the clavicle (refer to Figure 7.13). Fix anything that might have gotten turned; for instance, when Maya auto rotates things to fix the X-axis, it will reorient the Z's back to where it thinks they should be, which is sometimes not where you wanted them to be. You can unparent downstream joints temporarily before orienting joints to avoid this behavior and then parent again when you have fixed the one X-axis.

Figure 7.13 Clavicle and wing as a child of the closest neck/spine joint.

Where to attach that clavicle joint? Of course, we are not going to duplicate the complete bone structure of a real bird—we are just doing a visible generalization of the skeleton—so we'll make that clavicle a child of the nearest spine or neck joint. Be careful you leave a joint in your character that allows for neck movement that does not move the arms. You can look up without rotating your shoulders, right?

Mirror Wings

When everything in the wing is completely happy, then you are ready to mirror the wing. Select the **L_Clavicle_JNT** and select **Skeleton>Mirror Joints**. We will use the same options as we did on the leg. Use the **Behavioral, XY plane, replace "L"** with "**R**"s.

In class, many times our geometry is not completely symmetrical. If that is the case, when moving joints to be unsymmetrical, take care to not introduce joint orientation axis issues. Though it takes a little extra care when a character is not symmetrical, I do like it. If you or I were held up to the light, we would realize that we are not symmetrical at all, either by skeletal structure or musculature influence. We are close but the nuance; that is, us, is quite wonky. Some more wonky than others.

Remember that because you mirrored your joints with the behavioral option turned on, the mirrored side will have axis pointing differently than the original. You don't need to fix them. This is the desired orientation. If you grab both shoulder joints and rotate them in Z, they will both rotate down or up together since their Zs are opposite. This is a nice feature for the animator.

That Bone's Connected to the Other Bone

The legs should already be a child of the lower body joint. The wings are a child of the upper body joint, or the nearest spine, which is a child of the upper body joint. Both the upper body joint and the lower body joint are children of the root joint. Everything all parented nicely together? To include an image of the full hierarchy would be useless; it would be impossible to read. Please see the sample skeleton in the chapter material: chpt7_Marv_bird_RIG_Skeleton.ma.

Helper Joints

Before we end our talk about skeletons, let's talk about nonanatomically correct skeletons. Skeletons or bones are used to move the skin in rigging. So far, we have created mostly bones you can relate to. However, there are other areas of the skin

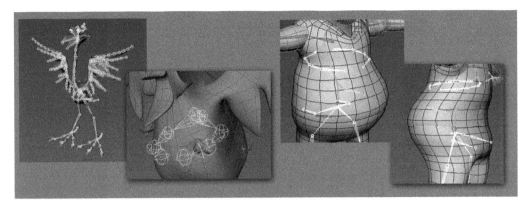

Figure 7.14 Bird with helper joints for the rib cage and a human character with rib, belly, and buttocks helper joints.

that need be moved beyond what is moved by the base skeletal structure. If we were really being perfect, we would have fat and muscles on our rig to help motivate the skin in other areas to move. Maya has a muscle system, but most productions use a proprietary system for that. For those who are not using muscles, we can use helper skeleton joints. Take a look at your character and look for masses that could use a joint to help it move solidly (refer to Figure 7.14). Helper joints I see used often are rib cage (for breathing), belly joint (to help the belly squash better), buttocks (really), shoulder blades, calves, etc. The *Art of Rigging* (see the Epilogue) has an excellent method for making dynamic calves, if you want to look that up. We won't make anything dynamic in our beginning rig but for those students who are always looking for a challenge—now you know where to go.

Finishing Up

Before going any further, look around the skeleton and make sure that your joint orientations are where you think you had them. When you parent joints, the joint orientation can change on you and you may need to re-attend to some of your joint rotational axis. I often click on orient joint when I meant to click on mirror joint. If caught in time with a quick "undo," it is not catastrophic. If, however, I don't catch it, I am mildly shocked when all of my rotational axes are mysteriously not where I last consciously placed them.

Give one last go over—you want to have all things correct with the skeleton before you move onto skinning. It sounds horrific, doesn't it—skinning? Images of something you'd see in *Predator*? I digress with useless but memorable imagery.

8

SKINNING

Once the skeleton is complete, you probably want to have your geometry move around with it, right? Now it is time to consider your pipeline and the state of your model. Let us answer a few questions to decide what our next step will be. Our choices are to skin now and create proxies later, or create proxies now and skin later. It depends on how you are going to create your proxies. If you create them manually, skin them later. If you are going to use an automated script, skin now.

What is skin or skinning? It is the process of making the whole mesh move along with the skeletons by assigning how much each vertex will move with a joint or joints. It is the extended task of being particular and working with the weights to get the proper movement. You've had a little experience with it earlier in Chapter 5.

What is a proxy? At one place where I was employed, we called them tootsie rolls. These are slices of a low-res geometry that are parented or parent-constrained to move along with the joints—no skinning is necessary.

Why use a proxy? If your geometry is going to change, you do not want to spend time skinning. If the geometry changes, you will need to reskin: holy missing vertices, don't do that! Instead, using a proxy allows your animator to go ahead and animate while you wait for the finalized model.

Why else would you use a proxy? Usually, you do not want the animator to work with the final skinned model anyway. It would be incredibly slow to work with. Instead, give the animator a proxy rig, maybe even adding a skinned low poly rig (since skinning the low poly model with super clean edgeloops isn't that taxing), and then save the high poly final skinned rig for the texturing and rendering phases. Also, using a proxy rig allows for animation to begin while the sculpting and texturing of the model can be finalized at the same time by someone else.

How to make proxies? You can do them manually, or you can skin your low-res, clean edge-looped model and use a script to make the proxies automatically. Refer to Figure 8.1.

When do you create UVs and textures? If you are using reference files (like we are), you can UV and texture the model

DOI: 10.1201/9781003431121-11

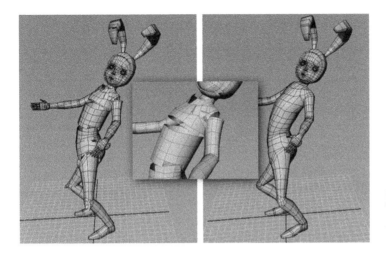

Figure 8.1 Rabbit model by Vivi Qin shown with proxy and low-res geometry (with permission).

at any time since the reference is brought into the rig file. Remember, if you bring in a model with new vertices after you have skinned them, those new vertices will need to be skinned, and your overall skinning may have to be tweaked, if not redone.

If your model resides in the same file as the rig, then you will want to complete the UVing and texturing prior to skinning. Remember to delete the history on the model after you UV and prior to skinning. Not deleting history after adjusting the UVs can cause the textures to swim after skinning.

In a previous chapter, I mentioned a no-skinning pipeline. It can be done, but isn't superbly useful. I developed it when a certain patch of Maya that we had was decidedly unstable in the area of skinning. See LowRes_HighRes_wToe_v3.ma as an example. To that point—when you get to the skinning stage, be very careful about software versions and patches. In class and group projects, I have noticed many skinning errors and changes happening when skinning in one version and then opening in a different version. I've also seen issues when crossing between Mac and PC. On a production, hopefully everyone is on the same patch/version. Now, let me add in here one caveat—the skinning issues I have seen may not have so much to do with versions, as they may have been introduced via cracked code being used by students. No one is going to admit using cracked software to me when we are testing, are they? (Thurston just came into the room, "*Lovey! They are talking about crack? I'm not sure if it is a noun or a verb. I hope not a verb, they aren't trying to crack my safe, are they dear? The noun isn't much better but at least it doesn't endanger my safe!*" [We hadn't heard from him in a while ... have you not been going to cocktail parties lately?])

Pipeline 1: Creating Proxies Manually, Then Skinning the Low-Res Geometry

The proxy geometry will actually reside in the rig file itself. We will start with two files: **chpt8_Marv_bird_RIG_v2.ma** from Chapter 8 and **chpt7_Marv_bird_GEO_v1.ma** from Chapter 7. Set your project (File>Project>Set) for Chapter 8's companion folder and open chpt8_Marv_bird_RIG_v2.ma. If your project is not set, Maya will not find the geometry file automatically. If it doesn't, simply navigate to find the geometry file when prompted.

1. Select the **bird** geometry and hit **1** on the keyboard to see the lowest version of the geometry.
2. Duplicate the geometry (**CNTRL d**). This copy of the geometry is now in the rig file and no longer referenced.
3. **Hide** the original **referenced geometry** so you don't mess it up. That will get skinned later on.
4. **Turn off the skeleton** in the **mask** section, so that temporarily skeletons will not be selectable.
5. Using your favorite method, select faces for the area of geometry that should move with the upper head. **Paint Select** or **Paint Lasso** tools, for example, are found in the tool bar. Then, right-click the mouse to select face mode. Note: holding the **CNTRL** key while painting subtracts from selection.
6. **Edit Mesh>Extract** (Keep separate faces **ON**).
7. With the new polySurface selected, **Delete History**; rename **head_PRXY**.
8. Move the **pivot point** of the proxy to match the **upper head joint**.
9. Select the **head joint** (driver) and select the **head_PRXY** geometry (make sure you are in object mode).
10. Create a parent constraint (**Constrain>Parent**).

Test. Rotate the head joint; the top of the head should move with the joint. Continue with the rest of the model, extracting, moving pivot points, and constraining the main joints of movement. This will take a while to do manually. Remember that you can delete areas of geometry. Your goal is to make slices of the character, which will move with the joints, for the animator to get a good idea of what the shape will look like. Refer to Figure 8.2. If the geometry did not have clear edgeloops and bend areas, then this task (along with UVing and texturing and skinning) will be very, very tedious. What was Rule #1? Oh yes... Edgeloops—a good or bad rig starts with the loops. I wasn't kidding.

Skinning

Skinning in Maya has changed many times over the years, especially in 2011 and again in 2016. Version 2011 introduced

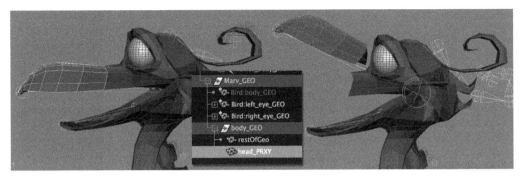

Figure 8.2 Creating proxy geometry for the animator's rig.

the concept of interactive skinning. With this concept, the idea of skinning was changed so that any vertex could have many skinning inputs, all of which could do mathematical wonders together to move the geometry. The trick is to get everything "normalized," or back into a 0–1 range. For versions 2011–2016 of skinning, refer to the first edition of this book. After Maya 2016, a whole new method of skinning was introduced. We'll cover that here. If you are using anything prior to 2010, you probably should update your software or find older manuals. We're in 2024 now, and I'm going to keep these references to 2011 and other versions of Maya when the skinning features started advancing. This way we remember where we came from.

First, let's talk about the different types of weight assigning. Once upon a time there was rigid and smooth binding. In newer versions of Maya, there is only **Bind Skin** and **Interactive Bind Skin**.

Interactive bind skin is, as it suggests, interactive. The workflow for this is to do an interactive skin bind first (as we have done in previous chapters), which creates skinning via interactive volume areas around each bone. This method also allows you to paint weights for finer tuning **after** completing the first rough adjustments with the interactive tool. Many students who have hated skinning in the past love the new interactive skin binding tool.

In the binding skin window, there are many options for **bind methods:**

Closest distance: This calculates the distance from the bone to the skin and binds the closest points, ignoring any bone hierarchy. Cons: It can cause small areas like fingers and legs to take ownership of the wrong vertices.

Closest in hierarchy: This calculates closet distance, but also bones' hierarchies are considered, and only the parent bone will have greater influence on vertices.

Heat map: This binding method was added in Maya 2014 and is used if you have influence objects placed on

your skeleton to influence the skin, like low-resolution muscles. The influence objects and all skeleton joints must be inside the skeleton for this method to work properly.

Geodesic Voxel: The newest binding method (2016) is quite interesting. Instead of looking at distance from bone to skin, it fills the skin volume up with voxels and then calculates where those voxels meet the skin, and this way it calculates the vertex ownership. It works across multiple meshes, even intersecting meshes, and even non-watertight meshes. Skeletons need to be contained inside the mesh for this method to work properly. Also, normals need to be facing out. There are two settings to be aware of. **Falloff:** 1 = very rigid bind. 0 = very smooth bind. **Resolution:** this is the resolution size of the voxels and how it calculates. The higher the number, the more precise the calculation, but the longer it will take to calculate.

Skinning methods.

- **Classic Linear:** This is a smooth binding method that was used in pre-2011 Maya.
- **Dual quaternion:** A method of skinning that preserves volume in areas that twist.
- **Weight blended:** A blend between the two skinning methods listed above based on a painted weight map you create.

The next topic is that of **normalization**. This is an option in post-2011 versions that shows up in a few places: in the Bind Skin option window, in the Paint Skin Weights window, and also in the skin node itself. What does it mean? The Normalize Weights options are as follows:

- **None:** This allows you to have weights that are over 1 or less than 0, but it does not normalize them. It can cause issues with the rig, according to the help documentation. I don't use it. If you use it, email me and tell me why: tohailey@yahoo.com.
- **Interactive:** When interactive is turned on, skinning behaves as it did in earlier versions. All skinning weights are adjusted so that they only equal 1. (Don't confuse the normalization method of interactive with interactive skin bind mode! Oh, the semantics issues.)
- **Post:** This is an option in post-2011 versions (and is on by default) in which the actual normalization (where the numbers really are 0–1) happens when you deform the mesh, not when you paint the weights. So, any tricks you used to have about setting one weight value to 1, thus automatically setting all other weights to 0, will no longer work. You have to paint weights to 1 for one joint and

then physically paint 0 as well for all of the other joints. Interactive binding needs this type of math in order to work.

Weight distribution: (You can only set these options if Normalize weights mode is set to Interactive.)

- **Distance:** Closer joints are given higher skin weights.
- **Neighbors:** Calculated based on neighboring vertex weights. Only works on polygon objects

I'm not usually one to go through all of the options; I usually show it at work instead. However, with skinning, it is easier to talk about the options, so you are well equipped when you tackle your particular skinning problems.

We have seen what types of binding methods there are, and how the numbers are normalized. The last thing to keep in mind is the bind pose. The bind pose is the "neutral" state of the geometry versus the skeleton system. Think of it as the "zero, zero, zero" point, which all things should come back to. In the latest versions of Maya, you are allowed to have multiple neutral or bind poses. This is super-useful when you have multiple pieces of geometry being bound to the same skeleton. There is an option titled **Allow Multiple Bind Poses** in the skinning options box. If turned **OFF**, all geometry must be bound at the same time. If you want to bind the separate pieces at separate times, turn the option **ON**.

To help with the chaos of skinning, you will find that the option titled **Maintain Max Influxes** will help limit the number of joints that can influence a vertex. If you set it to 1, that would equal rigid binding. If you set it to 2, that's a little more smooth. If set to 3, there's more influence, and that can help you simulate skin better. If set to 5 or higher, you have made yourself a skinning nightmare: only do that if you really have a reason. The gotcha built in is that if you set the max influence to a low number, say 2, and want to paint in a third joint, the system will keep the influence at 2 by removing influence from an existing joint and giving it to the third joint. In this way, Maya maintains a total of two joints influencing the vertex. This can be surprising when skinning at 3 AM and not understanding why your skinning assignment keeps subtracting itself from the joints you had working. In the Paint Skin Weights window that we'll see in a little bit, you can click on the button "hold weights" to keep the weights on a joint.

Skinning the Bird

We'll start with the newer geodesic voxel bind method and see where that goes. In the earlier version of this book, we started with the interactive bind tool.

Step 1: Binding

1. Select the **root_JNT**.
2. Shift select the **BirdBody_GEO**. (Do not select the eyeballs.)
3. **Skin>Bind Skin (options box)**.
4. Bind Method = **Geodesic Voxel**. Keep most of the default settings; Max influences = **3**; Falloff = **0.55**.
5. Click on **Bind** Skin.
6. Rotate various joints to see how well the skin is moving. Remember to zero out the joint's rotation when you are done testing.

Remember, this pass is a rough one and will not get all of the nuances needed in the joints or give the feeling of skin stretching with muscles. Refer to Figure 8.3. However, this new binding method gave some pretty good results. Next, we'll get that behavior with the painting of the skin weights. Also, only worry about one side of the character. We can mirror (copy) the skin weights.

Note: if you utilize the interactive bind tool, then paint weights you cannot return to interactive skin bind. If you return to interactive skin bind, the painted weight values get deleted! I have seen sad students do that. Another thing is to make sure you save versions frequently. There is a lot of work to be done in this area, and you don't want to lose it by putting all of your skinning into one corruptible file.

It would take 50 pages to go through skinning every joint of the bird together. Be prepared; it takes a good bit of time. Refer to Figure 8.4. You have to develop a methodology for going through the skinning to help you pay attention to the large bones, then the small bones; the large areas of movement, then the small areas of movement; from top to bottom, or bottom to top. Otherwise, it is easy to get lost, overwhelmed, and give up. Take breaks. Save often. Give yourself plenty of time; do not save this step for the last moment and expect it to go well the first time. As you gain more experience with skinning, it becomes easier—honest. I equate it to the same patience needed in UVing. In fact, skinning listens to UVs. If the UVs were done horribly or not done at all, that affects the skinning calculation, or so I read.

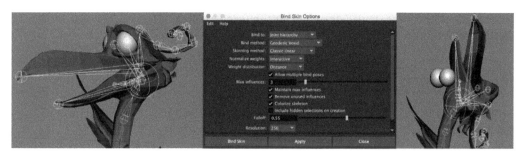

Figure 8.3 Geodesic Voxel Binding method yields good results.

Figure 8.4 Some areas move too much with joint rotation. We need to finesse those areas by painting skin weights.

Painting Skin Weights

There are many areas that need some extra finesse. We'll use the tongue as an example. When the bottom beak is rotated open, the tongue goes with the beak more than it stays with the tongue joints. We will paint the weights instead.

1. Select the bird **geometry**.
2. Select **Skin>Paint Skin Weights** (option box). This opens the painting weights window, much like what you have seen before.
3. If you **right-click** on the tongue joint and in the hot box menu select the north-most box, **Select Influence**, then the joint will be selected, and you can see the black-and-white representation of its influence as seen in Figure 8.5.
4. Using the **Add** operation and a value of **1**, paint in the tongue areas of influence for each joint.
5. Using the hot key "**b**," drag from left to right to resize the brush tool.

Figure 8.5 Painting skin weights on the tongue area.

6. In the Paint Skin Weights toolbox, click on other joints to see what influence they have. The bottom beak joint in mine has 100% ownership, too (it is all white when selected).

7. With the **bottom** beak joint selected, use the **Replace** operation and a value of **0** to paint out the influence from the top beak. As you paint out the influence, you will see the tongue geometry move to match the tongue joints.

8. Switch to the rotation tool and rotate the bottom beak to see that the tongue stays with the tongue joints now. Remember to put all joints back to their preferred angle (assume a preferred angle) or set their rotations to **0**.

Remember to select the geometry when you go back to the paint weight skins tool. If you have a joint selected but not the geometry, you will not see the black and white skinning representation that you want to see. You can also turn on the color-ramp to view the skinning representation as color. It helps some to visualize the skinning more easily.

Let's go over some problems with skinning and what to do about them:

Pokies: Where a vertex does not move with the area of geometry around it but moves with some other joint— for example, the vertex in this wing. To fix this, select the **Vertex** and choose under **Skin>Hammer Skin Weights**. There are no options for this tool. It sets the skin assignments based upon the neighboring weights. You can see it fixed the pokie in the wing. This option is also in the Paint Skin Weights Tool Box. Refer to Figure 8.6.

Unwanted Jiggles: Often, small movements will creep into the skinning and cause jiggles. After most of the skinning has been done, select the Geometry and click on **Skin>Prune Small Weight**. This will remove miniscule numeric values.

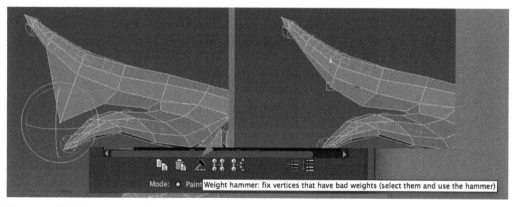

Figure 8.6 Weight Hammer to fix pokies.

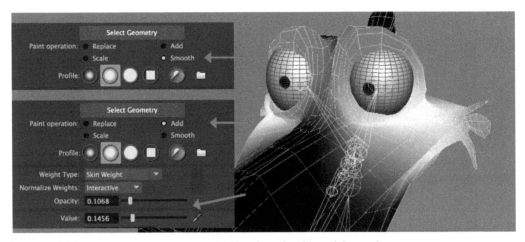

Figure 8.7 Adding jiggles using smooth and add in the paint skin weights tool.

Wanted Jiggles: A great way to get a good look and feel of
stretching skin is to add in just the smallest of influences
in fleshy areas. Say, for example, when the beak is open
and closed, a small bit of skin around the eye should
move slightly, too. To do this, select the bottom beak
joint and use the **Smooth** paint operation or the **Add**
operation with a very small opacity and value. Paint in
this "jiggle" around the bottom of the eye or anywhere
where the skin should stretch as the bottom beak opens.
Refer to Figure 8.7.

Joints showing up in X-ray, even if the option is turned off.
Although this isn't a skinning issue—it gets in the way. If your
joints show up in X-ray mode even though it is turned off, simply
turn on X-ray Joint mode and turn it off again. (The toggle is
found under the viewport's shading pull-down.)

Twisting or collapsing shoulder and wrist joints. With the
geodesic voxel method we utilized above, this isn't as large an
issue as it once was. If we had used closest distance or hierarchy,
we'd have more collapsing in the joint. Either way, our skinning
method is classic linear skinning. When a shoulder or wrist
or joint is rotated, the volume is not maintained, and the joint
collapses. There have been many methods for dealing with this
in the past. The newest is the introduction of dual-quaternion
skinning. What? Let's take a look.

Select the lower leg and rotate it up. Let's look at that joint to
see what the different smooth-bind skinning methods look like.
First, there is the classic linear skinning; see Figure 8.8. Find
the skin cluster node and change the skinning method to the
second option, Dual Quaternion; you'll see the geometry around
the joint gain a little volume; see Figure 8.8. The third option is
weight-blended. This option looks to a painted map that tells it

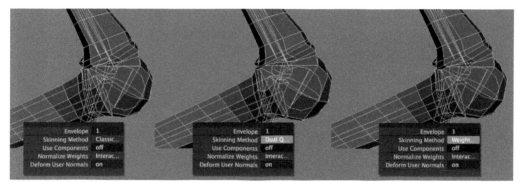

Figure 8.8 Weight blended between Classic Linear and Dual Quaternion.

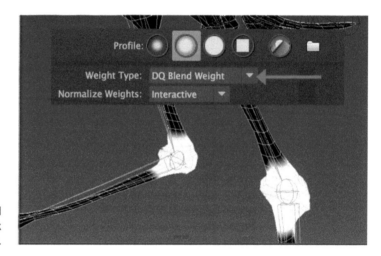

Figure 8.9 White (or 1) = full Dual Quaternion. Black (or 0) = classic linear.

which area should be Dual Quaternion, and which area should be classic linear. Keep the option of weight blended.

Return to the **Paint Skin Weights** Tool that you should be familiar with, and this time switch the Weight Type from Skin Weight to **DQ Blend Weight**. This is the map that indicates which area is classic linear and which is Dual Quaternion. White (or 1) = full Dual Quaternion. Black (or 0) = classic linear. Refer to Figure 8.9. This will allow areas to be calculated to preserve volume and others to stay calculated as classic linear.

Mirror Skin Weights

Once your main pass of skinning is done, let's go ahead and mirror weights since we only worked on one side of the character.

1. Make sure the skeleton is back in its bind pose (all bones are zeroed out in rotation). You can select **Skin>Go to Bind Pose**.
2. Select the **geometry**.
3. Select **Skin>Mirror Skin Weights**.

Figure 8.10 Mirroring, undoing, and remirroring the skinned weights so that adjustments on the bird's left leg are duplicated on the bird's right leg.

4. Make sure the mirror across the axis matches the bisecting axis of the character (our bird is **XY**).
5. Click on **Mirror**.
6. **Rotate** joints on each side to see that the mirror occurred correctly.
7. IF it mirrored incorrectly, take the unadjusted side and mirror it to the adjusted side—click on **Undo**.
8. Turn on or off (generally **off**) the **Direction** option (see Figure 8.10).
9. Repeat steps 5 and 6.

Mirroring weights will work mostly at this stage. Refer to Figure 8.10. It can sometimes obliterate any finesse you have done in smaller areas later on in the painting skin weight stage; there are new options that have been added in the past couple of versions to help with advanced mirroring needs.

Creating Proxies

At some point, we want to create proxies for the animator. You could create these proxies at the beginning of your process manually, so that the rig could potentially go into production while you spend time skinning. The skinned version could be updated into the animation at a later date.

Or, we can do a good pass at skinning and then use an automatic script to create the proxies. The danger is spending too much time on skinning before getting the controls created and getting the rig into production. Danger, danger! Don't spend too much time here just yet. Get the skinning workable, then continue rigging. Come back and twiddle

the skinning later, after you are sure the skeleton is even going to work for animation. If you have spent too much time skinning only to come back and have to redo it again—a sad rigger you will be.

Joint Adjustment

Before continuing onto rigging controls, you want to make sure that your joints are in the right spot and rotating correctly with the proper rotational axis. Make absolutely sure that there are no numeric values in the rotation attributes of the joints. Take the time to rotate each joint and look at how it rotates in relation to the geometry. Skinning issues may be in the way of you truly seeing good movement. Try not to noodle with the skinning too much now, wasting valuable time, unless you are very fast at skinning. Refer to Figure 8.11.

If you find a joint that is slightly in the wrong area, you can still adjust it after skinning has taken place (in versions of Maya post-2010). To adjust the skinned joints, use the **Skin>Move Skinned Joints Tool**. Remember to be careful; moving the joint can adjust your rotational axis. Make sure to unhide your main geometry so that you can make sure the skinning isn't twisting around when you adjust the joints. You can also adjust the rotational axis slightly. Watch the skin to make sure twisting isn't occurring. If too much adjusting

Figure 8.11 Skinned bird with proxies. Eyes are not skinned, so they do not move with the character yet.

needs to happen, you may have to unskin, adjust the rotational axis, and reskin again.

Our bird now has some skinning going on, proxies for the animator, and is ready to be rigged (chpt8_Marv_bird_RIG_v3.ma). The only geometry we have not dealt with is the eyeballs. They do not get skinned. We'll get to them later. See you in the next chapter!

9

UPPER BODY, LOWER BODY, AND ROOT: ALWAYS HAVE A CHA-CHA

Now, we will start adding character controls to our rig. For this first rig, we will put in visible controls. If you check out the advanced section of this book, there is a section on invisible controls in Chapter 17. We're going to add in the upper body, lower body, root, FK spine, head, and neck controls. This should all go pretty easily if your joint orientations are correct.

Warning: Beware of foster parents. Occasionally, while working on a rig with a referenced geometry file, I had a foster parent node show up in the outliner. I couldn't quite see why it was there. I deleted it, and nothing seemed to break. However, I have seen a foster parent node show up when the geometry's attributes are locked in the geometry file. When that file is referenced and then skinned, a foster parent (duplicate) is made in the rig file, and it can make things a little messy. This is why it is important **not** to lock the geometry attributes in the geometry file. Foster parent nodes show up normally when you parent something under a referenced item and then unload the referenced item. The foster parent shows up as a placeholder. It shows up when you unload the reference, save, or export. The foster parent should not stay around. It should go away once the reference is reloaded. If you continue to have foster parents, double check that you do not have extra references or have locked attributes on the geometry.

Back to our bird rig, open your latest version of the bird rig or the chapter material chpt9_Marv_bird_RIG_v3.ma, which references chpt7_Marv_bird_GEO_v1.ma. Take a look at the upper and lower body joints. Rotate them to remind yourself of the function they serve. Later on, the lower body will have a cha-cha function since the feet will be held down by IK handles. Right now, the feet go with the lower body joint since we haven't told them to do anything else. Let's install a script found in the scripts folder of the companion data: **rig101WireControllers**. This script was written in 2003 by Lluis Llobera and Javier Solsona and is distributed with their permission. Lluis works

DOI: 10.1201/9781003431121-12

at Pixar now, and Javier works at Sony Pictures Imageworks. Simply place a copy of the rig101WireControllers.mel script into your maya/#version#/scripts folder, type **rehash** in the script editor for Maya to relook at the script folder, or restart Maya. On a Mac, in the finder, click on **Go** and hold down the **option** key to find the path: Library/Preferences/Autodesk/maya/#version/ scripts. In the MEL window at the bottom left of Maya, type the command: **rig101WireControllers** (remember, the capital letters are important. If the window opens but is blank, click on a tab at the top of the window; it has a refresh problem in some versions of Maya).

Upper_Body_CNTRL and Lower_Body_CNTRL

1. Open up **rig101WireControllers,** or create your own control to represent the lower body.
2. Move the controller to be easily accessible to the animator, and visually, makes sense that it rotates the lower body.
3. Snap the **pivot** point to match the **lower body joint** and rename it to **LowerBody_CNTRL**.
4. Rotate the lower body joint to see how it is going to move the body, and make sure the controller is rotated to closely match the joint's rotational axis. You want it to rotate similarly so that it makes sense to the animator. The rotational axes don't have to exactly match, yet they should make sense to the animator and line up visually. If the spine of your character is straight up and down, there is not much adjusting you need to do since the rotational axis will match the world. Our bird character does not have a lower body and upper body joint that match the world; they are offset; we are going to have to do what? Do you remember the tentacle creature? Good job—create group offsets. We can do it manually, or we can use a script that I put together.

 Install the OffsetController.mel by first copying the script from the chapter material **scripts** folder and place it in your maya/#version#/scripts folder, type rehash or restart Maya. In the MEL window at the bottom left of Maya, type the command: **OffsetController**. At the moment, you aren't using the script correctly. You should receive an error message: "Gosh, you need to select two objects: Controller and Joint. DONE." If the script window isn't open, you might only see the word DONE.

5. Select first the lower body **control** and then the lower body **joint**.
6. Rerun the script by typing **OffsetController** in the MEL command line.

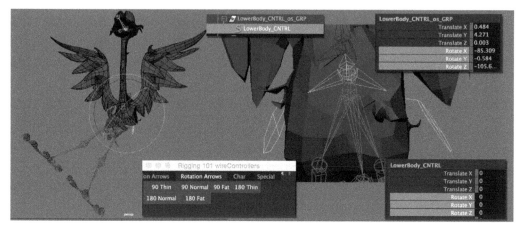

Figure 9.1 Lower body controls created with **rig101WireControllers.mel** then given offsets to match the joints using the **OffsetController.mel**.

This will get the rotational information from the joint, create a group node, make the controller a child of the group node, and freeze it. Look, it even names the group node nicely and gives you feedback as it works. If you want to see my steps to creating the script, there is a bonus chapter on the Focal Companion website. That saved a lot of clicking, didn't it? Boy, nothing beats a good script. And look at that, still working in 2024.

Repeat these steps to create an **upper body control** with the pivot point at the **UpperBody_JNT**. Name it UpperBody_CNTRL. Remember to use the OffsetController script. Refer to Figure 9.1. Select the controller and the joint (driver–driven), then run the script to get a perfect offset and a frozen and deleted history controller. These controls are going to rotate their corresponding joints. LowerBody_CNTRL rotates the LowerBody_JNT; UpperBody_CNTRL rotates the UpperBody_JNT. Their pivot points are in the same spot, so the constraint we use doesn't really matter. Since we just want to use rotation, we'll use an **orient** constraint. (We could have used a parent constraint with only the rotation turned on.)

Select the driver: **UpperBody_CNTRL** and select the driven: **UpperBody_JNT**, then create a **Constrain>Orient** with **maintain offset on**. Repeat for the lower body. Select the driver: **LowerBody_CNTRL** and select the driven: **LowerBody_JNT**, then create a **Constrain>Orient** with maintain **offset on**.

Test. Rotate the **UpperBody_CNTRL** to make sure the upper body joint and other upper torso joints rotate with it. Refer to Figure 9.2. Rotate the LowerBody_CNTRL to make sure that the bottom portion of the skeleton rotates with it.

What could go wrong? If your **CNTRL** turns **purple** when the lower body joint is selected, you made the connection backwards. You may have selected the driven and then the driver instead of driver and then driven. Find the constraint

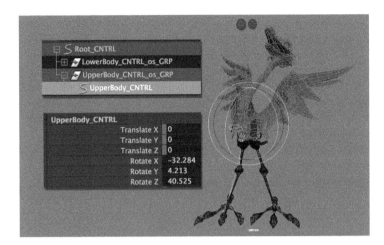

Figure 9.2 Upper body control constrained and working. Note the eyes are still not moving with the character. Deep breaths—it's OK.

in the outliner, delete it, and try again, selecting the joint and controller in the correct order. For these two controllers, **lock** the **translate** and the **scale** attributes.

Root_CNTRL

Since the upper body and lower body controls are so close together, we will place the root control at the back, between the wings. If this were a biped, I would like to put the control around the belly button. A control around the belly of the bird would just get in the way of the other controls. This control will ultimately squat the character down since it will move the lower body control but not the IK feet. Refer to Figure 9.3.

1. Create a **controller** and place it above the back of the bird.
2. Place the control's **pivot** point at the same place as the **root_JNT**.

Figure 9.3 Root_CNTRL constrained but not working completely yet—keep breathing deeply. It is still OK.

3. **FDH** (freeze, delete history). For the root controller, I am **not** going to use the offset script. The animator will want that controller matched to the world, I would think.

4. Rename: **Root_CNTRL**.

To hook up the root controller, we will use almost the same steps as the other body controllers:

1. Select the driver: **Root_CNTRL,** and select the driven: **root_JNT**.

2. The constraint we are going to use needs to translate and rotate. Since this control will squat the character down when translated and also rotate the whole body (except for any IK appendages), and since the pivot points are at the same place, it doesn't matter which constraint we use— orient and point, or parent. If this controller were offset with its pivot point elsewhere, we would use a point and orient constraint. However, we've got the pivot points at the same spot, so using the parent's (the Root_CNTRL) pivot point will be just fine. **Constrain>Parent**.

3. Make sure that **translate** and **rotation** are checked and maintain offset is on. (Joints have numbers in their translates. If you don't maintain offset on, your joint will jump. Eek!) Lock the scale attributes for the **Root_CNTRL**. Lock the translate, rotate, and scale attributes for both offset group nodes. You don't want the animator to accidentally move them. If you try to test the control right now, it will translate the whole rig up and down (except for the eyes and the other controllers), but it won't rotate just yet since we haven't created the control's hierarchy.

What could go wrong? You may have used a parent constraint, and the controller's pivot point is not at the same place as the joint. Or you made a backwards constraint with the control turning purple. Didn't you do that last time, too?

CNTRL Hierarchy

To make everything work the way you want, all you need to do now is make the **upperBody_CNTRL** and **lowerBody_CNTRL** a child of the **Root_CNTRL** in the outliner. Since we have the offset group nodes, they will be involved as well.

1. **LowerBody_CNTRL_os_GRP** becomes a child of the **Root_CNTRL**.

2. **UpperBody_CNTRL_os_GRP** becomes a child of the **Root_CNTRL**.

Now you can test. The upper body control should rotate the upper body. The lower body should cha-cha. Root control should move everything around except the eyes for now. Remember, the IK appendages will not move with the root control when we have a complete rig, as seen in the human

Figure 9.4 Upper body, lower body controls as children of the root control in the bird rig and a human rig (chpt9_Marv_bird_RIG_v4.ma). Human has his feet rigged, which is why they stay on the ground.

rig in Figure 9.4. It should be pointed out that the human biped and the bird have similar patterns. They are almost the same, with only slight modifications on the controllers. It is important to realize that rigging is more about pattern isolation and problem-solving. After a little bit of experience, you will find, as I hope you are finding in this book, that you have built a toolbox of problem-solving tools that you can build upon.

Well, that chapter seemed kind of short. OK. Take five; grab a coffee. I suspect the fun is just starting. See you in Chapter 10.

A cool trick that saved my sanity: I sometimes work on two screens, but I had unplugged to write on the porch. My script editor had been opened on the second monitor when I unplugged. Maya, when closed, will remember where the windows were open and write it into a preference file. The next time that I opened Maya, my script editor continued to open on the nonexistent second monitor. Bummer. I could delete the userprefs.mel file found in the maya/prefs folder, but I didn't want to lose all the other preferences that I like to keep. In this situation, you can do a simple window trick. To retrieve windows lost on missing second monitors I found this on a forum:

1. Open the window you need to retrieve (off screen).
2. Hit Alt + Spacebar to pop up the little minimize/maximize/close thingy.
3. Minimize it (it should now be docked at the bottom of the screen).
4. Drag it up where you want it.
5. Close it.
6. Open it again.

Problem solved in 25 seconds. Students—there is way too much help documentation and that interweb creation out there

to help you solve a problem; learn how to utilize it. (I am stepping off the soapbox.)

Technical editor note: not all UI windows minimize into the toolbar at the bottom of the desktop. In that case, select move instead of minimize, then hold down the arrow key pointing in the direction of your main screen (i.e., if your second monitor was on the right of your main screen, use the left arrow). Hold down until your window scrolls slowly into the screen, then grab it.

10

FEET AND KNEES: SIMPLE, GROUP-BASED, AND JOINT-BASED FEET

If you think about the foot of your character, or even your own foot, there are a couple of things we will want out of a rig. I'll pull out my floppy, flexible shoe to demonstrate. Please pull off your tennis shoe and hold it in your hand to help visualize the foot issues. If we were to put an IK handle on the leg, we could lift the foot up, move it around, and do a simple type of walk. (Lift and move your shoe around in the air.) We want to add the ability for the character to lift their heels up and stand on the balls of their feet. (Place your shoe on a table or the ground and bend up the heel.) This is important when doing a push-off pose for a walk cycle. We want to add a toe tap so that we can bend the toe up and slap it down to get a nice contact point when animating a walk cycle. (You can set the shoe on a flat surface again and lift up the toe. On some shoes, you can flex the toe down. In a cartoony rig, this movement, though not anatomically correct, needs to be exaggerated.) Even though we don't physically walk this way, not noticeably, it helps to get weight into the animation to have this toe tap.

The other functionality we want is for the character to be able to stand on a tippy toe or wiggle their foot while placing the contact point at the toe. So, to break the functionality down:

1. Peel heel.
2. Toe tap.
3. Tippy toe.
4. Move the whole foot.
5. Rotate the whole foot.

These are the minimum functions we are going to put into this rig. There are some other things that you could do, like adding in the ability to roll the foot to the inside or outside. I've collected many ways to do this over the years, and the two basic types involve creating this effect with a joint system driving it or using group nodes. Refer to Figure 10.1. Either one will work. I tend to use the group method since we have already covered grouping and pivot points way back in our first chapter together.

DOI: 10.1201/9781003431121-13

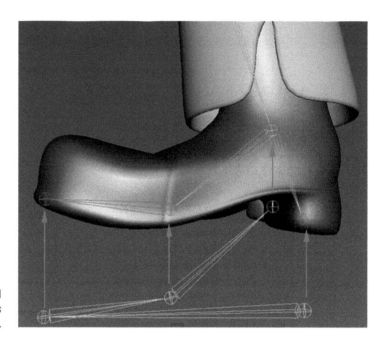

Figure 10.1 Joint-based reverse foot system does not use extra IK handles.

Remember the pivot point animation? It is the same principle applied here. How about that?

The joint method involves creating a snowshoe-type joint system that is fitted onto the existing skinned joints. The shoe joints are orient-constrained to joints to drive the feet. There are no extra IKs involved. The snowshoe looks like a reverse foot—it is where the name was derived. The Joint Reverse Foot seemed visually cluttered, so I gravitated towards the group system, even though it could be argued that the two IK handles that are created with the grouping method are extra steps. When toes start to get involved, I like the IK handles better for organization.

Our bird character will only have an IK leg. It will not have an FK/IK switching leg. The reason a character would have an FK leg is that if the feet were coming off the ground, the weight would be going somewhere else. The feet would not have contact with the ground and would be moved by the upper legs with no resistance, so FK would be the proper setup for that. That's more advanced; we'll ease our way up to an FK/IK switching appendage.

We'll do that with the arms/wings since many simple animations require an FK/IK switch in the arms. What is this FK/IK switch? Hold on; we'll talk about that in another chapter. Incidentally, a leg is a leg. The bird and the human have hips, knees, ankles, and toes of sorts. The difference is the knee bends the opposite way. The pattern of rigging is exactly the same, only making sure the knee points the other way. Open the file **chpt10_Marv_bird_RIG_v4.ma**. Before we start, left-click on each hip and select "**Set Preferred Angle**" just so that we know

Figure 10.2 IK handles for the ankle, balls, and toes. Only the ankle is rotational plane; all else are single chain.

that Maya knows this is the way the leg should rotate. It sets up good math for our IK handle. Refer to Figure 10.2.

1. Create a **Rotate-Plane** (RP) IK chain from the **Hip** to the **Ankle**. Name it **L_Ankle_IK**.

2. Create a **Single-Chain** (SC) from the **Ankle** joint to the **Ball**. Name it **L_Ball_IK1**. (Since this bird has three toes, there will be three ball IK handles.)

3. Create a **Single-Chain** (SC) from the **Ball** to the **Toe**. Name it **L_Toe_IK**. (Since this bird has three toes, there will be three toe IK handles.)

4. The very last joint of the toes is the claw. We'll put one single-chain IK handle from the ankle to the first joint of the dew claw. Name it **L_Dew_Claw_IK**. If you miss this step, the peel heel and toe tap will not rotate very well (I know—I learned the hard way). The leg should not have twisted or moved during any of this. If it did, remove the IKs and make sure you set preferred angle before doing it again.

Before we continue, we need to temporarily turn on a feature for the IK handles. Select the **L_Ankle_IK,** and in the **Attribute Editor>IK Solver,** turn the **sticky** attribute **on**. See Figure 10.3. Repeat for all of the L_Ball_IKs and the L_Toe_IKs. This will make the IK handles hold still, as if they had a controller or keyframe on them. This way, when we test, we'll know if our grouping/rigging in the next step worked or not. The IK handles visually change to have a red circle in the center when sticky is turned on.

Note: You don't want sticky on normally. If you have it on when doing the arms, for example, the arms will not behave correctly when you are testing. You'll freak out and email your professor. Don't do that.

A little note: When you add IK handles, it tweaks the math in the joints and adds rotational information. Usually, you'll see negative zeros show up.

Now, we will add group nodes to give the foot functionality. If this were just a shoed character with a one-joint system down the center of the foot, it would be much easier, obviously. The toed character gets a little more complicated, but the pattern is still the same—just more joints.

Figure 10.3 Turning sticky on for the IK handles.

Peel Heel

To create this functionality, select the **L_Ankle_IK** and the **L_Dew_Claw_IK**, and create a **group** node. Label this **L_PeelHeel_GRP**. **Move** the pivot point to the middle **ball** of the foot. See Figure 10.4. Now rotate that group node and see that

Figure 10.4 Adding peel heel functionality.

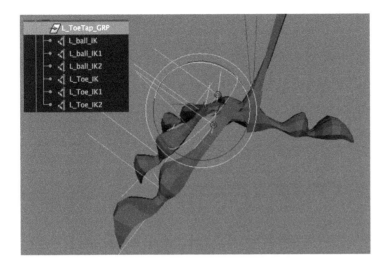

Figure 10.5 Adding toe tap functionality.

the heel should lift about the middle toe. If you rotate too far, the knee will flip backwards; that's OK. We haven't told the knee what to do yet. The heel lifts? Then you did well.

Toe Tap

To create this functionality, select the **L_Ball_IKs** and the **L_Toe_IKs** and create a **group** node. Label this **L_ToeTap_GRP**. Now, where should that pivot point go if you want the toe to tap? Yes, **move** the **pivot** point to the middle **ball** of the foot. Refer to Figure 10.5. Rotate that **L_ToeTap_GRP** to see that the toe does indeed tap. Good job. If you wanted individual toe tap functionality, you would need three separate group nodes, one for each toe. If the character isn't going to be drumming his toes or there are no close-ups on the feet during a walk cycle, that isn't necessary.

Tippy Toe

To create this final functionality, you want to select the **L_Toe_Tap_GRP** and the **L_PeelHeel_GRP** and **group** them. Name the group node **L_Tippy_GRP**. The Tippy Toe function lifts everything you have done so far up on its toes. Where should the pivot point go? Yes, move the L_Tippy_GRP **pivot** point to the **middle tippy** joint of the foot. Refer to Figure 10.6. When you rotate the L_Tippy_GRP node, everything should tip up on its toe.

Well, that wasn't too bad, was it? If you wanted to add in a roll left or roll right, you would add that group node just like you did the Tippy Toe, but with the pivot point in the correct place to get a roll.

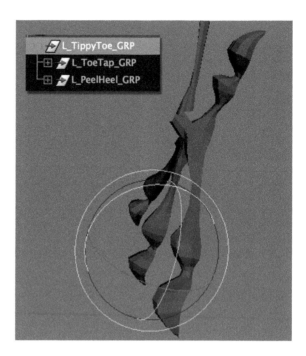

Figure 10.6 Adding tippy toe functionality.

Common Mistakes

1. The naming convention can be wrong, so confusion ensues.
2. Pivot points are in the wrong place, so you do not get proper rotation.
3. You forgot to put sticky tape on the IK handles. (The handle gets a little red circle on it when it is on.) With it off, the IK handles will not rotate properly.

Main Foot Movement

The last thing we want to do is add in a group node that will move the foot overall (and all of the other functions we just added) and also rotate the whole foot. For the bird, we'll keep the pivot point at the ankle; it is very close to the bottom of the foot. For a human foot, where the ankle is very far from the heel, I used to place the pivot point at the ankle as well. Then animator Matt Maloney pointed out that my rig could not rotate back on its heels and that rotating from the ankle didn't really give the best animation ability. He was right. In that case, you'd want to give yourself a joint to snap the last group node's pivot point to. To do that, you would:

1. Create a joint at the heel of your character. This is not a joint that needs to skin anything. It is only a joint to help us place the pivot points of our group. The pivot points must all be exactly the same. Name the joint **L_Heel_JNT**.

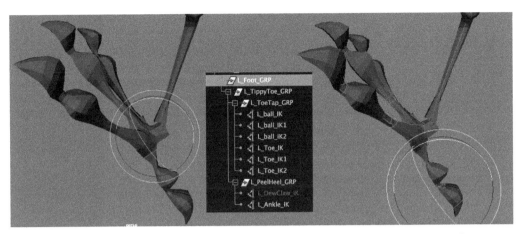

Figure 10.7 L_Foot_GRP pivot point placed at the ankle or the dew claw. Which rotates better?

Make it a child of the **L_Ankle_JNT**. Mirror that joint so that it appears on the right side as well.

However, in our bird, we don't need that joint; we actually already have the dew claw which could be used. Let's continue.

2. Select your **L_Tippy_Toe_GRP** and create another group. Name this **L_Foot_GRP**.

The pivot point of this group goes to the ankle joint. In a human character, it would go to the heel joint. If you want to test how it would look on the bird, put the pivot point at the dew claw and see how it rotates. Refer to Figure 10.7. When you move and rotate this group, the whole foot translates and rotates back on its heels. Later on, the dew claw can be either automatically animated based on the foot's rotation or left to be manually animated.

What other mayhem can you come up with for feet? Think about a tap dancer! How many places do they contact and push off with their feet? Golly.

Locking Them Down, Boss

Go through all of the group nodes and lock the translates and scales. Only the L_Foot_GRP will have the translates and rotates unlocked. I can be talked out of that. Test it and see what you think. You could utilize the translate function on any of these group nodes; it depends on how you want to animate. Rotating gives nice arcs. Translate gives nice poses. Hmm. Sounds like you should test an animation with that. Repeat the steps above for the right leg.

Adding Controls for the Animator

What do you want to give to the animator as a user interface? Here is where the rigs are absolutely different. You could

create a PeelHeel, ToeTap, and TippyToe attribute on a main foot controller. The main foot controller would connect to the L_Foot_GRP, and the attributes would connect one rotational axis to the three feet attributes. Yes, you could do that. That narrows your animation down to one axis for toe tap, peel heel, and tippy toe. Check it out with your animators; see if they like that. You could create a set-driven key (I saw this in a book somewhere) that, when slid from 1 to 10, goes through various stages of a foot step: peel heel up, toe tap down, toe tap up, peel heel down, and toe tap down. I can't say I've ever liked that one to animate with. Some people must. Because I have a tendency to not care for lots of sliders in the channels box and I want more than one axis of rotation, I will follow the more complicated method of creating on-screen controls.

1. Create a **controller** around the heel that will rotate the peel heel.
2. **FDH** (freeze transformations and delete history); name it **L_PeelHeel_CNTRL**.
3. Place the **pivot** point at the **ball** joint.
4. Create a **control** around the **ball** of the foot that will rotate the tap toe.
5. **FDH**; name it **L_ToeTap_CNTRL**.
6. Place the **pivot** point at the **ball** joint.
7. Create a **control** around the **tip** of the middle toe, which will rotate the tippy toe.
8. **FDH**; name it **L_TippyToe_CNTRL**.
9. Place the **pivot** point at the **middle toe** joint; refer to Figure 10.8.
10. Create a main foot **control** and position it under the foot. Name it **L_Foot_CNTRL**. Move the **pivot** point to the **heel**

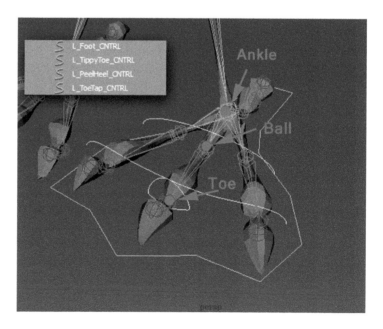

Figure 10.8 Creating controls to control the foot functions.

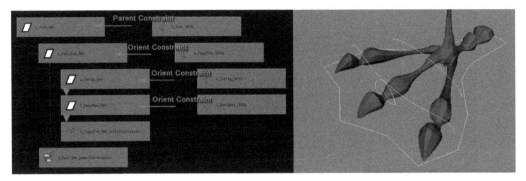

Figure 10.9 Controls constrained to group nodes.

joint or the ankle, depending on which way you have decided is best for the animator. On my bird, I'm using the ankle. On a human, I would use a heel joint. Freeze transformations and delete history.

Now to connect them; **except** for the **last** one, these are **all orient** constraints. Refer to Figure 10.9.

1. Select the **L_PeelHeel_CNTRL** and the **L_PeelHeel_GRP**, create **orient** constraint with the maintain offset **on**.
2. Select the **L_ToeTap_CNTRL** and the **L_ToeTap_GRP**, create **orient** constraint with the maintain offset **on**.
3. Select the **L_TippyToe_CNTRL** and the **L_TippyToe_GRP**, create **orient** constraint with the maintain offset **on**.
4. Select the **L_Foot_CNTRL** and the **L_Foot_GRP**, create a **parent** constraint since we want both translation and rotation information. In this case, the pivot point of the control is used, so make sure that the pivot point is at the same point as the **L_Foot_GRP**, which is the ankle.

If your pivot point for the L_Foot_CNTRL is somewhere else, say at the heel, you can use a point and orient constraint to use the group's pivot point. Check out how that works if you like animating this way or not.

Next, we'll set up the control hierarchy. We are going to mimic the hierarchy of the IK handles so that the controllers move the same way the group nodes do.

1. Make the **toe tap** controller and the **peel heel** controller **children** of the **tippy toe** controller.
2. Make the **L_Foot_CNTRL** a parent of the **L_Tippy_CNTRL** so that it moves all of the controls.
3. On all feet controls, lock the attributes you don't want animated.

Did you ask your animators? Did they say they liked translates or rotates? I'll only lock scales on mine to keep my options open. If they were new animators, I might only leave rotation unlocked. You now have a functioning foot with on-screen controls. Give it a test drive.

Repeat on the other foot. Simple, right? I remember the first time I saw the grouping foot method—I must have asked him to redo it five times so that I could get it. Craig Slagel—how did you put up with me?

The Knee

We will add a pole vector constraint, which is a little controller behind the knee that tells it which way to point. If this were a human, the controller would be in front of the knee. Create a **control**. I use the rig101 **spiral** and place it directly **snapped** to the **knee** (I do both knees at the same time), then **move** the control a little ways behind the leg of the character. I don't have a mathematical formula or rule as to how far; just far enough. Not too close (especially on a human where it would be in front), or it would need to be animated too much. Not too far (six units away), or it will need to be overanimated to do anything. Refer to Figure 10.10. In my head, I see a triangle from his foot to his hip to this pole vector, and I imagine it is a distance away from the knee, close to the length of his tibia—maybe. This is the easiest control you will make. **Freeze** transformations and **delete** history. Name the controllers **L_Knee_CNTRL** and **R_Knee_CNTRL**, respectively.

Select the **L_Knee_CNTRL** and the **L_Knee_IK**; create a pole vector constraint by clicking **Constrain>Pole Vector**. If you get too much of a jiggle in the leg (because the leg is not straight up

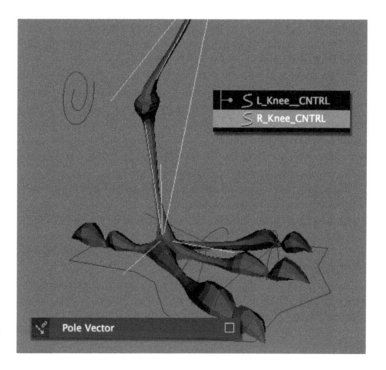

Figure 10.10 Pole vector controls for the knees.

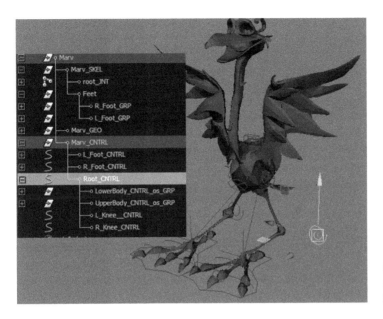

Figure 10.11 When the root control is moved down, the feet controls do not move.

and down), you can adjust it back to where it should be by using the pole vector constraint offset attribute of rotate X.

To see the pole vectors move, move the foot control while the knee stays pointing towards the pole vector control. **Lock** the **rotate** and **scale** attributes on the L_Knee_CNTRL and R_Knee_CNTRL. They should only translate.

Hierarchy: Where should this go? There are always healthy debates on this. Certainly, it should not move with the foot since your knee can move independently from your foot. Should it move with the lower hip? Well, I can cha-cha without affecting my knee direction. I'd say that the pole vector controls should be a child of the **Root_CNTRL**. Refer to Figure 10.11.

If you don't move the knees with the root, then you can move the body past the knees and the legs flip. You've probably seen rigs like that. It is up to you and your animators where you want to put those pole vectors. Everyone seems to be very opinionated about where they go, including me. Want to learn more? There are other methods for doing no-flip knees in *The Art of Rigging* (see the epilogue) or search for Adam White, a past student of mine who posted a video on this topic.

Cleaning Up

Where do the foot controllers go? They should not move with the root control since you want the root control to squat down. We haven't made a group yet for the controllers, have we? Let's make a Marv_CNTRL group by selecting nothing and **creating** an **empty** group. Make that empty group a **child** of the main **Marv** group. Make the **feet** control groups a **child** of the

Marv_CNTRL. Test that your Elvis cha-cha control (the lower body control) and your root control do not move the feet. Good.

What to do with those IKs? Take **both L_Foot_GRP** and **R_Foot_GRP** and group them together (yes, I like groups), then rename **Feet**. (There's a Richard Pryor joke in my head about "itty bitty feets.") Anyway, since IK handles are a part of the skeleton, make this feet group a child of the CHAR_SKEL group. Note that the pivot point of the feet group is at the origin. Any group we make for the organization should have the pivot point there. It's a nice, safe place and will do us well when we make this rig scalable.

Remember that foot movement is generally similar throughout most bipeds. A human foot has the same type of setup, simply minus the claws. Note that the heel peel used on the human foot in Figure 10.12 is moved via a translate instead of rotate. It could have been connected with a parent constraint (make sure that the pivot points are the same if you use a parent constraint) or a point constraint. If the controller and the group node's pivot points are in different places, then a point constraint will work better. What does translating instead of rotating do for the animator? It gives a different way to set the pose. For a dancer type of character, where there is much more foot placement control, translate might be better for the animator. Always check to see what they prefer to animate with.

Extra Effort: What things were left to do on that bird foot that would really make the rig do well? We did not add anything for the claws to rotate or for the dew claw. The animator may want to animate the claws individually. That would mean a controller driving the joint of the claw with an orient constraint. You will probably want offset group nodes over the controller. What would those controls be for a child? The main foot control, yes. What about the tippy-toe control? What would it look like if the claw controls were a child, or not a child, of that tippy toe control? Test it out and see. Another bit of functionality that could be added to the foot is an automatic movement of the dew

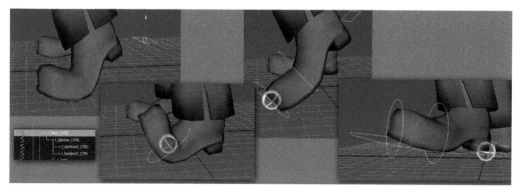

Figure 10.12 Human foot with a similar setup.

claw based on the rotation of the foot. If the foot rotates back, the dew claw could be set via a set-driven key to rotate to stay on the ground. Basically, it would be counter-rotating. Or is there a better way to deal with that dew claw? Once you get the basic rigging part down to something that is easy to do, then you have more time to deal with these other fun idiosyncrasies.

Excellent. This chapter might take a couple of tries until everything works. I'll take a coffee break and wait for you. Come on over to Chapter 11 when you are ready. Remember, take it slow and make sure you have the concepts before you move on. See file chpt10_Marv_bird_RIG_v5.ma for the finished rig from this chapter.

11

SPINES: FK, SPLINE AND SDK (SET DRIVEN KEY)

FK Spine

Open chpt11_Marv_bird_RIG_v5.ma. Well, here is an interesting thing in the bird rig—it barely has a spine. It has two spine joints and a super-long neck. The neck, in this case, will be rigged pretty much like a human spine. First, let's look at the functionality of this long, straight group of joints. If you select them individually and rotate them in Z, the character rotates nicely forward and nicely back. You have to select each one so that they can each individually rotate in Z. Double check in the outliner or the Hypergraph:Hierarchy if you aren't sure that you selected them all. Refer to Figure 11.1. If you have them selected correctly and they do not bend nicely forward and back, then there is a mistake in the joint orientations and you would need to fix that before going on.

We're going to rig the spine twice. First, we're going to do a nice FK spine, mainly because that is what I like to animate with. In terms of human character, I find it just enough. However, this bird character has such a nice, graceful neck that we should rig it as a spline-driven joint chain. I think it will give us much better control for the animator.

There is another type of back rigging technique (remember, we're treating this long neck like a back), which is an FK/IK stretchy spine setup. That would really be the best on this rig, but it is a bit too advanced to start with. You can find it in *The Art of Rigging* (see the Epilogue).

The bird neck won't have that many skinning issues. In a human character where there is a torso, you may find your geometry collapsing when he bends forward and backwards—that is a skinning issue that beginners mistake for an issue with the spine rigging itself. Displaying your tootsie roll/proxy geometry while you rig can help you overcome that beginner mistake.

For an FK spine, we are going to create a controller for each spine joint. Using Rig101WireControllers or your own, create a single controller and place the pivot point for each one at its corresponding spine and neck joints. The controllers should be

DOI: 10.1201/9781003431121-14

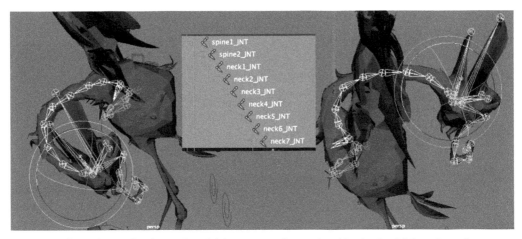

Figure 11.1 Selecting each spine and neck joint to rotate forward and back; check joint orientations.

close to the joint so that the animator knows what they control. For this bird, a circle might even look best.

Freeze transformations and **delete history**; name them **Spine1_CNTRL**, **Spine2_CNTRL**, **Neck1_CNTRL**, and **Neck2_CNTRL**, etc. You can adjust the CVs of the controller at anytime to make the controller look aesthetically pleasing to the animator. I can't stress that enough—a clumsy-looking control, which is difficult for the animator to select, slows down the animation process.

Creating Offsets

Anytime you create an FK control system, you really want to double check that the controllers are lining up the same way the joints are. We'll use the offset script. For each controller, select the controller and then the joint; run the **OffsetController** script. Repeat this for each spine and neck joint.

Hooking Them Up

Since we only want these controllers to rotate the joint, what constraint should that be? Yes, it depends on the pivot point. If the pivot points are the same, what type of constraint should we use? If the pivot points are the same, it doesn't matter; we can use orient or parent (with only rotation turned on). Good. You are getting it. To save a click, we'll use **orient** constraints for all of these controllers.

Select the first control and the corresponding spine: **Spine1_CNTRL** and then **Spine1_JNT**, for example, and create an **orient** constraint (**maintain offset** can be left **on**). Refer to Figure 11.2. Repeat for the other spine and neck joints.

Test the individual controls to make sure you have the constraint in the right direction. You learned your lesson last

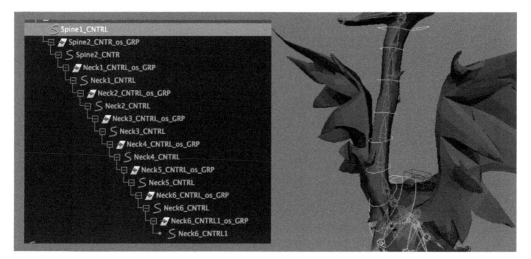

Figure 11.2 Creating a controller for each spine and neck joint of the bird with offsets.

time. Good. (If the controller turned purple, the constraint was created backwards.)

Hierarchy

To complete the setup, we want the controls to rotate one another in an FK fashion from the bottom of the spine to the top, since we bend from the hips; that is where the base of the rotation starts. This is true, unless, of course, we are being held by King Kong, which requires a different type of spine hierarchy all together—and drums.

Starting at the top of the hierarchy of controllers, make the **top**-most **controller** a **child** of the next controller. Since we have offset group nodes, the group node will be the actual child. For example, **Neck_6_os_GRP** will be a child **of Neck_7_JNT**, **Neck_5_os_GRP** will be a child of **Neck_6_JNT**, and so on. The controller hierarchy will mimic the hierarchy of the joints themselves.

Test. If you rotate the bottom spine control, the rest of the spine and neck controllers should rotate as well. If you select all controls from the youngest child up (I found that funny), I mean, from the bottom of the hierarchy (Spine1_CNTRL) to the top of the spine control hierarchy (Neck7_CNTRL), and rotate them all on their Z axis, you should get the same movement we had before where the character bends forward or back nicely.

The last step for the spine/neck is to make the **Spine1_ CNTRL_os_GRP** a child of the **UpperBody_CNTRL**.

Test. The upper body, when rotated, should rotate all of the spine and neck. Refer to Figure 11.3. Those eyes are still bugging out since we've done nothing to them. Lock: for all of the spine controls, lock the translate and scale attributes; those controllers are only meant to rotate.

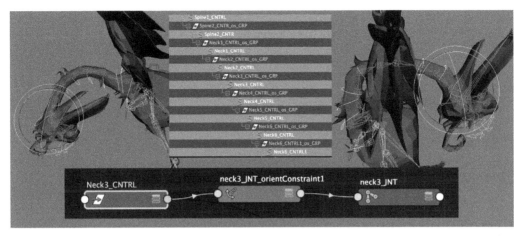

Figure 11.3 Controllers drive the joints with orient constraints and are placed in a hierarchy. The offset group nodes keep the controller matching the joint's rotational axis.

Why do I like the FK spine? In a human character, I can really push for a curved back when doing a lift animation and have individual controls for each spine to get the curve I need. I would want that in a cartoony rig. We don't really move like that anatomically, but when pushing a pose, it is needed. If you need to see the example file, this version of the bird rig can be found in the chapter material labeled: chpt11_Marv_bird_RIG_ v6_FK_Back.ma.

What other things could you do with this FK setup? I've seen a setup where the animator did not have individual controls for each spine; instead, there was one slider, which, when moved up and down, drove a set driven key that bent the spine forward and back. We did that back in our tentacle chapter. I've also seen that same type of setup where the set driven key was driving a group node over each of the individual spine controllers so that the animator could still tweak the individual spines. If you chose to do that, the set driven key group node would be under the offset node. In fact, let's try that.

Set Driven Key Spine

Let's add the ***set driven key functionality to the spine. All we need to do is add a group node over top of the controllers. Select **Spine1_CNTRL** and create a group node by clicking on **CNTRL+g**. You'll notice that the group node sets the pivot point at the joint and is offset correctly; it is also a child of the offset group node. Name it: **Spine_1_SDK_GRP**. Repeat this grouping step for each controller in the neck.

What we are going to do is create a set driven key so that when the Spine1_CNTRL is rotated, all of the neck rotates. The set driven key is going to go from the **Spine1_CNTRL's rotate** in

Z attribute to all of the **SDK_GRP's Z** rotates. You can also do the same for the Y and X rotate values.

To make the set driven key window a little manageable, let's go ahead and **lock** all **translate** and **scale** attributes on the **SDK_GRP** nodes. Want to learn a cool way to select all of the SDK_GRP nodes? At the top right of the Maya window, where we had been renaming things, click on the drop-down and choose Select by name. In the text field, type ***SDK*** and hit enter. Now all nodes with SDK in the name will be selected. Any click saved is time saved!

With all of the SDK nodes selected you can lock the translate and scale attributes, and all of their translate and scale attributes will be locked. With those still selected, open up the set driven key window by clicking on **Key>Set Driven Key>Set**. In this window, select all of the **SDK** nodes and **rotate** in **Z** as the **driven** attribute, **except** for **Spine1_SDK_GRP**. We actually aren't going to use that Spine1_SDK_GRP node. Instead, load the **Spine1_CNTRL** 's rotate in **Z** as the **driver**.

Click **Set** to set a set driven key for the neutral state of the bird's neck.

Setting the Forward Position

Select the **Spine1_CNTRL** and rotate it in **Z** forward to an extreme position. Select **all** of the **SDK** group nodes **except** for **Spine1_SDK_GRP** and **rotate** the neck **forward**. Click on the **Set** button in the set driven key window.

Setting the Back Position

Select the **Spine1_CNTRL** and **rotate** it in **Z** backwards to an extreme position. Select all of the SDK group nodes **except** for **Spine1_SDK_GRP** and **rotate** the neck **backwards**. Click on the **Set** button in the set driven key window. Repeat these steps for the rotation in **Y** and the rotation in **X,** if desired. Refer to Figure 11.4.

Test. Select the Spine1_CNTRL and rotate it back and forth in Z to see the automatic movement. The animator can still adjust all of the controls for each individual neck joint and keyframe them. The version of this rig can be found in the chapter material: **chpt11_Marv_bird_RIG_v7_SDK_Back.ma**.

Spline Spine

The last type of spine control system that we will put in requires that we **remove** all of the **FK** controls in the neck but **keep** the **Spine1_CNTRL** and the **Spine2_CNTRL**. Open chpt11_Marv_bird_RIG_v6_FK_Back.ma and select all of the neck controls and delete them. Make sure to keep the Spine1_CNTRL and the Spine2_CNTRL.

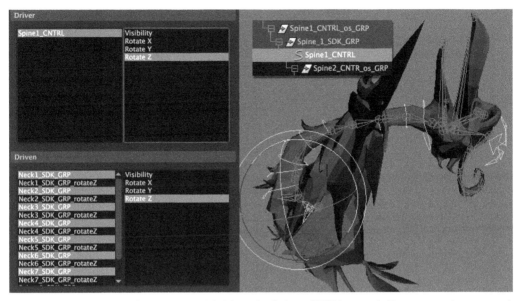

Figure 11.4 Set driven key functionality added from the Spine1_CNTRL rotate in Z to group nodes over each controller.

We are now going to add an **IK** handle from **Neck1_JNT** to **Neck7_JNT**. Select the option box for **Skeleton>Create IK Spline Handle**. We are going to use the default settings and change the number of **Spans** to **2** and the **Twist Type** to **Ease in out**. Click on **Neck1_JNT** and then on **Neck7_JNT**. This creates an IK handle for the length of the neck.

If you select the end effector and try to move it—you will not see a move manipulator. What does that mean? It means that this IK handle cannot be moved. Rename it to **Neck_IK**. If we can't move the IK handle, how can we move the neck? If you hide the geometry and the skeleton, you will see what was created: a curve. Select the **curve,** and with your cursor in the outliner, hit **f** on the keyboard. This will frame the curve in the outliner window so you can see it. This is what controls the joints; it is moved by moving the control vertexes. Be careful while testing here; move a CV to see it move and then undo once to put it back in the neutral pose. There isn't a way to zero out the CVs; we'll have to put controllers on these very quickly. Rename the curve to **Neck_Curve**. Refer to Figure 11.5.

Select a **CV**, show **joints**, and click on the pick mask option so that you don't accidentally select the joint. Move the CV to see how the joint reacts. Remember to undo once to put the CV back in its neutral pose. Use the up and down arrows on the keyboard to go to the next CV.

This moves very nicely, doesn't it? This is perfect for necks, tails, etc. An IK Spline setup gives a very different type of movement to the FK spine setup. The IK Spline will rotate from

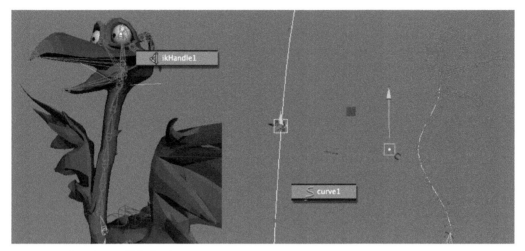

Figure 11.5 Creating an IK Spline handle on the neck.

the bottom of the neck, and then the inner portion of the neck is driven by translating the CVs. You can get a nice "s" curve out of it more easily, but not the easy curled-up motion you get with an FK. Now, set it up so the animator can get to it. How many CVs did we end up creating? We created three internal CVs and two external CVs. This was dictated by the number of spans we added in the option box. We are going to create **five controllers** to drive those CVs, but first we need clusters.

Creating Clusters

First, **select** each of the five control vertices (**CVs**) and **create** a **cluster**. Make sure that the cluster option for **relative** is turned **on**. It takes a little selection to get back to each CV. Hide joints, geometry, and IK handles so you can only see the curve. Name the clusters appropriately: **Neck_1_Cluster**, **Neck_2_Cluster**, for example. Refer to Figure 11.6.

Creating Controllers for the Center Part of the Neck

Create three controllers that line up close to the middle CVs. Let's go ahead and line the pivot points of the controllers up to the joints themselves. Name them **Neck_CNTRL_1**, **Neck_CNTRL_2**, and **Neck_CNTRL_3**. Use the **offset script** to properly line up these controllers by **selecting** the **controller** and then the closest **joint**; run the **Offset Controller** script.

Since the CVs don't correspond with a joint, what type of constraint will we use to translate when pivot points don't match and we want to use the child's pivot? **Point** constraint: excellent.

Select **Neck_CNTRL_1** and the corresponding **cluster**; mine is Neck_Cluster2. **Create** a **point** constraint by clicking on

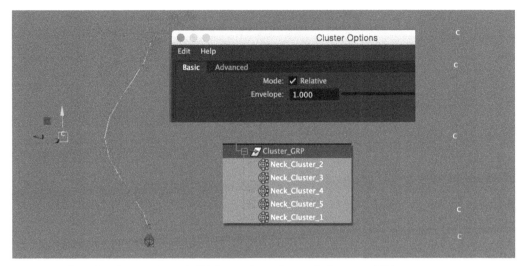

Figure 11.6 Creating clusters for each CV. Remember to have relative turned ON.

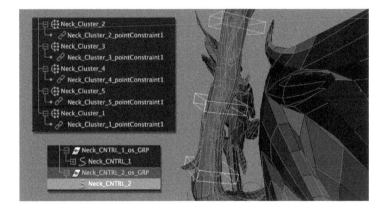

Figure 11.7 Creating controllers to drive the center clusters via point constraints.

Constrain>Point Constrain. Make sure that **Maintain Offset** is turned **on**. Repeat for the other two neck controllers. Refer to Figure 11.7. **Lock** the **scale** attributes on the **neck controllers**.

Creating a Controller for the Top of the Neck

The top of the neck needs a controller, just like the inner parts of the neck. If this were a human, it would truly be the neck joint(s). Humanistic biped characters really should get at least two neck joints. If you nod your head up and down, you'll see that most of the neck bend looks like it comes from the center of the neck. If you drop your head forward or jut your head forward (usually when making a funny face), the bottom part of your neck is engaged. Our bird is all neck; the very top part moves the base of the head and the head joint.

To keep things visually uncluttered, I will choose to use a controller that sits at the base of the neck—a pyramid. Create a **controller** of your own choosing and place it at **neck7_JNT**.

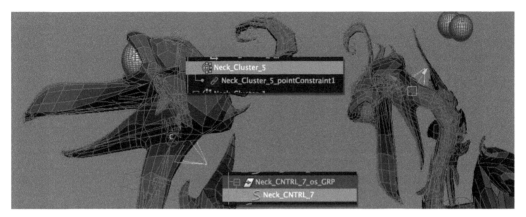

Figure 11.8 Top controller point constrained to the top cluster.

Name it **Neck_CNTRL_7**. Rotate it so that it lines up visually with the back of the neck, and make sure the pivot point is at neck7_JNT. Select the **Neck_CNTRL_7** and the **neck7_JNT** and use the **OffsetController** MEL script. Now your controller is well placed and ready to be hooked up.

Naming Convention Note: For some reason, I have labelled these as **Neck_CNTRL_7** instead of **Neck7_CNTRL**. I'll leave it that way since the companion data has it this way, evilly knowing that there are riggers out there who will twitch at seeing a name end with a number. Sorry Schindler.

Select the **Neck_CNTRL_7** and the **cluster** for the top CV of the neck curve; mine is called Neck_Cluster_5. Create a **point** constraint. Refer to Figure 11.8. Test by selecting just the controller and moving it around. The controller doesn't rotate with the neck yet; don't worry—we'll fix that in a bit. **Lock** the **scale** attributes.

Creating a Controller for the Bottom of the Neck

Well, here we come to a point where we need to think about how the neck works, and the use of an IK Spline. If we put in the ability to translate the IK spline at the very base, it will stretch the joint away from the non-IK-ed joint and look unrealistic. To see this, translate Neck_Cluster_1 and watch the bone between neck1_JNT and spine2_JNT. We're going to create a controller that is point-constrained to the cluster anyway; this way the cluster will move with the rest of the rig when it is moved, but we will not let the animator have the ability to move it.

Create a **controller** that sits **in front** of the **neck**. I will use a triangle. Name the controller **Neck_Twist_CNTRL**. Freeze and delete the history. Since this controller isn't meant to directly correlate to a joint's rotation, there is no need to do an offset on it.

Select the **Neck_Twist_CNTRL** and the **Neck_Cluster_1**. Create a point constraint (with **offset on**). Then promptly **lock**

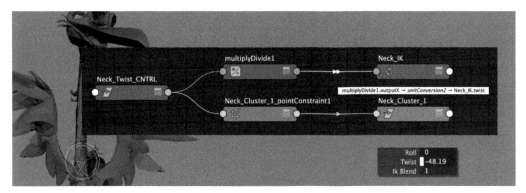

Figure 11.9 Creating a controller to move the bottom cluster and twist the neck. This controller has a multiply divide node to make the rotations match.

the **translate** attributes for the **Neck_Twist_CNTRL**. That constraint is only so the cluster will move with the rig and is not for the animator.

While we're working on this control, let's hook it up to an attribute you may not be aware of. Take a look at the Twist attribute on the **Neck_IK**. When adjusted, the Spline IK handle twists. Remember that ease in attributes we set when we created the IK handle? You can still adjust that, if desired, in the attribute editor. While you are there, turn on root twist mode to see how the twist looks slightly different. I'll turn it on for my rig. We could take the controller's rotation as an X value and hook it directly to the IK handle's twist value. That is a one-to-one connection. How do we do that? Do you remember? Somewhere close to Chapter 3. Correct. Refer to Figure 11.9. We can use the Connection Editor or the Node Editor window; you remember now.

Select the **Neck_Twist_CNTRL** and the **Neck_IK**, and open the Window>Node Editor window. Using the right mouse button, connect the **Neck_Twist_CNTRL's** rotate **X** to the **Neck_IK's** twist. **Lock** all attributes for the Neck_Twist_CNTRL **except** for the rotate **X**. Rotate the controller in X, and the neck should twist back and forth. Oh my! It rotates backwards from the controller. Goodness. I guess you'll need to use a multiply–divide node. Review Chapter 4 to remember how.

Hierarchy

Your gut instinct should be to take all of the offset groups for the neck controllers and make them a child of the Spine2_CNTRL. Better save your file first. If you make the offset groups a child of the Spine2_CNTRL, the neck will become all twisted. It works for all of the controllers except for the twist-neck controller.

So, to give a level of offset, take all of the **neck controllers** and **group** them. Label that group **Neck_GRP**. Make the **Neck_GRP** a child of the **Spine2_CNTRL**.

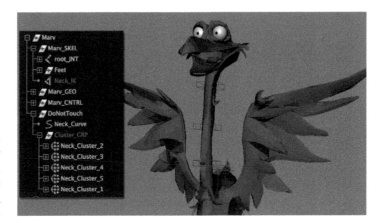

Figure 11.10 Placing the controllers in a hierarchy and putting the clusters, Iks, and curves out of harm's way. (chpt11_Marv_bird_RIG_v8_Spline_Back.ma).

We aren't out of the woods yet. Rotate the Spine2_CNTRL to see what you get. Oh goodness, a double transformation. What? Something is telling the neck to rotate twice as far as it should. This is the part that gets everyone messed up when they deal with Spline IK handles—because we automatically trust where Maya put the curve in the hierarchy and are afraid to move it. Move it, we must. Many books will tell you when making the IK Spline to turn off the option for auto-parent. We didn't—I'm evil that way. We'll learn how to get out of this very common mistake.

Locate the **Neck_Curve** in the outliner. If you switch to wireframe mode, you can see the curve being rotated forward by the joint. Select nothing and create a **group** node; name it **DoNotTouch**. Make the **Neck_Curve** a child of the **DoNotTouch** node. Make the **DoNotTouch** group node a **child** of the main character node named **Marv**. Refer to Figure 11.10.

Test your rig by rotating the Spine2_CNTRL to see that the neck rotates correctly now. What could have gone wrong there? Make sure you have the Spine2_CNTRL zeroed out before you move the Neck_Curve, otherwise your neck will be stuck in the double transform position.

The last little bits of clean-up are to group the clusters together and name that group **Neck_Cluster_GRP**. Make that group a child of the **DoNotTouch** group. Lastly, place the **Neck_IK** under the **Marv_SKEL** group. Go ahead and select the **DoNotTouch** group node and change the visibility to **0**. We don't want to see what we shouldn't touch.

Extra effort: Just to see how it would behave, I selected a neck joint and then the neck control and created an orient constraint. I repeated this for the three inner neck controls and the top neck control.

The top neck control, the pyramid, is the one that visually needs that extra constraint so it rotates well for the animator. There is no functionality in this constraint, except aesthetics. In animation tests, you can decide whether you like the constraint

or not. Lock the rotation attributes on the neck controls. In animation tests, you might determine that the box controllers don't look right when they are animated. They feel cluttered. Perhaps a simple ball at the back of the neck would have done better. Change as needed before putting your rig into production.

Head

There should, at minimum, be a head control that rotates the head. Since we have already rigged the neck as an extended part of the back, rotating the head joint is about all the functionality that is left to add a controller to. Create a controller for the animator to rotate the head with. I will use rig101WireControllers' **Arrows on Ball** icon. Move the control to be on top of the head; rename **Head_CNTRL**; freeze transformations; and delete history. With the controller so far away from the joint, you have a choice. Keep the pivot away from the joint, or place it in the same place as the head joint? It feels a little weird to the animator, in my opinion, to have the pivot point far away from the controller. So, I will keep my pivot point centered on the controller. If the pivot points are in separate places, what constraint can we not use? The constraint we cannot use is the parent constraint. That is fine, because the parent constraint won't work for the trick we're about to do anyway. If you try to use the parent constraint on this next bit, you'll get a cycle warning. Remember that—this one will give you a headache at 3 AM in the morning.

Select the **Head_CNTRL** and **Head_JNT**, and create an orient constraint with maintain offset **on**. This will cause the head to rotate when you rotate the head controller, but the head controller stays behind. Do you remember how to make it follow the head? Select the **head_feather1_JNT**, or whatever you called that joint, which is right at the top of the bird head, and then select the **head controller**. Make sure you select the joint first. Create a **point** constraint with an **offset on**. Now when you select the head controller and rotate it, it rotates the head but also translates in space to match the top of the head. Just as a reminder, a parent constraint won't work correctly with the pivot points and will throw a cycle check warning. A cycle check warning means that something is looping over and over again, and Maya has stopped that from happening. If it didn't stop the cycle, the character might jitter off the frame. **Lock** the **translate** and scale attributes on the head controller.

A note on a human neck with only two joints: I mentioned, back when we were creating the bird neck, that a human neck should have at least two bones to help approximate how we bend our neck. Here's a neat setup for that type of neck and its controllers. You would create a Neck1_CNTRL, and place it at the bottommost neck joint and do the typical orient constraint between Neck1_CNTRL and Neck1_JNT.

To get a nice blend for the second neck joint, you could create an orient constraint from the Neck1_CNTRL to the Neck2_JNT, and then also create an orient constraint from the Head_CNTRL to the Neck2_JNT. What this does is that the Neck2 joint will follow both the head and the neck1 and live somewhere in-between. This gives a nice blend between the head and the neck. I don't know when we came up with that one in class. Students in animation tests didn't like having multiple neck controls, and this was a good solution.

Hierarchy

Where to put the head controller? When you bend over your neck, it does not necessarily rotate with your body. It is separate in rotation. (Hold a chicken and move it back and forth to see this in action; a live chicken—it doesn't work the same with a dead chicken.) To make the head rotate with the body, you would make the head control a child of the top neck FK controller, or the top spine controller if you had a Spline spine. We don't really move this way; our neck and head are not tied to our backs, unless you have a rod up your spine.

The way we have the controller already point constrained to the joint means there isn't much we have to do to the controller. It already goes with the rig. Simply make it a **child** of the **Marv_CNTRL** group. Refer to Figure 11.11.

Test. When you rotate the upper body, the neck and head controllers move along with the joints. The head does not rotate with the upper body; I call this the chicken head movement. I spent a lot of time with chickens as a child.

For those advanced in the group. What if you did want the head to have the option of rotating with the body or not? You can turn constraints on and off and set up an animatable switch. With that switch, the animator could have the head rotate with

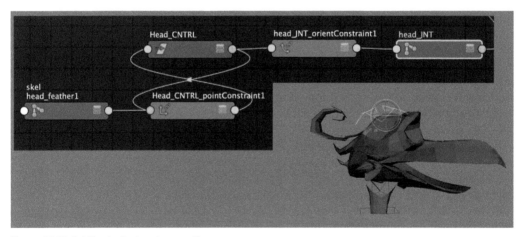

Figure 11.11 Adding in the head controller.

the body and then turn it off so they could have it animating without rotating the body. Hmm. Sounds like a fun setup. Go look at some rigs on https://www.highend3d.com/ and see if you see something like that out there. Look up space-switching. There is also a hint on how to do just that thing in Chapter 19.

For the rest of us mere beginning rigging mortals—we'll keep this setup. In the chapter materials, you will find a completed bird up to this point with an FK spine, a set driven key spine, and a Spline IK spine. I will continue rigging the Spline IK spine for the rest of the chapters. A current version of the rig can be found in a file named: chpt11_Marv_bird_RIG_v9.ma.

Jaw/Beak

Most characters will have a mouth of some type. This character has a beak but also has the addition of an upper beak joint to get a cartoonier feel. We'll add more functionality to the face later with blendshapes. For now, a bone driving the large open and close movements works very well. Some character setup artists choose not to use bones at all and drive the jaw completely with blendshapes. We'll add two controllers: one for the top beak and one for the bottom beak.

Remember, most characters will only have a bottom beak/jaw. I used a 180-degree thin rotational arrow as a beak controller. Move each controller to the end of each beak, one for the top beak and one for the bottom beak. Place the **pivot** points at the **tip** of the respective beak joint; freeze and delete history. Name them **Btm_Beak_CNTRL** and **Top_Beak_CNTRL**. To cause the beak to rotate open and closed when the controller is rotated, we will use a rotation constraint. Just like we did with the head controller, we will use a point constraint to make the controller move along with the joint.

Select the **Btm_Beak_CNTRL** and the **lower jaw joint**. Create an **orient** constraint. Select the **Top_Beak_CNTRL** and the **upper jaw joint**, and also create an **orient** constraint. To make the controllers move along with the beak as it opens, do the following: select the very **tip joint** of the **bottom** jaw and then select **Btm_Beak_CNTRL**; create a **point** constraint. Repeat these steps for the top beak: select the very **tip joint** of the **top** jaw joint and then select the **Top_Beak_CNTRL**; create a **point** constraint. Refer to Figure 11.12.

Test. Rotate the top and bottom beak controls, and the beak should open and close; put the controls back to zeros in the rotate attributes.

Test further. Rotate the Head_CNTRL and see that the beak is being left behind. Oops. Easily fixed: make the **beak** controllers **children** of the **Head_CNTRL**.

Test again. Rotate the Head_CNTRL, and the beak should rotate along. Give a double check on all the other controls to

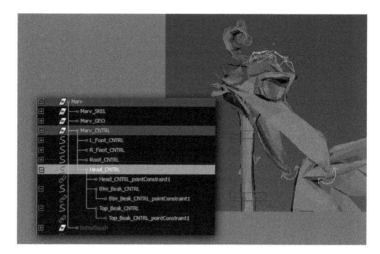

Figure 11.12 Adding in the beak controllers.

make sure you haven't accidentally undone something. I find that with chronic Z pressers (undo), oftentimes they undo too far back—and don't notice. They ultimately undo something that worked and don't realize it until much later. Also, with the technique of doing an orient constraint one way and a point constraint back the other way, be very careful with adjusting hierarchies or doing undos. Occasionally, undoing will cause the dreaded cycle error to show up. If that happens, delete the constraints and recreate them from scratch to make sure they are wired properly in order to not cause the cycle error.

There are other ways to get this chicken head type of setup. Digital-Tutors (http://pluralsight.com) has a rig setup where they use an IK handle to do this.

Check and save. The chapter material's version of this rig is named **chpt11_Marv_bird_RIG_v10.ma**.

Extra effort: What do you want to do with that feather controller? You could create a set-driven key for the animator to flop it about—good idea! Oh, there is always someone in the room who wants to make it dynamic. Not in this book. We ran out of pages. A hint: use a Spline IK handle whose curve is actually a dynamic hair. There's a bonus tool in Maya that does that.

Make sure that your controllers all work and zero out to the neutral position. Save your work. Good job! We are moving right along now, aren't we? I want to reiterate here that most of what we have done is very similar to what you would do for a human rig: a biped is a biped. When you are ready to move into advanced rigging, you will find the difference in exactly how it is going to move and what type of stretchiness you want to give it. Oh, that sounds like fun, doesn't it?

12

ARMS, ELBOWS, AND CLAVICLES: SINGLE CHAIN, TRIPLE CHAIN WITH WRIST TWIST (SDK OR CLUSTER)

I have such fun with arms that I think we should highlight a few ways to do them. There are a few methods around—some old, some new. The wing of the bird in this case is given bones pretty much like an arm, so it will have a similar setup (ignoring the concept of the feathers for now). Also, to make things a little simpler, I have added in some very basic shapes for the wing, hid the original low poly version, and unparented all the feather joints and hid them too (chpt12_Marv_bird_RIG_v11.ma). It was literally making me nauseous to look at all of that stuff while working on the wing. We'll focus on the core functionality of the wing/arm, with no need for bicarbonate.

Functionality

Let's think of an arm's functionality. First, there is the shoulder, which rotates the whole appendage. Next, there is an elbow that bends, generally in one direction. Afterwards, there is a lower arm twist, which rolls the lower arm/wrist/hand in a limited amount (in X). Then, the hand itself rotates up and down (in Y), and slightly side to side (in Z).

I won't insult you with a picture; please provide your own arm as an example and look at how it rotates. When animating an arm, using the FK method gives very nice arcs and is one of the original methods of animating appendages. For arms, you would want to utilize FK movement when the arms are naturally swinging from the shoulder and IK movement when the arms are contacting. If you haven't already done a few animations switching back and forth between IK and FK, please go do that first before continuing. It helps to understand how you would animate them (and even better, why it looks good or doesn't) before learning the complexities of rigging the feature.

DOI: 10.1201/9781003431121-15

IK/FK Switching Methods

Here are some methods for accomplishing a switch between IK and FK as seen in Figure 12.1:

1. Using one bone chain with an IK/FK switch. This is a newer method derived after Maya implemented an IK blend attribute for the rotational plane IK handle (Version 7.5+ of Maya). It works well enough, but can be prone to flipping issues or jiggles if you aren't careful.

2. The older style triple-chain IK/FK switch method is a hardy solution that works well and is slightly more advanced. With the triple-chain system, you have a main skeleton, which the geometry is skinned to, and then you have an IK arm (no hand) and an FK arm (no hand) that are rigged separately and constrained to drive the main skeleton via orient constraints.

To accomplish the lower arm wrist twist, there are also many methods.

1. **Set driven key**. This is easiest for artists, I find. We will do it in this chapter. This is where you simply create a set driven key that rotates the wrist twist joint when either the FK or IK wrist control is rotated. There is one thing to watch for—the blend node that is created could pump through both IK and FK set driven key information, causing a double twist in the lower arm. A simple utility node can be used to fix it if you want to be a purist; else, it is an issue the animator must be aware of.

2. **Cluster**. This is an interesting method where one clusters the lower arm skin and simply constrains those clusters to rotate with the wrist joint. You can use cluster weighting to handle the falloff.

 The gotcha with this method is that you only want to orient constrain the wrist control to drive the X rotation of the clusters. If they rotate off the bone, the result is undesirable. See Figure 12.2 for how undesirable it is.

IK > Hand off

FK > Hand off
FK > Arm Orients off

Figure 12.1 Single-chain (left, middle) and triple-chain (right) methods of IK/FK switching.

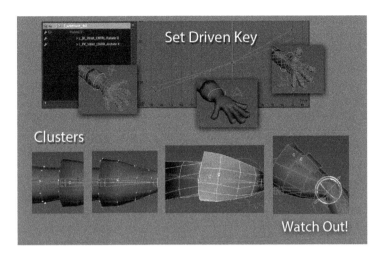

Figure 12.2 Methods of lower arm twist.

3. **Multiply/divide** node. You can also do a lower wrist twist with utility nodes; anything can be done with utility nodes. I love them, but my classes generally did not find them easy for a beginning method. If you want to try it, it is basically a multiply/divide node from the wrist controller to the wrist twist joint. The wrist twist joint should move less than the wrist—so multiplying it by 0.5 will slow it down.

Things to Understand and Be Aware Of

First, understanding IK handles a little more: IK handles can be turned off. If you select an IK handle and move it, the joints rotate as the IK solver instructs them to. If you keyframe the IK handle, you can no longer grab the joint and rotate it freely (in FK mode). So, you have to be able to turn off the IK handle in order to animate the join in FK. Select the IK handle and turn the IK Blend attribute to 0 (off), then you can rotate the joint in FK mode. If you move the IK handle, the IK handle will move, but the joints will no longer rotate with it. Since you have had experience with this type of animation (you put this chapter down and tested it out first, right?) and you have had a character that had to switch between IK and FK, you know how important this is in a rig. What type of character movement needs a switch? In class, we have an evil assignment (originally designed by Rob Bekhurs), where a character has his arms crossed, uncrosses them, and then places his hands against a wall to listen to something.

The arms are in FK mode, rotate with the body, and are driven by the shoulder while the arms are crossed and become uncrossed. But once the hands have contact with the wall, then the arms become IK. This way, the body can lean into the wall, but the hands remain in the same position. Another subtle example is if a character has his hands in his lap and he shrugs, then lifts his hand to wave. During the shrug, the hands are still

contacting his lap and thus are in IK. Once the character lifts his arm (with his shoulder) to wave, his arm becomes FK. The same can happen with legs, as we've mentioned before. Contact = IK. No contact = FK, usually.

Some people animate with IK all the time. Scrape. Scrape. Scrape. Scrape. Drags the soapbox out. Step; step; standing on my soapbox. I say—ICK! Shame on you! All that extra time wasted in the graph editor to get good arcs, which you get naturally with FK, but this isn't an animation book. Step; step; putting my soapbox away. Check out what Sir Wade has to say on the subject: https://www.youtube.com/watch?v=p6PYKyxR0aY.

Second, you need to understand numbers. When one switches from an FK arm to an IK arm, it is absolutely necessary that you have a good understanding of any numbers that are in the joints' rotations or in the offsets of the constraints.

1. The joints should have zeros in the rotations when you set the FK arm up. If you start to see odd numbers in the joints, stop, backtrack, and see where those came from. Any numbers will start to introduce a jiggle when you switch from FK to IK.

2. When the IK handle is added, it may add gentle rotational numbers to the joint. You'll see it in the blue attribute channels. (They are blue because of the FK controller constrained to them.) You can't do anything about those numbers, which is OK. The IK handle needs to do that to calculate the rotational plane, where it bends the elbow.

3. When you have a constraint that has two drivers (in versions 7.5 +), like an FK controller and an IK controller, they share one set of offsets. If you used an offset group node over the FK controller, then it will not need offset numbers in the constraint. If you did not, it will have offset numbers in the constraint, and the IK controller may also introduce numbers into the constraint's offset. But there is only one set of numbers. You'll need to watch those offset numbers and create a set driven key to make sure each mode has the offset it needs. In our bird's left wrist joint, this happens with just the IK controller. The symptom is a rotating hand when switching between IK and FK.

4. Negative and positive worlds can cause a flipping issue in the arm when switching between IK and FK. If your FK controller is giving a negative number when rotated down, but when the IK controller is moved down the joint it gets a positive number, the universes of the arms are reversed, and the arm will flip 360° when you switch between the worlds. This will usually happen on the character's right arm. How to avoid this? Placing the offset group node over the FK controller builds the offset into the group node and not in the controller, and eliminating the flipping issue. Refer to Figure 12.3.

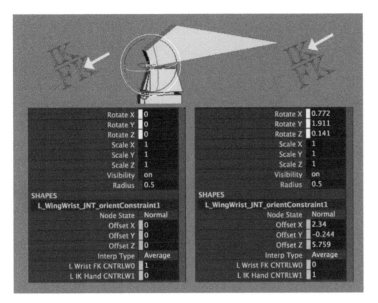

Figure 12.3 Rule #6: Clean math!

Not All Arms Are Created Equal

The most simple arm, which will not give issues, is an arm made completely in a T pose, created 90° from the body, with the shoulder, elbow, and wrist completely in a straight line with a bare trace of a bend in the elbow. In addition, the elbow, wrist twist bone, and wrist are all in a straight line. Whew! If you create that type of arm in your character, nine times out of ten there won't be much problem with the arm. In production, however, I've never seen that darn arm! Usually, the character designs are very stylized, and if the model was made with the wrist in line with the elbow, the deformation of the character wouldn't look as lovely. Chris Landreth (creator of Ryan and other fabulous 3D animation feats) wrote an article about how a proper arm should be at 30° and slightly in front of the body, aligned with the scapular plane of the skeleton. He also talks about it on *The Making of Ryan* DVD. I live on a mountain that just got internet in 2020. November 2020! So, hard-copy media is still in my life.

With the way we're going to cover arms, you should be able to tackle any of them that come your way, because I've tried to point out all the issues you might run into. Figure 12.4 reminds us that the arm and the hand are handled separately. When we speak of the IK/FK switch, we are talking about how the arm is handled. The hand movement is a separate function that you have to rig as well. In the image, I showed the rotational axis, just to remind you that occasionally they do not point down the bone. For this hand, the X-axis points down the center of the hand so that the hand rotates correctly when twisted from side to side.

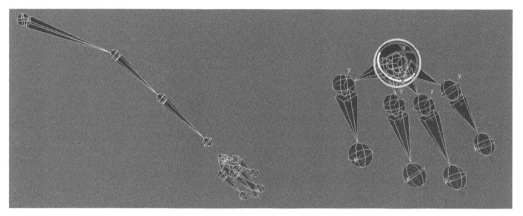

Figure 12.4 Arms that are created offset, which causes nicer movement and edgeloops, will need extra care to have clean math.

Down to Rigging That Arm: The Abstracted Steps

The first time you come across an FK/IK switch, it can seem daunting since it contains a lot of steps. Let's break it down into some simple blocks of steps to help you understand what it is you are actually doing. I find this more than helpful when trying to solve problems.

1. Rig the FK arm: rotate the shoulder, elbow, wrist/hand.
2. Rig the IK arm: translates arm from wrist and also rotates wrist/hand.
3. IK/FK_Switch for each arm:
 a. Turns FK off or on.
 b. Turns IK off or on.
 c. Turns the visibility of controllers off or on.
 d. Turns off or on which controller rotates the hand.
4. Add automatic wrist twist.
5. Don't forget the pole vector constraint for elbow and controller's visibility.

Single Chain Method

Goal 1: FK Arm

Create FK Controllers

We'll start with my simplified bird character found in the file: **chpt12_Marv_bird_RIG_v11.ma**. The FK arms are going to have controls for rotating the shoulder, the elbow, and the wrist. Go ahead and create an aesthetically pleasing control at the shoulder, elbow, and wrist. I like the 180-degree arc. Move them to their respective joints, and make sure the pivot point

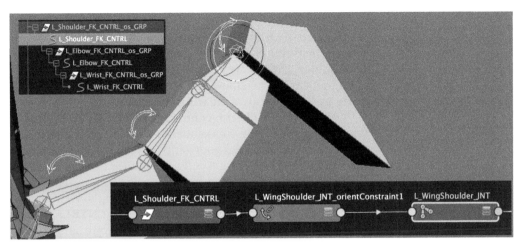

Figure 12.5 FK setup wing for both wings.

is snapped to the respective joint. Rename them: **L_Shouder_
FK_CNTRL**, **L_Elbow_FK_CNTRL**, **L_Wrist_FK_CNTRL**.
Remember to freeze transformations and delete history.

Do You Want a Perfect Rotational Axis?

If it bothers you that the rotational axis of your controller
doesn't 100% line up with your arm joints, then there is some
freeze transformation magic to be done. If you don't care, you
can skip this part, but this part will also save you from having
a possible issue show up in your rig where, when you switch
from IK to FK, the arm spins madly in a 360-degree arc or does a
horrible 90-degree jerk. Given that we have a script for it, there
is no reason to skip this step. Refer to Figure 12.5.

1. Select the **L_Shoulder_FK_CNTRL** and the **left shoulder
 joint**.
2. Run the **OffsetController** script.
3. The group node will always keep the offset numbers, so
 never freeze them; only the controller should be zeroed
 out.
4. To be safe—**lock** the attributes on the **offset group** nodes.
5. **Repeat** for the **elbow** and the **wrist** controllers.

Make the FK Controller Hierarchy

You want the FK controllers to rotate with one another, so
make the **wrist controller** a **child** of the **elbow controller** and
the **elbow controller** a **child** of the **shoulder controller**. If you
have the offset group nodes, then make the wrist offset node a
child of the elbow controller, and make the elbow offset group
node a child of the shoulder controller. The group nodes are just
in-between nodes.

Create Constraints

To make the controllers rotate the joints, we need to do an orient constraint. Select the **L_Shoulder_FK_CNTRL** and the **L_Shoulder_JNT**; create an **orient** constraint (maintain offset is **on**); repeat for the elbow and wrist. **Lock** the **translate** and **scale** attributes for all of the **wing FK** controllers.

Test. Rotate the FK arm controllers and make sure that the wing rotates correctly. Remember to zero out your controller when you are done. Check your joints—are they still all nice and blue and zeroed?

Repeat for the other wing.

Warning: You need to have very nice naming conventions to keep things less confusing here. These are **FK_CNTRLS**. This is very important since the constraints you create are named after the name of the CNTRL. You'll need those names to help you keep things straight later on.

Test and make sure your math is good. Refer to Figure 12.6. If your controllers are not zeroed out, or not named correctly, or there are numbers in your joints, fix it now before going on. We'll wait.

Clean up the outliner: While we're in the neighborhood, let's put the **FK arms** away nicely in the outliner. Since this portion of the rig is FK, all you have to do is look for the next thing in the FK hierarchy that the wings should be under. It would be the **closest spine** control if this were a human or a character with a straight spine. Since this bird does not have much of a spine, the **FK wing** controls will go under the **UpperBody_CNTRL**. In the outliner, the middle mouse drags the shoulder offset groups (and all, i.e., a child underneath them) beneath the Upper_Body_CNTRL control.

Test: When you rotate the upper body control, the FK arms should rotate as well.

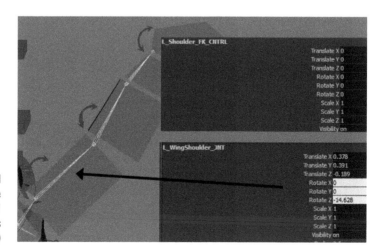

Figure 12.6 Oops! Rotational numbers in the joints before constraining the controllers! Redo. (Obviously, I did this while writing this chapter!)

Goal 2: IK/FK Switch for the FK

Before going on to set up the IK portion of the arm, we'll create the IK/FK switch that will turn the FK arm on and off. In class, I find that if I wait too long to do the switching, no one understands completely what is going on. So, we'll take it in little bits at a time.

If you select the left shoulder, elbow, or wrist joint, you will see a constraint listed in the inputs area of the channels box. For example, the shoulder FK constraint is called L_WingShoulder_JNT_OrientConstraint1. Under that constraint, there is an attribute L_WingShoulder_FK_CNTRL_WO. This is an attribute named after the control and is the on and off switch for the orient constraint. The W0 stands for weight number 0. You will see similar attributes under the elbow and wrist joints. If you turn those constraint weight attributes to 0, the FK controls will no longer work.

The FKs have been turned off. We will create a controller that turns those three constraints off and on. There are many places to put an IK/FK switch controller and many ways to create the controller. Usually, I place a small controller at the wrist, but with this bird character, there is too much visually going on to place the IK/FK switch anywhere near those wings. Instead, let's import a controller I have made. Import the controller into your rig by going to **File>Import** and selecting the IKFK_Switch.ma. This file contains a simple piece of text (IK and FK) and two controllers that have been limited to only moving so that they point to the IK or the FK text. Refer to Figure 12.7.

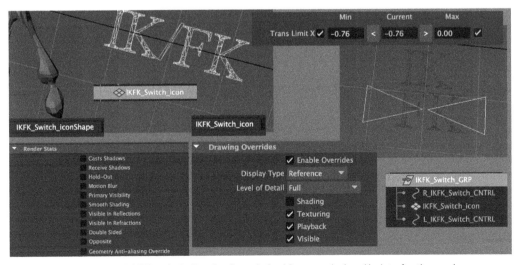

Figure 12.7 Creating an IK/FK switch. Render Stats is for Maya rendering. Update for the renderer you are using: Arnold, Redshift, etc.

There are other ways to create an IK/FK switch. You've more than likely used a custom attribute that switched from 0 to 1, or from 0 to 10. Those are just fine to use. But in the classroom, I found that the numbers caused a little confusion, and this method helps the idea sink in much easier. I think the first time I saw this type of controller used was with student Danny Tiesling, who used to work at Sony Picture Imageworks.

Open the set driven key window by clicking **Key>Set Driven Key>Set ….** Load the L_IKFK_Switch_CNTRL by clicking the **L_IKFK_Switch_CNTRL** (on the character's left of the text) and click on **Load Driver**. In the window, select the **Translate X** attribute.

The driven will be the three orient constraints. We'll have to do them one at a time since their attributes each have a different name. There are many ways to locate the orient constraint nodes. If you select the FK controllers and open the **Node Editor**, you can locate them easily. Also, by selecting the joints and hitting "f" in the outliner, you can open up the joints to find the orient constraints.

Create a set driven key that sets all three FK constraints to be on when the left triangle is pointing at the FK text, and create a set driven key that sets all three FK constraints to be off when the left triangle is pointing at the IK text. You should know how to do this by now, but as a refresher, here are the details:

1. Select the **shoulder** joint's **FK constraint**. Mine is named: **L_WingShoulder_FK_OrientConstraint1**. Click on **Load Driven** in the Set Driven Key window.

2. Select the following attributes in the Set Driven Key window:
 a. **Driver** is the **L_IKFK_Switch_CNTRL>Translate X**.
 b. **Driven** is the **L_WingShoulder_FK_OrientConstraint> L_WingShoulder_CNTRL_WO**.
 Remember that the WO attribute is the weight of the constraint: 0 = off, 1 = on.
 Key them on:

3. Make sure the **left triangle** is pointing to the **FK** text.

4. Select the **shoulder's orient constraint** weight, make sure that it is set to **1** (it is on); in the Set Driven Key window click on **Key**.

5. Select the **elbow's orient constraint** weight in the Set Driven Key window; make sure that the constraint weight is set to **1** (it is on); in the Set Driven Key window click on **Key**.

6. Select the **wrist's orient constraint** weight in the Set Driven Key Window, make sure that the constraint weight is set to **1** (it is on); in the Set Driven Key window, click on **Key**.
 Key them off:

7. Move the **left triangle** to point to the **IK** text.

8. Select the **shoulder's constraint** weight, make sure that it is set to **0** (it is off); in the Set Driven Key window, click on **Key**.

If you want to create your own controller—create a polygon text (Create>Type) which says "IK/FK." Turn off "enable extrusion" under the geometry tab. Place the controller at the feet of the character; rename to IK_FK_CNTRL; freeze transformations; lock all the attributes. Since this is a polygon, we will need to open the attribute editor and change all of the render stats to off and the display overrides to reference, so that the text is not selectable. Two NURBS triangles were created to point to the text, and the translations were limited.

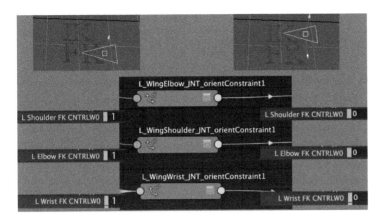

Figure 12.8 Creating a set driven key to turn the FK constraints on and off.

9. Select the **elbow's orient** constraint weight in the Set Driven Key window; make sure that the constraint weight is set to **0** (it is off); in the Set Driven Key window, click on **Key**.

10. Select the **wrist's orient** constraint weight in the Set Driven Key window, make sure that the constraint weight is set to **0** (it is off); in the Set Driven Key window, click on **Key**.

Test. Click on the **shoulder, elbow,** and **wrist** joints, and make sure in the channel box you can see that all the weight attributes under the **orient constraint** have a color (dark blue in newer versions of Maya, salmon in older versions), indicating they have a set driven key assigned to them. If you do not see that they have a color, then you have forgotten to set a driven key on them.

Test. When in IK mode, the FK controllers should not work. When in FK mode, the FK controllers should work. Do not continue until this part works. If something is broken in the FK arm and the IK/FK switch, it isn't going to get any better. Don't waste time building something else on top of it.

Warning: Remember to select the weight for each constraint and click on the key. Refer to Figure 12.8. It is easy to forget and thus not create a set driven key on it. Driver. Driven. Attribute. Key. Say it as you click.

Repeat for the other wing.

Goal 3: Rigging the IK Handle

First select the **shoulder** joint and **right** mouse click; select **set preferred angle**. This will make sure that the elbow will be calculated in this position. Look at the rotations in your arm—there are no numbers, right? The FK controls are all at zero, and the math is all good. If not, you will ultimately get jiggly arms. (If you ever had a relative with larger, flappy underarms, please think of that for a small smile.) I don't mean Auntie May's jiggly arms; I mean that the whole arm will twitch a little from shoulder to hand when you switch between IK and FK.

If you have numbers, make sure your controllers are all zeroed out. If your controllers are all zeroed out and there are still numbers, you might want to remove the FK constraints and freeze transformation on your joints. But you didn't miss that step way back when, so you don't have numbers in your joints, do you?

Next, we have to look at a special way to deal with the anatomically incorrect bone placed right in the middle of the lower arm: the wrist twist bone. If we were to place an IK handle from the shoulder to the wrist, the wrist twist bone would be treated as a second elbow, or a broken arm depending on how you look at it; probably not what you want. Instead, we will learn a way to tell an IK handle where to calculate, and we will adjust where the animator moves it from.

Create a **Rotate-Plane Solver** (RP) IK handle from the **shoulder** to the **wrist twist** joint located between the elbow and the wrist. Refer to Figure 12.9.

Warning: Read that carefully—a RP IK handle that stops at the wrist **TWIST** bone.

This will only calculate the elbow. Next, we need to adjust where the animator grabs the IK handle. **Select** the **elbow** joint and locate it in the outliner. (If you hit f in the outliner, the bone will be framed in the window.)

Open the plus sign next to the joint and **select** the **effector**. It has a number behind it, depending on how many effectors you have made. Mine is effector28. In the main window, using d and v moves, snap the pivot point of the effector to the wrist joint. Using the move tool, select the **L_Wing_IK** and move it—note that the elbow bends but the wrist twist does not, and the handle is at the wrist. Excellent. Undo once to put the **IK** handle back in its **original position**. Beware; do not undo multiple times, or you will undo your pivot move. Another method is to RMB on the shoulder

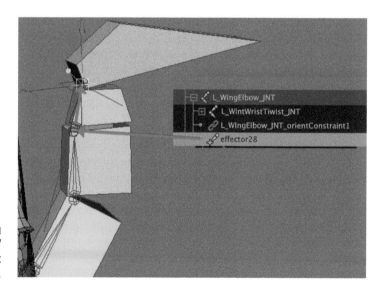

Figure 12.9 Creating an IK handle on a wing/arm that has a wrist twist joint.

and select Assume Preferred angle (dangerous, that method—I always accidentally choose the set preferred angle). You'll note I've added a material color to the wing; the gray was getting on my nerves. Repeat the IK handle procedure for the right wing.

Creating a Controller for the IK Handle

Create a **NURBS** circle or circle to look like a square and place it at the wrist of the wing. Make sure the pivot point is at the wrist; freeze and delete history; name the controller **L_IK_hand_CNTRL**.

We're going to add a **group** node over the **IK handle**, which we'll drive instead of the IK handle itself. This will keep the IK handle from having a refresh problem when we switch from FK to IK. Select **L_Wing_IK** and create a group node. Make sure the **pivot** point is at the **wrist** as well. Name the group node **L_Wing_IK_GRP**. Select the **L_IK_hand_CNTRL** as the driver, and select the **L_Wing_IK_GRP** as the driven. Create a **point** constraint (with **maintain offset on**).

What if you didn't have the group node? If you didn't have the group node, the constraint would absolutely have to maintain offset on. "Why does maintain offset need to be on?" a student in the back of the class asks, because the dogged IK handle has numbers in it. Prior to setting the constraint, you can try to freeze the IK handle, if you are brave. In the attribute editor, turn sticky on momentarily, then freeze transformations. Turn sticky off. If all goes well, the IK handle is zeroed and the wing doesn't twist sideways.

Test. The controller should move the IK handle around (via the group node). Refer to Figure 12.10. The FKs now won't work properly because we've added the IK. We'll get that fixed next.

Repeat for the right wing.

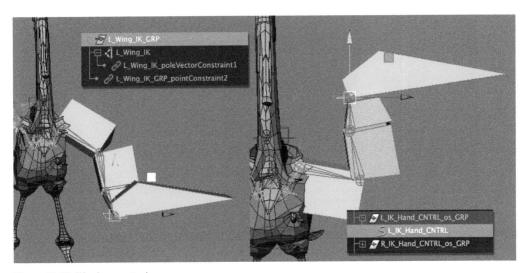

Figure 12.10 IK wing control.

Goal 4A: Turning On and Off the IK Handle

You will find an IK blend attribute in the IK handle's attributes. It is used to turn off and on an IK handle. We'll make a set driven key that turns that on and off with our IK/FK switch. Place the **IK/FK switch** into **IK** mode; in the Set Driven Key window, make sure the controller is loaded and the **Translate X** is selected as the **driver**. Also, select the **IK handle** and make sure it is loaded and the **IK blend** attribute is selected as **driven**.

1. With the IK blend attribute on (set to **1**) and the IK/FK controller set to **IK**, click on **Key**.
2. Turn the IK/FK switch to **FK** mode.
3. With the IK Blend attribute off (set to **0**) and the IK/FK controller set to **FK**, click on **Key**.

Test. Place the IK/FK switch into FK mode. Rotate the shoulder controller. The FK arm should rotate. Switch the IK/FK switch back to IK mode. The arm/wing should rotate back to the neutral position where the IK controller is. That is expected. You now have an IK control and an FK control, which can be moved independently of one another. The next step would be to hide the controls that aren't needed.

Repeat for the right wing.

Goal 4B: Turn Visibility of Controllers Off or On

The last thing for the IK/FK switch is to hide the controllers that aren't needed. We'll again use a set driven key. Create a set driven key so that when the IK/FK controller is in **FK** mode, the **FK** controllers are **visible** and the **IK** controllers are **invisible**. Refer to Figure 12.11.

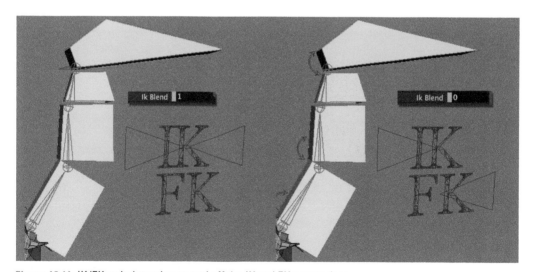

Figure 12.11 IK/FK switch turning on and off the IK and FK constraints.

Create a set driven key so that when the IK/FK controller is in **IK** mode, the **FK** controllers are **invisible** and the **IK** controllers are **visible**. Done.

Hint: You can select all the driven controllers for one wing at once in the Set Driven Key window. I'm not going to write the steps out—by now you should be able to do that. If not, it isn't mission critical and I challenge you to figure it out.

Goal 4C: Who Rotates the Hand?

The answer is that both of the controllers rotate the hand, or you can choose to have a separate control that rotates the hand. I don't care for separate controllers. When in IK mode, I like to move the arm by grabbing a controller at the wrist and also rotate the hand with the same controller. When in FK mode, I like to rotate the arm at the wrist as well. Since FK controllers really shouldn't follow the arm when the IK controller is running the show, using the FK controller for all of the wrist movement bothers me in a purist sense. You can come up with your own method. In this chapter, we're going to allow the IK controller to rotate the hand and the FK controller to rotate the hand. With that said, we'll have to make sure those constraints get turned on and off when we do an IK/FK switch.

A constraint already drives the hand (wrist joint) when you rotate the hand controller (L_WingWrist_JNT_orientConstraint1), and we have already set it to turn on and off with the IK/FK switch. We just need to add driving the wrist joint with the IK controller.

1. Select the **L_IK_Hand_CNTRL** and **the L_WingWrist** joint (driver>driven).
2. Create an **orient** constraint (with maintain **offset on**).

Test. The hand is listening to both controllers, so it will only move half as much as the controller.

Select the good old, very useful **L_IKFK_Switch_CNTRL** and load its **Translate X** as the **driver** in the Set Driven Key window. Locate the **L_WingWrist_JNT_orientConstraint1** in the outliner or Node Editor and load-**driven**. The W0 attribute already has set driven keys on it; that was the FK constraint. Select the W1 attributes, which should bear the same prefix as your IK controllers. (You labeled them correctly?)

1. With the IKFK switch in **IK** mode, the **IK constraint** should be set to **1**.
2. Click **Key** in the Set Driven Key window.
3. With the IKFK switch in **FK** mode, set the **IK constraint** to **0**.
4. Click **Key** in the Set Driven Key window.

Test. The hand should rotate completely with only one controller in the appropriate mode: with the IK controller when in IK mode and with the FK controller when in FK mode.

Jiggle alert 1: If you get a twitch in the arm itself when switching from IK to FK then there could be some potential issues that have crept in.

1. The joints had nonzero in them when you started adding the constraints.
2. The set preferred angle wasn't done before you put in the IK handle (in version 2012 + this can be an issue).
3. Rigging gremlins.
4. A constraint wasn't given a correct set driven key. There are a lot of steps, so it is important to check at each testing point that things are working correctly.

Jiggle alert 2: If you get a twitch in the hand when switching from IK to FK, then there is an offset that is being introduced into the constraint. I have it in the bird's left hand but not the right. So I might have goobered something in my own rig early on. You might not have it. I fixed it by adding in a set driven key to set that offset as keyed when in IK mode with the offset numbers, and then keying the offset to zero when in FK mode.

Finally the Wrist Twist

There are many ways to complete this task: expressions, utility nodes, etc. But you know what? Set driven keys work just fine and are a little more artistic and less mechanical in feel.

FK Wrist Twist

Again, open the set driven key window. The **driver** is the **L_Wrist_FK_CNTRL>Rotate Y**, the **driven** is the **L_WingWristTwist_JNT>Rotate X**. (Make sure you are in **FK** mode.) Refer to Figure 12.12.

1. Rest wrist twist position = **L_Wrist_FK_CNTRL** at **0** and the **L_WingWristTwist _JNT** is at **0**; set **Key** in the Set Driven Key window.

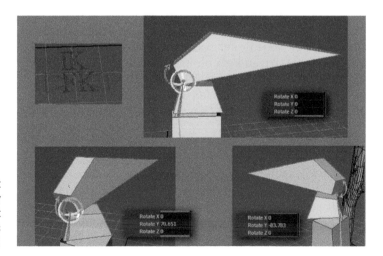

Figure 12.12 Wrist twist created with set driven key for the FK controller. Don't forget the IK controller gets the same treatment!

2. Left twist = rotate the **L_Wrist_FK_CNTRL** to the left; rotate the **L_WingWristTwist _JNT** to the left until it feels natural; set **Key** in the Set Driven Key window.

3. Right twist = rotate the **L_Wrist_FK_CNTRL** to the right, rotate the **L_WingWristTwist _JNT** to the right until it feels natural; set **Key** in the Set Driven Key window.

4. Remember, you can adjust those keys in the graph editor.

Test. The lower arm should twist with the wrist.

Repeat for the IK wrist twist.

Test. The lower arm now twists when either the FK or IK wrist is rotated in X.

You have a completed arm. Take a breath and do the final test: switch the arm from FK to IK. Any jiggle? Any flippage? If yes, redo it. The trick is to watch the numbers in the joints.

Extra effort: Anyone sees an issue in that type of wrist twist? Since it is a set driven key, you can't turn the "weight" of it on or off whether you are in FK or IK mode. So both handles constantly drive the wrist–twist joint. That does mean you could get a stacking of wrist twisting where both controllers would ask for a wrist twist. It is a shortcoming in this setup if you stop here. Many in my class do. If you want to put in that last little bit of extra effort and get thanks from your animator, you can set up a utility node and a set driven key to fix the double wrist twist that could crop up. In my version 12 of this rig, I left the right wing without this fix—so you could see the difference. Refer to Figure 12.13.

1. Insert a **blend** (Blend Colors) node utility node in-between the animation **curve** node and the **wrist** twist joint.

2. Plug the output of the **FK animation curve** into the **blend node's>color 1R attribute**.

3. Plug the output of the **IK** animation curve into the **blend node's>color 2R attribute**.

4. Plug the **outputR** of the **blendColor** node into the **L_WingWristTwist_JNT's Rotate X** attribute.

5. **Delete** the unneeded **blendWeighted** node that Maya had created for you.

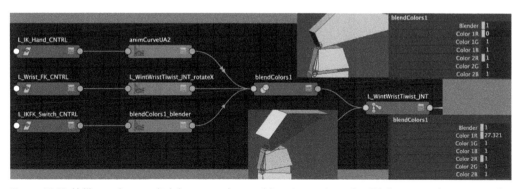

Figure 12.13 Utility node to switch between the set driven key wrist twist. Well now, we have some nice wings switching from FK to IK. Good job. Just some loose ends to tie up.

6. **Create** a **set driven key** that sets the **bendColor's Blender** attribute to **1** when in **IK** mode and **0** when in **FK** mode. In 0 the first color's numbers will be sent to the joint; when blender is set to 1, the second color's numbers will be sent to the joint. Remember, Maya starts counting at 0.
7. **Repeat** for the other wing.

Elbow Pole Vectors

I always forget to do elbow pole vectors in class, every single time. Once and for all, here are the elbows: **create** a **controller** worthy of being an elbow pole vector. I'm going to use the spiral. Place it in line with the elbow, then move it back away from the arm far enough so that if the arm/wing were bent, it would still have some room before touching the controller. Freeze it; delete the history; name it **L_Wing_PV_CNTRL**. Repeat for the right wing.

Let's talk about what a pole vector is. For most arms and legs, you don't really care because it is generally easy to create a pole vector constraint, that is, if the ankle is lined up below the hip or the wrist is lined up with the shoulder. For the other eight out of ten rigs, you'll have to know a little more. If you select the IK handle and look at where the rotational plane is being calculated (indicated by a white arrow), you can see how it relates to the pole vector rotational numbers.

There may be some numbers in there if you don't have a completely straight up and down appendage. You can see in Figure 12.14 there are some base rotational numbers that were added. When adjusting the Pole Vector's X value, it rotates the way the "elbow/knee" points. The other axis will adjust where the flipping point is.

Remember these numbers; we'll see them again. My wing has numbers in the Z: –0.534; also shown in Figure 12.14.

Select the **L_Wing_PV_CNTRL** and the **L_Wing_IK**; create a **pole vector** constraint (Constrain>Pole Vector).

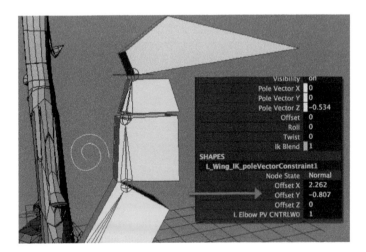

Figure 12.14 Pole vectors and the offsets needed for nonstraight arms.

If your wing swung backwards, it's OK. Deep breaths. Remember that number we looked at in the previous paragraph? Let's look again.

Select the **L_Wing_IK** and see what numbers it has now. Why, now the attributes are blue and there are numbers in the X and Y too! Those new numbers need to be subtracted from the pole vector constraint. Mine are: Pole Vector **X** = **–2.262** and Pole Vector **Y** = **0.807**.

Note what your numbers are. Look for the pole vector constraint, L_Wing_IK_poleVectorConstraint1, and add in the negative of those numbers in the offset attributes. My **Offset X** = **2.262** and my **Offset Y** = **–0.807**. The wing is now back in its original position.

Test. To test for jiggle, switch from IK to FK mode to see how much jiggle is in the arm. There should be barely any. Next, switch to IK mode, move the arm, and then move the pole vector controller to see the elbow move.

Repeat for the right wing.

Cleaning the Outliner

We need to lock up attributes and put away our IK controllers and handles.

- IK controllers: lock scale attributes.
- IK offset group nodes: lock translate, rotate, and scale.
- Elbow pole vector controllers: lock, rotate, and scale.

When you select the root control and squat the character down, you do not want the IK hands or feet to move with it. As we did before, select the IK controls and move them under the Marv_CNTRL group. Following what we did with the legs, move the elbow pole vector controllers under the root control. (That's where I tend to like them—you might disagree.)

For the IK handles themselves, I like to take the handle IKs and group them together, label them wing_IKs, and move them under the group node for Marv_SKEL. The reason being, IKs are not part of the animation group; they are part of the skeleton and should be kept away from the animator. The IK/FK switch can go under the Marv_CNTRL group.

Test. Make sure things still work after you have cleaned up the outliner.

Clavicles

It is a nice feature to be able to shrug the shoulders of a character. Some people like to translate the shoulders; some people like to rotate them. I like both.

1. Create a **SC** (Single-Chain) **IK** handle from the **clavicle** to the **shoulder**.

 Warning: Make sure you got that right—a SC IK handle; label this IK the **L_clav_IKHandle**.

2. You can place this **L_clav_IKHandle** under the **wing_IKs_ GRP** that we made earlier.

3. **Create** a small **controller** and place it at the clavicle; freeze; delete history; name **L_Clav_CNTRL**. Make sure the pivot point for the control is at the **clavicle**.

4. **Select** the **clavicle** control and the **clavicle IK handle**; create a **parent constraint** with maintain **offset on**. This will let you move the IK handle up and down and rotate the arm.

5. **Lock** the **scale** attributes on the controller.

6. You now **group** them together in a **Clavs_GRP** and place them under the **Spine1_Body_CNTRL**.

7. **Repeat** for the other wing.

You can check out version chpt12_Marv_bird_RIG_v12.ma to see the rig so far.

Pushing further: Looks like it would be a nice feature to have the clavicle automatically rotate when the arm tries to raise above the T pose, since that is how we naturally move. That sounds like some set driven key fun. Try it if you like. Remember, if you automate it—make sure the animator doesn't want access to it.

Triple Chain Method?

If you want to try the triple chain method, there really isn't much difference except that you duplicate the arm/wing twice. Those duplicates are still in the hierarchy of the joints. Name them FK and IK, respectively. Delete any joints in those duplicates that aren't a shoulder, elbow, wrist twist, or wrist. You rig them the same as described above. The addition is that the joints of the FK orient constrain/drive the main skeleton, and the IK orient constrain/drive the main skeleton. The IK/FK switch must turn on and off those eight constraints.

My heavens, did you make it through? The arm is where you have to be the most detail-oriented, I find, or the mistakes compound here. Take it one step at a time, and check things often as you go so you can see at what step they started to go mathematically awry.

HANDS: SDK, SDK AND KEYABLE CNTRLs

Hands are not super-difficult to rig for the animator, really, depending on the hand setup—there just might be a lot of controls. The trick is to find out how the animator wants to deal with the digits, give them what they need, and do not overcomplicate it.

Looking at the storyboards would be the first course of action. What is actually needed? The second course of action would be to talk to the animator.

What are some methods you might consider?

1. Set driven key for stored simple hand movements. If all that is needed is a few simple hand poses, since the character does very little with his hands, then a set driven key for those stored poses may be all that is required. We'll start with this method. Incidentally, this might be all that is used for a game character.

2. Set driven key for each finger to curl. This is something like what we did with the tentacle. It is easy enough, and is for the animator who does not require very much dexterity in the character's digits.

3. FK controls for each digit's joint. Here's where you get to create a controller for every joint in the hand. Personally, I like to use the auto-rigging function of Zoo Tools for fingers. But this bird character just won't work with that, will it? Darn.

The things to watch out for:

- Make sure that if you are combining set driven keys and constraints, you do not drive the animator's controls: the set driven key drives a group node over the animator's controls. Remember, the animator's controls cannot have constraints on them; it messes up when they animate.

- The hand controls move with the hand, whether it is in IK or FK mode. It is not part of the IK/FK switch. A good way is to parent constrain the whole hand control system directly to the main joint system's wrist joint.

- Do a super good job of labeling, as always. The animator will depend upon those names when they work in the graph editor.

DOI: 10.1201/9781003431121-16

Our bird rig has been updated slightly for this chapter. The file **chpt13_Marv_bird_RIG_v13.ma** has feather joints on the right wing but no feather joints on the left wing. I've also done a little bit of reskinning; not perfect, but better. This bird is constantly seen with his arms up in the air and holding up a fish. The only real articulation is in a thumb and a forefinger feather. We'll only work with those joints on the right wing. We're going to redo the hand a couple of times, so save with different names.

A Simple Set Driven Key

This should be a review for you. With your rig or this chapter's rig (version 13), **import** the following controller file: **hand_CNTRL.ma**. This controller has an enumerator attribute for open, close, and point.

Set the following set of driven keys, as seen in Figure 13.1. To have that controller follow the hand at all times, create a **parent constraint** from the **wrist joint** to the **controller**. (You'll need to unlock the attributes first.) Place the controller under the **Marv_CNTRL** group node. This example is saved in the file: **chpt13_Marv_bird_RIG_v14.ma**.

I made that too easy, didn't I? But what is the drawback of this method? The drawback is in the enumerator attribute for the hand position. It is either open, closed, or a point. It does not create any in-betweens or show any of the set driven key transitions—it simply pops from one pose to another. A different type of controller, which uses an integer, would be better to get the in-betweens. So why show you the other way? Now you know the problem it creates. Evil; I know.

Recreate the right-hand control by importing the file Finger_CNTRL.ma. (Take a look at those controls. How are they staying on the curve?) The L_PointerFNG_CNTRL should drive the rotations via its Y-axis. The L_ThumbFNG_CNTRL should drive

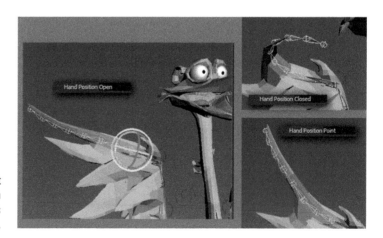

Figure 13.1 Creating set driven keys for hands with an enumerator control does not give in-betweens.

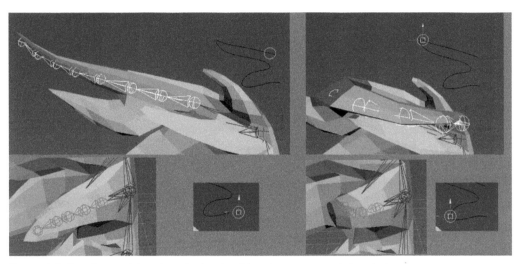

Figure 13.2 Creating set driven keys for hands with an integer control gives in-betweens.

the rotations via its Z-axis. Refer to Figure 13.2. (FNG stands for Finger. What were you thinking it was??)

You could continue and create a set driven key that folds up the feathers when the arm is folded close to the body. This example is saved in the file **chpt13_Marv_bird_RIG_v15.ma**.

What if you wanted to also allow the animator to adjust the rotation of the joints? This wing will need offset group nodes to keep the rotational axis lined up with the joints. This combines methods we have learned before.

1. Create a **controller** for each joint. Make sure the pivot point is at the joint. Name them L_Pointer_CNTRL# or R_Pointer_CNTRL#, depending on if you are rigging the right or left wing.

2. Create an **offset group** that holds the garbage numbers for that FK controller using our handy dandy Offset Group script. These are autonamed L_Pointer_CNTRL#_os_GRP.

3. Select the **controller** again and **create** another **group**. This is the group for the set driven key. The pivot point is automatically placed at the joint. Name them L_Pointer_#_SDK_GRP.

4. Place all of these **FK** controllers and **group** nodes in an **FK hierarchy** together, and make that hierarchy a **child** of the **wrist controller**. See Figure 13.3.

5. Select the **FK controller** and the **corresponding joint**; create an **orient constraint**.

6. Import the finger controls used previously, or create a **controller** for the set driven key.

7. Create a **set driven key** for **open** and **closed** positions from the set driven key controller to the group nodes that you created: L_Pointer_#_SDK_GRP. Since we labeled them well, you can type *SDK* into the outliner to show only those group nodes. See Figure 13.3.

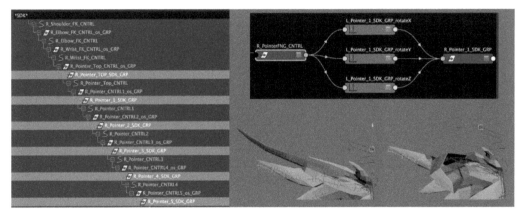

Figure 13.3 Creating a set driven key open and close with individual joint control system for the feather/finger. Note the naming convention is mixed up!

Test. You should be able to set a key with the set driven key controller to open and close the finger, and you should be able to set keys on the individual controllers to adjust the poses just a bit further.

To Clean Up That Rig

1. Select the **wrist joint** and the set driven key finger **controls**; **parent constrain** so they will move with the wing.
2. Place that hand's set driven key **controller** system under the **Marv_CNTRL** group. Mine is called R_Hand_CNTRLS.
3. **Lock** the **translate** and **scale** attributes on the FK controllers.
4. **Lock** all attributes on the **group** nodes. The animator does not need to touch them.

Repeat for the other wing. See chpt13_Marv_bird_RIG_v16. ma for an example. But this bird has so many joints in his finger/feather. Does the animator want to see all of those controllers, all the time? The answer is no.

Definitely, an excellent thing to do is to simplify the rig as much as possible. For instance, in this character, we could add a visibility control to the set driven key finger controls. Refer to Figure 13.4.

Every now and then, I have a student who brings up the concept of IK fingers. The only reason you would want that is if the weight is on the fingertips and there is a contact point there. If not, they would look like snakehead fingers, which move on their own. A one-off rig where you provide an IK control would serve the purpose fine unless the character constantly walked his or her hand around like something from Adam's family, or Mr. Bobinsky, who has to stand on his fingertips often. In that case, you would want to put in an IK/FK switch for the finger itself! Boy, I'd like to make an abstracted IK/FK switch that

Figure 13.4 Adding a visibility control to streamline the controllers.

could work on anything. That sounds like a good idea. I need to make a wish list of scripts. Good, robust scripts that work on more than one type of skeletal setup.

Well, while I dream of scripts and tools to make life easier, finish up the other wing, and I'll see you in the next chapter. P.S. If you look at the skinning on my rig, it is not so lovely. I'm not worried about that right now. I want the rig to work first. The noodley skinning can come at the last step.

14

EYES, BLINKS, AND SMILES

Are you sick of those eyeballs floating off into space? It is high time we did something with them. We'll look at eyeballs, blinks, and smiles. Let's start with those pesky eyeballs themselves. There are many methods for eyeballs. Since we are getting slightly more advanced in our rigging, we'll look at a few of them.

Joints

Eyeball joints, to be exact, which stem off of the head joint. This is exactly what has been created in our bird skeleton. Each eyeball gets a joint. This tippy eyeball joint handles the position of the eyeball. (Make sure the pivot points of the eyeballs are at the same place as the tippy joint.) This tippy joint can also handle the rotation of the eyeballs. If that is the case, the joint itself is aim-constrained to follow the controller. It is a neat method. Refer to Figure 14.1.

1. Select the **tippy eye joint** and the corresponding **eyeball**. Create a point constraint (**Constrain>Point**). This only locks down the translate of the eyeball so that it moves with the skeleton. The eyes will still look forward.

2. Select the **eyeball controller** and the **eyeball**, or if you wish, select the eyeball controller and the tippy joint inside the eye. Create an aim constraint (**Constrain>Aim**). Make sure the **aim vector** corresponds with the **axis** pointing from the **joint**, or geometry, towards the eyeball controller. If the geometry's x-axis is pointing out the back of it (-x), make sure the aim vector is also entered as -1 in X. If your bird's eye rolls back in its head, undo and relook at the aim vector. You can see an example of this type of eyeball in the file: chpt14_Marv_bird_RIG_v17.ma.

Groups

If you do not want to use joints for each eyeball, then you can group the eyeballs together and use that group node to make the eyeballs move with the character's head. Refer to Figure 14.2.

1. Select **both eyeballs**; create a **group**; name it **Eyeball_GRP**; **move** the **pivot** point to the head joint.

DOI: 10.1201/9781003431121-17

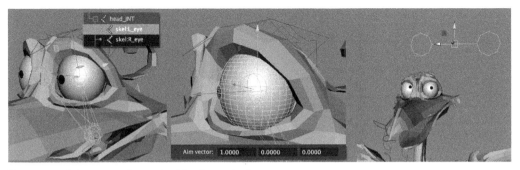

Figure 14.1 Joint constraint method for the eyeballs.

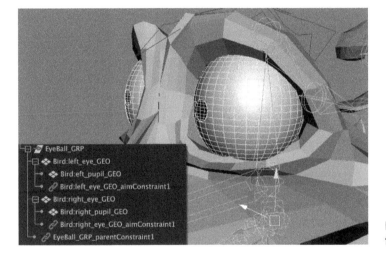

Figure 14.2 Group method for the eyeballs.

2. Select the **head joint** and the **Eyeball_Group** and create a **parent constraint** with maintain **offset ON**.
3. Select the **eyeball controller** and the **eyeball**. Create an aim constraint (**Constrain>Aim**). Make sure the aim vector corresponds with the axis pointing from the joint, or geometry, towards the eyeball controller. You can see an example of this type of eyeball in the file: chpt14_Marv_bird_RIG_v18.ma.

Fancy-Smooshy Eyes

What happens if the eyes are cartoony and not really spheres? If they aren't good round spheres, then when aim-constrained to look at things, the eyeballs will look weird when they move around; they will show off their oblong shape and poke out of the eye socket. Take a look at chpt14_eye_example.ma and refer to Figure 14.3.

In this file, you see two examples of nonround eyeballs. One has the geometry scaled to be nonround; the other uses lattices

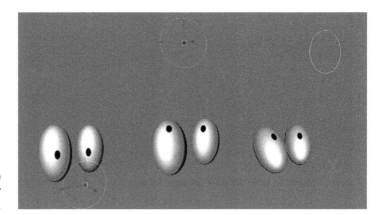

Figure 14.3 Group method with lattice for nonspherical eyes.

on each eyeball to create the oblong shapes. The incorrect eyeballs will rotate their oddball shape around to look at the controller. This will cause the eyeball to poke out of its socket—not nice. The correct eyeball has a lattice deformer used to create the odd size.

Here's how to do it.

1. Model the eyes as spheres.
2. **Select** both (or individual) **eye** spheres and **create** a **lattice** (**Deform>Lattice**). Make sure that the lattices have enough **S** and **T** divisions for you to adjust the shape of the eyes in their sockets.
3. **Right**-click the mouse on the **lattice**, choose **lattice points**, and **move** the lattices to adjust the shape of the eyes.
4. Select the **lattice**, **latticeBase**, and both eyes; create a **group**; label it **Eye_GRP**.
5. Snap move the **pivot** point of that group to the **head joint**.
6. Proceed as before in the group method; select the **head joint** and the **Eye_GRP**; create a **parent constraint** with maintain **offset on**.

Test. Rotate the head control to ensure that the eyeballs rotate correctly with the head.

Extra Effort with What You Know So Far

What would happen if you selected the left eyeball and the geometry and created a lattice? Then, what if you took both the lattice and the base lattice and scaled them to be just about the size of the eyeball and eye socket? Repeat for the right eyeball. Then proceed with steps 4–6 in the example above. Now what do you have? Oh, a lattice deformer on the whole eye socket? Makes a nice cartoony eye socket now, doesn't it? Good job. You can see that in chpt14_Marv_Bird_RIG_v19.ma. I left the character posed for you. I put those lattices under the "do not touch" group. Refer to Figure 14.4.

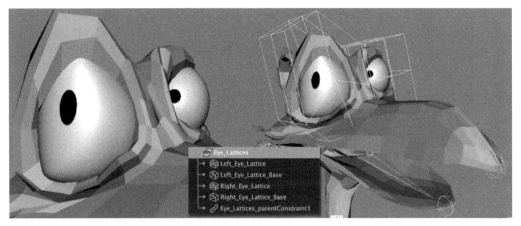

Figure 14.4 Group method with lattice applied to the eye and geometry for cartoony eye socket.

Where to Put the Look at Controller?

Well, how do you move your head and your eyeballs? Can you rotate your head while looking at something? You can? Well, then, the eyeball control should not go under the head control; same with the neck, or spine, or upper body. Well, that leaves the root control or the main control, which we have not made yet. I would suggest putting the eye control under the main control. Why? Can you squat (use the root control) while still looking at something? Yes. Then the root control should not be the parent of the eye control. For now, place the eye control under the Marv_CNTRL group. We'll make a main control soon. An example of this rig completed so far is found in the file: chpt14_Marv_Bird_RIG_v20.ma.

Advanced topic: Wonder if there is a way to make the vision control follow the main control OR the root control? Gosh, that would be something like animating constraints to drive a group node over the vision control.

Blendshapes and Referenced Files

If you see in the outliner that your geometry is referenced, as indicated by a blue dot, I would suggest doing all blendshapes in the original geometry file if you are using separate shapes for the blendshapes.

Here's why: blendshapes should happen prior to skinning. This way, the skeleton moves the geometry that already has a blendshape on it. Often, those blendshapes are created by someone else—the modeler, not the rigger. For example: Jane, who is the modeler, continues on sculpting Geo_V5, which contains all the blendshapes she thinks the animator needs based on his model sheet sketches. She has used ZBrush,

Mudbox, Maya, and anything else she could get her hands on to get the right deformation. Jack, the rigger, is still working on the rig to get the eyeballs working; he's following along in this book. Jane calls and says that V5 of the geo is ready. He opens version 23 of his rig, opens the File>Reference Editor, right mouse clicks on the Geo_V4 that is listed, selects Replace Reference, and selects V5. Now his character has blendshapes ready for him to add controls to. It's a nice pipeline.

If we look at another pipeline where there is no reference file, then the rigger/modeler would need to make sure when applying the blendshapes that the option At Front of Chain was selected under the advanced tab. This sets the deformation order correctly. Or, if they are using the new blendshape editor, they are creating all of the blendshapes in one file.

When References Go Bad

It happens in class; a reference is brought into the scene as an import or, for some reason, becomes real instead of a reference. That exact thing has happened to our chapter material! As I look at my example files, I see that my geometry file stopped being a reference around Chapter 12. Doh! When did that happen? I remember testing something and "importing reference files." I must not have undone that particular testing step. This could happen to you. You probably would have never noticed—but I had to point it out to you because it can be fixed. How do we fix that? We would need to export the skinning weights, recreate the reference pointer, apply the skinning to that via import skinning weights, and redo the eyes. I'll bet you want me to prove it. OK. Refer to Figure 14.5. In my latest version of the bird rig:

1. Select the geometry and choose **Skin>Export Skin Weights Map**. Make sure that the resolution is high enough to capture the skin weights, 2 K. Make it a TIFF, which is lossless. Click on export; give it a file name and say OK to the prompt that tells you it is going to make a lot of TIFF files. It will make a TIFF image for each joint. I chose 8 K: maybe that was a little high—it is taking quite a bit of time.

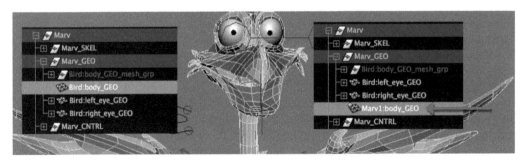

Figure 14.5 Recreating a lost reference.

2. **Delete** the evil, **unreferenced geometry**. (I've saved an intermediate 20_inprogress version, just in case.) You'll note I kept the eyeballs.

3. Create a reference (**File>Create Reference**) and point it to the geometry file. Figure 14.5 shows that I picked up a version from Chapter 12 at the time of writing. It could be any geometry file. Change the namespace to **Marv**.

4. The part that most people forget is that you need to go ahead and skin this geometry before you import in those exported weights. (Trial and error taught me that one; a lot of trial and mostly error.) Select the geometry and **bind** it to the skeleton.

5. Finally, select the geometry and choose **Skin>Import Skin Weight Maps**... Locate the weightmaps file. You might have to change the option to show "all files." Again, trial and error taught me that. Click on open.

If all goes well, your referenced geometry should be skinned. Huzzah! A little clean-up in the outliner is all that is needed now.

Put the referenced geometry under the Marv_GEO group node. You have the choice of redoing the eyeballs with the referenced eyeballs.

Instead, I'm going to hide the referenced eyeballs and place them under the "do not touch" node. We'd fix this before sending it into production. The fixed file can be found at: chpt14_Marv_bird_RIG_v20_refFixed.

Back to Blendshapes

In the chapter material, you will find a version of the geometry file that has a few simple blendshapes already created: **chpt14_Marv_Bird_GEO_V2.ma**. These have been applied to the geometry as separate geo-blend shapes and labeled. Remember, you can use whatever deformer you need in order to create the sculpt. In this file, I used a lattice for the smile blend shape and a wire deformer for the sad blend shape. Wire deformers use a NURBS curve near the surface, and you can paint the weight of the influence. I ran into a display issue in an older version of Maya when testing this; it showed in the wireframe and didn't show the actual black and white map. I painted anyway, like I knew what I was doing, and it worked fine. It might be a refresh issue when your model is not at display level 1. I don't see it in newer versions of Maya. You can choose between level 1, 2, or 3 for the display level by using the keyboard hot keys.

Cleaning the outliner: I like to group the blendshape geometry under a group node named BS because I think that is funny. Refer to Figure 14.6.

Advance tip: If you use the corrective blendshape script from *The Art of Rigging* (see the Epilogue) it will only be happy if the

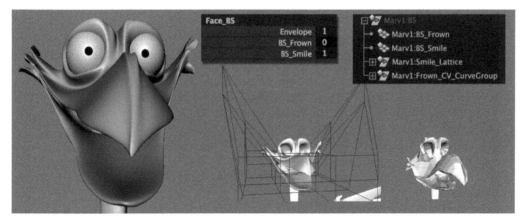

Figure 14.6 Blendshapes applied to Marv in version 2 of the geometry: chpt14_Marv_Bird_GEO_V2.ma.

blendshape node was created prior to any skinning node, no matter the deformation order. Creating the blendshape node prior to skinning or in the referenced geometry file makes it work just fine. (Trial and error combined with curiosity found that one.)

We're done with the reference file. Save if you made any extra blend shapes.

Updating the rig file: In the fixed reference rig file **chpt14_Marv_bird_RIG_v20_refFixed.ma**, we simply need to update the geometry reference to point to this new geometry file. **Open** the reference editor (**File>Reference Editor**); select the existing reference; select **Reference>Replace Reference** from the pull-down menu; locate the geometry version 2 file that we just saved. This will load in, and the referenced geometry will be in the outliner; place it under the Marv_GEO group node. You'll note that in newer versions of Maya, the namespace shows up as Marv1: in the outliner, as seen in Figure 14.6. That business started in version 2020 or maybe 2018.

The ultimate test: Bend your character forward using any controller that rotates a joint, and then turn on the blendshape. If the character stays bent over and the blendshape turns on correctly, then you did everything right. If the character's skin rips off his skeleton and goes back to the neutral pose but keeps the deformation of the blendshape, then your deformation order is incorrect. Fix this by creating the blendshapes in the geometry file instead of the rig file, or in the rig file, right-clicking on the geometry; selecting **Inputs>All inputs ...** in that window, the middle mouse drags the blendshape node to be below the skinning cluster node. (Remember, this window executes from the bottom up.) This should be familiar: we did deformation order back when we created the Medusa character.

Note on blendshapes: They should be so broad and big that during a critique they can be seen across the room. Give the animator enough room to act in. **chpt14_Marv_bird_RIG_v21.ma.**

What about the New Shape Editor Window?

Let's take a look at creating blendshapes for the bird with the new Shape Editor window. In a test file, do the following:

1. **Windows>Animation Editors>Shape Editor**
2. Select the bird's **geo**
3. Click **Create Blend Shape** in the Shape Editor window. This creates a blendshape node.
4. Click **Add Target** in the Shape Editor window; rename the target to **Happy**. This puts you in edit mode. The edit button turns red.

What could go wrong? In the Shape Editor, if you do not have the blendShape1 node selected, the Add Target button will not be accessible to click.

1. **Adjust CVs** for the Smile target using methods described previously, such as a **lattice**.
2. Turn the **Weight** for the Smile target to **zero**. Notice that the lattice affected the main geo and not the blendshape. This didn't work as you wanted. Ponder your mistakes.

Sadly, deformers do not work with targets created by the Shape editor; only translating, scaling, or rotating the vertices will work. We learned the Shape editor method in Chapter 6. You are as shocked as I am. But we were going to sculpt those blended shapes in Zbrush anyway. Now we know the deformers have no power here. Delete that test file. We'll return to our original method.

Blinks

A character that stands stock-still can still look lifelike with the addition of a blink. It also tends to be humorous. There are many ways to create a blink. I find that many rigging artists prefer one method over others. I, personally, don't use clusters very often. Others love them. Let's think of a few methods:

1. **Joints on an arc:** one joint for the upper lid and one for the bottom lid. You can use joints and skinning to drive the eyelids. Since eyelids rotate on an arc, a joint system that rotates from the center of the eye could be used to drive the eyelids. Cons: you have to skin it, and the folds of the eyelids may be difficult to obtain. Remember, the geometry also has to be there: folds of the eyelids must exist for you to rig.
2. **Joints along the lid lines:** each joint system rotated on an arc. This could be an interesting method; joints skinned to the lid so that you could ultimately move the individual joints to adjust the lid line.
3. **Clusters:** following the same lines as joints, one could use clusters to open and close the eyes. Make sure that you have

the relative option turned on for the clusters. You can paint cluster weights to create a smooth falloff.

4. **Blendshapes:** to avoid skinning and painting weights, creating blendshapes is sometimes a preferred method. Cons: blendshapes take careful planning so that no other blendshape is affecting the same vertices. (There are advanced ways around that with expressions; see Jason Osipa's *Stop Staring: Facial Modeling and Animation Done Right* [see the Epilogue].)

5. **Wire Tool:** While playing, I mean, experimenting with the other methods, I tried the wire tool. It can give flexibility as well. Refer to Figure 14.7. Let's see how that looks:

 a. Create a **CV curve**, and while holding "**c**," draw a curve that is snapped to the eyelid line; rename it to **L_Eyelid_CV**.

 b. Move and adjust this curve to be visible in front of the eyelid.

 c. Choose **Deform>Wire**; following the prompt at the bottom of the window—**select** the **bird** geometry and click on **enter**; select the **curve** and click on **enter**.

 d. Select the geometry and choose **Deform>Paint Weights>Wire**.

 e. Change the **value** to **0** and click on **flood**. This will take away all influence.

 f. **Paint** back in a value of **1** around the eyelid. Use **replace** and **smooth** to get a nice deformation.

 g. Test by moving the control vertices or rotating the curve itself.

Clusters can give the same type of feel (as mentioned in step 3). For any of the methods, group the deforming entity and place the pivot point of that group at the joint in the center

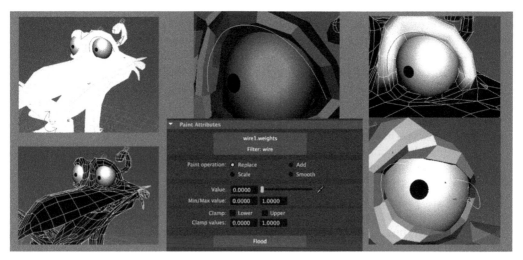

Figure 14.7 Using a CV curve as a wire deformer to adjust the eyelid.

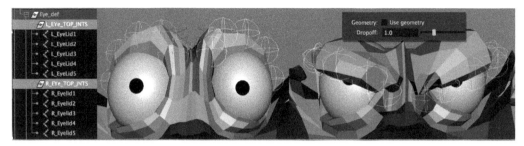

Figure 14.8 Using a cluster or joints to control the eyelids.

of the eyeball. Then rotate the group node and adjust the individual cluster, joint, or CV to get individual adjustments. I tested both the curve and cluster methods (see version 22 of the rig). I think I would rather use joints or the wire tool since painting cluster weights doesn't allow me to add vertices easily, whereas using joints and skinning allows adjusting weights only while in the paint weights tool without also having to adjust membership, as you have to with clusters. Some like it—choose which method suits you best. Refer to Figure 14.8. To use joints:

1. Create singular joints for the upper and lower lids. You could also use a joint chain.
2. Select the joints and the geometry, and choose **Skin>Edit Influences>Add Influence**. Set the **dropoff** to **1**.
3. Put the top joints in a group, with the pivot at the center of the eye. Rotate that group to see the effect.
4. Paint skin weights to get a good transition.

So, you've painted some type of weight or influence on some type of deformer to move the eyelid. Now what? What type of controller do you want to give your animator? Do you want a simple open, close controller? Remember, what you give them is what they have to act with. Make sure you have looked at the model sheet and can achieve the poses they need.

We'll create a simple set driven key mechanism for the functionality we have created in this chapter, which is limited. Push further into your own rig to create a full range of poses.

Here's a fun controller to create. Did you know that you can do a set driven key from the control's transform node to its components? For example, in Figure 14.9 there is an eye controller that looks like a convex curve. By setting up a set driven key from the **translate Y** of the **object's transform** node to the **control vertices' Y position**, a relationship is created so that when the control is moved down in Y, the controller's CVs adjust to make the controller look like a flat line. Neat, huh?

Next, create a **set driven key** from the **translate Y** of that **controller** to the **rotation** and **adjustment** of the **joints** for the eyelids. **Limit** the controller's movement in **Y** to make it easier for the animator to use. Try the same with a smile to a frown

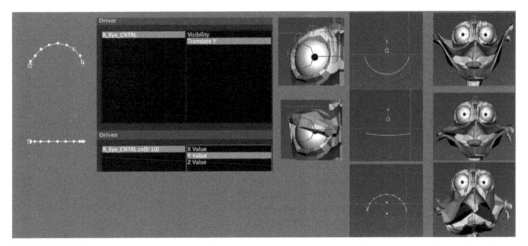

Figure 14.9 Creating set driven key controllers that adjust their own shape based upon their position. Those controllers are set up to drive the joints and the blendshapes via set driven key.

controller driving the smile and sad blendshapes. Open version 23 of the rig to see this as an example.

Don't forget to clean up the outliner. If you used joints or cluster systems for the eyelids, group all of those together. **Name** that group **Eye_def**, or something like it.

Where do we need to put that group of skinned deformers? Well, they need to move with the rig, but we don't want to parent them to anything. Let's handle how they move via a parent constraint, and then we'll stow them under the Marv_SKEL group node. First, to make sure they move correctly with the character, select the **head joint** and the group node **Eye_Def**; create a **parent constraint**.

Test this by rotating the head and checking that everything moves correctly without any double transformations.

If you used clusters, make sure relative is turned on! Next, place that Eye_def group under the Marv_SKEL group. We'll need it there when we make the rig scalable later on. Hide those groups too; we don't want the animator messing with them. If you want that, then create extra controllers so the animator can have the ability to adjust each cluster or joint.

Place the Face_CNTRL under the Marv_CNTRL group. I think I'll have my face control move around with the head by creating a parent constraint from the head joint to the face control. We'll see what that looks like. You might not like that. We'll get more into controllers in Part III of this book.

Obviously, we could stay here in this chapter for a very long time, really getting some great eyelid shapes and emotions. My sample rig is just that: a sample rig; see **chpt14_Marv_Bird_RIG_v23.ma**. Your tutorial rig will be a tutorial rig. When you get to that production rig, though, plan to stay right here for a very long time, getting it just right.

MASTER CNTRL AND SCALABLE RIGS

Well, here we are. How far you have come! Remember when we were just trying to figure out shape nodes and transform nodes? Here you are at the final touches of this rig, and it is really a review. You know these concepts; there are just a few things to point out. Let's finish up the rig by adding in a master translate control to make the rig overall scalable. As you know from previous chapters, if the CNTRLs have been kept separate from the GEO, it is an easy method to make the rig scalable.

Open file **chpt15_Marv_bird_RIG_v23.ma**. So far, we have an upper body, a lower body, and a root control that moves just about everything in the body. When the character is in FK mode, the wings move with the upper body. When the character is in IK mode, the wings do not move with the upper body. In fact, the controls that do not move with the root control are the IK hands and feet, the pole vector controls, and the eye aim control. We want some type of control that allows you to move the character completely and place them in the starting position for the shot. Or, if there was to be a scene with a flock of birds, certainly you would need a control that allows you to offset the characters, and you would probably want to be able to scale the characters so there is some type of size difference. Refer to Figure 15.1.

Main_CNTRL to Move and Rotate the Whole Character

We'll start with this chapter's rig version 23. The main controller should be something at the bottom of the character. Make it large and obvious. I'll use the "Transform" controller found in the Rig101 controller script under the "Character" tab. This newly created circle should show up at the bottom of the character, with the pivot point right at the origin of the universe (0,0,0). This is where everything has been lining up, so it is mathematically happy. Scale the controller so that it is aesthetically pleasing; freeze transformations and delete history; name it **Main_CNTRL** or Main_Transform_CNTRL, something like that.

DOI: 10.1201/9781003431121-18

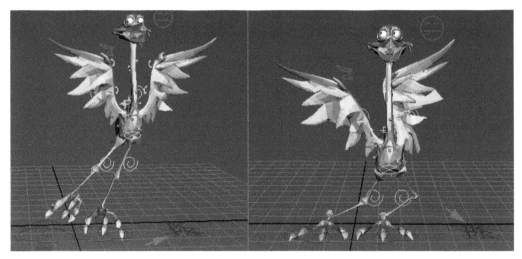

Figure 15.1 IK and FK wing behavior when moving Marv with the root controller.

What should this control do? It should be the **parent** of all the controls and tell the skeleton to scale. Move the **Main_CNTRL** under the **Marv_CNTRL** group. The middle mouse drags all controls under the Main_CNTRL to be children.

Test. Move and rotate the Main_CNTRL. Does everything go with it? Does anything twist? Even the IK arms and legs should go with the Main_CNTRL. No flipping going on? In my rig, there is a little flipping going on in the wings—notice it when you rotate the Main_CNTRL? See Figure 15.2 to see the wing flipping. Flipping can generally occur with the IK handles. If you get that, a solution is to create a parent constraint from the Main_CNTRL to the group node over the IK handles. You can see in Figure 15.2 I placed a parent constraint on the group node over the wing IKs. I did not place them as a child under the

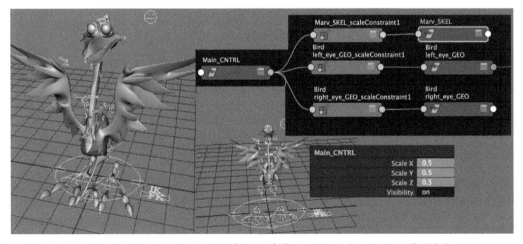

Figure 15.2 Bird controls scale but not the geo (on right). Scale constraints setup to fix this issue.

Main_CNTRL; that breaks our hierarchy rule and puts them out where the animator can get to them easily.

Main_CNTRL to Scale the Whole Character

If you scale the Main_CNTRL, you'll see that all the controls scale with it. The character does not—you still have to tell it to. (Review Figure 15.2. Watch for IK issues when rotating the character with the Main_CNTRL.)

Select the **Main_CNTRL** as the driver and the **group** node OVER the skeleton as the driven (**Marv_SKEL**). Create a scale constraint (**Constrain>Scale**). Now select only the Main_CNTRL and scale the controller. The rig and the skinned geometry should scale; anything that was not skinned (like the eyes) still needs to be told to scale. Remember to always reset controllers back to 0s and 1s (in scale) before you continue.

Scale Unskinned Geometry (Eyes, etc.)

Select the **Main_CNTRL** and select either the **group** node over the eyeballs (if you did a group method) or the **eyeballs** themselves (if you did a joint method); create a scale constraint (**Constraint>Scale**). In Figure 15.3, you can see I chose a joint method for the eyes, so I had to create a scale constraint for each eyeball individually. The eyes themselves have a point

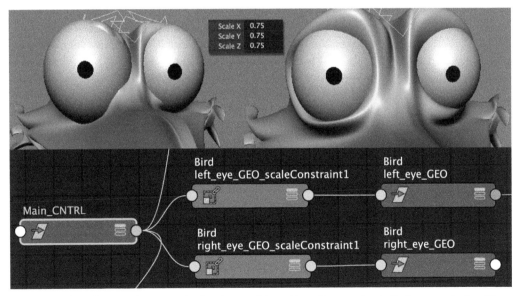

Figure 15.3 Creating a scale constraint for the eyes' (nonskinned) geometry. Left shows eyeballs with no scale constraint. Right shows eyeballs with a scale constraint.

constraint to the joint, an aim constraint to the eye control, and now a scale constraint to the Main_CNTRL.

Test. When you scale the Main_CNTRL everything should now scale. The real test is to rotate the Main_CNTRL so the character is facing a direction other than its normal zeroed-out position, move it somewhere, then scale it and rotate again. If you don't see anything jiggle or rotate oddly, you are good.

Problem Solving

Surely, it wasn't all perfect. Now is when you get to shine as a character setup artist, figuring out what the little issues are and fixing them.

Problems I'm noticing when moving the character around are:

1. Eyeballs seem to rotate slightly out of socket when the character is rotated with the Main_CNTRL.
2. The right finger/feather doesn't move with the IK hand.

Keep it to one issue at a time, and let's work through it. Before starting to problem-solve, save the version you are working on now. Inevitably, while trying to solve a problem, you might make something worse before you understand what the problem is.

Eyeballs that rotate slightly out of socket: sounds like a pivot point issue. To keep a good eye on the eyes, create a new camera (**Panels>Perspective>New**); tear off that panel and focus the camera directly on the eyes (**Panel>Tear Off Copy**). You can **select** the **eye** and then this **new camera** and create a **parent constraint**. This way, you can move the controllers in the original perspective, and you have a face cam that will always focus on the eyes. This can help you see exactly when the issue is occurring. Sure enough, when I rotate the Main_CNTRL, the eyeballs move slightly out of the head. If I look at my eyes, the pivot points don't look to be off from the joint, which is usually the issue. Instead, I notice that the pivot points of the eyeballs are not centered in the eyeballs themselves! They are just barely off. Delete, center, and freeze; then move the eyeballs to make sure they are snapped to the eyeball joints; now reapply the constraints. Fixed! Incidentally, you could keep that camera around and name it Face_Cam. Refer to Figure 15.4. Animators like that type of camera that constantly looks at the face for dialog.

Finger joints that do not move with the rest of the hand/wing are common. The finger had FK controls placed on it, so those are driving the joint. Are we sure the FK controls are being driven by the rest of the skeleton? Let's check. Make sure all controllers are set back to 0s and 1s (in scale). Bend one finger. Rotate the wrist. The finger moves fine with the wrist in FK mode; however, in IK mode, the finger does not rotate with the wrist. What did we do there? Well, let's turn on the visibility for our FK controls while

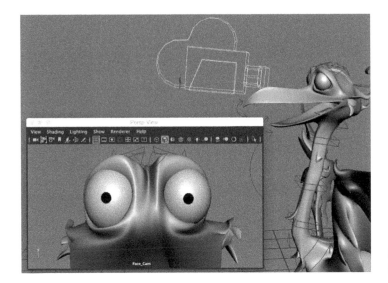

Figure 15.4 Creating a face cam.

we are in IK mode. Wait, we can't see those finger controls; oh, we put the controls under the FK wrist control. So, those FK finger controls are listening to the FK hand control for visibility and for position. Refer to Figure 15.5. I thought we point constrained those to the wrist? Anyone see the typos in that outliner? I do.

Let's see what fixes it. Make sure all controllers are zeroed out before you do this. The FK controls for the finger are buried in the outliner. If you unparent them now, they will fly off somewhere in the world. Instead, **group** them—this is basically another offset group node. Now, **unparent** that group node so that it and all the FK finger controllers are all alone in the outliner. Create a **parent constraint** from the **wrist joint** to that **group node**.

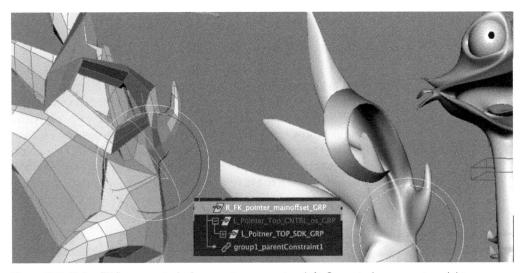

Figure 15.5 Fixing FK finger controls. Incorrect movement on left. Corrected movement on right.

Name it whatever makes sense: R_FK_pointer_mainoffset_GRP. Make that group a **child** of the **Main_CNTRL**.

Test. Test. Test. Look to see what needs fixing and attend to it.

What could go wrong? Usually, I see something in the clavicle go odd because someone has forgotten to add in a translate constraint to the IK handle. Or IK handles for feet and arms weren't grouped with the skeleton or anything in the rig, and thus were unparented—poor orphans! Those orphans were left behind when the character rotated and scaled. Mostly, it is forgotten scale constraints on bits that were unskinned.

Bulletproofing

Now, go through and double-check that things are ready for motion testing. Let's make a list:

1. Hide the skeletons and IK handles (generally everything in the Marv_SKEL and DoNotTouch groups).
2. Make all geometry unselectable. (I have mine in a layer with reference turned on.)
3. Select all the controllers and make sure all can be zeroed out.
4. Go through each controller and make sure attributes that shouldn't be animated are locked.

Are you ready to hand this rig off and let the animator give you feedback? Better double-check your blendshapes and skinning first.

Mine, in the chapter material, definitely needs some tender, loving care in those departments. If you want to use this rig for an animation, you'll have to work just a little. Evil—we established that. The rig at this point can be found in the file name: chpt15_Marv_bird_RIG_v24.ma.

Animating the Rig

As the rig gets animated, you want the ability to change the versions of the rig so the same referencing idea happens in the animator's world. They create a new file, and within that file, they create a reference to your rig. As you update the rig with new skinning or as the modeler creates new blendshapes, the files and reference pointers need to be updated. Animate your rig this way first to make sure there are no issues cropping up that need to be fixed before the rig rolls out into prime time. You want to keep it so that fixes in your rig are not major or involve hierarchy changes. If that happens, animation will more than likely need to be redone.

Remember, the geo file and the rig file must travel together. Refer to Figure 15.6. Usually, there is a production area where all rigs and geometry are stored. From this global area, scene layout

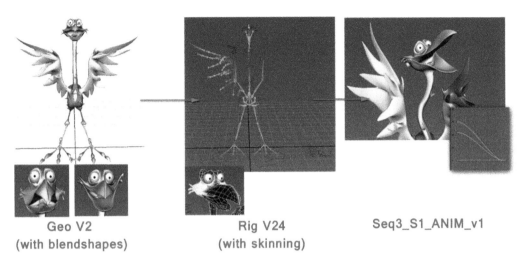

Geo V2	**Rig V24**	Seq3_S1_ANIM_v1
(with blendshapes)	(with skinning)	

Figure 15.6 Model file referenced into the rig file, which is referenced into the animator's file.

artists can create the Maya files with all of the environment and characters needed for each scene. Animators can take those files and begin to animate.

What can go wrong? At this point, you might notice that any key frames accidentally created in the rig file cannot be deleted in the animator's file. All other things should be skinning fixes and tweaks to any controller not behaving well.

The End of the Beginning

I don't know what to say. We've come so far, and here we are at the end of lots of small rigs and one big rig. How did you do? Don't feel bad if you have to go back and redo lots of parts until you understand it. The biggest aim of this section is to ensure that you truly understand what is going on. Once you have that down, we can move onto the next section of this book—where we talk about automating the things you have just done and pushing concepts further. First, let me put on another pot of coffee. See you there.

ADVANCED TOPICS

OMG-GIMBAL LOCK

I hate writing and thinking about gimbal lock because it is given such connotations of fear. It's just a thing—do your rig with some forethought, and it isn't that big of a deal. It is frustrating as an animator, though. So, if you don't look out for this in your more advanced rigs, you are liable to get that good old phone call, email, text, IM, smoke signal, or fuming animator at your desk. You can pick up all sorts of explanations on the subject from any manner of book, help documentation, or YouTube. They all explain the same issue.

Gimbal lock is when your axis rotates in such a way you lose one axis of freedom. This happens because two axes align and, when rotated, both cause the object to move in the same direction. This causes difficulty when animating. It can also cause unwanted flipping behavior between key frames when the numeric value of the rotation interpolates between a positive and a negative number. Let's think about this logically and break it down into its components.

What Is Rotational Order?

When you rotate something on three axes, the final result depends on which order you apply the rotations. For example, if you apply a 90-degree rotation to each axis using the default rotational order of XYZ, you will get the visual result seen in the top row of Figure 16.1. If the rotational order is applied differently, the end result would be different as well. The bottom row of Figure 16.1 shows the results of different rotational orders. If you still don't get it, hold a coffee cup in your hand (make sure it is empty). Turn it 90 degrees; first in X; then in Y; then in Z. OK. Now, return it to its normal position. Turn it 90 degrees; first in Y; then in Z; then in X. See? I have to learn hands-on, too.

What Does It Look Like When You Lose an Axis of Freedom?

There is something else going on in those images. Do you see it? We have lost an axis of freedom. It happens naturally in the animation process. Let's consider the default rotational

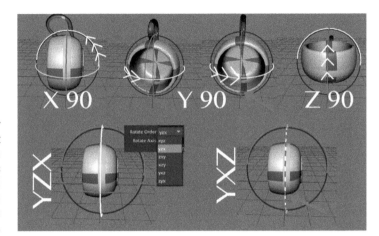

Figure 16.1 XYZ order of rotation is the default setting, shown on the top row. Order of rotation gives different results: YZX and YXZ (bottom row). Rotation order is changed in the Attribute Editor.

order of XYZ. Look back at Figure 16.1 to see if you can tell which rotational axis was lost and when. Take a look at Figure 16.2—the precise moment when we lost the axis of freedom was upon the Y-axis rotation. When we rotated in Y, the X-axis lined up with the Z-axis. Figure 16.2 shows the Y rotation being applied, in which you can see the X-axis starting to line up with the Z-axis. The picture on the right shows the Z-axis as having been applied and rotating slightly in Y to show the X and Z are still aligned. What does that mean? It means that your animator has lost an axis to animate on. It will happen; what you need to do when rigging is to decide which axis is most and least important.

Side note from the technical editor: Gimbal Lock isn't just an animation thing. Go watch *Apollo 13* or *Top Gun*. Gimbal lock is a very common problem for fighter pilots; it brings planes down! Which is terrifyingly cool!

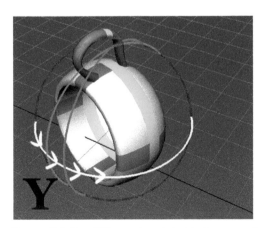
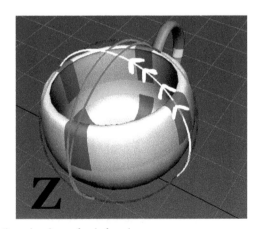

Figure 16.2 X and Z becoming gimbal locked, meaning there is a loss of axis freedom.

What Rig Is More than Likely Going to Hit Gimbal Lock?

If your character is mostly going to do walk cycles and do straight-up acting in front of the camera, a more than likely gimbal lock will not be an issue. If your character is going to spin in circles, do a cartwheel, do gymnastics, or do anything that causes a rotation in more than a 90-degree movement, especially a 360-degree movement, you will need to take care to avoid gimbal issues for your animator.

What Can We Do to Avoid Gimbal Lock?

If the problem all stems from how Maya calculates the rotational axis, you can minimize the issue with the following methods:

1. Create a group node for each rotational axis, and keep the hierarchy reflective of the order of rotation. Why, we learned that in the first chapters of this book, didn't we? In that age-old pivot point exercise. No wonder it is still a useful thing to know!

2. Since we can't use group nodes for each rotational axis when we are using joints, you will need to create joints and controllers that match the proper order of rotation.

Proper order of rotation? If you know that you are likely to lose an axis of freedom, the next step is to decide which is the most important axis of rotation and which is the least. In the coffee cup example above, you saw that the rotational order can be set in the attribute editor. This is the same for joints. When you create a joint system, think about the movement that the joint system is going to do, and that helps determine the rotational order.

For example, an arm with X down the bone, as seen in Figure 16.3. If we look at the lower arm joint, the most important

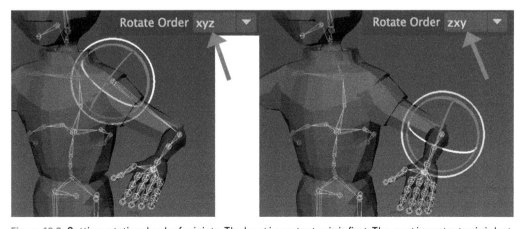

Figure 16.3 Setting rotational order for joints. The least important axis is first. The most important axis is last.

rotation is the Y-axis, and the least important is the Z-axis (since you don't move this way without a great amount of pain). When setting the rotational order, the **most important axis is the last axis**; the **least important is the first**. Why? Well, I think I saw that in a book somewhere about multiplication of matrixes. The last one described is the first one applied. (Sounds likely to me, but I never took that math class.) A shoulder joint would be different. The most important would be Z (since it rotates up and down), and the least amount of movement would occur in X. Remember to match the order of rotation for both the controller and the joint in the attributed editor.

What Does It Look Like When You Have Flipping Issues?

Often mistaken for gimbal lock are flipping issues when in-betweens are created by Maya. Sometimes, this is because the axes have aligned, and indeed, it is a gimbal lock issue. In this case, the numbers have wrapped around from negative to positive. Sometimes, it is the animator themselves who creates the problem by rotating the object around 360 degrees and not noticing the math issues they have created. In Figure 16.4, the images on the far right are key frames that are over 360 degrees different but are visually almost the same. The problem becomes apparent when Maya interpolates the in-betweens. This is an animator-created flipping issue. Also known as an Euler flip. This also occurs when a rigger has placed a switch from IK to FK modes, which are not aligned using offset nodes. Thurson asks, "Did you say—oil?" He is right. Euler is pronounced *oiler*.

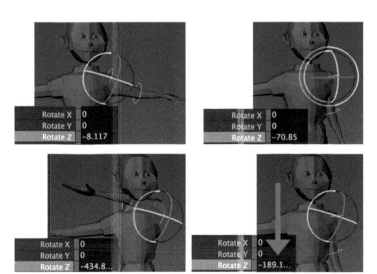

Figure 16.4 Animator flipping issues. The two key frames on the right look the same but mathematically are very different.

What Can We Do to Avoid Flipping Issues That Are Animation Issues?

Flipping issues can occur naturally when animators animate and may not always be gimbal issues. Often, when switching between an IK and an FK arm, the pure math states that the FK is in a positive position and the IK is in a negative position, even though visually they look the same. What occurs is a natural interpolation from negative to positive, which is a flip. Animators can avoid this by carefully not overcranking the FK versus the IK arm when animating. There is also the ability to apply filters to help get out of this sticky situation.

1. Euler rotational interpolation. In Figure 16.5, I applied an **Euler Filter** to the over cranked animation curve. This basically adjusted the key frame to something that is visually the same but is also closer mathematically. This function is found in the graph editor under **Curves**.
2. Quaternion rotational interpolation. Another method is to change the interpolation type to quaternion. This really does calculate the shortest distance between points. In order to do that, though, you will need all three axes of rotation available and keyed. This function is found in the graph editor under **Curves>Change Rotation Interp**. Refer to Figure 16.6

What Can We Do to Avoid Flipping Issues That Are Rigging Issues?

Respect the universe. In other words, if you are setting up a switch from one rotational axis to another, make sure that you have added a buffer. As stated before, this truly shows up in a

Figure 16.5 Using an Euler filter (pronounced "oiler").

Figure 16.6 Using a quaternion interpolation: **Quaternion Slerp.**

simple IK/FK setup where the IK is generating positive numbers and the FK is generating negative numbers; in other words, their universes are reversed. To fix this, the FK controller needs to have that good old offset node, which holds the garbage numbers in it, so that the animator animates in the same positive world. The math interpolates correctly, and the animator is none the wiser that there is a deep, dark secret going on underneath what looks like a normal animation controller.

That wasn't so bad, was it? It can be painful for the animator to get in the way, but it is not the zombie apocalypse. Speaking of that, we're about ready to talk stretchy, aren't we? This is going to be fun.

17

ADVANCED CONTROLS

Control Systems and How They Are Hooked Up

In most of this book, you have learned about using NURB curves as controllers, which drive various parts of the rigs. We learned that there are different ways to hook up those controllers. These concepts don't change. Advanced controls have to do more with how they are visually represented. You've already learned how to actually make them work. Let's review that here. Refer to Figure 17.1.

1. **One-to-one control** via direct connection: a controller's attribute can be piped directly into an object's attribute. For example, a custom attribute titled "Low/High" can send its number of 1-3 into the polySmooth's "Division" attribute.

2. **One-to-many** via direct connection: a controller's attribute can be piped directly into one or more object's attributes. For example, a custom attribute titled "Low/High" can be sent to multiple object's polySmooth node's "Division" attributes, since each object in a hierarchy would have its own polySmooth node.

3. **Constraint** connection: a connection between attributes from a driver object to a driven object—translate, scale, or rotate are the most commonly used. For example, a controller's translated information can be sent via a constraint to an object. This is useful if the pivot points are in different places or if keeping the controls in a separate hierarchy from the objects.

4. **Set driven key** connection: where one attribute of an object can drive many other attributes via a key frame system. Using this method is akin to the statement "when object X's translate equals this, then objects Y and Z are translated, rotated, and scaled like this." It is a visual system.

Those definitions are somewhat cryptic; we'll assume you read this book up to this point, or this is a review. If it isn't a review, you know what to do. There are 16 chapters waiting for you.

We've touched on the topic of how controls need to be visually appealing and not get in the way of the animation. We also have

DOI: 10.1201/9781003431121-21

Figure 17.1 Examples of one-to-one, one-to-many, and constraint-connected controls.

a rule that the controllers should make sense to the animator, and they should be intuitive. I have never studied the art, but there are those who are very much into interface design. If you have the opportunity to read up on it or even find someone who has that predilection, take them to lunch; it will be time well spent. I can't pull student examples, or even random examples from the Internet, to point out awful ways of not creating control systems. I trust you can look on your own and find the stinkers: the ones whose controls get in the way of seeing the pose of the character. When trying to push the concept of controllers further, it comes down to making the controller more intuitive so that it is self-explanatory and functions in such a way as to keep the animator's focus on the character's pose. We can push this so far as to make the controllers invisible. Doesn't that sound fun?

Control Systems and How They Are Represented Visually

Besides straight NURBS curves, there are some fancy things one can do to help the controllers be more self-explanatory as to how they function. We started the beginning of this book with mere NURBS circles and then advanced into changing the look of those circles into squares and triangles. From there, we used a MEL script that had prebaked controllers made from NURBS curves. By using arrows, arcs, and controllers that were easily representative of the type of direction and rotation, as well as controllers that looked like glasses, we were able to create excellent basic controls. For the main movement, this can be enough for a controller since there is usually only translation, rotation, and scaling as functionality.

But what about other areas that aren't mere transformations? Things driven by blendshapes, for instance: facial setups, or things driven via set driven keys like FK fingers and feathers.

A circle hanging out in space, or an arc, might not be enough to visually tell the animator, at a glance, what it is driving.

Controller driving itself: Controllers can be setup to drive their own components and can also have multiple shape nodes. We learned one of these methods with the biped rig. The other method is a gateway to a very cool way of making controllers.

Transform to Component Set Driven Key

A controller can be made to "morph" and change as it is moved to help visually explain what the animator is doing. We did this with the happy/sad blendshape controller with the bird rig. We'll reiterate the steps here. This time we'll create an IK/FK switch. We'll start from scratch. First, we'll create the controller out of two text objects.

1. Create the text "FK" by clicking on **Create>Type**.
2. Locate the **type1** tab in the **Attribute Editor**.
3. In the **type1>Geometry>Extrusion**, tab click **off** the **Enable Extrusion** checkbox.
4. In the **type1>Geometry>Mesh Settings**, click **Create Curves from Type**; locate the curve in the outliner, unparent it, and rename it "**F**".
5. Repeat steps 1-4 to create a "**K**" shape.
6. **Scale** these shapes to a much smaller size, **freeze** transformations, and **delete history**.

Next, let's create a set driven key so that when the "F" is moved up, it becomes an "I."

1. Open the Set Driven Key window (**Key>Set Driven Key>Set ...**).
2. Select the "**F**" object and click on **Load Driver** in the Set Driven Key window.
3. Choose the **Translate Y** attribute as the driver. (Remember, only one attribute can drive when hooked up in this window.)
4. Select the control vertices of the "**F**" object by right-clicking on the object and selecting **Control Vertices** (CVs). Left mouse drag to select the CVs—they should be highlighted in yellow.
5. In the Set Driven Key window, click on **Load Driven** and select the three **translate** attributes.
6. This is the neutral position, with the Y translate at **1**, the "F" position, so click on **Key** in the Set Driven Key window.
7. In **object** mode, reselect the "F" object. Translate the "F" to **1** in **Y**.
8. Refer to Figure 17.2. In component mode, select all of the **CVs** and move them back down to look as if they were back in the neutral position, **reshape** to look like an "**I**."

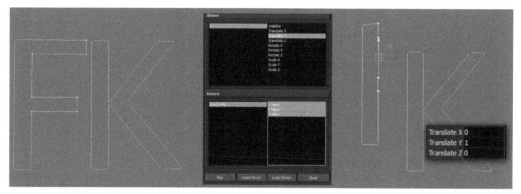

Figure 17.2 The "F" object looks as if it is not moving since the components are counter-animated via set driven key.

9. Click on **Key** in the Set Driven Key window. Test by selecting the "F" in object mode and moving it from "0" to "1" in Y. **Limit** the "F" controller to only move from "**0**" to "**1**":
 1. Select the "**F**" in object mode.
 2. Open the attribute editor by using the hot key **Alt key + a**.
 3. Click on the "b" transform node's tab.
 4. Locate **Limit Information>Translate**.
 5. Set the **Y** attribute to have a minimum of 0 and a maximum of **1**.
 6. In the channel box, **lock** Translate X, Translate Z, and the rotation and scale attributes.

This leaves us with a controller that changes how it looks based on its translate value. What to do with that leftover "K"?

Transform with Multiple Shape Nodes

Did you know that you could have multiple shape nodes? You might recall that way back in Chapter 1, we discussed that shape nodes and transform nodes did not show up as linked in the Node Editor window. In fact, their only connection is truly a hierarchical one. The shape nodes are generally not shown and, therefore, not messed with. If they are connected via good old hierarchies, like what you see in the outliner, then it stands to reason that we can have one transform node with multiple shape nodes. That is, what we will do with the leftover "K" object. The "K" object itself does not need to do anything but looks like a "K."

1. Select the transform node for the "K" and freeze transformations on it, if you have not already.
2. In the **Outliner,** click on **Display> Shapes**.
3. Select the **shape** node for the "**K**" and the "**F**" **transform** node. (Always pick the desired parent last.) Refer to Figure 17.3.

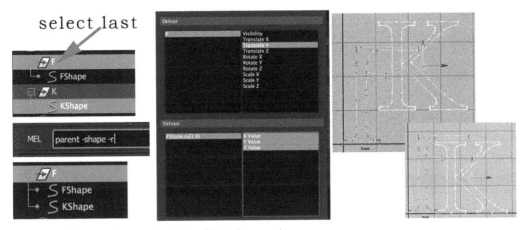

Figure 17.3 One transform node with multiple shape nodes.

4. Enter the following MEL command into the command prompt and hit enter on the keyboard:

 parent -shape -r

5. You will note that both the "F" and "K" shape nodes now appear under the "F" transform node.

6. You can **delete** the useless "**K**" **transform** node.

Test by selecting "K." Both the "F" and the "K" should be highlighted. If you move the object now, the "K" will move up and down since we did not create a set driven key on its components to make it stay dormant. You can do that at this time.

1. In the Set Driven Key window, make the "**F**" transform node's **Translate Y** attribute as the driver.

2. Select all of the **CVs** of the "**K**" shape node and make their **transform attributes** the **driven**.

3. Create a **set driven key** for the **neutral** position (Translate Y = 0).

4. Move the "**F**" transform node to **1** in **Y**; move the **CVs** of the "**Z**" **shape** node back to where they were; create a **set driven key**.

You can see an example of this FK controller in the file **chpt17_New_FK_v1.ma**. The FK was not scaled down so as not to be missed.

That was a little fancy. There are a few things that could go wrong. The second object needs to be frozen before you do the parent-shaped node trick; otherwise, it will move. Also, the parenting MEL command uses the "-r" flag, which stands for relative. If you don't have that flag, but the object was frozen, Maya will add an extra transform node over the shape node. This is not really what you want. You want a clean transform node with two shape nodes.

Let's try it one more time with a simple example to help illuminate what else this is good for. You've probably seen this in some rigs you have worked with. Figure 17.4 is an example of

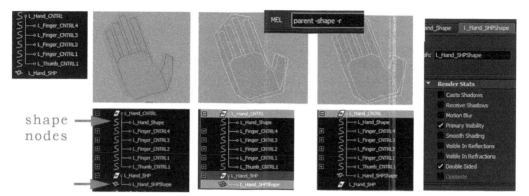

shape nodes

Figure 17.4 Polygon hand as a shape node to the NURB controller transform node.

a NURBS control you're used to using with an added polygon to help make the controller visible. The polygon shape was created using **Mesh Tools>Create Polygon**. The shape itself was given a basic lambert shader and had the transparency set to high. Open the file **chpt17_Hand_v1.ma** to see for yourself.

What we want to do is take the polygon's shape node and make it a child of the NURBS controller's transform node.

1. Make sure the shape nodes are visible in the outliner (**Display>Shapes**).
2. Select the polygon's **shape** node, **L_Hand_SHPShape**.
3. Select the hand controller's **transform** node, **L_Hand_CNTRL** (the hand should be green and the polygon white).
4. Type the parent shape node command in the MEL window: parent -shape -r (the whole hand and polygon should be green now).

The outliner should have the **L_Hand_SHPShape** as a **child** of the **L_Hand_CNTRL**. The leftover transform node L_Hand_SHP can be deleted; it is the parent of nothing. Test by selecting the polygon, and the controller should select the whole hand. The finished controller can be seen in the file **chpt17_Hand_v2.ma**. The extra transform node is left there for you to see its uselessness.

Warning: Putting the polygon exactly in the same plane as the NURBS controller can cause selection issues with children. The polygon in the sample file was created just slightly behind the NURBS controller. If it is in the same plane, then after the shape node is made a child of the hand controller, the individual finger controllers would be difficult, if not impossible, to select. (Obviously, I know from experience. I try to make every mistake for you first!)

The last thing to think about with this type of controller is the whole concept of hiding controllers. Now that you have introduced a polygon into your controllers, your animator cannot easily flip off the Show>Nurbs Curves display to hide the controllers. Also, the polygon will render. So, if you like this

type of controller, you need to do two things to be kind to your animator:

1. In the attribute editor, make sure that the polygon is non-renderable by turning off all settings under **Render Stats**, except for double-sided.
2. Create a way for the animator to easily hide all controllers by (just a few suggestions):
 a. Placing all controllers in a visibility layer.
 b. Making sure the visibility on the main controller hides all controllers.
 c. Making an extra-easy-to-find switch for controller visibility.

Invisible controllers: What if there wasn't a visible controller? Would that work? We asked that once in an advanced rigging class of mine, and a graduate student took me up on the challenge. He found YouTube videos of rigs that had no controls. What would that be like to animate with? Would it make sense to grab the area you want to control and just control it? Sure, it could work. How would you do it?

Hidden Proxies as Controllers

A simple way is to use proxies covering the outside of your geometry as the controllers and make them completely transparent. That's the easy way to do it. You could make the proxy's shape node a child of a NURBS controller (like we did with the hand) to make it a little more visible. Refer to Figure 17.5. Let's give that a try.

Open the file **chpt17_head_v1.ma** to find a piece of that poor bird's head. There are a few things already set up for you. First, there is a joint system that is skinned to the main geometry. (The skinning could be tweaked a little.) Second, I created a duplicate of the skin, scaled it up a bit, and cut it into proxy sections. Each of those proxies has been setup just like an FK controller, as you did earlier in this book with NURBS circles.

Figure 17.5 Hidden proxy controllers.

You'll note I used the offset controller script and the rig is mostly bulletproof. All should be working just fine for an FK feather. Give it a try. Click and rotate on any of the proxy geometries. That works fine for a controller. But what if you hid those proxies, would it still work? I've seen some pretty complicated ways to do this, but for us—simply grab the **lambert** material applied to the proxy geometry and turn the **transparency to 0**. The proxies are still there. Simply invisible. Make sure that the **wireframe on shaded** is turned **off,** and you'll see that the proxy controllers are not visible. Once you click in the general area, they do become visible, and you can utilize them. Deselect them, and they are invisible again. How about that? The same thing applies as with previous polygon controllers; make sure to set them as non-renderable. Open the file **chpt17_head_v2.ma** to test the hidden proxy controllers.

Controllers Driving Other Controllers

Let's take a moment to learn a few cool things in Maya before we see them all working together in a large script.

Custom attributes in the attribute editor versus in the channel box. We have already learned how to add custom attributes to the channel box. These attributes are seen by the animator and are generally used to animate. What if you want to add an attribute but not put it out for the world to see? When you add an attribute, select **hidden**. You can add an attribute by selecting an object and viewing the **Attribute Editor** (click CNTRL + a), you'll notice that there is a pull-down "**Attributes>Add Attributes...**". This pops up in the same window as choosing Add attributes from the channel box. When hidden, the attribute shows up under the tab labeled **Extra Attributes** and not in the channel box. If you right-click on any attribute after you have made it, you will note that these attributes can be made nonkeyable. With them hidden inside the attribute editor, what are they good for? Good question. Holding information like variable names or commands that a script might want to call.

ScriptNode: I actually don't care for ScriptNodes that much. They can be slightly sinister since they are normally invisible (unless you know where to look for them) and they can be set to always evaluate.

However, usually they are set to only execute when you open or close a scene. They can be good for setting up an auto-export feature needed for a pipeline, for example. Let's create one that simply prints something when you change the timeline to see how it works.

1. Open the Expression Editor window (ooh—a new window!) by clicking **Windows>Animation Editors>Expression Editor.**

2. This window lets you see expressions, object's attributes, and the gnome-like script node. Click **Select Filter>By Script Node Name**.

3. We'll create a new script node. Type **myTest** in the Script Node Name field.

4. At the bottom of this window, we'll add our script in the script area by typing:

   ```
   print("\nTesting\n")
   ```

5. Click on **Create**. This adds the script to the ScriptNodes list and selects it.

6. Now you can edit when the script node works. Change the **Execute On** pull-down to be **Time-Changed**. Hint—if you edit the script itself, make sure to click on the **Edit** button when you are done, or else you'll lose the changes. (I do that every time.)

Refer to Figure 17.6. Test by moving the timeline. The word "Testing" will print in the main script window every time you change the time in the timeline. This could be used in all sorts of ways. You may have noticed it can be set to execute upon opening or closing a Maya file. You could add one of these to your scene files to always save a backup file when closing or to always load a certain shelf button when the scene loads. The drawback is that it always gets evaluated, and that does cost a little on the memory side of things. Overuse of such a tool could slow things down. Refer to Figures 17.6 and 17.7.

ScriptJob: If I don't like ScriptNodes, I really don't care for ScriptJobs. They do evaluate all the time. To me, they seem like an evil gnome, always whispering in Maya's memory. Despite that, they are kind of neat to use. ScriptJobs exist in Maya's

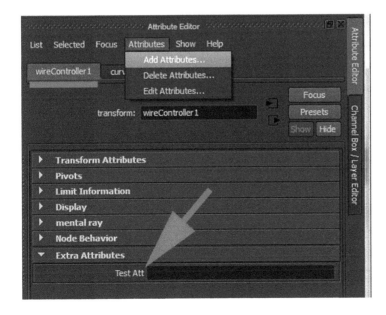

Figure 17.6 Hidden attributes in the Attribute Editor.

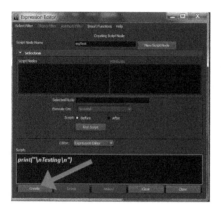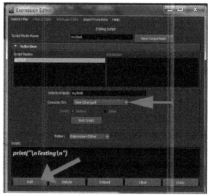

Figure 17.7 Creating a ScriptNode.

memory from the moment you create them and do not go away until the application is shut down. There is no window in which you can see them, like you can with a ScriptNode. They are jobs—which in Unix/Linux land is something that runs in the background. In the script editor, enter and execute the following code:

```
scriptJob -ct SomethingSelected "print this";
```

This returns a number in the script editor; remember that number. In the scene, create an object and deselect it, then select it again. When you select the object, "this" should be printed in the help line (or in the script window, if you have it open). The command you wrote above creates a script job that runs when the condition "something selected" is true. So, when something is selected, the script job does the last thing in the command, which is to print the word "this." The opposite would be to use the flag—cf, which would print "this" when nothing is selected.

How do you delete a ScriptJob? Did you see the number it returned when you created the script job? For example, mine returned a number of 164. To kill it, type the command:

```
scriptJob -kill 164;
```

Putting it together: Now that you know the pieces, we're going to put them all together to create a nice little controller that selects something else. What we are going to do:

1. **Secret Name:** create a secret name hidden in the controller's attributes.
2. **Listener:** create a ScriptJob that is always listening to see if you have selected anything.
3. **Execute:** create a ScriptNode that contains a script that will check to see if the selected object has a hidden secret name. If there is a secret name, then it selects the object whose name matches the secret name.

Step 1: Create the Secret Name

1. Open the scene: **chpt17_MagicController_v1.ma**.
2. Select **the Controller** and open the Attribute Editor; make sure the transform node is selected.
3. Select **Attributes>Add Attributes...**; create a string attribute named **magicName**. Note the visible "Nice Name" in the Attribute Editor, which turns it into two words and capitalizes the first letter—just to make things sporting. Click **OK**.
4. In the newly created attribute **Magic Name** (found under the Extra Attribute area), enter the sphere's name, **theGEO5**.

Note: If you accidentally create the attribute on the shape node and then try to recreate the attribute on the transform node, it will throw an error since you've already used the "magicName" name. Re-open the file without saving to clear that attribute name from the memory. Ask me how I know.

Step 2: Create the Listener

This will create a script node, which creates a script job automatically every time you open the file. This script job stays in Maya's memory until the application is closed and listens for when something is selected. When something is selected, it will run a script called secretName.

1. Open the **Window>Animation Editors>Expression Editor**.
2. Click on **Select Filter>By Script Node Name**.
3. Enter a script node name: **myListener**.
4. Enter the following into the script box:

```
//create everlasting job that listens for
anything selected.
   scriptJob -ct
   SomethingSelected secretName;
```

5. Click on **Create**.
6. Change **Execute On** to **Open/Close**.

Note: If you didn't create this ScriptJob with a ScriptNode, you would have to enter the command every time you opened the file.

Step 3: Create the ScriptNode with the Actual Code

1. In the **Expression Editor**, click on **New Script Node**.
2. Enter a ScriptNode name: secretName.
3. Enter the following into the script box:

```
//checks to see if the controller is the secret
controller
```

```
global proc secretName() //checks selected
object for a secret name
{
    string $isPicked[]='ls -sl'; //what is
    selected?
    if (attributeExists("magicName",$isPick
    ed[0])) //does the first thing selected
    have a magic name?
{

    print "You found a Magic Button\n";
    select -cl;
    select -add 'getAttr ($isPicked[0]+".
    magicName") ';
}
    else print "np\n"; //remove line if it
    bugs you
}
```

4. Click on **Create**.
5. Change **Execute Open/Close**.

This ScriptNode will place the secretName procedure into memory when the file opens. To test it out, save the file, reopen it, and select the controller. It should select the sphere. Or, instead of closing and opening the file, you could also click on "test script" for each of the ScriptNodes you created. You can also see a finished file by opening: **chpt17_MagicController_v3.ma**.

The fun thing about this is that nothing is "hard coded;" all you need are those two script nodes, and any controller that you create, which has a secretName attribute, will be listened to. In testing the scene, you might notice a small behavioral problem. No, this scene can't be sent to the principal's office—but we can adjust the code.

The issue is when the sphere is selected; if you select the controller again, the secretName script doesn't get called. It only gets called if nothing is selected, and then you select the controller. Hmm—that adds an extra button click; I don't like it. Go back to the **Expression Editor**, select the **myListener** script node, and edit the code to be: **scriptJob -e SelectionChanged secretName;**

Refer to Figure 17.8. Click on the **Edit** button when you are done. The code now listens for an event instead of checking to see if something is selected. It executes automatically when the selection changes. If you test the file now, you'll see that you can click on the controller again, even after the sphere is selected, and it will automatically select the sphere. Nice, a button click removed. Save and congratulate yourself.

Extra effort: There is a MEL command called buttonManip that creates a circle button that can be used. It is interesting to work with but is limited in how it can be viewed and scaled;

Figure 17.8 Magic controller via ScriptNode and ScriptJob. Both scripts should execute on Open/Close.

therefore, it is not what I use. Incidentally, this is how Zoo Tool's trigger system works, somewhat.

GUI Control Systems

I hesitate to even get into this subject because it is such a deep subject and can suck your time right away if you start worrying over GUIs (graphical user interfaces). Maybe that is just my experience. This is a large rabbit hole for me because I get obsessed with button placement. We'll give a simple example—you can go to other books for more information. We'll start with a simple, simple, simple window, work our way through buttons, and then to commands.

MEL Windows: A Simple Example

You can look under Help>MEL command reference to see what commands there are for making windows using MEL. We'll use the simplest command. First, you use the command to make the window, and then you have to tell Maya to show it. Enter the following into the script editor:

```
string $window = 'window -title "My Controls" ';
showWindow $window;
```

The first line executes the window command, gives it the title "My Controls" and catches the name Maya gives that window. That returned name is stored in the variable called $window. The showWindow command is then called and given that variable name. This creates a basic window. Refer to Figure 17.9.

Figure 17.9 Basic window.

Make sure to close the window. If you try to create another window with the same name while this one is open, it will throw an error. (There are ways around that, but we're just getting started here. When you are ready, check out some scripts and see if you can spot the code that basically asks, "if a window with this name already exists, close it and remake this.")

Add a layout: The next thing to add to the window is a layout. A layout dictates how the buttons and other things can be placed in the window. You can look in the help documentation to see how many different layouts there are. We're going to use a grid layout that has three columns. Refer to Figure 17.10. Enter the following into the script editor:

```
string $window= 'window -title "My Controls"';
gridLayout -numberOfColumns 3 -cellWidthHeight
90 50; showWindow $window;
```

The result looks exactly the same. We'll need to add some buttons to see them laid out.

Add buttons: The next bit of code will add some labeled buttons. The buttons don't do anything yet. Refer to Figure 17.11. Add the following into the script editor:

```
string $window= 'window -title "My Controls"';
gridLayout -numberOfColumns 3 -cellWidthHeight
90 50;
```

Figure 17.10 Basic window with a layout added.

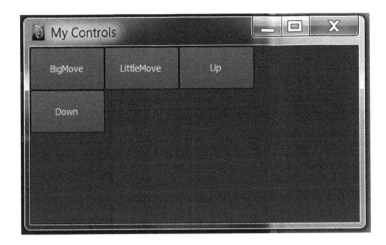

Figure 17.11 Window with buttons added to a grid layout.

```
button-label "BigMove" ;
button-label "LittleMove" ;
button-label "Up" ;
button-label "Down" ;
showWindow $window;
```

Add commands: I suppose you want those buttons to do something. Let's add a command to each one. Enter the following into the script editor:

```
string $window= 'window -title "My Controls" ';
gridLayout -numberOfColumns 3 -cellWidthHeight
90 50;
button-label "BigMove" -command ( "print
BigMove") ;
button-label "LittleMove" -command ( "print
LittleMove ");
button-label "Up" -command ( "print Up ");
button-label "Down" -command ( "print Down") ;
showWindow $window;
```

Each time a button is clicked, the command is executed. Those commands could be anything you can put in the parenthesis. Refer to Figure 17.12. It could call a procedure you have created that is already sourced or a MEL command.

What if you wanted a picture for the button? Now, here is where the idea starts to get applied. What if you wanted to take a picture of your character and make a picture button that selected the controller? That would be an interesting interface, wouldn't it? This is exactly what many production houses have done: created a visual interface for their rigs. Create a new file and save it in the chapter material folder for this chapter. In that folder is a **gui_image.bmp** file we want to use. Or, if you want to use your own image, replace the "gui_image.bmp" name with

Figure 17.12 Buttons with print commands.

the full path to the image you want to use. Enter the following code into the script editor:

```
string $window= 'window -wh 300 221 -title "My
Controls" ';
gridLayout -numberOfColumns 3 -cellWidthHeight
90 50;
symbolButton -w 100 -h 221 -image "gui_image.
bmp" -command ( "print test") ;
showWindow $window;
```

You'll note that the command is different. This is a **symbol Button** instead of a **button**. Refer to Figure 17.13. You can find out what different types of buttons and fields there are by looking up the **Window>Controls** in the MEL help documentation.

Put it all together: Using what you know, we'll create a multiple-button interface for the muppet character. I created the multiple images by taking a screen grab of the character and then slicing it in Photoshop. I then saved those images. For some odd reason, one is a jpg, and the rest are gifs. I left it like that to see if Maya would read them in. Also, they are all different sizes—you might want them to be nicely sized. Open the file: **chpt17_BlueMonster_GUI_v1.ma**. Next, enter the following into the script window:

```
string $window= 'window -title "My Controls" ';
gridLayout -numberOfColumns 3 -cellWidthHeight 98
221;
symbolButton -w 100 -h 221 -image "gui_pics/
gui_image_01.gif" -command ( "print test") ;
symbolButton -w 98 -h 145 -image "gui_pics/
gui_image_02.jpg" -command ( "print test") ;
symbolButton -w 102 -h 221 -image "gui_pics/
gui_image_03.gif" -command ( "print test") ;
button -w 100 -h 221 -label "blank" -command
( "print test") ;
```

Figure 17.13 Button with an image and a print command.

Figure 17.14 Creating symbol buttons as an interface.

```
    symbolButton -w 98 -h 67 -image "gui_pics/
gui_image_04.gif" -command ( "print test") ;
    button -w 102 -h 221 -label "blank" -command
("print test") ;
    showWindow $window;
```

Since the buttons are placed in the grid layout, they line up. The sizes would look nicer if they were all the same, in my opinion. Refer to Figure 17.14.

Extra effort: That wasn't too bad, was it? You have enough to get you started and wanting to look at examples. Things you can do to stretch your skills right now are to try doing the following to the script:

1. Add commands that select the correct controllers when the buttons are pressed. Hint: look up the select command.

2. Create a ScriptNode that automatically opens this GUI script when the file is opened. To see it working, open the file chpt17_BlueMonster_GUI_v2.ma

Now, isn't your head just buzzing with possibilities? I better put down a list of all my favorite reference books you might want to research. In the last pages of this book, I'll place a reading suggestion list.

18

STRETCHY

Imagine a class of 20 new animators who have been exposed to simple rigs with simple features. They have learned how to set key frames, are beginning to make peace with the graph editor, and have figured out how to use a torn-off camera pane in lighting mode (hot key 7), which displays the character in silhouette to help them pose for the camera. However, a simple rig can only go so far, and they are stuck with what ends up being a rigid character that does not pose very well unless it is a very naturalistic character, like a digital double. Then imagine showing them the "stretchy" button, which turns on the stretch feature. You hear 20 collective exclamations of relief, and the fun begins as they start to pose the character in new ways. I think that moment is why I like teaching so much.

Stretchy is a very important part of rigging for animation. Stretchy can be a difficult part as well, and sometimes one technique doesn't fit all animation needs. At the end of the day, it is about making the rig easy to animate and allowing for nice poses. Let's break down the concept of stretchy down into some typical patterns of how one could look at it, and then put together a few applied examples. Feel free to take some of the concepts and go wild with them. Figure 18.1 shows a stretchy character. This rig is downloadable from https://www.highend3d.com/.

It is the "Andy Rig," created by John Doublestein, who once graced an animation class of mine years ago. In this image, you can see controllers being moved to adjust the bendiness of the arm and a view of the silhouette in a torn-off panel set to lighting mode.

Stretchy Skin

Making the skin be able to stretch right off the bone can be used to get noodle arms, for example, where the silhouette of the arm can be made to look wavy instead of like a typical arm with an elbow. This, obviously, is used in very cartoony characters. The thing to remember is that it isn't just that the arm can be bendy, but that the bendy portion of the arm can be adjustable. This allows the animator freedom to obtain a good arc in their character's pose, no matter what camera angle or body position. The trouble with many bendy arm tutorials is that they make a "bend" in

DOI: 10.1201/9781003431121-22

Figure 18.1 Stretchy character posed.

the arm that is very limited and mathematically correct. I don't know about you, but mathematically correct, in my opinion, equals a sterile, lifeless pose. In Figure 18.1, the bendy is not mathematically correct; the bendy is under the animator's control via a controller that is translated. I prefer this type of method for the animator. So, what ways are there to make stretchy skin?

Thinking back on what we have learned in this book, let me pose a question to you. What do you know stretches the skin right off the skeleton? In fact, it might have tripped you up at one point in this book when we switched from hierarchical objects to skin and bone objects. Deformers—you are correct. Nonlinear and other deformers work with the components of the geometry, just as skinning does. If you place a deformer on an object already skinned, the bones tell the geometry how to bend, and then the deformer gives additional transformation information, causing the "skin," or geometry, to pull right off the bone. Man, that does sound painful. Remember, we found that if the deformation order of things was backwards, then when the deformer (like a blendshape) was turned on, the skin returned to its default binding position before it did the prescribed deformation. We fixed that by going to the input window and changing the order of deformations on the deformer and the skeleton. Now that you remember, let's relook at a few methods you could use to purposefully pull skin off the skeleton with deformers.

Clusters

Open the file chpt18_HogarthRig_Gee.ma. This character has a two-bone arm and a normal skeleton, similar to what we have learned to do in this book. We can use clusters to give the

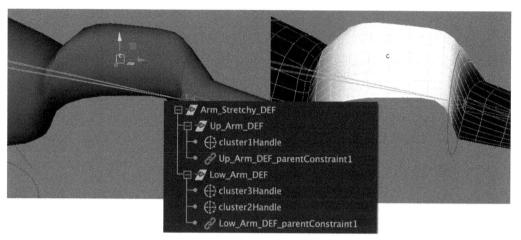

Figure 18.2 Clusters driven by skeleton for stretchiness of skin.

animator the ability to offset the skin and round out the arms when in a pose. Remember Rule #1: in order to have proper deformation in a character, you need proper edgeloops. If you do not have nice edgeloops in the geometry, the bend will not be smooth. Refer to Figure 18.2.

1. Using your favorite selection method, select the top portion of CVs on the arm.

 Note: It is easier to pick too many CVs and paint them out later. It is more difficult to add CVs to a cluster after it has been created.

2. Select the option box for **Deform>Cluster**.

3. Make sure that **Relative** is turned **ON**.

 Note: You can add or subtract vertices from the cluster by using the Deform>Edit Membership Tool. It will prompt you (in the help line at the bottom of Maya) to use Shift + LMB to add vertices and Ctrl + LMB to remove vertices.

Repeat these steps for a lower portion of CVs on the arm and a middle portion of CVs on the arm. You can add as many clusters as you think you need. Open the file **chpt18_HogarthRig_Gee_V1.ma** to see the arm with clusters applied to the skin on the left arm. You want to make sure that the clusters follow along with the skeleton when it moves. Determine which clusters should follow the upper arm and which clusters should follow the lower arm.

1. Select the **upper arm clusters** and **group** them together. Name the group: **UpArm_DEF**.

2. Move the **pivot** point of the UpArm_DEF to be at the **shoulder**.

3. Select the **lower arm clusters** and **group** them together. Name the group: **LwArm_Def**.

4. Move the **pivot** point of the LwArm_Def to the **elbow**.

5. Select the **shoulder joint** and the **UpArm_Def** and create a **parent** constraint with **maintain offset on**. (The translate of the joint has numbers in it. You don't want those jumping to the group node.)

6. Select the **elbow** joint and the **LwArm_Def** and create a **parent** constraint with **maintain offset on**.

Test. Rotate the joints of the arms to see that the clusters rotate along with the arm. Move the clusters so that the arm skin can be positioned to create a rounded pose. Rotate the joints of the arm; the clusters maintain their offset position but rotate along with the joints.

To get a good blending between the clusters, make sure to have the cluster vertex ownership overlap and adjust the falloff of the clusters by using **Deform>Paint Weights>Cluster**. If two clusters own the same vertices, those vertices listen to both clusters, so make sure their weights are not 100%, or you'll get double transformations. The next step is to create a control for the animator that connects to those clusters since they are difficult to select. You use your favorite method to create a controller. Now, hide the clusters and put them in their own group. Then, to be organized, place that group in the SKEL group. They will ultimately need to scale along with the skeleton, so keeping them in the SKEL group will help you implement that functionality.

Joint Balls Driven by a Joint System

For years, being very stubborn, I refused to use clusters, so I found other ways to do the same thing with joints. Reopen the file **chpt18_HogarthRig_Gee.ma** to start the arm again. This time, we'll use free-range joints. (Yes I think, i.e., a funny statement too. How many chapters have you been with me—I have a funky sense of humor.) These joints will be bound to the geometry. The main movement of the character won't come from them, though—they will be driven by the skeleton the animator works with. It is an interesting concept because, ultimately, the bound rig (the rig, i.e., skinned to the geometry) is no longer what is animated. The animated rig, which the animator manipulates, is completely separate. That's a rabbit hole of a subject right there, if you wanted to jump in. It is a whole other method of rigging, but this is the idea in its essence.

So, we'll first unskin the character, and then we will utilize two separate joint systems: one that drives the skin and one that is driven by the animator.

1. Select the geometry and unskin it by clicking **Skin>Unbind Skin**.

2. Create five to six separate joints by clicking **Skeleton>Create Joint**; click once anywhere on the screen; hit **enter** on the keyboard.

 Repeat five or six times as needed.

3. **Move** these **joints** to line up with the existing animator skeleton. These new joints will serve the same purpose as the clusters.

4. **Select** these rogue, free-range **joints** and then the **geometry,** and bind them together by selecting **Skin>Bind Skin.**

5. **Test** by **moving** one of these joints around. They are free; there is no rotational axis to worry about. They are the equivalent of a cluster except that they are driving the skinning of the geometry.

6. Make sure to undo each time you move a joint; those free-range joints can't be zeroed out.

 Now we'll group up those rogue joints and constrain them. They will be driven by the main skeleton (animator's skeleton).

7. Like we did with the clusters, **select** the **joints** bound to the top arm and **group** them. Name the group: **UpArm_DEF.**

8. **Move** the **pivot** point of the **UpArm_DEF** group to be at the **shoulder.**

9. Select the **lower arm** rogue joints and **group** them together. Name the group: **LwArm_Def.**

10. **Move** the **pivot** point of the **LwArm_Def** to be at the **elbow.**

11. **Select** the **shoulder joint** and the **UpArm_Def** and create a **parent constraint** with **maintain offset on.**

12. **Select** the **elbow joint** and the **LwArm_Def** and create a **parent constraint** with **maintain offset on.**

Test as before: rotate the animator's skeleton, then move your rogue joints to adjust the pose. This example in Figure 18.3 shows the technique applied to the leg. To make sure the transitions are smooth, the same techniques of painting skin

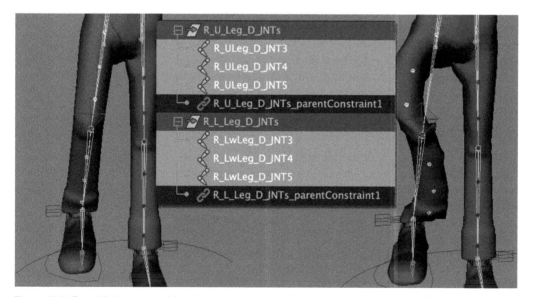

Figure 18.3 Bound joint system driven by an animator joint system to get cartoony results.

weights can be used here, along with overlapping of influence. This example can be found in the file **chpt18_HogarthRig_Gee_v2.ma**. The right leg rogue joints are driven by the animator's skeleton. The left leg is left for you to constrain the rogue joints to the animator's skeleton. Those rogue joints should be placed under the SKEL group so that they are scalable with the rig.

Lattice Skinned to Skeleton

This next technique has been around for a long time—it was once used with NURBS surfaces. Objects made with NURBS patches had multiple pieces of geometry stitched together to form one surface. In order to have all those individual pieces move together as one, you could use lattices to move them. Lattices are still great for deforming multiple objects at once. In this case, we're going to use the lattice to deform the geometry and let the animator move the lattices with the skeleton system. Refer to Figure 18.4.

1. Re-open file **chpt18_HogarthRig_Gee.ma**.
2. Detach the skin by selecting the geometry and selecting: **Skin>Unbind Skin**.
3. Select the vertices of the geometry, for example, a jaw or tail.
4. Create a lattice by selecting **Deform>Lattice** with the **group lattice** and **base** options turned **on**. (This saves you a step in the outliner when organizing.)
5. Add enough divisions to the lattice to allow for proper deformation for the animator.

This creates a lattice and a lattice base that are centered around the geometry by default. If you look in the outliner, you'll see the lattice and lattice base. If you adjust a lattice point, you can adjust the shape of the geometry. Put the lattice back in its original position by selecting **Deform>Edit>Lattice>Remove Lattice Tweaks**.

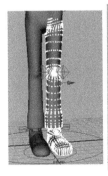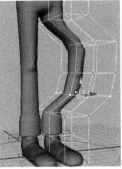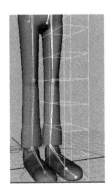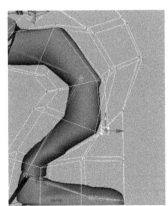

Figure 18.4 Lattice bound as skin to the skeleton and used to adjust geometry.

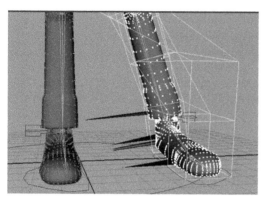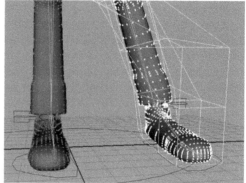

Figure 18.5 Fixed vertex membership for the lattice.

1. Select the **skeleton** and the **lattice**.
2. Skin the lattice to the skeleton by selecting **Skin>Bind Skin**.
3. The next time you add a lattice to the skin system, use **Skin>Edit Influences>Add Influence**.

 Test. The animator can rotate the skeleton, animating the character as normal, then select the lattice points to further adjust the pose of the skin. Whatever control system you want to put in place—for the lattice points—will play a key part in how easy this system is to use. Once the lattice is bound as skin, the "Remove Lattice Tweaks" option no longer works. However, each individual lattice point can be zeroed out in the channels box. Refer to Figure 18.5.

 You'll note in my sample file, **chpt18_HogarthRig_Gee_ v3.ma**, that when the left leg is moved, a few vertices stay behind. Select the lattice and then the tool **Deformer>Edit Membership Tool**. This selects the vertices in the lattice's membership. Oops—I missed a few. Let's follow the directions it gives us at the bottom to fix that error. **Left mouse click** while holding **shift** on the unowned vertices. They add to the lattice membership and snap into shape. The fixed version is in the file **chpt18_HogarthRig_Gee_v3b.ma**.

Stretchy Skeletons

All of the above techniques were just for the skin. You can also add methods in the next section, which is all about making the skeleton itself stretchy. Usually, a cartoony rig needs something that allows stretchiness, like what we'll cover next, at minimum. There are a few scripts floating out there that recreate some of the principles we are going to go through. Sometimes they work; sometimes they give errors. I haven't found one-script-that-fits-all for stretchiness yet. Even if we had one, we would still need to learn how it works. Let's look at the different types of methods:

Stretchy FK Skeletons: Scale Down the Bone with Set Driven Key (Easy)

This is a simple scale feature to add. It is good for FK (forward kinematic) types of bones that you do not need a specific contact point with. Tails, ears, joint-driven hair, stretching cloth driven by joints, etc., can use this simple solution. Refer to Figure 18.6.

1. Open the file **chpt18_Shroom_Kingsberry_v1.ma**. This is the noodle arm that has been skinned. These arms are FK, and the animation we'd use them for would have no contact points, as you would with IK (inverse kinematic) arms. You could add an attribute to the Hand_CNTRL controller or create a separate on-screen controller for this stretch feature. I'm going to choose to do a stretch on-screen controller.

2. Create a **NURBS** circle that is **small** and place it towards the end of the left arm chain; **freeze** and **delete history**; name **L_Arm_Stretch_CNTRL**.

3. In the **Attribute Editor>Limit Information>Translate**, set the **Translate X** to have a minimum of **0** and a maximum of **1**. This will limit the controller to only moving from side to side a little bit.

4. In the Channels Box, **lock all** other attributes **but Translate X**.

 This controller's X translate is going to drive all the X scales in our joint system. Open the **Key>Set Driven Key>Set...** window. Make the **L_Arm_Stretch_CNTRL** the **driver** and all of the **arm** (and any fingers or thumb) bones for the left arm as **driven**.

5. Select the **driver** as **L_Arm_Stretch_CNTRL>Translate X**.

6. Select the **driven** as all of the **joints>Scale X**.

7. Since everything is in the neutral position, click on the **set key** to save the neutral position.

8. Move the **L_Arm_Stretch_CNTRL** to translate **X = 1**.

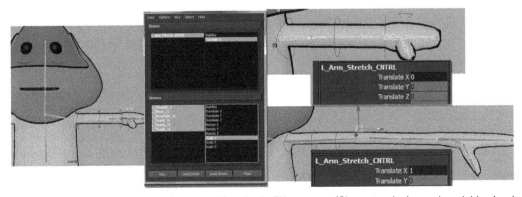

Figure 18.6 Set driven key stretchy control for simple FK systems. (Character design and model by Jarel Kingsberry, with permission.)

Figure 18.7 What stretch looks like due to orient constraint offsets.

9. Select all of the individual arm joints and change their **scale X** value to be the largest you would ever want the arm to stretch: **3,** for example.
10. Click on the **set key** to save the stretched position.

Test. When the controller is moved from the left to the right, the arm should stretch on the X-axis, which is the axis pointing down the bone. That's pretty simple.

Warning: If your controllers were already setup to drive the joints via orient constraints, the end result might look a little skewed. See Figure 18.7 for what it would look like. It is because the orient constraints are working when the arm is in a normal position but not when it is scaled.

To fix rotations caused by orient-constrained controllers using the constraint's offsets:

1. Return everything to the neutral position. Make sure there are no rotations in the joints.
2. Create an orient constraint from each controller to the respective joint by selecting the controller and then the joint (Driver>Driven).
3. Go ahead—you want to see it break. Stretch the arm to see the funkiness. Return the stretch back to 0.
4. Create a set driven key from the **L_Arm_Stretch_ CNTRL>Translate X** to the **offsets** in each of the arm controller's orient constraints. Click **Set Key** for the **neutral** pose.
5. Move the **L_Arm_Stretch_CNTRL** to the stretch position. Select the **elbow** joint and look in the channels box. There are rotations in the joint! The horror. Put the **opposite rotation** value in the **offset** value of the **orient constraint**. This should straighten out the joint. Continue for any other affected joints in the arm. Click **Set Key** for the **stretch** pose.
6. Test it now. There should be no funkiness. See Figure 18.8 for an example.

To tidy up, do you want the controller to go with the end of the arm? Sure, you do.

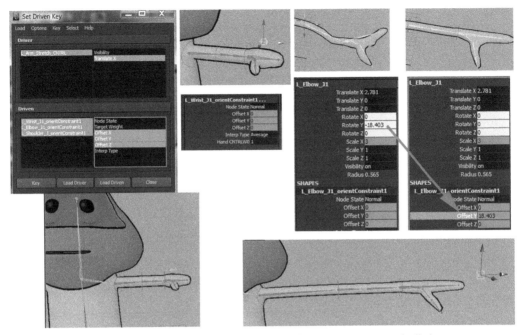

Figure 18.8 Creating set driven keys to offset orient constraints to create a stretchy limb.

7. Select **L_Arm_Stretch_CNTRL** and create a **group** node. Name it **L_Arm_Stretch_GRP**.
8. **Center pivot**.
9. Select the **wrist joint** of the arm, and then select the **group** that you just made: **L_Arm_Stretch_GRP**. (*Very important*: do not select the controller—select the **group**. You remember why, right?)
10. Create a parent constraint. Constrain>Parent. Maintain offset shouldn't have to be on because everything is zeroed out.

 Test. Move the stretch controller left and right. The arm should stretch, and the controller should go with it. Since we connected to the group node, there is no cycle warning. Another good test is to keyframe the stretch controller to make sure that doesn't break anything. Key framing: a controller that has a constraint on it will override the constraint. That is one of the reasons we use the group node to hold the constraint. To see the limb in action, open the file: **chpt18_Shroom_Kingsberry_v2.ma**. As usual, you'll note my skinning is not lovely but serviceable.

Stretchy Skeletons Based on End Point (Like the IK Skeleton): Scale Bone to End Point with Utility Nodes (Not Super Easy, But You Can Do It)

This involves a few steps, but you've done most of these things before, so we can break it down into some chunks of

to-dos that can be digested easily. The interesting thing about most scripts that deal with this type of scale is that they limit themselves to IK handles. It doesn't have to be that way. It can be any end point you want to scale to, though usually this does mean an IK handle. For example, if you grab a hand control and drag it out in Z, you want the arm to scale right along with the movement of the controller. Imagine a character like Reed Richards from *Fantastic Four*, or Elastigirl from *The Incredibles* who can stretch their limbs to tremendous lengths. We'll learn how to do just normal objects first, and then come back and do an IK arm.

Part 1: What Is the Rest Length?

We want to find out what the normal distance from start to end is. This is the distance of the object when it is not scaled from start to end. How long is Reed Richard's arm when he isn't stretching? Open the file **chpt18_BasicStretchy_v1.ma** to follow along. Refer to Figure 18.9.

A start locator has already been created (**Create>Locator**) and placed at the left of the oval: **Start_LCT**. And an end locator has been created (**Create>Locator**) and placed at the right of the oval: **End_LCT**.

1. Whatever you do: **DO NOT FREEZE transformations**. We need to know those exact numbers.
2. **Select** both locators and open the **Node Editor Window**.
3. Right-click and choose **Create Node...**; click on **Distance Between**, found under the utility nodes.
4. In the Node Editor window, locate this new DistanceBetween node and the two locators; click 4 on the keyboard to display all of the connectable attributes.
5. Connect **Start_LCT Translate** to **DistanceBetween.point1**.

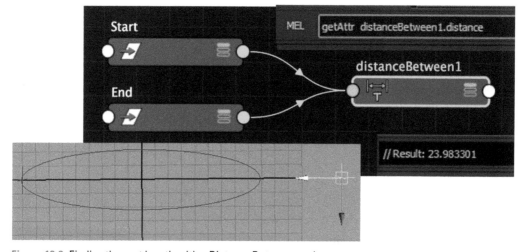

Figure 18.9 Finding the rest length with a DistanceBetween node.

6. Connect **End_LCT Translate** to **DistanceBetween.point2**.

 This distance node calculates the distance between the two locators. How do we find out what that distance is? Later on, we'll hook that node up so we can get that number, but for now, we can ask what the number is. Try this:

7. Move the **End_LCT** and type this MEL command into the command line:

 `getAttr distanceBetween1.distance`

8. The result should be printed on the help line. Make a **note** of that number. It is your **rest length**.

9. **UNDO** to put the locator back in the beginning position.

Part 2: Is the Current Distance Smaller or Larger than the Rest Length?

This next part introduces a new utility node. Refer to Figure 18.10. We will use a conditional node to ask the following conditional statements:

If the rest length is greater than the current length, then send the **rest** length number through to the next node. That means if the current is smaller, don't scale the joints.

If the rest length is less than the current length, then send the current length through to the next node. This means that the end point has been moved further than it originally was; scale the joints to catch up.

Now, to create a conditional node that asks those conditional statements:

1. In the Node Editor window, make sure you have the **DistanceBetween** displayed.

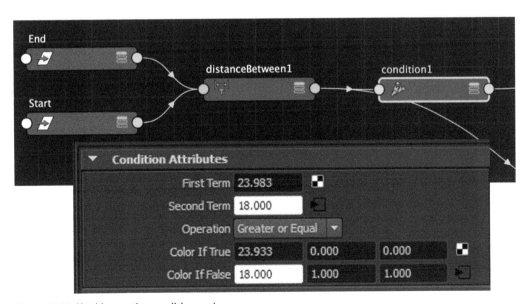

Figure 18.10 Hooking up the condition node.

2. **Right Mouse Click** and select **Create Node…**
3. In the pop-up window, select a **Condition Node** found under the **Utilities** tab.
4. **Type** the **rest length** into the following places:
 a. **First Term**
 b. **Color if True Red** (the first box).
5. We'll need to add connections to find out the current length. Connect the output of distanceBetween1.distance to the following:
 a. **Second Term**
 b. **Color if False**
6. Set the **Operation** to be **Greater or Equal**.

Double check what you have hooked up. Because the locators are set at their default place right now, nothing needs to be scaled. So, the numbers in the condition node should be the same in the First Term, Second Term, Color if True, and Color if False. Also, the following fields should be yellow: Second Term and Color if False.

Why are they yellow? Incoming connects, just like the channel box. The *technical editor states, "Take that, Thurston!" *It is a great match when the technical editor starts telling the same style of jokes as the author. Moving on to the next section.*

Part 3: Create a Scale Value

We're not done yet. We have the length from the conditional node. We need to take that length and turn it into a scale value that we can pump into a scale attribute. Let's say the output of the condition node was 5. That happens to be our rest length, too, so we don't want anything to scale. OK. That means that we need to put a 1 in the scale attributes. How do you get 1 from 5? Divide it by itself? Good job. Refer to Figure 18.11.

1. In the **Node Editor window,** make sure you have the **DistanceBetween** node visible.
2. **Right Mouse click** and select **Create Node…**

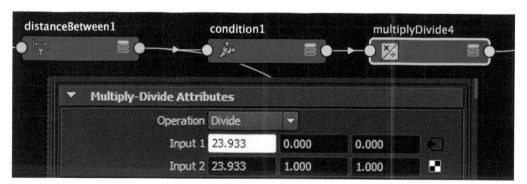

Figure 18.11 Creating the scale value.

3. In the pop-up window, select **Multiply Divide,** found under the **Utilities** tab.
4. Set the operation to be **Divide**.
5. **Type** the **rest length** into the **Input2X** value.
6. Connect the **Condition1.outColorR** to go into the **Input1 X** of the multiply divide node.

Double check before moving on: the numbers should be the same in the X values, and the Input 1 should be yellow.

Before finally hooking this up to scale something—let's understand what numbers are going through these connections.

- Pretend the rest length is 5, and our current length is 5.
- Condition node asks:
 - Is the rest length of 5 greater than (or equal to) the current length of 5?
 - Yes
- Condition node gives the true value of 5 (which you typed onto the First Term).
- Multiply/Divide node divides the output of the condition node (5) by the rest length you typed in (5).
- Our scale value is 1.
 What about the other way:
- Pretend the rest length is 5, and our current length is 10.
- Condition node asks: Is the rest length of 5 greater than (or equal to) the current length of 5?
 - No.
- Condition node gives the false value as the current length (10).
- Multiply/Divide node divides the output of the condition node (10) by the rest length you typed in (5).
- Our scale value is 2.

It is helpful to think about the numbers step by step to see what the nodes are doing. I personally have to write them on sticky notes and move them around if there are too many nodes going on. Refer to Figure 18.12.

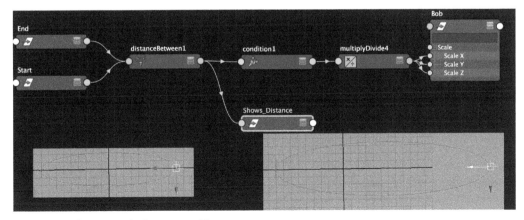

Figure 18.12 Auto stretchy feature working.

Part 4: Hook Up the Scale Value

Here's the easiest part of our quest for scaling. Connect the output of the **Multiply/Divide** node to the scale value of the item or items you wish to scale. Make sure that the object you are connecting to has had its transforms frozen and that there are ones in the scale attributes. In the sample file, the object to scale is the curve named **Bob**. (A test name.) Connect the output of the multiply divide node to all scale values you wish to scale.

Test. At long last, test your hard work. Move the end locator and watch the scaling magic happen.

Isn't that nice? Now you have a working auto-stretch feature that works for objects. Save this file, and you can use it again and again. How? Import this file into any rig you are working on. Point constraint the start locator at a character's belt (for example), and then point constraint the end locator to the cell phone dangling from the character's belt. Look to see what the oval is stretched to—that's your rest length.

1. Note this new **rest length**.
2. Change the **rest length** value in the:
 a. Conditional node's **First Term** and **Color if True** fields.
 b. Multiply Divide node's **Input2X** field.
3. Connect the **output** of the **multiply divide node** to the object's **scale** values.
4. Delete the oval. It is no longer needed.

What about IK Chains?

The only difference between the above and what you would do for an IK chain is how you find the rest length. The rest length is equal to the length of the arms (legs/spine) when they are straightened. Then, when the IK handle is moved further than that length, you want the arm (or leg, or spine) to stretch to stay with the IK handle. There are two ways to find that rest length. Open **chpt18_Shroom_Kingsberry_v3.ma** to play along.

1. Straighten the arm (or leg, etc.) to find the rest length.
 - Translate the IK handle temporarily to straighten out the arm.
 - Use the locator method described earlier in this chapter by placing a locator at the shoulder and a locator at the IK handle, located at the wrist. This gives you the rest length of the arm.
 - Undo the move of the IK handle so the arm returns to the default position.
 - Make sure there are no rotation values that have crept into your joints.
 - Continue as described above by creating the conditional node and multiply divide nodes.

2. Use a temporary spline curve to find the length of the joints. Spline IK handles automatically create a curve for the length of the joint system. We can ask that curve how long it is. This gives an approximate value, but not the closest value for the rest length. The higher the number of spans on the curve, the closer the value is to the actual rest length.

- Create a duplicate of your arm or leg joint chain, whatever it is you want stretchy.
- Create a splined IK handle from the top to the bottom. (**Skeleton>Create IK Spline Handle**). Note the name of the curve it generates. Mine is called **curve1**.
- Select curve1 and type the following command: *arclen –ch*
- Select **curve1** and open the Node Editor window. There is a new node called curveInfo1, which was created by our *arclen* command.
- Select it and look in the Attribute Editor for the field **Arc Length**. The number in that field is the length of the curve along the joint system, which is the rest length. Note the rest length.
- You could have also found that information by typing the following command: getAttr curveInfo1. arcLength
- That's all you needed, so you can delete the temporary duplicate chain.

Gosh, for some reason I had to stop writing this chapter to write a script for it, even though there are plenty of auto-stretchy scripts out there if you search. Refer to Figure 18.13. If you want to test it, load the script **MakeItStretchy_v3.mel**. Go ahead and make that a shelf button. Here's how it works. In the pop-up window, load the **shoulder** as the **start** object and the **IK handle** as the **end** object. Load the **shoulder**, **elbow**, and **elbow twist** as the objects to **scale**. This should scale in the **X**-axis, since most joints scale in x. Turn that check box **on** and click on

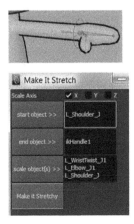

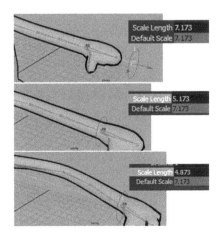

Figure 18.13 Make it stretchy script.

"**Make It Stretchy.**" The script looks to see if you have selected a joint and an IK handle. It will work if you select two joints. If you select two items, it adds locators for you and hides them. It also adds an attribute on the IK handle, which allows you to see what the rest length was set at and allows you to adjust it. You can even set it a little lower to get an extra stretchy arm. If you select locators as the start and end points, it knows they are locators and assumes what's in-between them is the rest length. It is not completely bulletproof. If you undo, it doesn't undo well and won't work correctly unless you re-open the scene. There must be some node that is still hanging out when you undo, or perhaps, ... oh, you know, I bet it is a leftover global variable that holds garbage from the last time. Those global variables will get you there. If you find a newer version in the chapter material, I had time to address the issues.

Now, remember that if you were to use a stretchy setup on a three-joint chain FK/IK limb, you would need to make sure that both the IK and FK joint systems have their own stretchy setup, and a scale constraint would need to connect the FK or IK joints to the main joints.

Auto Blendshapes to Make Pleasing Silhouettes

(In other words, don't let the math dictate your stretchiness.) Here's a concept that comes up quite often in class. Let's consider Reed Richard's arm again. (That's Mr. Fantastic from *Fantastic 4*, who has super-stretchy limbs.) When you stretch his arm way out, the stretchiness comes from the scale of the joint. Well, what if you wanted it to taper a bit at the ends and not be a uniform stretch? In other words, what if you wanted some type of artistic control on the stretch? You will want to add in some automatic blendshapes based on the stretchiness. Open file **chpt18_Shroom_Kingsberry_v3b.ma**. This simple joint system stretches via a utility node setup, like we learned earlier in this chapter. Grab the hand controller and move it to the right. Refer to Figure 18.14. You see that the arm stretches. As it stretches, a blendshape is dialed in, causing the arm to thin out. This is simply a blendshape driven via a set driven key.

In older versions of Maya, this posed a problem with the blendshape and skinning warring with each other. Since the addition of the Shape Editor window and the retooling of blendshape calculations in Maya 2016, it behaves a bit better. See the first edition of this book to force it to work in older versions of Maya. For Maya 2016 + open **chpt18_Shroom_Kingsberry_v3_STRETCH_NOBS.ma** and complete the following steps:

1. Select **the Hand_CNTRL** and translate to **X 10**.
2. Select **Shroom_Mesh_G** (the geometry).

Figure 18.14 Auto-corrective blendshape sculpted from the stretched position hooked up correctly and incorrectly (at bottom).

3. Open the shape editor (**Windows>Animation Editors> Shape Editor**).
4. Click on the **Create BlendShape** button; rename **ArmFix**.
5. Create a target by clicking on the **Add Target** button; rename **Squish**. You will automatically be in edit mode. Adjust the geometry vertices to create a thinned-out arm; click on **edit** when complete so that the button is no longer red.

What this new method has done for you is let you sculpt your blendshape directly onto a skinned and stretched character. You couldn't do this so easily just a few versions ago. Cool. Now, to set up the blendshape so it only turns on when the arm is pulled out in X.

6. Open the set driven key window. (**Animation>Key>Set Driven Key>Set...**).
7. Load the **Hand_CNTRL's Translate X** as the driver;
8. Open the **Node Editor** and locate the **ArmFix blendshape node**. Load that as the **Driven** in the Set Driven Key window and select the **Squish** attribute.
9. Key the **Squish blendshape** to be off when the arm is at the neutral position of X = 0.
10. Key the **Squish blendshape** to be **on** when the arm is at an extended position of **X = 10**.

See the file **chpt18_Shroom_Kingsberry_v3_STRETCH_ BS.ma** for the completed example. Refer to Figure 18.15.

It isn't that hard at all. The thing to watch out for is that multiple blendshape nodes will counteract one another. So, plan ahead for your corrective blendshapes, which can be created in the shape editor.

Incidentally, this is a good method to use for one frame in your animation to fix any icky issues in your rig. Keyframe it in time to be on for the one frame and off for the others, and "presto-chango;" weird interpenetration issues solved. There is also another method of creating automatic corrective blendshapes that you might have come across in the Pose Editor

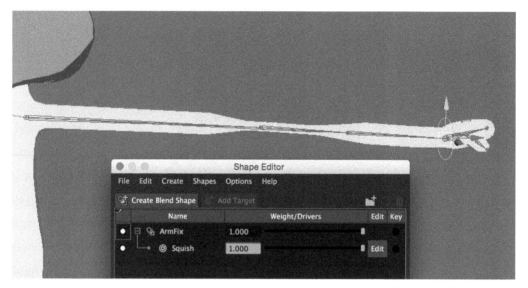

Figure 18.15 Using the shape editor window to create set driven key blend shapes on the stretched geometry.

documentation. That method only works with the rotation values of joints and controllers. Let's look.

The Pose Editor

There is an automated way to create corrective blendshapes, but it is only based on rotational information. We'll look at two ways to utilize the pose editor. The first way is if you are utilizing the bone itself. The second way is if you are utilizing a controller. Open the file **chpt18_correctiveBS.ma**.

1. Open the Pose Editor Window. (**Windows>Animation Editors>Pose Editor**).
2. Select a joint in the BoxOne rig; click **on the Create Pose Interpolator** button in the **Pose Editor Window**. This creates a node titled BoxOne_joint1_joint2_poseInterpolator.
3. **Rotate** the **joint** and click the **Add Pose** button in the Pose Editor Window.

 You need to choose what is listed by selecting the type. Swing, according to the documentation, is good for legs and arms that swing in one axis. Twist is better for a rolling mechanic like a wrist twist in one axis. Swing and Twist allow for multiple axes of rotation. This creates a blendshape in Edit mode.
4. **Adjust** the geometry's **shape** by pushing vertices and faces onto the geometry. Click on the **Edit** button to end editing the shape.
5. **Double-click** on the pose named **neutral** in the Pose Editor Window to return the joint system back to its original position.

Figure 18.16 Automatic corrective blendshapes using the Pose Editor.

Test: Rotate the joint back up and notice that the blendshapes dial in automatically. You can click the blendshapes on and off in the Pose Editor window to see their effects. In Figure 18.16, you can see the blendshape turned on (left) and off (right). That's a very easy system to use! Much better than what we had to jump through manually in version one. But it only works with rotational information.

What if you have a CNTRL system in place controlling your joints. Try to do the same thing with **BoxTwo**. I'll wait. You got an error message? So you did. The joint has an incoming connection from the controller. So we need to do a little more work here. Refer to Figure 18.17.

1. Click on NO to create a pose interpolator **without** the neutral poses. We need to manually add those.

Figure 18.17 Manually adding default pose rotational reference points, using the advanced features in the pose Editor.

2. Open the outliner and display the attributes (Channels) so that you can locate the rotate X, Y, and Z attributes.
3. Open the Advanced tab in the **Pose Editor** by selecting **View Advanced**.
4. Drag and drop the controller's rotate X, Y, and Z attributes into the Pose Editor one at a time. Choose the corresponding axis in the Driver settings.
5. Click on **Poses>Add Neutral Poses** and continue as we did in the above example.

We'll keep an eye on the shape and pose windows, as they are sure to receive updates in future versions of Maya.

All of the Above (Osipa)

Lattice skinned to skeleton. Skeleton made stretchy. Animator skeleton, then add a twist of blendshapes. What if we wanted to put a few of those all together? We're going to take a

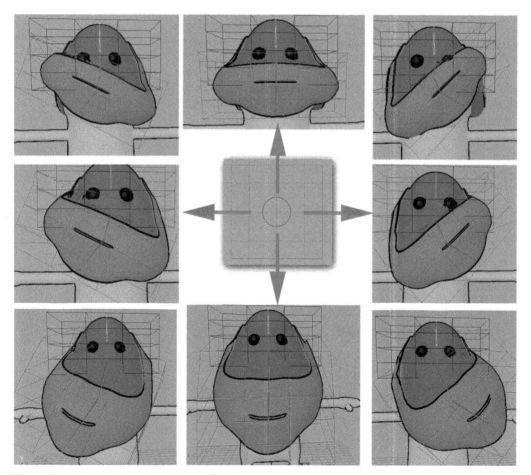

Figure 18.18 Lattice driven by a skeleton. Skeleton stretchiness and rotation driven by a controller via set driven key.

look at a type of setup that is something akin to what Jason Osipa talks about in his second *Stop Staring* book. We're going to break the concept down step by step. Refer to Figure 18.18.

1. **Lattice driven by skeleton**. Open the file, **chpt18_Shroom_ Kingsberry_v4.ma**. This file has a skeleton that goes to the top of the head and the bottom of the head. The geometry has a lattice applied to the top vertices and another lattice applied to the bottom vertices. Remember, you can always adjust your membership with the edit membership tool. These lattices are skinned to the aforementioned (I always wanted to use that word) skeleton. Things to watch out for— overlapping of lattices.

2. **Stretchy skeleton:** The skeleton that drives the lattice itself also has some stretch built in. The stretchiness is driven by the controller via, set driven key, easy—you know how to do this. That means the controller is driving the following: Up = scrunch, Down = stretch. Left = rotate Left, Right = rotate Right. See Figure 18.18 for the example, as well as the **chpt18_Shroom_Kingsberry_v4.ma file**.

3. Animator's skeleton drives the stretchy skeleton. Open the **chpt18_Shroom_Kingsberry_v5.ma** file. A new skeleton has been added—this is the animator's skeleton. This skeleton handles the normal rotation and translation of the geometry. This type of setup allows you to have a main animation rig that drives the deformation rig. Osipa talks about this type of rigging in his books. You'll note that the skeleton drives the bound skeleton (the one in step 2) via parent constraints. If it were made stretchy, it could drive the bound joints via a scale constraint as well. Double-check lattice memberships to make sure there are no vertices left behind. Check out the sample file as an example. Refer to Figure 18.19.

4. Blendshapes on top of everything else add more deformation to the object. Blendshapes can be controlled via the animator and can also be automatic. This simple rig has a happy and sad blendshape driven by a controller. Open the file **chpt18_Shroom_Kingsberry_v6.ma** to see the example. Refer to Figure 18.20.

The files need some love when it comes to the membership of all the deformers. Be very careful as you go along with smoothing the lattice membership. If you don't pay enough attention to the membership, it becomes a battle as to what owns who as you go along. Test each position to see that you get nice poses.

This just gets you started into the realm of stretchy. Now that we've examined the components, hopefully you'll be able to mix and match the various techniques to get what you need. Keep your outliners neat as you go to aid your sanity.

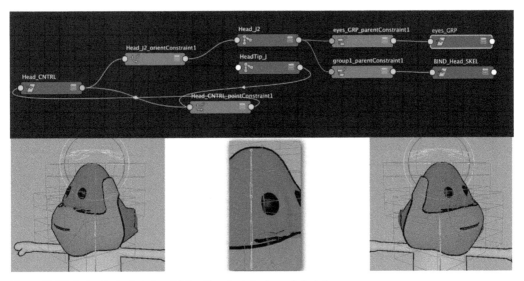

Figure 18.19 Animator's skeleton driving the stretchy bound skeleton.

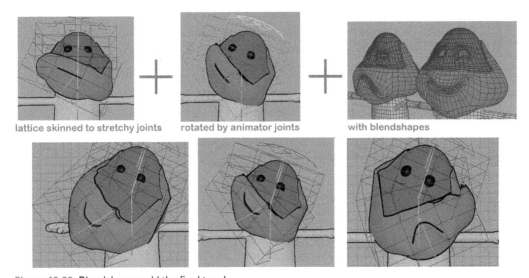

lattice skinned to stretchy joints rotated by animator joints with blendshapes

Figure 18.20 Blendshapes add the final touch.

19

BROKEN RIGS AND DANGLY BITS

The term Broken Rigs refers to a different type of skeleton creation. It allows for an extremely stretchy rig. Remember how we made the skeletons for all the previous rigs in this book? They were all connected. There was a root joint that was the parent of everything. The legs, head, spine, and arms were all children of one another. With a broken rig, each of the limbs and sections of the skeleton are detached from one another and treated separately. This means that you can literally pull a limb off to the side or forward as needed to cheat a pose for the camera. The skin stays attached to these types of rigs. Steps have to be taken to make sure the skin stays nice-looking, whether it is via a sculpt deformer or a corrective blendshape, etc. There is also the concept where parts of a rig that move with the main rig can be detached completely without the skin staying attached, such as a character whose head falls off—imagine robots, zombies, or something of the like.

Breakable Rigs (Independently Movable Skeletal Sections)

Now that you know the concept exists, I'll bet you could figure it out on your own. Just in case, we'll go through some of the finer points together.

Open the file **chpt19_Scoops_Bedsole_v1.ma**. Refer to Figure 19.1. This character was designed and modeled by David Bedsole, a SCAD student, in 2011. The character has some skeletons already skinned on the model. There are four distinct skeleton sections: the head, the lower body, and the two arms. Each of these sections of the skeleton is independent of the other. Refer to Figure 19.2.

This rig has some functionality for us to work with in this chapter. The main thing we want to look at is the **Head_LW_CNTRL**. This controller drives the head skeleton via a parent constraint. If you select the Head_LW_CNTRL and translate or rotate it, the skeleton for the head moves around. Since the head skeleton is not attached to a spine, the skin automatically

DOI: 10.1201/9781003431121-23

Figure 19.1 Mr. Scoops by Mike Bedsole, with a partial skeleton and controls applied.

stretches. You can see where a corrective blendshape here might give some more taper to the shape. The controller is also driving a scale constraint. That connection is from the controller to a group node over the head skeleton. This is just like you've been doing in the rest of this book, only now isolated to the head. You can see that scale is working for the head, but the "hair" and eyeballs are left behind. Why is that? They aren't skinned. You have been reading along, haven't you?

If you look at the hand controllers, you'll see that they move the IK hand. These were created using my MakeStretchy script.

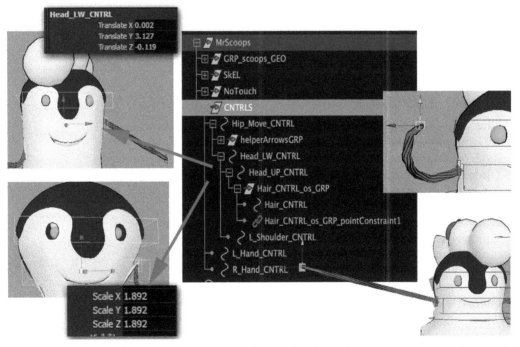

Figure 19.2 Head_LW_CNTRL moves, rotates, and scales head. Hand control moves IK hand, which is stretchy enabled.

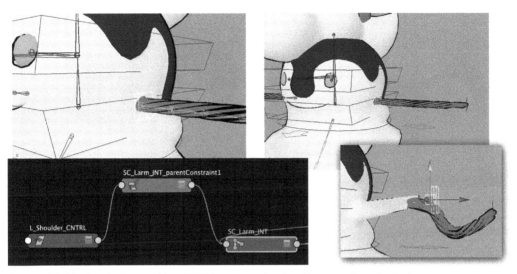

Figure 19.3 Moving the L_Shoulder_CNTRL to move the shoulder away from the body.

Boy, it is handy for me. If you rotate the hand controller, you will also see that the twizzler arm twists. These are single-chain IK handles.

Already you can see the benefit of having a broken skeleton— you get auto-stretchy in the in-between bits of geometry. Notice the left arm has a controller driving the shoulder. This controller is a child of the Head_LW_CNTRL so it moves and rotates with the head. I debated this behavior for a while, but ultimately liked it for this character.

Refer to Figure 19.3. Notice what happens when you select the **L_Shoulder_CNTRL** and move it. Since this controller drives the shoulder via a parent constraint, it moves the shoulder away from the body.

This is an amazing function for your rig. This allows the animator to cheat a pose by adjusting the shoulder to get a better silhouette. Usually, the weirdness, which would give it away as a cheat, would not be seen by the camera (see Figure 19.4 as an

Figure 19.4 Cheating a pose for the camera makes a good silhouette. Hope the director doesn't change the camera angle on you.

Figure 19.5 Improper skinning to joints can cause the eyes to look like they are moving incorrectly. It is really the skinning.

example). As a side note, I also used the **ScaleLength** attribute that my script added to the IK handle to get the arms to arc a bit more when they stretched for a better pose. This rig does not have a control hooked up to that ScaleLength attribute. It should be added, of course, before being sent off to animators.

A note about broken skeleton rigs: they become problematic for lighters and the look development department. Since the rig is broken and being cheated, any self-shadowing can give away the illusion. Making sure that the camera angle is not going to show the shadow too badly helps. A further note: this type of rigging becomes a large headache for cloth and hair simulations.

Skinning note: The skeleton in this character has a joint right in the center of the head. This might happen in a cartoony rig that is going to have lots of overlapping action. A thing to watch out for is the eyes. You might think you have a constraint problem, a math creep problem, or a pivot point problem because the eyes don't seem to rotate with the head correctly. In actuality, it is probably a skinning issue (see Figure 19.5 as an example). This shows the normal skinning, which makes the eyes look like they are rotating incorrectly, and a rig with the skin corrected so that the top half of the head with the eye sockets moves 100% with the top skeleton.

Detachable Parts

So, I went straight to thinking about zombies, but detachable parts could mean hats or eyeglasses, etc. In fact, though I wish I had a zombie character, I have a salesman character. That makes me giggle, because it could be a zombie salesman with just a little bit of adjusting. A student made this character, so I won't deface it—you can, though. Open file **chpt19_Salesman_Kingsberry_v1.ma** to see the salesman model created by Jarel Kingsberry, a SCAD student in 2012. I've added a bit of a skeleton, enough to

Figure 19.6 Stretchy salesman. (Model by Jarel Kingsberry, SCAD 2012, with permission.)

turn the head and eyes. We're going to look at the detachable skeleton that is in him, and then look at that hat.

Look closely at the head and neck joints. The head joint and neck joint are driven by a controller with a parent constraint. With this setup, the head can be moved and the neck is stretchy (without any utility node business!). See Figure 19.6 to see the head stretched away from the body. I chose not to parent the head joint and the neck joint together since there is really no need in this rig; the skinning is the same whether they are parented or not. The controls drive the joints the same—thus, it has no effect to have a hierarchy in the joints. Also, there is some purist thing in my head that does not want to see joints in a hierarchy translated. If it bothers you, simply parent the head joint to the neck joint. There is no behavioral difference, only a visual one.

Let us consider the hat on the salesman's head. Our animators probably want to have that hat move with the head and be able to animate it on its own. Let's implement that. Refer to Figure 19.7.

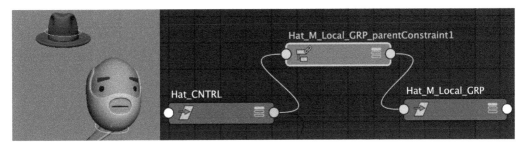

Figure 19.7 Hat with local control.

Make a Control for the Hat Itself So It Can Be Animated on Its Own

1. Select the **Hat_GEO** and **lock** its attributes. We don't want to key it.
2. With the **Hat_GEO** selected, create a **group**; name it **Hat_Local_GRP**.
3. Place the **pivot** point of the group at the **head joint**.
4. Create a **controller** that will move and rotate the hat; name it **Hat_CNTRL**.
5. Place the **pivot** point at the **base** of the **hat**.
6. Select the **hat controller** and the **Hat_Local_Grp**; create a parent **constraint**.
7. **Test**. Your hat should move about on its own—but does not move with the character yet.

Make the Hat Follow the Head

1. Select the **Hat_CNTRL** and great a group; name it **Hat_Global_CNTRL_grp**.
2. Place the **pivot** at the **head joint**.
3. Select the **head joint** and the **Hat_Global_CNTRL_grp**; create a parent **constraint**.
4. **Test**. The hat should move and rotate with the head and also be able to counter-animate by being moved via its own controller. Refer to Figure 19.8.

If you look in the Connection Editor, you see that the parent constraint connections are not in a cycle, even though the hierarchy of the Hat_Global_CNTRL_grp node and the controller make it feel like it should do a double transformation. Double-check that I am not lying. Save first, and then add some key frames to your controllers and see if there is any odd behavior. There shouldn't be.

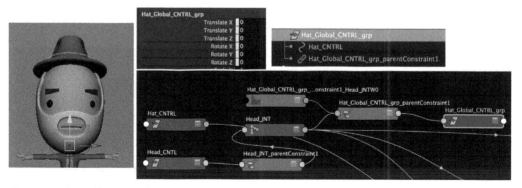

Figure 19.8 Hat with constraint added so that it follows with the head.

Turn the Follow On or Off

1. Select the **Head_CNTRL**.
2. In the channel box, select **Edit>Add Attribute**.
3. Create an enumerator (**enum**) attribute named **Follow**.
4. Change the default names to **Head** and **None** by clicking on the words "Green" and "Blue" to change them; click on **OK**.
5. Open the set driven key window (**Key>Set Driven Key>Set...**).
6. **Hat_CNTRL>Follow** is the **driver**.
7. The global parent constraint's **weight** is the **driven** (**Hat_Global_CNTRL_grp_parentConstraint1>Head JNTW0**).
8. Set a set driven key (**Key**) to create the default position. When the controller **follow** attribute is set to "**Hat,**" the global parent **constraint** weight is **1** (**ON**).
9. Turn the hat controller's **Follow** attribute to "**None**" and the **global** parent constraint weight to **0** (**OFF**).
10. Create a set driven key (**Key**).
11. **Test**. Rotate the head and turn the follow attribute off and on to see the difference. Refer to Figure 19.9.

To see the completed version, open the file: **chpt19_Salesman_Kingsberry_v2.ma**. Refer to Figure 19.10.

Necktie

If you would, open that completed file from above, **chpt19_Salesman_Kingsberry_v2.ma**. We're going to learn a new constraint that will allow us to pin the necktie to the skinned

Figure 19.9 Adding the enumerator attribute.

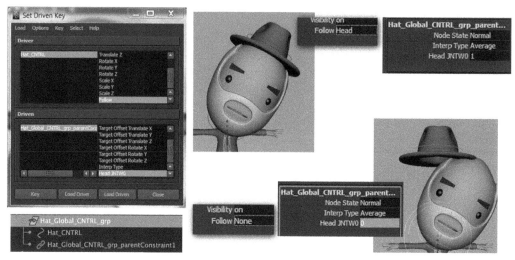

Figure 19.10 Hat with follow head or follow nothing set driven key.

geometry of the body. There used to be a script on HighEnd3d called rivetT. I'm not sure the script still exists. It is a very nice script, allowing you to pin things to skinned surfaces, and they will follow along, like buttons, badges, lapel flowers, bushy eyebrows that were modeled separately, etc. However, there is a constraint in Maya that will get you about the same result. It is called the **Point On Poly** constraint. Let's try it out. Refer to Figure 19.11.

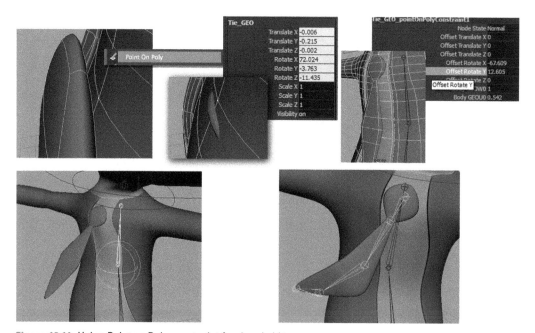

Figure 19.11 Using Point on Poly constraint for dangly bits.

1. Select a **vertex** in the middle of the **chest**, right **behind** the **tie**. The easiest way for me is to right-click on the chest and select Vertex mode, then click on the desired vertex. It highlights yellow.

2. **Shift** select the **geometry** of the **tie**. This is selecting the two items: driver> driven. The vertex is going to drive/move the tie. The tie should turn green.

3. Choose **Constrain>Point on Poly**. (Use the default settings.)

4. The tie will jump back a little—it is actually rotating back.

5. Locate the **Tie_GEO_pointOnPolyConstraint1** in the shape area of the channel box. Click on it to expand the attribute list.

6. Rotate the values for **Offset Translate X** and **Offset Translate Y** until the tie appears back in its proper place.

7. **Test**. Rotate the **Spine_JNT1** to see that the top of the necktie moves along with the body as it rotates. See file **chpt19_Salesman_Kingsberry_v3.ma**.

You could hook a controller up to drive those offsets, so the animator could animate the tie geometry. Or rethink what we just did. What if you created a skeleton and skinned the tie geometry to it. Then do the steps above, but this time selecting the top joint of the tie skeleton instead of the geometry. Will it work? Check out **chpt19_Salesman_Kingsberry_v4.ma** to see. The same thing applies: create controllers for the constraint's offset rotations. That will allow the animator to animate the top of the tie as it follows the body. Then create FK controls for the rest of the joints in the tie for overlapping action functionality.

Knowing what you know now—what if the story called for the tie to fall off? You got it—look for the weight attribute on the constraint. It would have a "W0" at the end of the name since there is only one constraint. The tie will probably default to the center of the universe when you turn the weight off.

I hope that you are starting to experiment on your own now and piece together these different methods. Excellent. I'll get a cup of coffee while you work on that zombie rig, which I hope you are itching to make a prototype of.

20

RIGGING FOR A PARALLEL WORLD

'Premature optimization is the root of all evil.'
—Donald Knuth, author of *The Art of Computer Programming*, called the "father of the analysis of algorithms", who also owns and plays a custom built pipe-organ: https://www-cs-faculty.stanford.edu/ ~knuth/organ.html

While it is important to know how to not implement something devastatingly inefficient, you can go too far. Rig it right—then rig it fast. Create something that works, then evaluate it to see how it can be improved. Remember, a super-fast, efficient rig that doesn't do what the animator or production needs is useless.

So, how do we know if the rig works? Testing, you probably said—and you'd be right. Have your animators do a calisthenics animation test with the rig. They'll see if the rig can match the poses they had in the model sheets. The rig/model will need to match what the supervising animator and art directors had in mind for posing, and more importantly, it needs to be responsive. The rig cannot slow down the animator. See example target keyframes needed for the rig in Figure 20.1.

Many of the techniques in this book are designed already to be efficient. In recent versions of Maya, newer, more efficient techniques have been added under the hood. One in particular, parent offset matrixes, is a game changer. Also, tools for testing how well your rig/scene runs have been added, thanks to many industry studios whose input and requirements drive Maya's development. This chapter will touch on these subjects to help you get started on the next level of rigging: rig it fast.

What Is Parallel Threading?

First, we need to understand how Maya organizes its thoughts and uses the computer's CPU and GPU to execute them. There are different evaluation modes in Maya. By default, Maya works in parallel evaluation mode. Before 2016, you only had the option of DG (dependency graph) evaluation mode. There is a

DOI: 10.1201/9781003431121-24

Figure 20.1 Thesis character design concept by Joseph O'Hailey showing a few target keyframes needed for a rig.

third evaluation mode called Serial. It limits the processing to one core and is only meant for evaluating errors.

If you work with a rig that is slowing down or behaving oddly, switch to DG mode and see if the rig behaves better. The trade-off is that the timeline will not cache and you may not get 24 fps playback. But that may be the lesser of two evils. You can switch modes in **Animation Preferences** > **Settings** > **Animation** > **Evaluation Mode.** See Figure 20.2 as an example.

Let's understand parallel processing as best we can. Picture the drive-thru at a fast-food restaurant. There is one lane – everyone queues one behind the other and waits their turn. You only wanted a cold drink but had to wait for the multi-car soccer team in front of you to get their order. This is how DG, or dependency graph, evaluation mode (pre-2018) handled items based on how the CPU could execute the commands. It did its

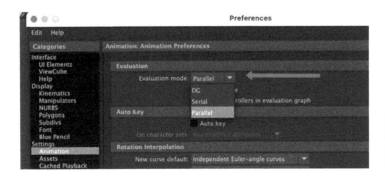

Figure 20.2 Changing evaluation modes in the animation preferences window.

best to identify what things in a rig could be ignored and only evaluated the things that were marked "dirty" or needed to be evaluated one at a time and put them in the queue: soccer teams and thirsty folk one behind each other.

Now picture a fast-food restaurant that has multiple drive-thru order windows, maybe even one identified as drinks only. Now the cars can be split up, their orders received and executed in a more distributed fashion. The drinks-only crowd can proceed quickly through their lane and not have to wait on the soccer team (or a black coffee crowd vs. the 17-step coffee crowd if you want to put this analogy in a coffee shop, which I'm quite shocked I didn't start there in the first place). Things are more efficient, yes? Merging back into the one take-out receiving window can be a little stressful. You still might have to wait a moment before receiving your drink and small French fries. But it is much more efficient.

Same thing happens between Maya and your computer's GPU/CPU. It breaks up the things needed to be executed and distributes them to the processing threads on your CPU. Deformations and skinning, etc., can be sent to the GPU if your graphics card supports it. Once executed, Maya brings all those answers (or French fries) back together and shows them on the screen.

If one of those event blocks being executed has a lot of things that it needs to calculate, then the process can slow down. Imagine a large van of soccer players where no one has decided what to order and is sorting it out at the speaker. Or the soccer team has a number of equally unprepared cars, and only one of them is paying for all of the orders. Could you imagine? What if the coach with the credit card is in the last car and everyone has to wait on him to get up there to pay before the food can be handed out? Cold French-fries. (I swear, this is not from personal experience.)

The same thing can happen in our rigs.

For example, constraints themselves are a little bit like the coach with the credit card in the last car. The orders get processed, they have to get up there to pay, and then the orders get passed out, starting with the front car that has pulled forward. It makes for a cyclical thing.

Constraints are slightly cyclical as well. They ask where the driver is (remember driver – driven in previous chapters?), then ask where the driven is, then move the driven to match the math received from the driver. There is some cyclical talk between the parent constraint and the driven transform node. I'm hugely paraphrasing how constraints work (and possibly abusing the concept of math), but if we look in the node editor, maybe we can see it visually. See the example on the left side in Figure 20.3 below. See the yellow lines between the parent constraint and the geometry? Now compare it to a different

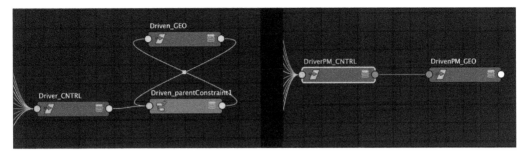

Figure 20.3 Parent constraint vs parent offset matrix connection.

method of controlling the driven without a constraint visible on the right side of Figure 20.3.

That straight line is a direct connection, something like we saw in the connection editor some chapters back. But it is using a feature introduced in 2020 that simplifies the math: the Parent Offset Matrix. It simply takes the position of the driver and pops it onto the transform matrix of the driven. This is a mathematically easier and less cyclical way to achieve a parent constraint. *Now* I tell you. It also isn't as straight-forward to create; we have to get a little more under the hood. But you are no longer a beginner; I can show it to you now.

How to create a transform offset parent matrix connection:

1. Select the **controller** (driver) and the **geometry** (driven). Load them into the **Node Editor.** Hit **3** on the keyboard to expand the nodes and see their connectable attributes.
2. Click to open the Controller's (driver) **World Matrix** to find the **World Matrix[0]**
3. Connect that to the—wait a second—there isn't an input for the geometry's (driven) Parent Matrix, only an output. Scratch your head.
4. **Right Mouse Click** on the **driven** geometry and choose **Edit Custom Attribute List**. This will show the Offset Parent Matrix.
5. Now you can connect the **Controller's** (driver) **World Matrix > World Matrix[0]** to the **Geometry's** (driven) **Offset Parent Matrix**

This creates a direct connection that does the same as a parent constraint, but mathematically is much more elegant and faster to calculate.

If you look in the **Attribute Editor** and open the **Transform Attributes > Offset Parent Matrix** area, you can see the incoming connection listed and any transformation values received. Since these are on the DAG nodes (the transformation nodes), you can daisy-chain them directly together, for example, in an FK arm or tentacle. You can also add a multiply/divide node to adjust the incoming connection in the node editor. See Figure 20.4 as an example.

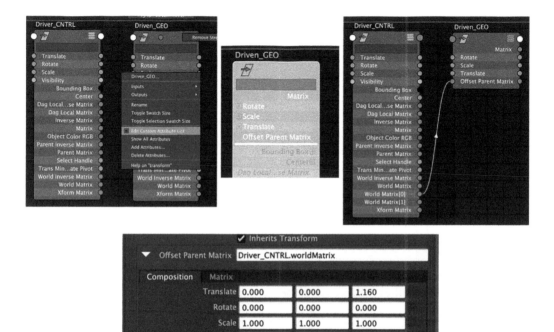

Figure 20.4 Creating an offset parent matrix connection.

Another example of areas that can be sped up is the controllers themselves. It's minimal, but a lot of minimal adds up to a fair amount. The controllers, which don't need to be rendered by default, are getting passed on to be rendered even though they are just curves; they *could* be generating a surface. So, Maya evaluates them. If you have hundreds of controls (which you do get on production rigs), that slows down the process. What if you could tell them not to evaluate? You can.

In the rigging menus, select **Control** > **Tag as Controller**. Items tagged as controllers with nothing keyed (or even static animation channels) will not get evaluated. Check out the documentation to see all the things this does. Looks like this was added around 2022. You might have noticed a setting in **Animation Preferences** > **Settings** > **Animation** directly below the evaluation mode: "Include controllers in evaluation graph." This pre-populates the controllers in the evaluation manager when enabled. See Figure 20.5 as an example.

Another benefit is that you can use this tag to hide and show controllers. **Display** > **Hide** > **Hide Controllers,** and **Display** > **Show** > **Show Controllers**.

So, now you know there is more. A deeper level of looking at connections, that is faster. One last thing to briefly look at before we end our journey together is evaluation.

Figure 20.5 Tagging a controller and including them in the evaluation graph.

Evaluating your rig:

There are a few tools to pay attention to in Maya. These appeared around 2014 and have been getting updated with each version release as the software has been getting serious modifications on how it handles memory management.

1. Profiler
2. CPU/GPU evaluation window
3. Curve Manager
4. Evaluation Tool Kit

Here lies the path to becoming a technical director/artist. (It is called something different in every studio.) When evaluating a rig that might be bogging down, first you'll start with the task manager or activity monitor or htop, depending on your operating system. Use those to evaluate if it is Maya slowing down or something else. Once you've figured out that Maya is taking up 90% of your CPU, it is time to look deeper into your scene. What is it thinking about?

Before continuing to debug, a good tool to use is the **File** > **Optimize Scene Size** tool. Go through that menu and remove unused nodes, shaders, empty transforms, deformers, etc.

Next, let's take a look at the profiler. Open the following scene, chpt21_Shroom_Kingsberry_v3_STRETCH_BS.ma found in the companion data. Next, open the profiler under **Windows** > **General Editors** > **Profiler** and click on **Start Recording.** Wait a brief moment, then click on **Stop Recording**. The Profiler window lists the events that happen based on:

• Category View
• CPU view
• Thread View

Choose the various views to see the visual report in the window change. It's trying to show you everything that Maya thought about while you were recording. That can be a lot—so, let's narrow it down to one frame.

Quit out of Maya and place the **profileFrames.py** script in your scripts folder, if you haven't already placed it there, and restart Maya.

1. In Maya, import the script by typing in the Python command line "**import profileFrames**"
2. Make the current frame: **6**. Then, run the script by typing "**profileFrames.run()**" in the Python command line. See Figure 20.6 as an example.

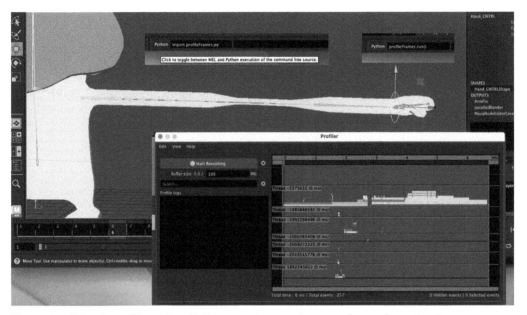

Figure 20.6 Using the profiler and profileFrames script to evaluate one frame of an animation.

The command **profileFrames.run()** will run the python script, which records only one frame from the timeline (the current frame) and puts the findings in the profiler. This makes the information a little easier to look at, and easier to pinpoint a slowdown in any animation.

3. First, look at **View** > **Category**, which is the default. You can see the evaluation line. We can look a little closer.

4. In the Profiler window, click on **View** > **Threads** to see how the rig and animation in the scene are being distributed across multiple threads on the CPU to calculate. Remember our drive-thru line and the soccer team?

The thread view will never look exactly the same each time. It depends on what else Maya or the computer is thinking about. But the core bits should be similar.

What Are We Looking at?

This is a visual representation of each process being executed across the multiple threads of the CPU. You can use your normal camera hot keys to zoom in and pan across the window. As you hover the mouse over each event block, you'll be able to read names that will correlate to joints, iksolvers, meshes, etc.

The colors are indicators as to what type of thing is going on.
- Pink and Purple = Dirty propagation
- Light/Dark Yellow = GPU Override CPU Usage
- Peach, Tan, Brown = Evaluation Manager Evaluation
- Dark Green = Pull evaluation
- Blues = Rendering, Qt Events, Updates, etc.

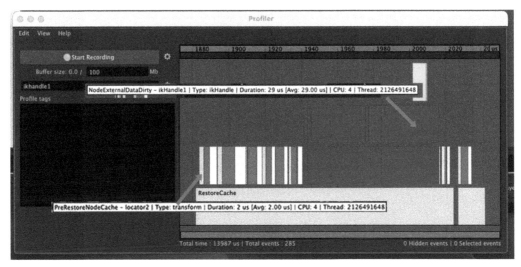

Figure 20.7 IK handle show in the profiler. This event block is read from bottom to top.

There is much more – but these will be the basic ones you see. Take a look at the documentation to see a solid explanation with images of these.

https://help.autodesk.com/view/MAYAUL/2024/ENU/?guid=GUID-0FF1BA78-0493-463F-8E66-8014FB0F47BC

To help narrow what we are looking at for this first blush, let's search by name. Type "**ikhandle1**" into the left-hand search bar, and the IK handle for the left-hand will get selected in the Profiler window. Hit "**f**" on the keyboard to frame the IK handle, then scroll out just a little to see the blocks around it.

This chunk, as seen in Figure 20.7, shows the block where the ikHandlel is. Read this from the bottom to the top. The first line is waiting to receive results from the blocks on top of it. In this case, it is waiting to find out where to move the IK handle. The second line starts by evaluating the locator, then the joints, then the effectors, IK handles, and lastly, the gray and white boxes are the condition nodes and utility nodes for the stretchy evaluation. You can see the names as you scroll over the boxes. The third line is re-evaluating data that was marked dirty from the joints up to the locator.

What Do We Look for?

Overall time of the whole block. By looking at the time the bottom event block takes to evaluate, you can determine if this is very slow or at an adequate speed. The time is listed in milliseconds. (What is an adequate speed? You want the rig to run at 24 fps. So, one frame cannot take longer than 41.667 milliseconds (ms) to calculate.) [ADD FOOTNOTE 1. *Jayme Wilkinson, '24 fps. Each frame is 1/24th a second which equates to 0.0416666667 seconds: 41.667 ms.'*]

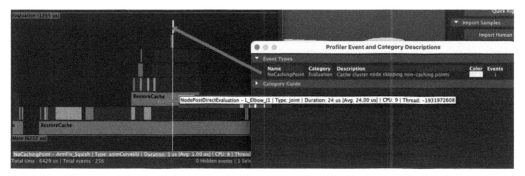

Figure 20.8 Events shown in the Category view. Profiler event and Category description window showing selected event description.

1. Are there long event blocks that are taking a lot of time to calculate and have other rows above them, meaning they are waiting for something else to evaluate?
2. Are there large gaps between the blocks? This is wasted time.

Toggle back to the category view (**View** > **Category**) and try to find the same block of events there. Can you see them? The arm fix blendshape is the gray box at the very top. If you're even more curious, open the **View** > **Event Descriptions...** window and click on any of the event blocks to see what type they are. See Figure 20.8 as an example.

It can be overwhelming at first, when you are new, to read this and to see where things can be improved. We are most certainly under the hood and examining the chassis. Your next question is how to improve it? Let's ask it this way: What can slow things down? For starters:

1. Expressions
2. Python nodes
3. Static animation curves
4. Node dependency

Expressions, which I don't use in this book or normally, have always been slightly slow as to how they evaluate. They cannot be pushed into parallel processing. Other things can be parallel processed while they wait for the expressions to finish their thing before continuing. Use expressions sparingly.

Python nodes, meaning plugin nodes that have been written outside of Maya and brought in, do not lend themselves to multi-threading either. Python isn't built that way. They get black-boxed and also hold up the evaluations until they are done doing their thing and spit out information. As a note, C++ plugins can be written for multi-threading, but they have to be designed that way, or else they will be inefficient as well.

Maybe surprisingly, static animation curves cause issues. Maya sits there looking at the animation curve, wondering if it is going to change, and slows down. For rigging, avoid using static

keyframes that get changed frequently on attributes. We haven't done anything like that in this book. Documentation suggests "consider adding 2 keys, each with slightly different values, on rig attributes that you expect to use frequently". This keeps the animation curve from being marked for reevaluation. When animating, we tend to delete static channels anyway, but a good test is to animate the rig with everything keyable and see how it preforms. The documentation suggests locking attributes that shouldn't be animated. Huzzah! We already do that.

This is a whole new journey, evaluating. Open your rigs. Use the profileFrame script. See what patterns start to jump out.

Another window to tackle is **Windows** > **General Editors** > **Evaluation Toolkit.** This is a grab-bag of useful debugging tools. I'll highlight a few areas.

If you are using Maya 2021+, you'll note that **01) Modes** includes a check box for GPU override and controllers. Looks familiar, right? Those evaluation modes presented are the same as in the animation preferences settings. A place to start looking for slowdowns is the GPU. Deformers, skinning, etc., get pushed to the GPU. Depending on your graphics card, that could be an issue. Some graphics cards do not play nicely with Maya.

Next, look at the debugging tools: **03) Debugging**. From here, you can launch the Profiler, the **Analytics Window**, and a very useful **Scene Lint Window**. See Figure 20.9 as an example.

Under **04) Custom Evaluators**, click on the **"n"** next to **curveManager**. I ran it on the sample scene for this chapter, and it shows the static animation channels: rotate and visibility

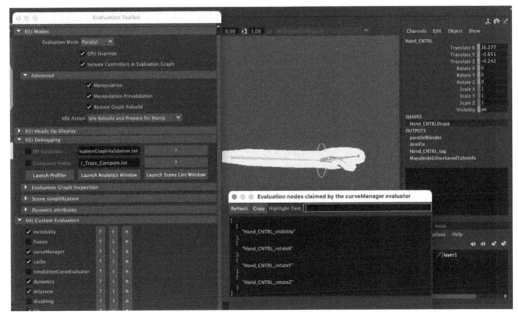

Figure 20.9 Evaluation Toolkit > 03) Debugging.

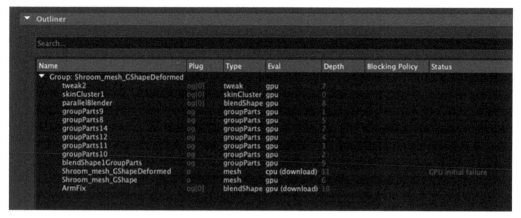

Figure 20.10 Evaluation Toolkit's GPU Override> Outline.

for the Hand_CNTRL. Those keys could be pruned. If I had hundreds of static channels, that could be a potential slowdown.

06) GPU Override. You can use this area to print, either to the script editor or to a. pdf, the various deformation graphs. In the example scene, I opened the **Outliner** area to see what was being sent to the GPU and then back to the CPU. Remember the fast-food drive-thru? Getting everyone back to the one pickup window is a bottleneck. You'll see that in Figure 20.10 on the CPU download. Also, we start to see how naming conventions will keep things from getting crazy.

If you work with volume stages or anything in real time, learning to optimize your rigs is an absolute must. Even in normal animation, be kind to your animators and rig it fast.

Here are some additional resources to help you with efficient rigging.

- Empowering Rigs using Offset Parent Matrix: https://www.youtube.com/watch?v=JOYMV-bQdlM
- Profiling in Maya by Ravi Jagannadhan: https://books.apple.com/us/book/profiling-in-maya/id790626892
- Master Class: Debug your Maya Files with Jayme Wilkinson: https://www.iamag.co/master-class-debug-your-maya-files/
- Straight documentation on parallel in Maya: https://damassets.autodesk.net/content/dam/autodesk/www/html/using-parallel-maya/2024/UsingParallelMaya.html https://damassets.autodesk.net/content/dam/autodesk/www/html/using-parallel-maya/2024/UsingParallelMaya.html#troubleshooting-your-scene

EPILOGUE

Congratulations if you made it to the end of this book by way of page after page of tutorials and bad jokes. I, as seen in Figure E.1, applaud your fortitude and hereby diagnose you as having a terminal case of being a rigger. You have it; and you might as well own up to it. Let me show you the way to some great resources out there to help you continue to grow your skills.

Rigging Level Zero. This is a great website with videos and tutorials to get you primed for this book and to use as a reference. The website was created by the technical editor of the second edition of this book, Kori Amacker, who works at Sony Picture Imageworks. Wait. ILM now. https://koriamacker.wixsite.com/rigginglevelzero.

Figure E.1 Tina O'Hailey. (Photograph by Mark Ostrander.)

These books are older. I don't see anything out there that covers advanced topics and is new. Everyone has probably moved on to videos now. A lot of wisdom in these books:

Art of Rigging, by Kiaran Ritchie and Jake Callery, 2005, CG Toolkit, California (defunct publisher). There are three volumes, and they are out of print now. If you can come across a used copy, you'll really get an understanding of MEL with those books. What we covered in this book is mentioned in about two pages of that book! They cover stretchy as well, including an IK/FK stretchy spine.

Body Language: Advanced 3D Character Rigging by Eric Allen and Kelly L. Murdock, 2008, Sybex, NJ. This is a swell book and delves deeper into some concepts we have brushed across, thus the "advanced" in the title. It has a stretchy spine system you might want to check out.

Stop Staring: Facial Modeling and Animation Done Right by Jason Osipa, 2010, Sybex, NJ. I didn't even realize until just now that (a) this was the third edition already, and (b) we had the "right" similarity in our titles. We must have the same marketing team. Due to Osipa, I did not include a silly little chapter on facial setups; he has books dedicated to it. I could not do the topic justice with one chapter. He uses a lot of expressions in this book, and blendshapes have changed how they are done. But the core idea and his CNTRL systems are phenomenal.

On the subject of MEL, there are a few books out there nowadays and lots of material online. You would also be setting yourself up for success by learning Python for Maya as well. I was expecting to change a large part of this book to Python, but found that the MEL scripts still worked and were slightly faster.

I'm talking about the scripting level inside of Maya. You'll want to learn how to script your rigging process so that you can automate the routine parts and spend more time developing new things.

There is a deeper path—and that is writing native nodes that work inside of Maya. For that, you would learn C++. Full stop. That is the computer science path and a lovely one. Python doesn't help you there since it cannot be implemented in a threaded fashion inside of Maya and therefore slows down everything. You can find courses on scripting and deeper plugin coding here: https://ondemand.riggingdojo.com/

My favorite places for rigs:
- **https://www.friggingawesome.com/**
- **https://agora.community/**
- **https://www.iashwin.net/rigs**

There are autoriggers out there. Here is an interesting one on the horizon: Ozone 3D. (https://www.ozone3d.com/). From what I understand, it will rig independently of any software and then export to what you are animating with: Maya, Blender,

Unreal, etc. It was created by four former PIXAR riggers. I'm going to keep an eye on this one. Great people. Wonderful idea.

I'm sad to end this journey with you. It's been a long road; we've laughed and cried together. I've patted your back when you cursed the gods that crash Maya, and I've done the happy dance with you when you bested the 'puter gremlins and got your rig to work. You've done a great job; damn skippy. Be good to your animators and rig it right.

Warmly,
Tina

INDEX